FILM

Space
Time
Light
and
Sound

Lincoln F. Johnson
Goucher College

Holt, Rinehart and Winston, Inc.
New York Chicago San Francisco Atlanta Dallas
Montreal Toronto London Sydney

Editor Rita Gilbert
Picture Editor Joan Curtis
Manuscript Editor Joanne Greenspun
Production Assistant Patricia Kearney
Production Supervisor Sandra Baker
Designer Marlene Rothkin Vine
Design Assistant John Macellari

Scenes from *Moana* copyright © 1926 by Famous Players Lasky
 Corp. Copyright renewed.
Scenes from *The Last Command* copyright © 1928 by Paramount
 Famous Lasky Corp. Copyright renewed.
Scene from *Citizen Kane* copyright © 1941 RKO Radio Pictures,
 a division of RKO General, Inc.
Scene from *Modern Times* copyright © The Roy Export Company
 Establishment.
Scenes from *A Fool There Was* copyright © 1922 Twentieth Century-
 Fox Film Corporation. All rights reserved.
Scene from *Visions of Eight* copyright © 1973, Wolper Pictures.

Library of Congress Catalog Card No. 73-20887
College ISBN: 0-03-078050-0
Trade ISBN: 0-03-013111-X
Composition and camera work by New England Typographic Service, Inc., Connecticut
Color separations by Offset Separations Corp., New York
Color printing by Lehigh Press Lithographers, New Jersey
Printing and binding by Halliday Lithographic Corporation, Massachusetts
6789 006 98765432

Preface

The purpose of this book is much the same as that David Wark Griffith no doubt had in mind when he said, "What I want to do is to make you see..." And one of its principal assumptions is expressed quite clearly by the character Nevers in *Hiroshima, mon amour:* "I believe the art of seeing has to be learned."

Film: Space, Time, Light, and Sound concerns itself primarily with the end product of the filmmaker's art—the film as it appears on the screen. But it assumes that, as with any art, perception and comprehension are extended by some understanding of how the filmmaker works and by some awareness of the various forms the medium has taken during its brief history. Therefore, it closely examines the filmmaker's materials—space, time, light, and sound—his methods of organizing them into complex structures, and the technical processes available to him insofar as these affect the ultimate result. While particular elements or aspects of film are treated in separate chapters, the interrelationships among them are stressed throughout.

The opening chapters deal with the factors that make film unique among the visual arts and isolate for special consideration the elements of space and time, showing how movement through both gives the film medium its extraordinary and characteristic plasticity. A look at the principles of continuity, harmony, and contrast reveals some of the filmmaker's most expressive tools. Because of their importance to the filmmaker's visual vocabulary, color and tone provide the subject matter of an entire chapter, which is illustrated by series of color stills from two important films as well as by several briefer sequences. Subsequent chapters explore the expressive uses of sound, the articulation of tenses in film, several of the most popular modes of approach to film structure, and a number of familiar styles or genres. A final section touches upon the individual contributions made by

various film personnel, who most often are for convenience grouped under the general category of "filmmakers": the writer, cameraman, editor, actor, director, producer, and that least conspicuous but often pervasive presence, the censor.

Because films are, above all else, a sensory experience in the realm of human vision, every point advanced in the book is supported by visual evidence taken from actual films. To further promote coherence and continuity, each chapter (with one exception) concentrates for analysis and illustration on a single complete film or on an important integral segment. Along the way, the text refers to other films and is illustrated by individual stills from them. Films chosen for illustration are those that demonstrate some particular historic or aesthetic significance. At the same time, the general availability of the films has been taken into account, in the hope that readers wishing to view the works discussed could gain access to them through standard lending services. The date associated with each film is that of its original release, and, in the case of foreign films, the title is that by which the film became known in the United States.

Most of the illustrations are frame enlargements made from actual films, rather than shots taken with a still camera during the course of production, for the latter frequently differ considerably from the image that appears on film. Their variable quality results in part from the unpredictable quality of the available originals, but even more from a phenomenon one discovers early in the study of the medium and repeatedly thereafter: images that seem sharp and clear on the screen often are not so in fact.

A terminal filmography lists full credits for virtually every film mentioned in the text. Both the glossary and the bibliography contain much information beyond the specific references made in the main body of the text; the intent here was to acknowledge the several ways through which films can be approached and the diverse interests present among readers. Altogether, they should provide both leads to further study and a vocabulary capable of application to many situations.

In the course of its development the text suggests, without labeling them as such, a variety of approaches to the study of film, from the examination of single frames and frame-counting to a consideration of methods of narration and exposition and types of symbolism. The detailed analysis so often implied is not, of course, an end in itself, but a means of expanding awareness.

The art of seeing films is perhaps one of the most difficult to learn, for the study of film—in the 20th century that most characteristic, popular, and seemingly ubiquitous of the arts—creates special problems for the serious viewer. The appropriate subject of study, the film itself, consists of an intangible complex of images and sounds that appear and disappear in an instant. When they have vanished, there is little to consult but words, and as often as not the words are concerned with paraphrasable content, the story or narrative, and the ideas these inspire. And while these subjects hold undeniable importance, they offer only a fragment of the total film experience. Here, the great number not only of illustrations but also of series of illustra-

tions, the intimate relationship imposed upon the images and the text they illustrate, and the emphasis on visual and temporal structures—all constitute an attempt to apprehend those vehicles that carry so much of the expressive content of films and at the same time offer delight in and of themselves.

ACKNOWLEDGMENTS

Directly or indirectly a great many people have helped in the production of this book, too many to acknowledge individually.

Theresa M. Johnson, my mother; Elizabeth Geen, Dean Emeritus of Goucher College; and Gertrude Rosenthal, Chief Curator Emeritus of the Baltimore Museum of Art provided support, challenge, encouragement, and occasionally goading.

Professors Standish D. Lawder of Yale University, George H. Bouwman of the Institute of Film and Television at New York University, John H. Hunter of San Jose State College, William C. Childers of the University of Florida, and Dean Bernard Hanson of the Hartford Art School all read a preliminary draft of the manuscript, and their thoughtful and constructive criticism was of great help in preparing the final version. In addition, Dr. William Mueller, Director of the Humanities Foundation, Inc.; Professor Brooke Peirce of Goucher College; Professor Carol Peirce of the University of Baltimore; and Christopher Johnson read parts of the manuscript and offered valuable comment.

A number of people have provided information, advice, counsel, and help in finding films, filmmakers, and photographs, among them Professor Frank Anderson Trapp of Amherst College; Phyllis M. Dubois Hunt, formerly of the Johns Hopkins University Library; Jaromir Stephany, head of the Department of Film and Photography at Maryland Institute College of Art; Helen St. Cyr and Carolyn Hauck of the Films Department, Enoch Pratt Free Library; Paul Spehr, Prints and Photographs Division, Library of Congress; Mrs. Washington McIntyre Bowie, Audio-Visual Assistant, and Christine Backus, Art Assistant, Goucher College Library; Norman Lear of Tandem Productions, Inc.; Robert Pike of the Creative Film Society; and Adelle Mencken. Betsy Jane Gould was of inestimable help in compiling the filmography. To all these I proffer my sincere thanks.

The Committee on Research and Publication at Goucher College, through the award of a Danforth Foundation Fellowship, freed a portion of my time from regular academic duties and enabled me to complete work on the text.

I owe a special debt of gratitude to the staff at Holt, Rinehart and Winston who were more directly involved in the project; to Dan W. Wheeler for supporting it almost from its inception; to Rita Gilbert, who enthusiastically assumed its sponsorship and controlled every facet of the production; to Joan Curtis, who performed the herculean and often thankless task of marshalling the illustrations and securing permission to reproduce them; to Patricia Kearney, who corrected each stage of proof and prepared the index; to Joanne Greenspun for so carefully editing the text and the supplementary material; to

Marlene Rothkin Vine, whose imaginative and appropriate design provided a visual framework for the contributions of the others; and to all of them for saving me from some embarrassment and the reader from some confusion.

My special thanks must go to the filmmakers, whose works have provided so much delight and stimulation, thereby making this book necessary and possible.

Finally, I am most appreciative of my son Michael's patience, temperance, and fortitude, and of the manifold aids and comforts provided during the long and sometimes arduous weeks of production by Rodica Helena Isaila.

Towson, Maryland L.F.J.
March 1974

Credits

The author and publisher wish to thank the following companies or individuals who hold rights to the illustrated films:

Kenneth Anger (526)
Argos Films (690)
Production G. de Beauregard/S.N.C., Paris (440, 441, 486, 630)
Stan Brakhage (695)
Luis Buñuel (696–723)
Joseph Burstyn, Inc. (620–629)
Canadian Pacific/Cominco (548, 549)
René Clair (107, 108, 115, 635–657)
Shirley Clarke (542)
Columbia Pictures, a Division of Columbia Pictures Industries, Inc. (760, 769)
Bruce Conner (675, 676, 753–756)
Contemporary Films/McGraw-Hill (7, 8, 522–525, 527, 529–536, 550, 682, 683, 685, 686, 694)
Contemporary Historians, photos by John Ferno (545, 546)
Arnold H. Crane (758)
Dan Drasin (22, 23, 605–609)
Emlen Etting (538, 539)
Famous Players Lasky Corp. (446, 610–612)
Films 13 (117)
Föreningsfilmo (57–68, 410)
Franco London Film (447)
Franfilmdís (602, 658–674)
Grove Press (273, 445, 782–787)
Alexander Hammid (124–176)
Alfred Hitchcock (541)

Hattula M. Hug (566)
Joris Ivens (442–444)
Janus Films (6, 40, 42, 46–48, 183, 430–435, 537, 601, 774–781)
Macmillan Audio Brandon (409)
Courtesy of the Rosa Madell Film Library, Artkino Pictures, Inc.
 (20, 21, 31, 33–39, 43, 44, 187, 274–408, 411–425, 579–599)
Burgess Meredith (677–681)
Antonio Musu (603, 604)
National Film Board of Canada (521, 684, 688, 689, 763)
Robert Nelson (750–752)
New Yorker Films (687)
Ohio State University Department of Photography and Cinema (184)
Patrick O'Neill (452–459)
Paramount Famous Lasky Corp. (222–229, 540)
Parc Film mag Bodard (448–451, 487, 488)
RKO Radio Pictures, a division of RKO General, Inc. (429)
Hans Richter (565)
Leni Riefenstahl-Film (246–272, 766)
Rizzoli Film (69–75, 83–90, 93–106, 239–245, 460–479, 490–517)
Raymond Rohauer (177, 543, 544, 631–633, 725–749)
The Roy Export Company Establishment (41)
Sandrew Film & Theater AB (32, 52–56, 109–114, 489)
Michael Snow (78–81)
Ralph Steiner (692, 693)
Paul Strand (691)
Svensk Filmindustri (528, 765)
Terra-Film (551–564)
Twentieth Century-Fox Film Corporation (480–484)
United Artists Corporation (50–51)
Herman van der Horst (178–181, 221)
Walter Reade Organization (5)
Clifford West (439)
James Whitney (762)
Courtesy of Wolper Pictures (4)

PHOTOGRAPHIC CREDITS
Alinari-Art Reference Bureau (49)
Anthology Film Archive (542, 690, 771, 772)
British Film Institute (3, 187)
Culver Pictures, Inc. (518, 770, 773)
Giraudon (12, 14)
Kem Electronic Mechanic Corporation and Peter W. Weibel (182)
Museum of Modern Art (1, 2, 36, 48, 50, 51, 91, 92, 116, 299,
 409, 436, 525–528, 536, 537, 540, 541, 545–547, 551, 566, 613,
 615, 617, 634, 640, 655, 663, 685, 686, 692, 693, 757, 758,
 764, 769)
Herman G. Weinberg Collection (117)
Wide World Photos (600)

Figure 24 adapted from *Georges Seurat* by John Rewald
 (New York: Wittenborn & Company, 1946).

Contents

1

Film as a
Unique
Medium

On December 28, 1895, in the Salon Indien of the Grand Cafe, Boulevard des Capucines in Paris, Antoine Lumière presided over the first public exhibition of films in the form in which we know them today. The work of his sons Louis and Auguste, Lumière's offerings were short and described simple events: a train arriving at a station (Fig. 1), laborers demolishing a wall, workers emerging from a factory (Fig. 2), parents feeding a child (Fig. 3). One narrated a simple but amusing anecdote (Fig. 436): a gardener is hosing down a garden; a boy steps on the hose; the water is cut off; the gardener turns the nozzle to his face to see what is wrong; the boy removes his foot; the water shoots into the gardener's face; the gardener drops the hose, runs after the boy, and spanks him. These are all ordinary subjects, certainly, of a type we might associate today with "home movies," but at the time the simple fact that the images moved seemed miraculous, and the projection of moving images to the screen transformed the most banal activity into marvel.

THE NATURE OF FILM

Today the physical structure of film and the manner in which it produces an illusion of motion—a "living picture" as it was sometimes called in the early years of film history—are essentially the same as those employed in that first public exhibition. Film is a thin, flexible, transparent ribbon or band of plastic material—now generally cellulose acetate, at one time cellulose nitrate—that provides a base for the *emulsion*, a layer of light-sensitive silver halide suspended in gelatin, too thin and insubstantial to hold its shape without support. Recorded on the roll of film are a series of still photographs or *frames*. The transformation of these static images into apparently moving ones depends on simple mechanical and optical principles.

As a rule, film is moved through the projector from a feed reel to a take-up reel by gearlike teeth or sprockets and by fingerlike claws that fit into perforations at the edge of the film. The movement is not continuous but intermittent, however. Each frame passing in front of the aperture through which light is projected stops for a fraction of a second while a shutter opens; then the shutter closes to provide an interval of darkness during which the next frame can be brought into position. Generally, the film proceeds through the projector at a speed of 24 frames a second, although the rate may vary according to the gauge or size

1. *The Arrival of a Train.*
Antoine Lumière. France, 1895.

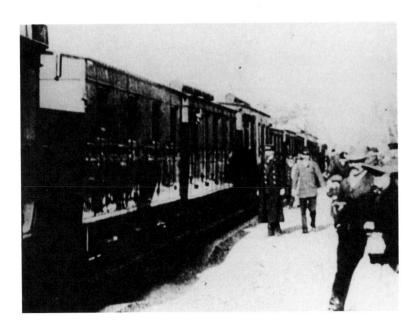

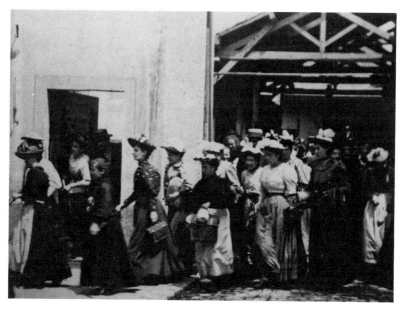

above: 2. *Workers Leaving the Lumière Factory.* Antoine Lumière. France, 1895.

below: 3. *Feeding Baby.* Antoine Lumière. France, 1895.

of the film and can be deliberately accelerated or retarded for certain effects. According to the principle of persistence of vision, the eye retains the static image during the period of darkness, so that one image, in effect, is dissolved into the next to provide either a continuous view of a static image or, more important, an illusion of continuous motion.

If the materials and methods of filmmaking now and three-quarters of a century ago are similar, responses clearly have changed. Audiences today no longer can experience the excitement of discovery. Films have become, for those living in the western world at least, a familiar and commonplace part of daily life. They are accessible in the local theaters,

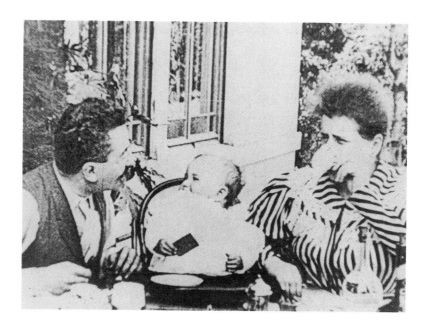

available on the television screen, projected in classrooms and even in places of worship; they serve as tools of scientific research, as historical records, as aids to instruction, as instruments of persuasion, as means of entertainment; they treat the whole range of human knowledge, interest, and feeling. In sum, the presence of film is so pervasive that it would not be at all impossible for some individuals to have viewed a film every day of their lives from the time they could discriminate between light and dark. In one form or another, the moving image on the screen might be as much a regular part of our daily fare as bread.

Yet very often we look without being entirely aware of what we are seeing—or hearing. The information a factual film conveys may be so interesting, the story a fictional film narrates so diverting or gripping, and the rush of images on the screen so rapid that we miss as much as we see; for the content of a film and our reaction to it emerge not only from the subject matter or the story but also from the manner in which the filmmakers manipulate their materials. The selection of images and the order in which they are presented; the control over space, light, and sound; the tempo, accent, and rhythm in which visual images and sounds are organized—these, too, convey meaning and provide delight.

FORMAL ELEMENTS OF FILM

Space, light, sound, tempo, accent, and rhythm do more than simply carry a story; they shape it, modify its content, determine its meaning. Light and space can be thought of as an alphabet through which the filmmaker expresses his ideas, its "letters" the raw materials he renders articulate—molding, shaping, and building them into expressive structures, translating form into meaning. The "words" in his vocabulary are the infinitely various degrees of light between white and black—that is to say, *tones*—and the different attributes of space: shape, size, position, direction, proportion. Of course, space and light, form and tone lack the specific connotations of words. They are more generalized than the most abstract concept stated in words and susceptible to an infinite multiplicity of application. In effect, these elements form the roots of a visual vocabulary in which light is, as it were, declined and space conjugated, but a visual vocabulary in which inflection must be reinvented or readapted to every new context. Much the same thing might be said about sound, although there are thousands of films without sound and more that contain long passages of silence in which, and *through* which, meaning is conveyed.

4. *Visions of Eight.*
Arthur Penn segment.
U.S.A., 1973.

Tempo, accent, and rhythm all involve relationships in time. For the filmmaker time is not simply the interval in which a particular action takes place, but a malleable element to be shaped into patterns, shortened or extended, retarded or accelerated, even invented. Language moves forward in rhythms and accents so modulated that they convey all manner of overtones. In film, too, patterns of time condition our responses, sometimes lulling our eyes in slow and ponderous cadences, sometimes assaulting them with metrics so brisk and crackling they are scarcely bearable. In either case time lends a new dimension to the thing seen or even transforms it completely. The funeral cortege, the embrace, or the athletic contest, viewed at anything but normal speed—whether accelerated in fast motion or retarded in slow motion—assumes an unexpected significance, perhaps comic or pathetic or ritualistic (Fig. 4).

Some sense of how deeply the filmmaker can be involved in time is revealed in the Swedish actor Max von Sydow's description of Ingmar Bergman's methods of directing: "He gives you the distance to the other actor, to the other character. He gives you the rhythm in the action. He gives you the pauses, the increasing speed of the action. He gives you the point where the explosion comes, or where it should have come but it doesn't."[1]

Because other arts employ light, space, time, and sound as their formal raw materials, film inevitably shares certain characteristics with them. Awareness of the similarities often misleads the viewer or even the filmmaker into treating film as though it were an extension of some other art form, such as literature or drama. Many regard it as a method of painting with light. Ingmar Bergman observes that film has nothing in common with literature but is more akin to music, while the great German director Leni Riefenstahl once said that the law of film is architecture, balance. And Maya Deren, the American avant-garde filmmaker, constructed many of her works as choreog-

raphy for the camera. All these interpretations have the value of suggesting certain aspects of the medium, but none of them, obviously, defines it. Film is a complex medium with its own peculiar characteristics, potentialities, and limitations. Nevertheless, it is worth considering, if only briefly, the ways in which film resembles and differs from other media in order to achieve a clearer understanding of the nature of film itself.

As an art of patterned light and space, film resembles the other visual arts—painting, drawing, sculpture, and architecture. However, except for kinetic paintings or sculptures and light art—which as often as not were inspired by the example of film—film stands alone in its incorporation of movement and its consequent immersion in time. This difference is less in kind than in degree, not so much a question of motion and time being included but of the extent to which they control the spectator's vision. A sophisticated viewer may well perceive in the progressions of form and color in painting, sculpture, and architecture something resembling rhythm and may therefore invest static compositions with temporal import. And he will of necessity apprehend the work not all at once but in an accumulation of views, each focusing on a particular part. Even more is the spectator's experience of architecture subjected to time and controlled by a building's design. The Gothic church, for instance, inhibits his vision by its darkness and at the same time impels him toward the nave and ultimately to the altar. As he walks, spaces open and close about him, forms flow into one another or follow one another in orderly sequence, light changes in intensity, and the experience of a static construction becomes an experience in time. In the end, however, the visitor looks and moves wherever he wishes and for as long as he wishes. Film, by contrast, is far more manipulative of the viewer; it can determine the scope of vision, the direction of the glance, the order in which parts will be seen, and the duration of the viewing. In film, as compared with the other visual arts, movement is not merely a possibility and time an undifferentiated context; together they comprise the strictly measured, immutable mold of experience.

[1] All annotations will be found in a special section that begins on page 326.

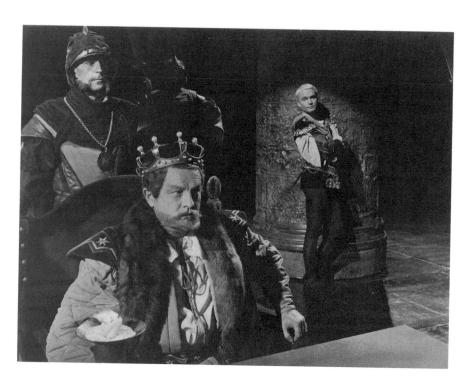

5. *Hamlet.* Laurence Olivier. Great Britain, 1948.

Dance and drama also offer the audience a particular sequence of events, but they in no way control his visual field. Viewing the stage, one apprehends the available space, selects the details on which to focus, and to a considerable extent regulates the order in which he will view them. He can choose to concentrate on the whole or a part, the expression on a face or the gesture of the hand, the action or the response, the setting or the players. Thus, the experience of seeing the same play on the stage and in a film can be quite different. In a shot from Laurence Olivier's filmed version of *Hamlet* (1948; Fig. 5), several devices serve to color the audience's responses: Hamlet's somewhat detached air as an observer and his languid posture are brought into direct conflict with the tension and almost angular attitude of the king; the conflict of lines and the forced contrast of light and dark inject visual instability into the scene, making the dramatic manifest even in this silent, immobile photograph. Most obvious (and therefore perhaps easily overlooked) is the viewer's immersion in the scene, as opposed to his physical de-

tachment in a dramatic theater. The film draws the spectator into its space, placing him across the table from the king as if he were a participant in the drama. All these observations can be applied equally well to presentations of the dance (Fig. 6), in which the film can isolate a certain view to reveal what the spectator might otherwise not notice. On the other hand, of course, filmic interpretations of drama or dance also limit the spectator's vision to that of the filmmaker.

In its control over audience attention film resembles the literary arts, which are also embedded in the matrix of time and thus require that specific fragments of information be apprehended in a given sequential order. Film is like literature, too, in the freedom with which it operates in time and space, instantaneously transporting the spectator from one point to another, eliminating intervening distances and moments, acting with the speed and fluidity characteristic of elisions of the mind. There are, however, important differences quite apart from the obvious contrast between a visual medium and a verbal one. While literature is confined to a one-dimensional linear scheme—in which objects, conditions, action, ideas, or phenomena can be pre-

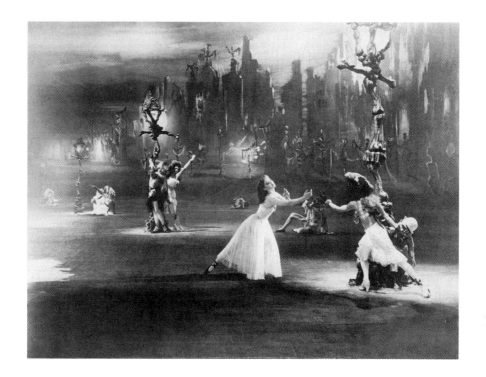

6. *The Red Shoes.* Michael Powell
and Emeric Pressburger. Great Britain, 1948.

sented only by listing the details separately
—film offers ideas and sensory stimuli at one
and the same time. Light and color; impres-
sions of plane, volume, mass, density, and tex-
ture; movement and stasis; sound and silence;
even different kinds of space—all appear si-
multaneously, creating a chord in which the
tenor of one part is modified by all the rest.

The famous rugby scene from René Clair's
Le Million (1931) illustrates the nature of the
cinematic chord clearly and simply (Figs. 7,
8). On the stage of an opera house two oppos-
ing factions are trying to gain control of a
man's jacket, which contains a winning lottery
ticket. The jacket is passed like a football
from one person to another. There are passes,
attempts at interception, and great pileups
of bodies. At any one moment both spatial
and tonal patterns are confused. But through
it all the movements of camera and figures
provide a dancelike, rhythmic order, as the
coat moves first to one side, then to the other.

As the action develops, the viewer becomes
aware that the sound track is commenting

7

8

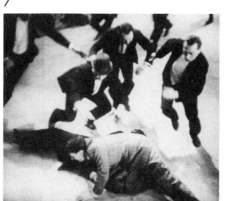 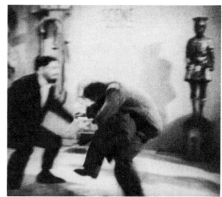

7, 8. *Le Million.*
René Clair. France, 1931.

on the scene: there is a roar from a crowd (hardly opera fans), the shrill whistle of a referee, all the familiar uproar of a football game. Any view of the field of battle alone would suggest confusion and excitement, but the rhythmic movement in each shot and a rhythm in the sequence of shots order the confusion, while the sound track translates the action from simple excitement to humor. In short, each aspect contributes to a single, if complex, meaning that no one aspect could convey. As many filmmakers have noted, in its chordal character and in its rhythm of change, interval, and duration, film is very much like music.

For all its resemblance to the various media, the art of the film is not simply a conglomerate of the others. The space of film is not the space of painting, sculpture, architecture, or the stage; its movement differs from the movement of dance or drama; filmic sound remains quite distinct from that of drama and music; and the parallel to music is in the use of time only. Above all, film is a medium of expression in which light, space, time, motion, and sound are inseparably bound together, shading and modifying one another. It is the very integration of these elements that makes film a unique medium.

We apprehend physical reality, as we do film, through interrelationships of light, space, movement, time, and sound; still, it would be absurd to conclude, as some theoreticians do, that film is necessarily concerned with the representation of physical reality. The dimensions of art are not the dimensions of the "real" world but are created by the artist and made articulate by him. How filmic space, time, light, and sound are invented and how they become articulate will be explored in the following chapters.

2
Space

Unwavering in its brilliance and unmodulated by the faintest trace of shadow, a patch of light thrown onto a screen from the arc lamps of a projector in a darkened room confronts the viewer with an enigma. It communicates nothing but its light. If the viewer has just entered the room and his eyes have not adjusted to the light, he will not readily be able to judge the distance between himself and the screen. Lacking the familiar measure provided by rows of heads and seats, unless he is familiar with the room, he will be unable to say for certain that the screen is 10 feet away or a hundred; nor can he be sure that the patch of light is not a hole in the wall looking out into a space beyond the confines of the room. And not knowing the distance between himself and the light, the viewer cannot begin to measure the area of the light to know if it is large or small. Nor can he be certain whether the patch of light is solid or void, opaque or transparent. It is simply a neutral space in which anything or nothing might happen.

THE ARTICULATION OF SPACE

Let us imagine that the silhouette of a man appears on the lower edge of this patch of light (Fig. 9). The figure, by intruding into this unmodulated space, shatters the enigma, since it provides a scale for determining the measurements of the space. There are still uncertainties, however. The figure may be in the same plane as that of the rectangle, or it may be standing in front of it or behind it. The bright area around the figure remains amorphous and suggests a space beyond the plane where the light falls. Indeed, this bright area, framed by the surrounding darkness, may be a wall with specific limitations or it may be sky, which is limitless.

If the figure is placed higher on the screen and a horizontal line is established behind it, if contours of walls and floor lines appear, the two-dimensional plane will be hollowed out and the void shaped into three dimensions (Fig. 10). The relative size and distance of objects will become evident and the space articulate. But this space will no longer be the space of a rectangle projected on the screen. It will now be the space of the image pictured in the rectangle, a space that establishes a system of measurement and an internal consistency of its own. For whether the image

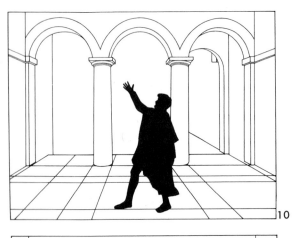

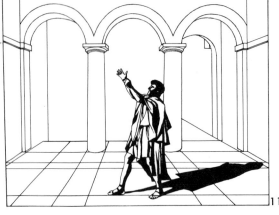

9–11. Spatial ambiguities are gradually resolved as more and more information is provided.

on the screen is in fact 300 feet tall or 3 inches tall, whether it is placed above its original position on the rectangle or below it, it will still appear to be as tall as a human being, and the space around the figure will become comprehensible. Although it approximates the space of human experience, it will, of course, be a space created by the artist.

The enigma has now been totally shattered and a paradox has been revealed: the image of a man on a screen, no matter what its size, will still appear to the viewer to be the size of an actual man, and the space surrounding the image will maintain the same relationship to it whether we look up or down at the figure or from the side. We have only to think of a figure magnified many times larger than actual size on the screen of a drive-in theater or reduced to a 6-inch television set to realize that our eyes and mind adjust to these changes in scale and that we still "read" the image as that of a man, not a giant or a dwarf. But even if the image maintains an internal and quasi-objective consistency and the human eye and mind exercise their capacity to accommodate, the size of the image and the angle of vision are not without significance, as we know from the way we choose seats in a theater to find the distance and angle of vision most comfortable for us. Just as all the dimensions of the film—color, light, movement, sound—play their parts in compelling our attention, engaging our minds, rousing our emotions, stimulating our intuitions, and establishing a subtle almost indefinable rapport between film and spectator, so, too, in almost subliminal ways, does our position in space. Seen from afar or on a television set, film becomes a specimen we can examine with detachment; seen up close it overwhelms us with its giantism and confuses us with grotesque distortions and vagueness.

Our eyes seem to adjust most readily when the scale of objects in the picture approximates the scale we know from ordinary visual experience, when the area of the images approximates the normal field of vision, and when the angle of vision approximates that of the camera's lens. The rectangular image cannot duplicate the normal visual field, of course, partly because it is rectangular while

the optical field is more or less circular—so that even the extension into wide screen and the embracing wings of Cinerama offer a decidedly meager field by comparison to the environment to which we are accustomed—and partly because it does not encompass the area included in our peripheral vision. But it can, if we assume the proper distance, approximate what might be described as an area of focus, filling our visual field sufficiently to minimize distracting elements around the edges. When we view the screen from such a point, the spatial order of the film seems most convincing. We can identify with a familiar scale, and the image, even abstractions, will gain in clarity, significance, and capacity to involve us.

The subtle force with which the spatial relationship to the image works on us becomes dramatically apparent if we change our position with respect to a picture presenting strong lines of perspective projection. As we arrange ourselves so that our eyes are on the same level as the horizon in the picture and our distance from the image is the implied distance of the camera, the perspective suddenly conforms to our normal way of seeing, space expands before us, and forms snap into relief as our eyes lock into the perspective system of the projected image. In effect, we enter the space of the film, and the notion of aesthetic distance is translated into geographical or physiological terms.

So important is the weight of experience in viewing perspective that we will perceive even a linear outline, like that of our illustration, as existing in depth if we hold the picture at the proper level and distance (Fig. 10). The pictured space at this point presents itself simply as a scaffolding, for the lines represent only the contours of the solids and tell us little of the density, mass, and texture that make the solids palpable and endow them with verisimilitude. If these appear (Fig. 11), the space becomes more fully articulate, expressing itself by virtue of the things within it, communicating dimensions, shapes, positions, directions, densities, textures, qualities we can measure and, as it were, touch with our eyes, qualities that assure us of the existence of the space and, by extension, our own.

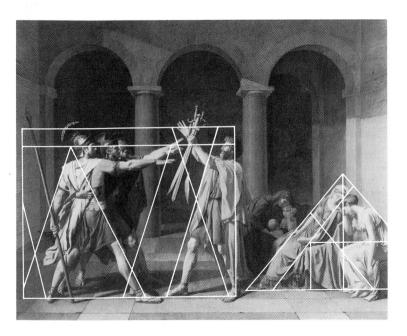

12. Jacques-Louis David. *The Oath of the Horatii.*
1784. Oil on canvas, 10'10'' × 14'.
Louvre, Paris.

THE EXPRESSIVE CONTENT OF SPACE

If the affirmation of spatial existence consti-tuted the total content of spatial articulation, *filmic space,* that is, the space the filmmaker delineates, would be of little importance to the study of film, and we could take it for granted, accepting it simply as the vehi-cle for some kind of action. But filmic space has the same range of expressive potentiality as space in the other plastic arts and may ar-ticulate not only itself but also an individual's attitudes toward the world or toward the ma-terial with which he is working, revealing the manner in which he structures ideas and emo-tions, injecting reason or dramatic intensity into the filmic event, and conveying what we will designate expressive content.

Among the other plastic arts, some of the closest parallels to film can be found in the art of painting, which has, in fact, served as an inspiration and model for many filmmakers. Sergei Eisenstein, for example, based much of his film theory on his study of painting and many of his filmic compositions on principles that seem to have been derived directly from the art historian Heinrich Wölfflin. In *Intoler-*

ance (1916), D. W. Griffith imitated the com-positions of old masters, 19th-century aca-demic painters, and illustrators of Sunday-school texts to give his films a naïve, even simple-minded authority (Fig. 30). An exami-nation of the expressive use of space in some familiar styles of painting will demonstrate the similarities between the two arts and help to clarify the important differences as well.

The diagrams to which we have been re-ferring in this chapter are based on a late-18th-century painting well known to students of art, *The Oath of the Horatii* by Jacques-Louis David (Fig. 12). The incident depicted derives from the legendary history of Rome and concerns the rivalry between two ancient clans, the Horatii and the Curiatii. Rather than engage in mass slaughter, the clans each chose three champions to fight for them. David represents that moment in the story when the champions of the Horatii take an oath to fight to the death to defend the honor of their clan, while their wives—who are also the daughters of the Curiatii—anticipate the outcome, which will be tragic for them no matter who wins. The children looking on ap-prehensively serve as innocent symbols of the interrelationship between the two clans.

David manipulates each spatial aspect of the scene to reinforce the narrative content and its moral implications; size, direction, shape, position, measure, and proportion all contribute overtones of stoic fortitude and de-termination. Relatively large within the for-mat, the figures assume heroic proportions consistent with their noble attitudes. The con-tours and axes of major volumes define regular geometric configurations—triangles and rec-tangles with bases solidly planted on the ground plane. Further, the principal structural lines echo the frame of the picture, so that figures and architecture are locked into a tight tectonic grid. The intervals between one ele-ment and another—both across the picture plane (the frontal surface of the painting) and back into the picture space (the illusory three-dimensional area created by the artist)—are relatively regular and develop a solemn visual rhythm. In the rigidity of construction, as sol-idly based as a Roman temple, in the regular-ity of the interval, and in the heroic simplicity

of forms, David seems to translate into visual abstraction the moral firmness of the participants and the ceremonial solemnity of the occasion. At the same time, while the grouping of the women and children conforms to the triangular and rectangular patterns established throughout, their smoothly flowing contours within these outlines contrast with the more angular attitudes and abrupt changes of direction in the outlines of the men, thus suggesting the melting pathos of their position as well as basic ideas about femininity.

The expressive aptness of David's composition becomes even more apparent when it is compared with a quite different compositional configuration, such as that in Peter Paul Rubens' *The Lion Hunt* (Fig. 13). There are many similarities between the two works. In both, the close proximity of the figures to the picture plane enhances a heroic scale, and an underlying grid of rectangles and triangles orders the compositions. However, the emphasis in each painting is quite different. Whereas David presents triangles firmly based on the ground, Rubens balances his triangles on their apices; while David stresses architectonic forms like rectangles, Rubens builds explosive radial patterns; and David's relatively long intervals and flowing contours contrast with Rubens' short intervals and broken contours. Once again, narrative content is translated into spatial terms. Rubens' composition seems freed from the confinement of the frame, its major lines suggest momentary action, dynamic spontaneity, force, vigor, and uncertainty. A lion hunt in the style of the *Horatii* would probably seem a tame sport indeed, more like a symbolic, ritual act. Conversely, an oathtaking in the style of *The Lion Hunt* might appear irresolute or hysterical.

What happens when the two artists undertake the same theme is truly instructive. In depicting the reconciliation between the Romans and the Sabines, Rubens approaches David and David approaches Rubens (Figs. 14, 15). In all the paintings we have considered, the plane geometric figures we discern— the triangles, rectangles, radial configurations, and the larger structures into which they are built—have little to do with the representation of things or actions but rather concern

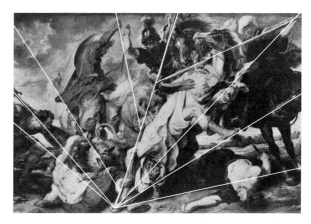

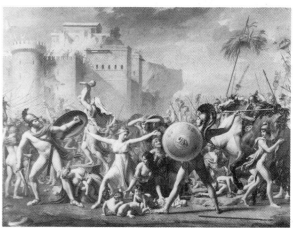

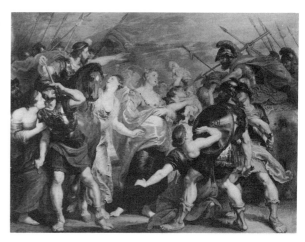

top: 13. Peter Paul Rubens. *The Lion Hunt.* c. 1617. Oil on canvas, 8'2" × 12'3⅝". Alte Pinakothek, Munich.

center: 14. Jacques-Louis David. *The Sabine Women Ending the Battle between the Romans and the Sabines.* 1799. Oil on canvas, 12'8" × 18'. Louvre, Paris.

above: 15. Peter Paul Rubens. *Hersilia Concludes a Peace between the Romans and the Sabines.* c. 1617–19. Oil on canvas, 8'2" × 11'1". Alte Pinakothek, Munich.

right: 16. Piet Mondrian. *Composition with Red.* 1936. Oil on canvas, 20 × 19⅞". Philadelphia Museum of Art (A. E. Gallatin Collection).

far right: 17. Wassily Kandinsky. *Painting 198 (Autumn).* 1914. Oil on canvas, 5'4" × 4'¼". Solomon R. Guggenheim Museum, New York.

below: 18. Peter Paul Rubens. *The Rape of the Sabines.* c. 1635. Oil on canvas, 5'7" × 7'9". National Gallery, London.

bottom: 19. Nicolas Poussin. *The Rape of the Sabine Women.* c. 1637. Oil on canvas, 5'7⅞" × 6'10⅝". Metropolitan Museum of Art, New York (Harris Brisbane Dick Fund, 1946).

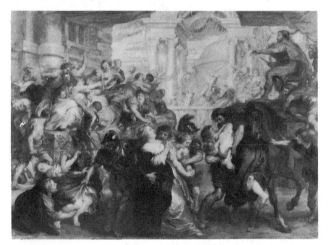

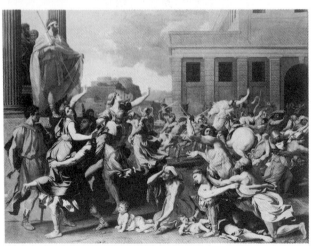

patterns that might be presented in abstract terms. But even as abstract diagrams they carry an expressive charge, just as abstract paintings do. In fact, two works by artists known primarily for nonrepresentational expression—Piet Mondrian and Wassily Kandinsky—seem almost to offer a paradigm of the differences between David and Rubens; there is a similar contrast of static and dynamic organization, yet with all particularization removed (Figs. 16, 17). Obviously, the potential variations in relatively free or constricted compositions are infinite, each combination establishing its peculiar overtones.

Two paintings depicting *The Rape of the Sabines,* one by Rubens and the other by Nicolas Poussin (Figs. 18, 19) yield still another comparison of this nature. Rubens' freer, curvilinear, dynamic organization evokes the sensual aspects of the event, relating it to the universal energies of life that inspire it; Poussin's rather constricted form—static, taut, rectilinear, absolute in its clarity—ties the event to literary archaeology, suppressing its living energy, transforming the rape into a formal rite.

The filmmaker has at his disposal the same spatial elements that the painter employs, and he can order them in a similar diversity of

compositions for equally expressive effects. However, the possible degree of control varies widely, depending on the conditions under which the film is made and the expressive intention of the director. Whereas the painter can maintain nearly absolute control, the filmmaker is often a victim of circumstances.

Documenting an aspect of life, the filmmaker may have to accept contingencies of lighting and action that the painter could ignore or modify to suit his will. Or, in an effort to demonstrate the causal character of life ruled by the laws of chance, he may simply choose to film with minimum control, accepting compositions as they develop, as Jean-Luc Godard often did in *Breathless* (1959). He may even try to work like a painter, as Eisenstein did in *Ivan the Terrible, Part I* (1944).

In preparation for *Ivan, Part I,* Eisenstein made sketches and studies for the disposition of forms and spent days fussing over the arrangement of drapery, cutting into the material to make it conform to the configurations in his mind. The contrast between two scenes will illustrate how he exploited the expressive potentialities of compositions like those of David and Rubens. Ivan's wedding is celebrated with imperial pomp and solemnity, with expressions of joy that are essentially ceremonial (Fig. 20). Eisenstein establishes a pattern of absolute symmetry with a succession of regularly spaced parallel planes receding down the banquet hall to the wedded pair. All is balance and order. Suddenly, the banquet is interrupted by the revolt of the boyars, and the rigidity of the static patterns is broken (Fig. 21). The repetition of horizontals and verticals is supplanted by the thrust of diagonals, the constrictive rectangular pattern broken by free forms, the regular rhythms of triangles shattered by interrupted contours. Stasis gives way to dynamics, and the composition, which at first resembled *The Oath of the Horatii,* begins to seem more like that we saw in *The Rape of the Sabines.* The compositions in *Ivan, Part I* were conceived and plotted over long periods of time, but even the documentary photographer, grabbing his shots on the run, may sometimes be able to approximate similar effects, as Dan Drasin does in *Sunday* (1961; Figs. 22, 23).

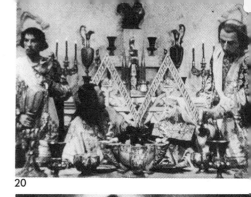

20, 21. *Ivan the Terrible, Part I.*
Sergei Eisenstein.
U.S.S.R., 1944.
Ivan's wedding feast presents a closed, tectonic composition with recession in planes parallel to the picture plane. When the boyars interrupt the feast, the tectonic order disintegrates.

20

21

22, 23. *Sunday.* Dan Drasin.
U.S.A., 1961.
Even a documentary photographer may fortuitously capture dramatic compositions in his lens.

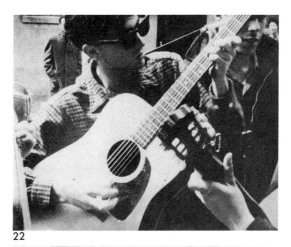

22

23

Spatial articulation, then, can project as its content something more than the identification, affirmation, description, and decoration of space. It can express emotional overtones of varying degrees of intensity and complexity, reason and order, disorder and chaos. Its potential breadth is comparable to that of language, which leads some critics to speak of the "language" of space, vision, or design. In this context the word language becomes a metaphorical substitute for cumbersome phrases like "means of expression" or "method of communication." But spatial organizations resemble linguistic ones only in a general way.

A literal interpretation of the word language, of course, implies tongue, speech, words, units of sound that have been assigned arbitrary significance and by customary usage retain a particular meaning or set of meanings in whatever context they appear. The language of space is more fluid and variable, lacking the arbitrary assignment of content, the precision, consistency, and systematic quality of verbal language. Just as a man is always a man, a triangle is always a triangle, but their implications within a particular spatial context will vary much more widely than the connotations of the words man or triangle.

Some artists, to be sure, have attempted to codify spatial form in the manner of language. The post-Impressionist Georges Seurat saw particular expressive overtones in certain types of configurations: the horizontal line was passive, the vertical active; lines descending from the horizontal were expressive of lugubrious content; lines ascending from the horizontal implied joyous content (Fig. 24). By combining directional forces in varying quantities he hoped to express complex moods with depth and precision (Fig. 25). Similarly, Pablo Picasso and Georges Braque, working in the mode that has been termed Analytical Cubism, reduced pictorial form to a vocabulary of geometric shapes and created a grammar of relationships which, in its calculated ambiguity, its continuously shifting planes, now advancing, now retreating, seems to express the perception of a universal dynamism (Fig. 26). Mondrian carried this method a few steps further, reducing the formal idea of the world to straight lines and rectangular figures.

Even when confronting these pictorial systems, however, the spectator's response is likely to be more direct, intuitive, and global than his response to language, which interposes a screen of conventionalized meanings between the reader or listener and the idea. Modern writers have frequently tried to create short circuits to avoid that screen, as Mallarmé's famous comment to Degas suggests: "One writes poetry, my dear Degas, not with ideas but with words." Verbalized sounds dissociated from referents have been used frequently, in fact, but their resemblance to scat

below: 24. Drawing after a sketch by Georges Seurat, in a letter to M. Beaubourg dated August, 1890.

right: 25. Georges Seurat. *Le Chahut* (study). 1889. Oil on canvas, 22 × 18¼". Albright-Knox Art Gallery, Buffalo.

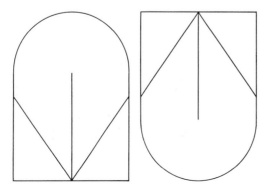

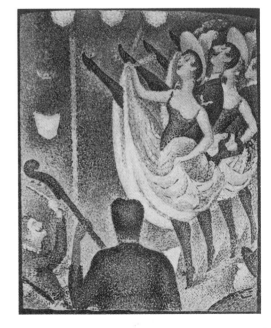

singing should suggest that when language loses its referents it turns into music. That there is a coherent relationship between visual stimulus and response seems possible, but even Kandinsky (Fig. 17), who seems to have given as much thought to the subject as anyone, finally concludes that the system, if it exists, is too complex to rationalize.

The intuitive nature and the effective power of responses to spatial relationships is suggested in Edward Twitchell Hall's *The Silent Language,* which investigates the reactions of people from various social backgrounds and ethnic origins to the relative proximity of another person. The subtle, almost preconscious responses that Hall's analysis implies suggest the way people may react to space in pictorial images. His study shows that within specific societal groups there is a consistency of response to spatial relationships, however little it may be consciously manipulated. For example, Hall demonstrates that Latin Americans generally prefer to converse at a distance that North Americans (by which he seems to mean individuals of northern European descent) may regard as disconcertingly intimate. Spatial relationships do carry content of emotion, but because the expressive potentialities of space have not been systematized, the filmmaker, in effect, creates his spatial language as he goes along.

SPATIAL FACTORS IN FILM COMPOSITION

The spatial factors most obviously susceptible to expressive manipulation are format, angle of vision, proximity, proportion, and relative degree of closure.

Format

Although a film's format usually provides merely a neutral field in which action can take place, it sometimes plays a more active role

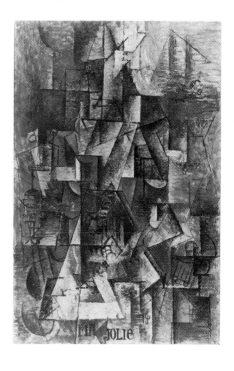

26. Pablo Picasso. *Ma Jolie.* 1911–12. Oil on canvas, 39⅜ × 25¾″. Museum of Modern Art, New York (acquired through the Lillie P. Bliss Bequest).

in the spatial drama. We are accustomed to seeing pictures—whether paintings, graphics, or photographs—as rectangles and, more often than not, as rectangles horizontally disposed. We accept the horizontal format so easily that deviations from it gain in expressive force and tension, perhaps because we are familiar with horizontally disposed images, perhaps because we are more generally aware of the extent of the horizontal field of vision than the limits of the vertical. In film, the horizontal rectangle —whether of conventional proportions, in wide screen, or in Cinerama—usually provides a unifying constant within which and against which the spatial play can occur. However, the filmmaker need not accept the rectangular format or the standard proportions; he can control or reshape his field by means of masks (Fig. 27) or mattes, which block transmission of light to the film except in desired areas.

below: 27. A selection of possible masks.

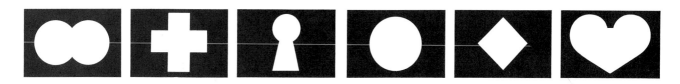

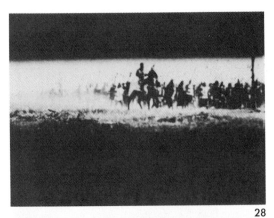

28

29

30

28–30. *Intolerance*. D. W. Griffith. U.S.A., 1916.
Masks serve to reinforce the main lines of the
action or setting or to emphasize a particular ele-
ment.

31. *Potemkin*. Sergei Eisenstein. U.S.S.R., 1925.
A particular setting, in this case the open hatch,
can change the format.

With a mask, the filmmaker can translate the
format into whatever shape he desires—verti-
cal rectangle, square, circle, triangle, star,
even free form. The very fact that the format
is not the one to which we are accustomed
serves to create dramatic emphasis, a kind
of visual italics, while the relationship of an
unaccustomed format to the pattern within
can, in turn, create a chord with an enhanced
harmony of likeness or tension of contrast.

Few directors have made much use of vari-
ations in format and proportion. The most
fundamental exercises in this dimension of ex-
pression are to be found in the work of one
of the first influential directors, D. W. Griffith,
notably in *The Birth of a Nation* (1915) and
Intolerance. Griffith exploits a vertical rectan-
gle to emphasize the height of the walls of
Babylon; a long horizontal to stress the direc-
tion of a chase (Fig. 28); a triangle to point
up perspective (Fig. 29); a circle to focus on a
grouping of figures or special detail (Fig. 30).

Most filmmakers have tended to avoid such
drastic changes in format, probably because a
change in format interrupts spatial continuity,
and the sudden change—from horizontal to
vertical, let us say—creates a visual shock that
wrenches the spectator from his involvement
with the film as a whole and reawakens his
consciousness to the inherent unreality and
abstraction of the medium. Instead, they have
sought more subtle means of achieving the
same effects, creating frames within the frame
of the picture, thereby retaining simulta-
neously the continuity of the ordinary format
and the expressive intensification of the ex-

traordinary format. Columns, arches, windows, doors, trees, people, even patches of light or shadow serve as framing elements to provide variety within the horizontal format (Fig. 31). Maya Deren's *Meshes of the Afternoon* (1943) is especially rich in variations of interior format. Doorways (Fig. 142), circular and rectangular windows (the latter transformed into trapezoids by the angle of vision), openings in a stairwell (Figs. 152, 153), areas of shadow, even broken and unbroken mirrors modify the basic rectangular space, clarifying a transition from reality to dream, enhancing the cumulative intensity, and enriching the sensual quality as well. Such interior frames, presented within the rectangular frame, we think of as constituting the *effective format.*

Angle of Vision

Moving about in our daily lives and occupied by our thoughts, we are essentially blind to the patterns that offer themselves to our eyes. Our knowledge and experience, our tendencies to conceptual thought, all impede vision. We know as a matter of fact that rooms are rectangular or square, that steps meet walls at right angles, that people walk erect, and that their proportions to the spaces they occupy vary only so much. Viewing a room and seeing no rectangle, we seldom react to the visual drama of patterns unless we search for it, perhaps in the camera's viewfinder. Then we recognize the drama created by angle of vision. Further, in viewing people, from whatever angle we see them, we tend to think of them as whole; they are people whether we look at them from below or from above. But if, because of an extreme angle of vision, they do not conform to our idea of how people should look, we may not identify them (Figs. 50, 51).

Except in moments of emotional intensity, excitement, or intimacy, one must undertake a deliberate dislocation of consciousness in order to transcend the impediments of conceptual thinking and see things as they actually present themselves to our vision. But film, by the simple process of translating three-dimensional experience into two-dimensional image, clarifies the nature of immediate visual perception, and the filmmaker exploits the capacity of the camera to reveal things as they appear rather than as we know them to be. Varying the angle of vision, he can expose the reality of immediate visual experience and control the dynamism of the pictorial image.

The dramatic potential of an extraordinary angle of vision is familiar to any filmgoer and quite obviously can become so overworked that it functions as a visual cliché. How often have we looked up from below at a bully, a thug, a demagogue, or a visionary hero, who thus ceases to be an ordinary man and becomes a giant or preternatural being. In this way Albert, the circus owner in Ingmar Bergman's *The Naked Night* (1953), sees the theatrical director from whom he wants to borrow costumes when his own are ruined (Fig. 32).

The example is extreme, but every angle of vision carries meaning, and even the customary angle may be used to convey or reinforce subtle and complex intuitions, clarify the action, or enhance credibility by adopting the position of a putative spectator. Sergei Eisenstein exploited the potentialities of spatial construction with extraordinary expressive cogency, nowhere more consciously or directly, perhaps, than in *Ivan the Terrible, Part I*, in which, as we have seen, no spatial element seems left to chance. The manipulation of patterns described earlier results in large measure from differences in the angle of vision, which changes throughout the film to

32. *The Naked Night.* Ingmar Bergman. Sweden, 1953. The unusual angle of vision transforms an ordinary man into a fearsome giant.

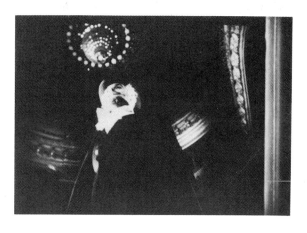

33

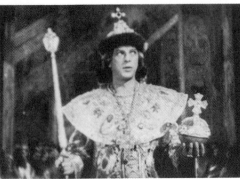

34

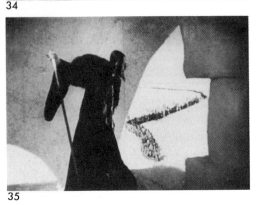

35

33–35. *Ivan the Terrible, Part I.* Sergei Eisenstein. U.S.S.R., 1944.
Personality and increasing power are revealed through varied angles of vision, with accompanying changes in scale. Ivan is seen first as a tiny figure in the crowd, next as a crowned hero, finally as a semidivine figure looming over the populace.

36, 37. *Alexander Nevsky.* Sergei Eisenstein. U.S.S.R., 1938.
A broad view gives little indication of the battle's intensity, which is revealed only by proximity.

the social status of the subject by elevating him physically above the eye level of the spectator. By the simple change of angle Ivan is raised above the spectator and invested with the symbolic stature of the hero or demigod.

The final shot, too, is a model of expressive economy: the camera views Ivan from below, as it so often does; simultaneously it views the populace of Kiev from above (Fig. 35). The combination of two angles of vision in this particular relationship clearly expresses Ivan's almost paternal envelopment of the masses and his role as a semidivine personification of power as well. The position of the masses is stated with poetic ambiguity, for it enhances their unity and diminishes the individual.

Proximity

As we have seen, the relative distance of an object in the picture space helps to establish and qualify the space. Similarly, it determines our comprehension or apprehension of it: distance generalizes, proximity particularizes; distance removes, proximity involves; distance conceals, proximity reveals; distance relaxes, proximity intensifies. Filmmakers inevitably make use of a variety of distances, which are usually described in terms of the contents of the frame rather than the actual distance in linear measure, since a change in the focal length of the lens may have the same effect as a change in the distance of the camera from the subject. There is some flexibility in both the terminology employed and the application, since, as one writer points out, a long shot of the Sahara may be a close-up of the earth. But the following terms are in more or less general use:

develop the plot and express Eisenstein's interpretation of Ivan. In the coronation scene at the beginning of the film, the transformation of the Moscow prince into Emperor of all the Russias manifests itself as much through the change in angle of vision as through the action. Ivan first appears as a miniscule figure in the coronation procession, diminished by foreshortening a distant view from above that seems to embrace the whole cathedral (Fig. 33). As the ceremony progresses, the camera moves to view him from below in an angle of vision familiar in grand-manner portraiture (Fig. 34), which often attempted to enhance

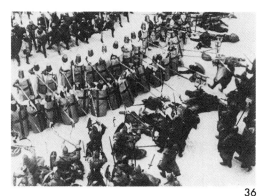

36

37

most clearly in scenes that involve much action. A good example is the battle on ice in Eisenstein's *Alexander Nevsky* (1938). The distance shots, which establish the setting and the general action, remove the spectator and permit him to observe almost as if he were watching a battle of toy soldiers or a game of chess (Fig. 36). It is only with the medium shots and close-ups that the skull-breaking intensity of the battle appears in full force (Fig. 37). Returning for a moment to *Ivan, Part I,* distance is employed to reveal various aspects of the central character. In the view of Ivan on the hill at Kazan, he is seen as an impersonal figure, almost an icon (Fig. 38); the close-up focuses on his personality as a human being (Fig. 39).

The Swedish director Ingmar Bergman demonstrates special sensitivity to distance as to all things spatial. Some of the overtones he conveys by manipulation of this element appear in sharp contrast in the final shots from two of his films, *A Lesson in Love* (1954) and

Extreme close-up: a shot of an eye, hand, or ashtray, for example

Close-up: a shot of a head, foot, basketball

Medium close-up: a shot that would include the head and shoulders of a figure

Medium shot: a shot encompassing a figure from the head to the waist or knees

Full shot: in the case of human beings or animals, a shot of the full figure, or of objects, the complete object; but also a shot that includes the complete setting for the action

Long or distance shot: a shot that embraces a large area with important elements visible in some detail

Extreme long shot: a shot that includes a large area in which details become relatively obscure; for example, an aerial view of a football stadium

Consideration of the angle of vision has implied the expressive importance of relative distance. But, since relative distance has become one of the most familiar and expressive tools of the filmmaker, it is appropriate to examine the possibilities in some detail. The implications of distance manifest themselves

38, 39. *Ivan the Terrible, Part I.* Sergei Eisenstein. U.S.S.R., 1944.
Variation of distance transforms Ivan from an icon into a human being.

38

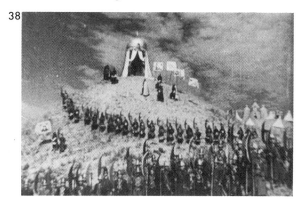

39

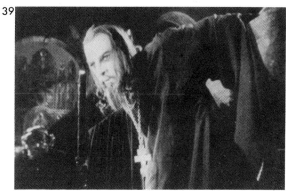

Monika (1953). *A Lesson in Love* (Fig. 40) involves jealousy and antagonism between a husband and wife. In the last sequence a reconciliation takes place, and the camera withdraws to view them from a distance. Their individual, personal differences are diminished by the very distance of the lens. Thus, the intense focus on their emotional problems shifts. They are restored to a larger world, and the world goes on.

The distance shot is so effective as a means of terminating action and suggesting a resolution for the drama that it has become at times a cliché, as in the Western, where the hero and heroine ride cheerfully into the sunset. On a secondary level of expression, the very fact of the actor's turning his back to the audience may convey nostalgia and regret (Fig. 41).

Bergman's *Monika* (Fig. 42), on the other hand, ends with an extreme close-up of Harriet Andersson's face looking at the spectator as she sits in a bar listening to a Dixieland band play "Panama," after having left her husband and child for a more independent life. Here there is no resolution; the problems inherent in the film, the conflict and interdependency of freedom and restraint that have been developed throughout the film continue. In addition, Monika, whose behavior by this time has probably alienated the viewer, regains something of her sympathetic character merely by the relative intimacy of the shot and

the glance. She recaptures the central role that had been shifting gradually to her husband and reestablishes herself as a proper subject for study and concern, an effect that would have been impossible if the last shot were a distant one. Distance would simply have confirmed a judgment and left her in hell, but for Bergman and for the film and the audience, judgment is not so easy.

Proportion

Proportion, too, is an expressive variable of primary importance. Comparative size, of course, is one of the most obvious and familiar ways in which ideas of distance and depth are communicated. Once again, Eisenstein manipulates this element with extraordinary effectiveness. In the final scenes of *Ivan, Part I*, for example, Eisenstein's sensitivity to proportion extends to every dimension of the film—the settings, the costumes, the shapes of individuals, the masses of light and dark. Nikolai Cherkassov, in the role of Ivan, becomes a malleable plastic, modified in size and contour as the film progresses. Not only by selection of camera angle, but also by stilting Ivan on platform shoes, narrowing his facial contours, and shaping his shoulders, Eisenstein gradually transforms Ivan from the brash and youthful prince into the ascetic, monkish, spiritually driven emperor.

Most of the figures, robed in heavy costumes that hang in simple folds, attain a bulk and monumentality that remove them from reality and transport them into an operatic, epic, and symbolic world (Fig. 43). Architectural settings, too, enhance the grand proportions of the figures, for despite the large scale, the sets include such devices as low walls and even lower doors, which force the characters to

40. *A Lesson in Love.* Ingmar Bergman. Sweden, 1954.
Disengagement through distance is conveyed by this shot from the final sequence. Subsequently, the camera draws back across the canal.

41. *Modern Times.* Charles Chaplin. U.S.A., 1936.
A sense of nostalgia accompanies this closing shot.

42. *Monika.* Ingmar Bergman. Sweden, 1953.
Proximity of the image engages the viewer.

40

41

42

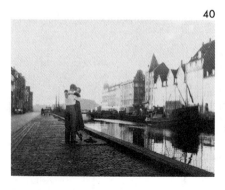

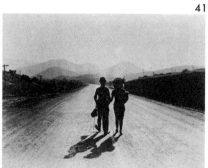

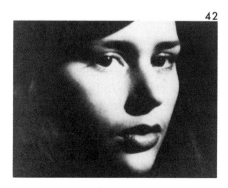

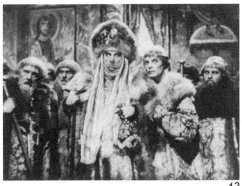

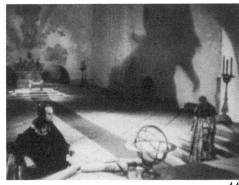

43

44

stoop as they go through them. These are es-
sentially theatrical means, but Eisenstein also
employs more purely cinematic methods. In
a scene in which Ivan gives instructions to his
emissary to England, his enormous shadow—
hovering over the screen, dwarfing the figures,
and embracing the globe—becomes a projec-
tion of Ivan's personality, adding to the verbal
exchange some of the emotional dimensions of
his thoughts and political intentions (Fig. 44).

Relative Closure

The viewer's response to a visual image is
inevitably conditioned by the overall pattern
of forms. This is especially true in film, since
patterns are likely to change so rapidly that
secondary detail escapes our vision before we
have had time to absorb its parts. In fact, when
the filmmaker wants the spectator to note a
particular aspect of the total image, he is
likely either to hold it on the screen or move
in for closer examination. Among the infinite
possibilities for the arrangement of forms in
the picture space, one general type of varia-
tion is especially important because it does
involve the overall form. This is the relative
degree of closure.

Closure involves an arrangement of forms
that permits the audience to see them as a
complete and self-contained pattern within
the picture space, usually a pattern that is
simple in its structural framework and rem-
iniscent of regular geometric shapes of one
kind or another. It is a pattern in which com-
positional thrusts and tensions seem to move
inward—to be implosive rather than explosive,
one might say—a pattern that tends to imitate

or imply, as a whole or in large part, the for-
mat of the picture. The geometer might call
this effect a satisfactory figure, the psychol-
ogist a satisfactory gestalt. Patterns that as-
sume the character of architectural relation-
ships, stressing the vertical and horizontal, and
that can be reduced to squares and rectangles,
trapezoids and triangles, wheels and circles
exemplify *closed composition.* Such a configu-
ration is illustrated in David's *Oath of the
Horatii* (Fig. 12). The contrasting form is *open
composition,* free and often organic in charac-
ter, explosive rather than implosive, sugges-
tive of incompleteness and movement. Ru-
bens' *Lion Hunt* (Fig. 13) typifies this.

In considering these structural types it is
important to recognize that they refer to pat-
terns, not to the spaces represented or photo-
graphed and the objects within them. A view
of a landscape almost invariably implies infi-
nite extension in any direction, but the ar-
rangement of forms in light and shadow may
present a closed pattern (Fig. 45). A close-up

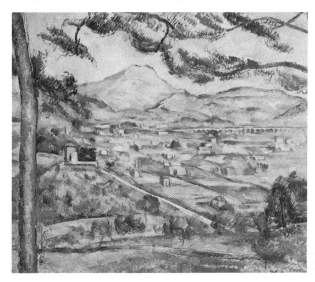

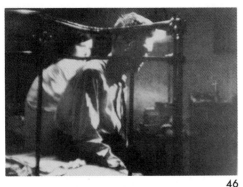

46, 47. *Monika.*
Ingmar Bergman.
Sweden, 1953.
A closed composition, provided by the bedframe, expresses marital tension; an open composition, with the boat moving off into the distance, suggests ascent into freedom.

46 47

of a hand presents only a fragment of the total human being and assumes the rest of the body, but it may appear in either a closed or an open pattern. Each of the types carries overtones of feeling that seem inherent in the form: closed form is constrictive while open is free; closed form suggests rational calculation, open spontaneity and immediacy; closed form is taut and formal, open loose and informal. Obviously, when we characterize patterns in this way we are concerned only with appearances and subjective responses, not with the process of creating the pattern: An open composition may derive from rational calculation, a closed form from spontaneous recognition.

Ingmar Bergman offers innumerable examples of the expressive use of the closed and open form, which almost become symbols of attitudes toward life. Often, when his lovers quarrel or when interior tension mounts in an individual, we look at the characters through the vertical pattern of the bedframe or some other enclosing and constricting structure (Fig. 46). Conversely, in more idyllic moments the figures move in unfettered freedom and in seemingly limitless unstructured space (Fig. 47). Of course, we cannot expect such one-dimensional interpretations always. One of the culminating shots of Bergman's *The Seventh Seal* (1957) is a distance view in open form of Death leading a *danse macabre* along a ridge (Fig. 48). The shot poses a question at the same time that it describes an incident. Death indeed comes to these characters, as it does to everyone, but the sharp division into dark and light does more than dramatize the event. It continues to pose the question that has been manifest throughout the film: What is death—escape into the radiance of a Christian heaven or consignment to the black hell of nothingness?

While it has been necessary for the sake of clarity in analysis to consider each of the compositional factors separately, these elements, quite obviously, never appear in isolation in any film. Rather, they form clusters in which one factor—format, angle of vision, proximity, proportion, or relative closure—conditions and qualifies the rest to make a complex statement. And in film, most importantly, the spatial order of the particular moment is modified by what precedes and follows it, by patterns of movement and change that can be grasped only through the dimensions of time.

48. *The Seventh Seal.* Ingmar Bergman. Sweden, 1957.
The ambiguities of posthumous destiny are suggested in an organization of space and light.

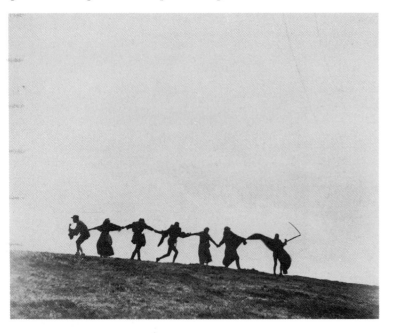

3
Movement in the Articulation of Space

Besides affording pleasure to the eyes, moving patterns can be extraordinarily seductive. Through constantly changing patterns of light and dark, even the dullest film can hold our attention as hypnotically as the flickering flames of a fire or the ceaselessly coalescing and dissolving patterns on the surface of a pond. And part of the value of any film surely is in its sensuous appeal to our eyes. But movement does more than give life to the empty, neutral, passive space that contains it. Like the configurations in the paintings illustrated in the last chapter (Figs. 12–19), into which so often we seem to project ideas of energy, movement, and dynamism, the patterns of movement articulate space and give it expressive significance.

We can apprehend space visually by looking at it or into it, but our comprehension will be only partial. Complete understanding demands movement within it, as our experience of being inside a building like St. Peter's Basilica in Rome most graphically demonstrates (Fig. 49).

The measure of St. Peter's is vast, for it is one of the largest spatial areas man has ever enclosed; yet the visitor, entering at the west end, may well feel a twinge of disappointment. The scale of the various parts is so consistently monumental and grandiose, the in-

terrelationships of parts so complex that a visitor standing at the entrance has no real comprehension of the distance to the altar or to the vaults above, much less an awareness of the true shape of the space he stands in. The little *putti*—or infant angels—hovering above the fonts are larger than he is, so that the one clear standard of measurement, the size of a human being, is missing. Moreover, the architectural elements—moldings, rinceaux, pilasters, and piers—do not approximate in size any similar elements he may be familiar with. Only when he has walked the distance from entrance to altar, watching the volumes change as he passes from pier to pier and chapel to chapel and finally observing the soaring height of the dome, does the visitor begin to realize—not just visually but kinetically and temporally as well—the immensity of this structure and the richness of its voids. By moving through the space, the spectator also recognizes the intellectual order imposed on the masses and understands that the absence of parts in normal human scale dedicates this building to the institution of the Church and to a concept of divinity. Thus space, the rational aesthetic of its order, and its expressive content manifest themselves completely only through the viewer's movement. In film, too, movement defines space, gives order to its forms, and reveals its significant content.

THE DUALITY OF FILM SPACE

Films usually confront us with two kinds of space. There is the implied space of the setting and the things within it, which the filmmaker may reveal to his audience all at once, explore in continuous movement, or describe in separate views. And there is the space of the rectangle or frame that appears on the screen. This second kind of space, called filmic space, is created by the filmmaker, who, as he causes people and things to move or moves his camera, modifies the angle of vision, the relative

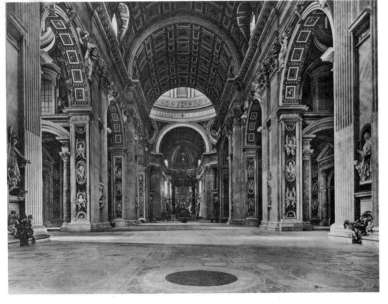

49. Michelangelo, Carlo Maderno,
and Gianlorenzo Bernini.
Interior, St. Peter's Basilica, Rome.
The vastness of the space and immensity of the proportions create ambiguities of scale.

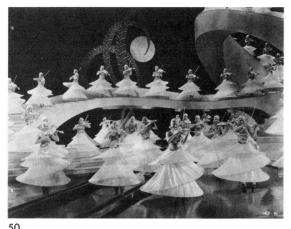
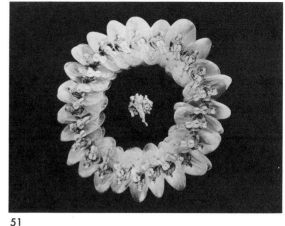

50 51

50, 51. *Gold Diggers of 1933.* Mervyn Le Roy. U.S.A., 1933.
This dance sequence by Busby Berkeley shows how the identity of figures as human beings can be lost by changing the angle of vision.

proximity, the shape of objects, and the relationship of one object to another, composing the visual raw material into patterns comparable to those in paintings and still photography. As the film proceeds in its movement through time, the configurations in the space of the setting and the integral forms of people and things as we know them to be may and, in fact, usually do become less significant than the configurations created by the filmmaker within the frame.

Actors in motion, for example, operate in two ways: as persons they embody whatever the human form is capable of expressing through attitude, gesture, and movement in familiar dramatic terms. But besides being people, actors are physical forms—planes, shapes, and volumes, parts of a pattern. This duality of identity is especially apparent in the dance extravaganzas Busby Berkeley created for films like Mervyn Le Roy's *Gold Diggers of 1933.* Both the dancers and the camera move. The camera first observes the dancers at an angle that identifies them as human beings existing in a three-dimensional space (Fig. 50), then it ascends so that it looks straight down on them (Fig. 51). At this point the dancers lose much of their identities and become parts of a geometric pattern. The space, which had seemed clearly three-dimensional, now appears flat as the dancers form geometric figures that open and close, expand

and contract, like the constantly changing patterns in a kaleidoscope.

The space-shaping function of the movement of dancers and camera is obvious in this instance, but the expressive content is limited. The movement may excite sensual delight and inspire admiration for the control and discipline implied, but little more. The spatial configurations and the movements that produce them are essentially decorative.

Ingmar Bergman's *The Naked Night,* however, almost continuously illustrates the expressive manipulation of movement and changing spatial patterns. In one passage, Anna, a bareback rider in a traveling circus and the mistress of the circus owner, goes backstage of a theater in a town where the circus is playing to find an actor who has made advances toward her. Her motivations seem to be as uncertain and confused to her as they are to the audience. She is in awe of the actors and their claim to be creative artists rather than entertainers like circus people; she is flattered by the actor's attentions and is obviously in search of adventure. But there are other considerations as well. The circus owner has gone to visit his wife and children, and Anna is apprehensive about how that visit will affect her life. Also, she is rather tired of moving from place to place and hopes in some vague way that a liaison with the actor will lead her to a more settled life.

52

53

54

55

56

52–56. *The Naked Night.* Ingmar Bergman.
Sweden, 1953.

As Anna makes her way to Frans' dressing room, apprehension, uncertainty, and excitement are translated into space and light, with a final resolution.

After watching the end of a rehearsal from the wings (Fig. 52) and overcome with emotion at the actor's performance, Anna—awestruck, uncertain, timid, and confused—makes her way through a maze of sets, props, and costumes (Figs. 53, 54) to the actor's dressing room (Fig. 55). Her feelings are translated into visual terms by the continuously changing confusion of jagged, angular shapes and sometimes by Bergman's deliberate deception of the spectators, who at one moment may believe they are looking at Anna only to discover they are looking at her image in a mirror (Fig. 54). Her arrival at the actor's door brings a

moment of resolution; the pattern begins to stabilize and clarify itself in a neater geometric order as she stands outside, and falls into a clear, simple pattern as she opens the door and looks in (Fig. 56). In this passage, the space of the setting is defined only by its confusion; spatial description yields to the expression of feelings.

In a segment from another Bergman film, *Frustration* (originally known as *Ship to the Indies;* 1947), movement defines space and expresses the dramatic development simultaneously. The film concerns the captain of a salvage barge who is going blind and wants to leave his wife and business and escape to the Indies with his mistress before he loses his sight completely. The captain is first seen in a restaurant at the edge of an amusement park. He quarrels with a sailor and then leaves with companions to make his way across a plaza in the park. The sailor attempts to engage him in a fight, but the captain shoves him away,

continues his passage, stops momentarily at a Punch and Judy Show—which in effect carries on the argument in parody—and then enters a theater. There is some activity backstage, and then on stage a singer, who we learn is the captain's mistress, performs, followed by cancan dancers. During their act the sailor enters, advances to the front, and forces the captain into a fight. After fighting for a few minutes, the captain jumps up on the stage, runs backstage and up a flight of stairs to the singer's dressing room, stumbling over a pail as he enters and landing sprawled on the floor.

As the captain, along with some companions, emerges from the restaurant, the camera begins to follow them, observing from a distance and from a high vantage point (Figs. 57–59). Though the park is enclosed by structures of some sort, the lens finds no coherent pattern in the plaza itself or in the aimless activity of people within it, until the captain appears to give it some unity and, for that matter, some *raison d'être* by tracing a path across it. But if the space of the setting exhibits no particular form except that provided by the captain's progress, the filmic space—the space of the rectangle on the screen, the space created by the filmmaker—is shaped and controlled. As the camera follows the captain, intervening objects like girders introduce order into the space, now enclosing the actors in the interior frames they create, now letting them escape.

The movement of the captain among such forms, in addition to ordering the space, gives visual expression to the quarrel. The captain does not proceed in a straight path. He walks in arcs and zigzags, saunterings and passes, tracing a broken line across the plaza in a pattern that conveys his intention to cross the open space and the human obstacles that impede his crossing. The shapes of the scaffolding break up the space much as the sailor breaks up the captain's advance, substituting their jarring fragmentation of the picture space for the violence of the altercation, which is seen at such a distance and angle that it seems almost trivial.

In the theater the captain once again defines a space by the direction of his movement. This time, however, he does not actively pro-

57

58

59

60

57–68. Frustration. Ingmar Bergman. Sweden, 1947.
Space is described by the movement of camera and players, while drama is enhanced by a disintegration and reconstitution of spatial order.

61

62

63

64

65

66

67

68

which contrasts so strongly with the irregularity of the exterior views.

When the camera moves to focus on activity backstage and then observes the singer from the audience (Figs. 63, 64), the same sense of regular order is established: verticals and horizontals predominate, symmetry is approximated, the form remains more or less closed, and planes recede in space at fairly regular intervals. The orderly composition begins to disintegrate once again when the cancan dancers appear in a flurry of skirts, thighs, and buttocks (Fig. 65). Then, when the captain and the sailor fight, the geometric patterns of the setting disappear totally in the darkness; the form becomes open, balance is disturbed, and—in place of the order that characterized the captain's entrance and the actions of the performers—movement occurs in all directions at once (Fig. 66). Regular geometric order begins to reestablish itself as the captain scampers up the stairs (Fig. 67), and it dominates the space again as the captain is caught by converging lines of perspective in the singer's dressing room (Fig. 68).

In sum, as the action moves from exterior to interior and the intermittent quarreling becomes a vicious fist fight, the shapes that clearly describe the actors and setting give way to more expressive shapes—abstract shapes in a space that is equally abstract.

This example demonstrates the movement of actors and changes in spatial configuration to express a quite specific dramatic content. Of course, not all movement and change of pattern perform so particular a function. The opening scenes of Federico Fellini's *La Dolce Vita* (1960) reveal a helicopter with a gilded image of Christ slung beneath as it traces the path of the aqueducts leading to Rome. When it reaches the city, it disappears from the frame, although its movement is apparent through a crowd of children who race after it on the ground and through its shadow crossing the walls of buildings. Some young women sunbathing on a rooftop spot the craft and the flying Christ and rise to watch it (Figs. 69, 70). Their seemingly casual movements are plotted

duce order in a formless space, but rather passively imitates the shape of the room, moving from right to left away from the spectator across the back (Fig. 60), down the aisle at the side (Fig. 61), and back toward the spectator as he finds his seat at the front of the house (Fig. 62). The direction of his movement thus describes the rectangularity of the room,

69

70

71

69–75. *La Dolce Vita.* Federico Fellini. Italy, 1960.
Women sunbathing on a rooftop spot a helicopter from which an image of Christ
dangles. The movement of the camera and that of the women are blocked out in such
a way that they increase in quantity and complexity, thus intensifying the viewer's
involvement. The camera dollies from right to left, simultaneously moving closer and
tilting up, following first one woman, then another, and another. At first, the women
move in a direction roughly parallel to that of the camera, then they execute a
crossing movement, and finally turn in place.

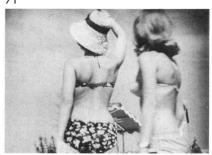

72

and blocked out with extraordinary care. The
women's attention is caught. One, in a large
straw hat, moves at first to a sitting position
and then rises. A second, in a sailor hat, starts
toward the camera (Fig. 71). A third, bare-
headed, enters from the right and crosses be-
tween the stationary woman and the camera
(Figs. 72, 73), while the woman in the sailor
hat crosses behind the stationary woman (Fig.
74). Then all turn around in place to face the
camera (Fig. 75). Throughout this set of
movements the camera has been advancing
toward the women and at the same time mov-
ing left.

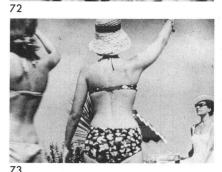

73

There is nothing overwhelmingly signifi-
cant in this action. The women's sunbathing
may suggest a certain indolence in the center
of Christendom; the contrast between their
revealing bikinis and the concealing robes of
Christ may convey an ironic contradiction in
notions of modesty; and the efforts of the cen-
tral figure of the screenplay, Marcello, to
communicate with the women from the heli-
copter do begin to establish aspects of his per-
sonality. But the movements of the women
and of the camera in themselves serve pri-
marily to maintain direction of movement
from right to left and to anticipate the pivot-
ing of the helicopter when Marcello catches
sight of the women—in short, to maintain the
impetus and urgency of the film during its
progress through time.

74

75

Sometimes the movement of a character serves no purpose other than to create a formal pattern and maintain an established rhythm. This would appear to be the case, for example, in portions of *Ivan the Terrible*, when Eisenstein has his central character zigzag through space for no other reason.

MOVEMENT OF THE CAMERA

At the beginning of its history, the camera acted like a one-eyed spectator standing in a fixed position. The point of view, the angle of vision, was that of a member of an audience in a theater. A mechanical eye on a tripod, the camera peered straight ahead, its field unchanging. In a rather short time, however, filmmakers attained a freedom of action that characterizes the use of the camera today. Indeed, there are some films in which the camera is almost constantly moving. There are four general categories of movement:

1. Those in which the body of the camera is not moved but the relationship of the lens to the film is altered—*change of focus* and *zoom;* and those in which movement is synthesized by the process called *stop motion*
2. Those in which the body of the camera moves but only with respect to a fixed support—the *pan, swish pan,* and *tilt*
3. Those in which both the support and the camera move—*tracking, dollying, trucking,* movement on a crane, cable, or any other mobile support—to produce *traveling shots*
4. Those simulated or created in laboratory and known as *effects* or *special effects*

SYNTHESIS OF MOVEMENT IN THE CAMERA

Change of Focus

Change of focus is used to shift the viewer's attention from one speaker to another when the two are separated from each other in depth; to reveal something that has hitherto been obscure, very often in order to create shock or surprise; and to simulate subjective vision. An early example appears in Erich von Stroheim's *Foolish Wives* (1921). A bogus count, who subsists by passing counterfeit money, is caught in a rainstorm with the wife of an American businessman, whom he is setting up as his next victim. They take refuge in a peasant's cottage and the woman is persuaded to remove her clothes while they dry. The count, playing the perfect gentleman, takes a seat with his back to her. But of course he is not a perfect gentleman; he fishes out a mirror and gleefully observes her as she disrobes. To reveal what he sees, the focus changes from the count in the foreground to the lady in the background (Figs. 76, 77).

Zoom

Through a complex system of lenses, the zoom allows the filmmaker to simulate the move-

76, 77. *Foolish Wives.*
Erich von Stroheim. U.S.A., 1921.
A change of focus occurs as the count views the businessman's wife in a mirror.

76

77

78

79

80

81

78–81. *Wavelength.* Michael Snow. U.S.A., 1967.
The entire length of the film is a continuous zoom.

ment of the camera in and out of deep space and to maintain continuous focus in the process. However, since the camera usually remains fixed, the illusion of camera movement is only approximate, and many of the changes in shape and proportion that would present themselves to the moving camera do not take place. Thus, normal perspective effects are distorted. More distant objects, for example, may become larger than they would ordinarily appear, an effect quite frequently seen in television coverage of football games in which players farther from the camera seem to dwarf those nearer to it.

Nevertheless, the zoom provides a useful means of shifting attention, and, like almost every other technical invention in the history of film, it has led to some extraordinary virtuoso performances. In his short film *Praise the Sea* (1961), Herman van der Horst explores the Dutch countryside in rapid, rhythmically controlled zooms that to some extent imitate the selective focus of the eye. But even more importantly they suggest the energy and dynamism that underly the placid landscape and by their repetition impose a formal order on the camera's explorations (Figs. 178–181).

A direct contrast with Van der Horst's almost frantic zooming is provided by Michael Snow's *Wavelength* (1967), which incorporates a zoom that advances almost continuously and imperceptibly for 45 minutes, moving through a large loft and coming to rest on a photograph of the sea pinned to the wall, as if to suggest that room and sea are part of the same spatial continuum, and the zoom could go on forever (Figs. 78–81). From beginning to end the zoom discloses a constant change of pattern reinforced by lighting and color modulations that not only reveal an extraordinary richness in visual effects, but also give the room a life of its own.

Wavelength is two-thirds as long as many feature films, yet very little of dramatic import occurs. People occasionally enter the room and leave; about two-thirds of the way through a man enters and falls out of the frame

to the floor with a thud. A woman appears and telephones somebody. But whether the man is drunk, ill, simply unconscious, or dead the film does not reveal. Nor does it seem of great importance that the audience know, since what happens to the man is less significant than how the room is affected by his presence.

Stop Motion

Stop motion is a procedure employed for synthesizing movement in the camera and for creating effects in which figures and objects pop on or off, appear or disappear, or radically change position in the picture space. In its simplest use, the camera remains fixed. The object to be animated, a chair perhaps, is placed in position. The filmmaker runs his camera for a fraction of a second and then stops it. Next, the object is moved a certain distance, and the operation is repeated again and again until the complete movement has been realized. The speed of the movement depends in part on the distance involved and in part on the number of frames used to register a phase in the movement.

This technique for animating figures and objects is frequently called *pixillation*. We find an unusually complex early example in Emile Cohl's *The Automatic Moving Company* (1910), in which baskets containing furniture and household goods mount a flight of stairs, enter rooms, unpack themselves, and leave (Fig. 82). Human beings can be animated in the same way; in fact, some of the first moving pictures, presented not on film but on glass slides, were made by stop motion. As a device

to make things pop on or off the screen or radically change their location in the frame, stop motion appears in Deren's and Hammid's *Meshes of the Afternoon* (Figs. 155, 156).

MOVEMENT OF THE CAMERA ON ITS SUPPORT

Pan

In the pan, the camera moves laterally on its vertical axis to explore a setting, follow a moving person or object, direct attention to someone or something outside the original field of vision, or sometimes simply to maintain movement in the film.

Fellini, whose camera seems to be in almost constant motion in *La Dolce Vita*, uses the pan in the rooftop scene previously described (Figs. 69–75). For another scene he causes the pan not only to follow the action but also to introduce a minor character. Marcello, discovering that his mistress has attempted suicide, takes her to a hospital. The camera documents their arrival at the hospital in a pan from left to right, then, reversing its direction and simultaneously tilting upward, reveals a nurse at the head of the stairs. Again reversing its direction and tilting downward, the camera follows the nurse for a moment as she descends the stairs (Fig. 83–90).

A pan away from embracing lovers was employed frequently in popular films until the 1960s. This device had the effect of disengaging the spectator from the characters, avoiding offense to the censors, and also, depending on where the camera finally rested, suggesting

left: 82. *The Automatic Moving Company*. Emile Cohl. France, 1910.

opposite: 83–90. *La Dolce Vita*. Federico Fellini. Italy, 1960. When Emma and Marcello arrive at the hospital, the camera dissolves into a pan to the right, then a pan to the left, a pan to the right, and another dissolve. The dark mass of the stairs operates like a wipe. A continuous movement of camera, car, and figures maintains the urgent rhythm.

83

87

84

88

85

89

86

90

either the lovers' psychic detachment or their impassioned embroilment.

Much more varied and potentially more complex techniques come into play when the pan accompanies the filming of dialogue. If two people are conversing, the camera can move from one speaker to another, following the development of the exchange in a series of pans that, when not handled sensitively, may lead to what is sometimes called the ping-pong effect. Or, on the assumption that the words will convey the dialogue and the voice identify the speaker, the camera may concern itself with the reaction of the listener. Or it can move very freely indeed between speaker and listener depending on the dramatic content of the speech and the relative importance of the speaker's statement and the listener's reaction.

The camera can also develop a rhythmic movement of its own in no way tied to the words. This method was exploited by Jean-Luc Godard in *My Life to Live* (1962), in which the rhythm of a dialogue is countered by a second rhythm, that of the camera, acting seemingly of its own volition. The polyrhythmic relationship lends a nervous quality to the dialogue and serves as a visual counterpart to the psychic and social dislocation of the characters.

Sometimes the camera will pan away from the speakers entirely, as it does in Shirley Clarke's *The Connection* (1960), gliding from a heroin addict waiting for a fix to a large expanse of dirty wall on which a roach, as lost as the man, crawls in paths that are at once decisive and aimless (Fig. 542).

Swish Pan

The swish pan is a special type of pan in which the camera moves so fast that the image dissolves into streaks and is identifiable only at the beginning and end of the camera's movement. It can create emphasis, impact, or shock, maintain the impetus of film movement, and very often mask the physical joining of two pieces of film—called *splicing*—necessitated by a shift in camera position. A splice that occurs when nothing is in focus and the camera is in motion will usually be impercep-

tible, so that a swish pan may seem to start on one continent and end on another. Deren and Hammid employ the swish pan for just such a purpose in *Meshes of the Afternoon* (Figs. 124–176).

Tilt

In a tilt, the camera revolves vertically on its tripod head, causing an effect similar to that of the pan, except in the direction of its movement. The hospital scene in *La Dolce Vita* (Figs. 83–90) includes a tilt in conjunction with a pan to introduce the nurse.

MOVEMENT OF THE CAMERA WITH ITS SUPPORT: TRAVELING SHOTS

Tracking

In tracking, the camera is mounted on a support that moves along a rail; the camera's action is therefore relatively limited.

Dollying

Dollying takes its name from a relatively small wheeled support or dolly, which is either pushed about or moved by a motor. The dolly allows for relatively free movement but is limited in the speed at which it can move.

Trucking

When the camera must follow rapid movement over large areas—running horses or speeding automobiles, for example—it must be mounted on a truck or similar large vehicle; hence the name trucking.

Movement on a Crane

A crane is a large apparatus especially designed for filmmaking. The camera is mounted on the end of a *boom*, or movable arm, which also supports the camera operators and the director. With personnel and gear in position, the crane can move vertically, horizontally, or at an angle; it can advance or withdraw. A common application begins with a comprehensive view from above a large area, glid-

This overview of a square in Babylon and close-up of dancers illustrate two phases of a crane shot.

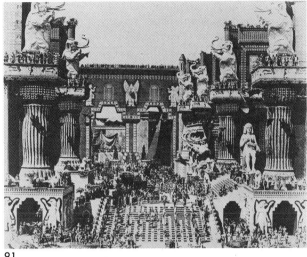
91

92

ing smoothly to focus on a small part of the scene. One such use—impressive for both its scope and its precocity—occurs in D. W. Griffith's *Intolerance,* when the camera takes in an enormous square in Babylon and then slowly moves down and forward to concentrate on a group of dancers (Figs. 91, 92).

Other Mobile Supports

All sorts of devices have been called upon to give the camera mobility. In F. W. Murnau's *The Last Laugh* (1924), Karl Freund suspended his camera from a cable and swung it toward the bell of a horn in a street band to suggest a certain quality of sound. For another scene he strapped it to his chest and spun in a chair to create the impression of vertigo and drunkenness. In fact, the camera achieves its greatest freedom of movement when the cameraman becomes the support.

THE EXPRESSIVE POTENTIAL OF MOVEMENT

The terms used to describe camera movement scarcely begin to explain what happens on the screen. Of necessity, the movement of the camera generates other movements within the picture space, which are of fundamental importance in filmic expression even though they may pass unnoticed by the viewer. For example, a camera can move laterally from left to right observing the façades of row houses

on a street, and it may seem to carry the spectator along with it. In the frame of the picture, however, the images of the buildings will move in the opposite direction, from right to left. Furthermore, they will *actually* move, not merely *seem* to move. In fact, if segments of the building were not identifiable as doors, windows, and steps—if the forms were purely abstract—they, not the camera, would seem to be moving. Filmmakers have sometimes exploited this phenomenon to create the illusion that a static object is in motion. The ambivalence that results when fixed objects seem to be moving is of some importance, because it can enrich the expression of deep space and augment the activity taking place on the screen, heightening the sense of excitement.

When the camera travels in front of the buildings, the façades, in effect, present one plane in depth and move in one direction. However, if the camera follows an actor walking in front of the façades, the result is two planes in depth and movement in two directions, the actor from left to right, the façades from right to left. The effect will be that of a crossing movement, comparable to that of the young women on the rooftop in *La Dolce Vita* (Fig. 73). The sensations of depth and motion are thus multiplied.

A setting in which a great variety of objects present themselves at varying distances from the camera or the picture plane will obviously take on a depth quite lacking in the setting just described. For example, in a landscape seen from a train or a car, such elements as trees, telephone poles, and houses will cross the screen as if pivoting around some hidden point on the horizon. Similarly, a road at right angles to the track or highway will make its appearance canted at an extreme angle, then sweep across the field of vision like a windshield wiper. Depending on their distance from the camera, the objects will seem to move at different rates of speed. A telephone pole in the foreground will rush past, a house in the middle distance will glide, and a hill in the distance may seem stationary. Any multiplication of moving objects and rates of speed will further augment the visual dynamism.

The very slightest penetration of space can increase sensuous awareness of three-dimensional relationships and activity within the frame. In *Meshes of the Afternoon*, when the shadow of a young woman crosses a wall, deep space must be inferred (Fig. 125); but when it undulates across a grill of turned wood (Fig. 128), the impression of deep space is more positively activated.

While the lateral movement of camera and planes in depth can effectively articulate three-dimensional space, actual movement in depth will more directly involve the spectator. By changing from a lateral movement to an advancing one, the filmmaker can subtly manipulate the viewer's sense of involvement, engaging and disengaging him as seems ap-

93

94

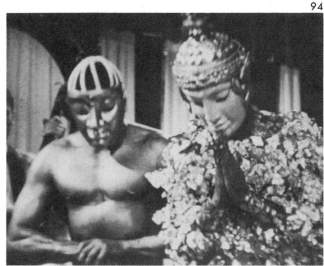

93–106. *La Dolce Vita*. Federico Fellini. Italy, 1960. This extended shot, which terminates the nightclub sequence, is in itself like a short sequence made of individual shots. The camera moves into different positions, viewing from various angles and distances. The figures emerge and disappear, obscuring and revealing other figures to create ever-changing spatial configurations.

95

propriate. Alain Robbe-Grillet and Alain Resnais employ this device in *Last Year at Marienbad* (1961). As the film opens, the camera first moves laterally across walls, paneling, moldings, ceilings; then it advances along corridors, through doors that open mysteriously, around corners, through more doors—pulling the spectator along with it and drawing him deeper and deeper into the spaces of the film and also into its mysteries. The movement of the camera in conjunction with the narrator's words seems not only to take the viewer from one space to another, but also to peel off layer after layer of consciousness, leading to a realm halfway between dream and reality. At first an observer, the viewer has very nearly become a participant (Figs. 551–564).

96

Some measure of the freedom of movement that can be achieved with the camera and something of the expressive potentialities of camera movement as well are beautifully illustrated in an extraordinary shot from *La Dolce Vita*. The setting is a nightclub. The shot begins with the camera observing in close-up three dancers who are taking a bow (Figs. 93, 94). Panning to the left, it picks up the band (Fig. 95) and then a young woman, who emerges from behind the band (Fig. 96). It follows her as she descends some steps to the dance floor (Fig. 97), then stops momentarily while she dances in place waiting for a partner (Fig. 98). A partner arrives, and as the pair move off to the left, Marcello is discovered in the middle distance (Fig. 99). A dancing couple move from left to right (Fig. 100), and the camera draws forward to a medium close-up of Marcello (Fig. 101), then follows him as he approaches the bar to greet his friend Maddalena (Fig. 102), pausing once again while the two talk (Fig. 103), and continuing to the left as they start for the exit (Fig. 104). Finally, the camera withdraws to the dance floor as they walk away (Figs. 105, 106).

97

98

99

100

39

93–106. *La Dolce Vita.*
Federico Fellini.
Italy, 1960.

101

102

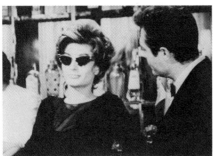

103

104

105

106

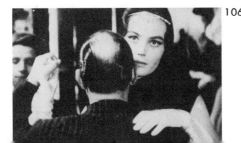

As far as the screenplay is concerned, the shot is relatively inconsequential. It does bring a longer segment of the film to an easy close, and it accounts for Marcello's being in the company of Maddalena in the next development of the narrative. But the entire sequence could conceivably have been eliminated without greatly affecting the viewer's understanding, and it certainly could have been simplified, as both a conclusion to one scene and a transition to another. However, if the shot develops little dramatic excitement, it offers a great deal of visual activity.

While the entertainers bow and the band plays at the beginning of the shot, the figures remain fixed in place; movement through space is created by the camera alone. With the appearance of the young woman from behind the band, the movements become more complex: as she crosses to the left and down, the camera leads her, and the background shapes move to the right. When the woman reaches the dance floor, the space opens up, the number of planes in space are multiplied, and added moving elements are provided by the couples crossing in front of the camera.

The discovery of a motionless Marcello is a mildly surprising climax to the accelerating movement. During the conversation between Marcello and Maddalena the closeness of the camera and the general lack of activity contrast strongly with the earlier part of the shot, a shift that serves to dissociate them from the surrounding activity with which they have become thoroughly bored. The compound movement created when Marcello and Maddalena walk away from the camera while the camera retreats from them underscores the idea that this movement is a conclusion to one phase of the narration. In sum, then, while it contributes little to the advancement of the main narrative, the shot is constructed in itself as a drama of movement and space that is extraordinarily rich in visual effects and generates much excitement.

MOVEMENT CREATED IN THE LABORATORY: SPECIAL EFFECTS

The movement of people, things, and camera within a setting accounts for much of the ac-

tion the audience will see on the screen. But movement can also be synthesized in the laboratory to create what are known as *effects* or *special effects*. These result from any deviation in the filmmaker's basic procedure wherein he records a space that has actual existence and reproduces his record unchanged in the context of the film. The definition of special effects is necessarily vague, because the term embraces such a wide range of operations that, in turn, have varying purposes when seen in the finished product by the audience.

Generally speaking, special effects fall into two categories. One type is calculated to produce an illusion of actuality that does not in fact exist. Two or more settings may be combined to create the appearance of a unified scene. For example, action filmed at one location—the studio, perhaps—may be integrated with a setting filmed at another location; a still photograph may be joined to a three-dimensional setting; models can be substituted for buildings, ships, or similar large constructions. When successfully produced, this type of special effect will not be apparent on the screen. The processes for creating these effects include the *model shot*, the *glass shot*, the *process shot*, and *rear projection*, all of which are described in the Glossary individually and under the general heading of special effects.

The second type of special effect comprises modifications of the raw footage that are perceptible to the audience. The image fades in or out; one image is superimposed over another or dissolves into another; the format and scope of the image change; the screen is split or fragmented into a number of sections; or one image pushes another out of the frame. Most of these effects can be produced in the camera, but generally they are created in the laboratory on printing machines.

There are two basic types of printing machines: the contact printer and the optical printer. In the *contact printer*, as the phrase suggests, already processed film is in direct contact with the film on which the image is to be duplicated. In the *optical printer*, the image on the processed film is projected from a distance to the film on which it will be copied, much as, in still photography, the

negative image is projected through an enlarger to a piece of printing paper.

The optical printer allows the filmmaker the same kind of flexibility the enlarger affords the still photographer; that is, it enables him to manipulate and modify the visual image. He can enlarge a part of the original to fill the whole frame; reduce the size of the original so that it occupies only a part of the frame; simulate camera movements like pans and zooms; combine images from separate sources; change the shape of the effective format; superimpose one set of images on another; change the color balance and relative lightness or darkness of the print.

The laboratory effects most important in a consideration of movement are the *fade, superimposition*, the *dissolve*, the *split* or *divided screen*, the *wipe* and its special forms including the *pushoff* and the *iris*. Some of these effects, like the fade and dissolve, would seem to have little to do with movement; but by the end of this chapter their relationship to movement should be quite clear.

Fade

A fade is a change in the relative degree of darkness and lightness, the amount of contrast, and the degree of clarity in a visual image. A *fade-in* involves a transition from a uniformly dark screen to a clearly perceptible image; a *fade-out* indicates the opposite. Fades generally are used to mark the beginning and end of a major film segment, where they soften the transition from dark to light or light to dark, or between one segment of film and another.

Superimposition

Superimposition requires that one image, and sometimes more than one, be placed over another to yield a double or multiple exposure. Its effect is to augment the sense of movement, to enhance the feeling of rapidity, to suggest disorientation or confusion, to reveal a number of actions occurring at the same time, or to introduce a metaphor. René Clair's *Entr'acte*, a short avant-garde film of the 1920s, makes frequent use of superimposition. At one moment in the film a chessboard is

107

108

superimposed on the Place de la Concorde in Paris as if to draw a comparison between the two (Fig. 107). In another, Clair combines several views of a roller coaster to suggest rapid changes in direction and their vertiginous effect on the rider (Fig. 108).

Dissolve or Lap Dissolve

A dissolve results when a shot that is fading in is laid over a shot that is fading out to create a link between the two. Very often the dissolve is treated in a more or less perfunctory manner, but Ingmar Bergman in *The Naked Night* employs the technique in ways that enhance its effectiveness as a transitional device and expand its significance as a means of expression.

The film concerns Albert, the owner of a traveling circus, who has left his wife and children for one of the performers, a bareback rider named Anna, whom we encountered on her visit backstage earlier in the chapter (Figs. 52–56). As the film opens, the circus caravan is moving through the countryside, and Frost, one of the clowns, is telling Albert of an incident that very much affected his life—the time when he suffered agonies of humiliation because his wife Alma had stripped and gone swimming in full view of an artillery regiment. Frost's story is enacted as he tells it and becomes a prologue to the remainder of the film.

The circus sets up its tents on the edge of the town where Albert's wife lives. While Albert is visiting his wife, Anna becomes involved with an actor in the local theater. In

107, 108. *Entr'acte.* René Clair. France, 1924. The superimposition of images—in this case, a chessboard on the Place de la Concorde—invites comparison, while a superimposition of views of a roller coaster creates excitement.

making his way back to the circus, Albert catches sight of Anna leaving the theater and infers what has happened. After undergoing the same kind of torments Frost has experienced, he finally accepts the situation, is reconciled with Anna, and the two go on together to the next stop.

As the caravan moves at the beginning of the film, Bergman dissolves from the rotating vanes of a windmill to the rotating wheels of one of the wagons (Figs. 109–111). The similarity in movement between the vanes and the wheels smoothes the transition from one form to the other and brings harmony and unity to the two quite disparate shots. In this case, the dissolve serves a purely formal purpose. However, when Albert sees Anna leave the theater, the significance of the dissolve expands. The camera moves in for a close-up of Albert's tortured face (Fig. 112). Then the dissolve begins. A set of lines and patches appears on Albert's face, which for a moment becomes the painted face of a clown (Fig. 113). Then the lines and patches assume the shape of a queen on a playing card (Fig. 114), which Anna, back in the circus van, has just laid out to find her fortune. Here, of course, the dissolve functions as a comment on Albert's state, identifying him as a parallel to the clown and suggesting his travail will be like the clown's.

109

110

111

112

113

114

109–111. *The Naked Night.* Ingmar Bergman. Sweden, 1953.
The camera dissolves to harmonious shapes and movement.

112–114. *The Naked Night.* Ingmar Bergman. Sweden, 1953.
A dissolve serves to draw a metaphor.

Split Screen, Divided Screen, Multi-Image Shots

In split-screen and multi-image shots the frame is divided into two or more parts so that different spaces or actions or various aspects of the same space or action can be presented simultaneously. Printing split-screen effects requires at least two exposures. In the first, mattes or masks prevent exposure of the part of the frame that the second image will occupy. In the second exposure, a countermatte masks that section of the film already exposed.

Split-screen and multi-image shots have been used in a great many contexts and for a great variety of purposes. In *Entr'acte,* during a wild chase after a careening runaway hearse, the space of the frame suddenly splits in two to enhance the impression of speed and sub-jective disorientation, as well as to maintain the mood of fantasy (Fig. 115). In *The Life of an American Fireman* (1903), Edwin S. Porter shows the fireman dozing at the station and then inserts a circular vignette of his wife putting a baby to bed, an obvious projection of his thoughts and a means of establishing the time of day (Fig. 116). Abel Gance in *Napoléon* (1927) breaks the screen into three rectangles to suggest the excitement, animation, and heroism of a battle scene (Fig. 117). And Storm de Hirsch's semiabstract film poem *Third Eye Butterfly* (1968) makes similes and metaphors by means of multi-image shots. The same printing procedure can be used to present a continuous space in which two or more images of the same person appear, as in *Meshes of the Afternoon* when the central figure confronts two other manifestations of herself (Fig. 157).

Wipe

The wipe can operate like the fade as a means of introducing or eliminating an image gradually, or it can work like the dissolve to replace one image with another. Unlike the fade and the dissolve, however, the wipe usually maintains constant contrast and clarity in the image. A geometric figure appears at some place on the screen and expands until it fills the frame. The figure may be of any shape and may move in any direction or in several directions simultaneously. Figure 118 demonstrates a few of the possibilities.

In professional filmmaking, wipes are generally made in the optical printer with the aid

of a *traveling matte*, essentially a series of masks that regularly change in size, shape, or position—or some combination of these—from frame to frame. The traveling matte in Figure 118 would simply black out the image, moving from right to left and increasing in size until it filled the frame, acting as a simple lateral wipe. Another form of the lateral wipe would introduce a new image, rather than blackness, into the frame (Fig. 119). Both examples call for the new image to mask, cover up, or wipe off the image already on the screen. In some types of wipe the new material seems to push the existing material out of the frame in one direction or another (Fig. 120), and are therefore called *pushoffs*. An especially popular kind of wipe is the iris.

Iris In, Iris Out

An iris is a contracting and expanding diaphragm like that in the eye. Taking the form of thin metal plates, it is used in cameras to control the amount of light reaching the film and to change the depth of field. The iris is simulated on a traveling matte by a series of

118. A selection of traveling mattes.
119. The effect of a wipe.
120. The effect of a pushoff.

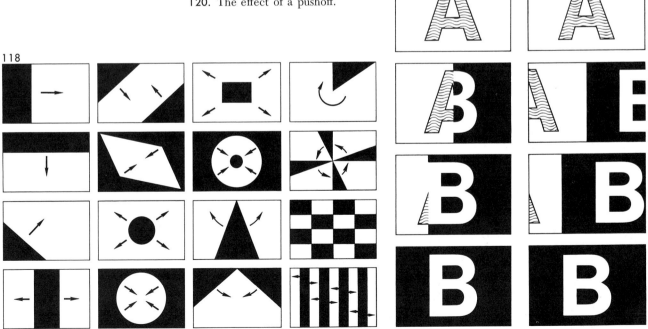

121

122

121–123. *The Birth of a Nation.*
D. W. Griffith. U.S.A., 1915.
The iris is combined with a pan to the right.

123

circles regularly increasing or diminishing in size from frame to frame. The term *iris in* refers to an expansion of the visual image from a circular point to full-frame size. An *iris out* implies the reverse effect.

The iris appeared early in the history of film, and D. W. Griffith utilized it in *The Birth of a Nation* as the basis for a particularly rich shot that develops almost like an argument. The screen is black. A point of light appears and expands into a circle (Fig. 121), which frames a group of women and children cowering behind rocks and bushes. The circle pans to the right to reveal a battle taking place in the distance (Fig. 122). After a short pause, the iris resumes its expansions until it places the embattled armies and the innocent victims in

direct contrast (Fig. 123). The same contrast, suspense, and sense of a developing thesis could be achieved by using three separate shots, but Griffith's method is especially effective because it maintains a continuous relationship between the two groups by the movement of the camera and the iris.

As the foregoing description and examples indicate, movement in film is not an isolable element. Whether it originates with the actor, in the camera, or in the laboratory, it affects one aspect or other of the spatial configuration that appears on the screen. The effective format changes in shape; the field of vision changes, expands, or contracts; the angle of vision rises, descends, or swerves in one direc-

124

125

126

124–176. *Meshes of the Afternoon.*
Maya Deren and Alexander Hammid.
U.S.A., 1943.
The film explores both physical and
psychic space.

tion or another; the focus moves from point to point; and the forms in the space move in patterns that are simple or complex, passive or active, austere or rich, articulating the space and giving it expressive force. Most of these variations in the character of space, some of the infinite range of expressive effects that result, and many of the methods of achieving them are illustrated in *Meshes of the Afternoon.*

MESHES OF THE AFTERNOON

Produced by Maya Deren and Alexander Hammid in 1943, *Meshes of the Afternoon* constituted an important step in the history of the avant-garde in America. Its mingling of

dream and reality—its preoccupation with the irrational, the mysterious, the erotic, and the idea of death—owes much to the methods and concerns of the Surrealist movement, which was an important force in avant-garde circles at the time. *Meshes of the Afternoon* spawned a whole generation of films based on similar themes, motives, and constructions, but few have equaled its expressive power and subtlety of construction.

The basic outline of the narrative is comparatively simple. A hand places a poppy on the sidewalk (Fig. 124). A young woman picks up the poppy, walks along the street (Fig. 125), and catches sight of a mysterious figure robed and hooded in black, with a mirror for its face (Fig. 126). Almost immediately the

127

131

128

132

129

133

130

134

135

136

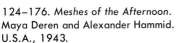

Figures 127–139 show how three shots are made to look like one. A swish pan over an area of uniform tone masks a cut necessitated by a change in camera position to view the dining room. A second swish pan masks a cut required by the change of position to view the stairway.

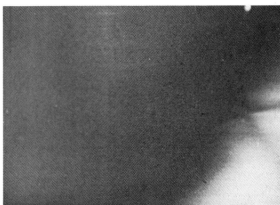

137

figure disappears. Somewhat shaken by the apparition, she enters a house and pauses at the door to survey the living and dining rooms (Figs. 127–135). On the dining table is a loaf of bread with a knife stuck in it. As she watches, the knife falls to the table top (Fig. 136), and the camera quickly pans to the stairs (Figs. 137, 138), where a telephone has been placed on one of the steps (Fig. 139). The woman crosses to the stairs (Fig. 140) and mounting them (Fig. 141), enters a bedroom to turn off a phonograph which has come to the end of a recording and is spinning pointlessly (Fig. 142). She returns to the living room, sits in a chair facing a window (Fig. 143), falls asleep (Fig. 144) and begins to dream (Fig. 145).

Her dream repeats much of the action with slight but dramatic changes in both movement and setting. This time she runs after the hooded figure (Fig. 146). When she enters the house, there is a knife rather than a telephone on the stairs and a knife and a telephone on the bed. Though she starts up the stairs (Fig. 147), she then appears to enter the bedroom

138

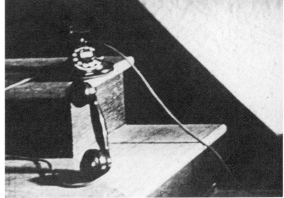

139

140

144

141

145

142

146

143

147

148

149

150

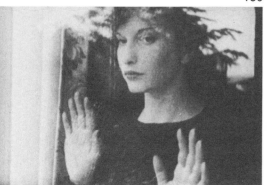

151

124–176. *Meshes of the Afternoon.*
Maya Deren and Alexander Hammid.
U.S.A., 1943.

through a window (Fig. 148) and falls out of the window into the stairwell (Fig. 149). In the living room, she watches herself sleeping in the chair with the phonograph on the floor beside her, its turntable still revolving (Fig. 150). She goes to the window and looks out (Fig. 151). The hooded figure enters the house, ascends the stairs, and she follows (Figs. 152, 153), watching from the top of the stairs as it places the poppy on the bed (Fig. 154). Then she seems to pop from one step to another, now below, now above, now somewhere in between, her changes of position discontinuous and apparently without goal (Figs. 155, 156). The figure suddenly disappears.

Once again she enters the house, and this time her key becomes a knife. She casts lots with two likenesses of herself (Fig. 157), then, picking up the knife, rises from her chair into the open air (Figs. 158, 159), stalks across the landscape to the living room (Figs. 160–171), and begins to lower the knife into the mouth of her sleeping self.

Suddenly she seems to waken. A young man is bending over her (Fig. 173). The two proceed upstairs, where once again the phonograph is turned off. The woman settles onto the bed, with the poppy still lying on the pillow. The poppy turns into a knife. As the young man leans over to kiss her, she grasps the knife and throws it at him. He becomes the hooded figure, the mirror of which shatters to reveal the ocean (Fig. 174). Fragments of the glass fall on the beach (Fig. 175). What had seemed like reality has turned again into a dream. The young man walks up the sidewalk to the house, enters, and discovers the young woman sitting in a chair, dead, draped in seaweed, with pieces of the mirror scattered around her (Fig. 176).

Meshes of the Afternoon is extraordinary both in the way it describes, defines, and limits the space of the house, and in the way it manipulates space and movement within the house to give visual form to the dream and to instill feelings of anxiety. The house never appears as a whole, but its location on the street

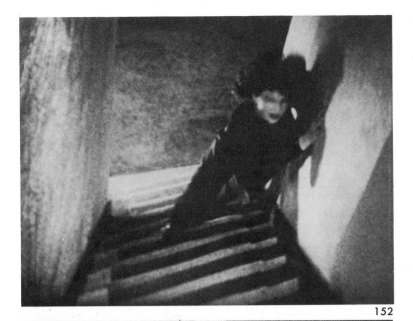

152

153

154

155

and the disposition of its rooms are clearly established. The long, slow pan across the living room to the dining room stresses continuity of space, a pushoff to black serving to mask the splice necessitated by a shift in camera position as the pan reaches the dining room. A swish pan from the knife to the telephone accomplishes the same purpose as the camera reverses its direction and quickens the pace to conform to the stride of the woman approaching the stairs. The camera follows around a bend in the stairs and into the bedroom. Each space—living room, dining room, stairwell, and bedroom—is thus linked to the next by the movement of the camera.

As the camera moves, it also picks up the contrasting textures of carpet, wall, bread, knife, and so on, and by concentrating on the woman's feet as she mounts the stairs seems even to suggest the relative resistence of the treads. When the camera descends the stairs with the woman, viewing the spaces from a different angle, they become even more clearly defined. The physical description, in short, is relatively complete.

This initial exploration of the interior does something more than present the setting; it also establishes the reality of the situation.

124–176. *Meshes of the Afternoon.*
Maya Deren and Alexander Hammid.
U.S.A., 1943.
155, 156. Stop motion allows the woman to move about the stairs without taking a step.

154–170. By matching movement from shot to shot Deren creates a continuity of space where none actually exists.

156

157

158

159

124–176. *Meshes of the Afternoon.*
Maya Deren and Alexander Hammid.
U.S.A., 1943.

160–170. As the young woman stalks
across the landscape, she moves ef-
fortlessly and without interruption
from beach to field to pavement to
floor.

160

163 164

167 168

161 162

165 166

169 170

171 172

124–176. *Meshes of the Afternoon.*
Maya Deren and Alexander Hammid. U.S.A., 1943.

The camera sees things as one would expect to see them. Vertical lines in the setting appear vertical, horizontals are horizontal, and any deviations imitate normal angles of vision. The space appears entirely coherent and stable, and both the woman's movements and those of the camera are fluid, and natural.

The woman drops off to sleep and the camera moves in for an extreme close-up of her eye. The format changes radically, and the camera withdraws through a cylindrical tube, as if entering through the woman's pupil into the recesses of her mind. In the dream the space becomes quite different and so, too, do the woman's movements and the movements of the camera. Space is no longer continuous; actions begun in the interior continue in the exterior. At one point, when the woman smashes the mirror, exterior and interior appear simultaneously. The compositions within the frame become unstable, the patterns fragmented and jagged. The camera repeatedly adopts odd angles of vision and sometimes tilts abruptly and rocks from side to side. There are no more long, continuous pans. The woman's

173 174

175

movements are stylized, while normal speed and continuity are abandoned and gravity is ignored.

At one point the woman mounts the stairs in slow motion. Later, as she claws her way up the stairs again, she seems to be thrown from side to side as if on a rocking boat. On another occasion, through stop-motion photography, she seems to pop from step to step. When she descends, she gives the impression of floating close to the ceiling. And when she stalks over the land with her knife, she steps in unbroken strides from beach to gravel to grass to concrete to carpet, so that distance

is abolished. But with the young man's return in the last scene, everything is restored to normal—except the young woman.

In all the examples we have considered in this chapter, actual movement occurs or is recorded. People and things vary their position within the frame, inanimate configurations in the setting move as the camera moves, and the image is visibly modified by manipulation in the laboratory. But there are films that do not exhibit movements similar to these and thus do not conform to our conventional idea of movement in film.

176

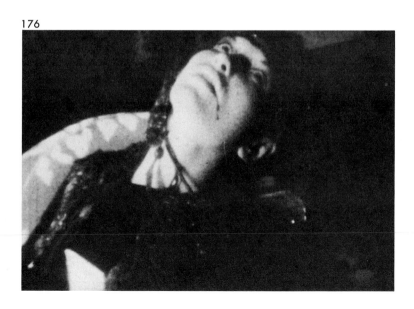

177. *The Day Manolete Was Killed.*
Barnaby Conrad. U.S.A., 1957.

Barnaby Conrad's *The Day Manolete Was Killed* (1957) is made up entirely of documentary stills (Fig. 177). Nothing moves within the frame: people and bulls are frozen in static attitudes and gestures with the settings fixed in place; the camera is stationary. Yet, as each still photograph appears on the screen, the spatial configurations change and the various spatial elements are brought into play, appearing and disappearing at different intervals of time—rapidly in the examination of the *corrida*, slowly as death arrives, the changes seeming to express the dynamics of life, the stasis of death. And there are purely abstract films like Peter Kubelka's *Arnulf Rainer* (1960) and Tony Conrad's *The Flicker* (1966), which are simply composed of a series of black frames alternating with a series of white frames presented to the viewer in rhythmically changing intervals.

In films like these, we are confronted with an aspect of movement we have until now generally ignored: its involvement with time. Actually, movement can be considered as a concretization of time. All three films—and optical effects like fades, which seem to have nothing to do with movement—contain a kind of movement in which actions in space have been made almost entirely subservient to time, in which change alone gives thrust and impetus to the filmic experience and propels the film and the spectator through time.

4

Time as a
Plastic
Element

Like movement, time is an element the filmmaker can manipulate at will, for there is no absolute time. In the electric clock the current flows, the gears revolve, the hands move; we number the seconds, minutes, hours, days, months, and years. But whether we adjust our measure to Greenwich time, to the sun and stars, or to the disintegration of the atom, the units are determined by agreement and learned by experience. Accustomed to a fifty-minute class hour, the teacher given eighty minutes to fill may feel a strange malaise at the end of fifty, as will the student. Travelers changing time zones often experience a disruption of the metabolic process and a disjunction in their thinking. But even the measured rate of breathing and the regularity of the pulse afford no clue to the passage of time in normal experience, since the rate at which the lungs expand and contract or that at which the heartbeat quickens and slackens varies with the situation.

An absolute time—time as simple duration, a mere accumulation of units, if we could imagine it—would be little more than no time at all, for time involves change and incident, and the incident in such a case would be nothing more than the unit of measure repeating itself. Time as experienced is a subjective perception of change and incident. Since it is subjective, it is elastic: hours contract into minutes, minutes stretch into hours according to the nature and quality of the incident and change. Time in film detaches itself from any standard measure; it is not only an elastic element but a malleable one, which the filmmaker can modify at will. Thus he can either imitate time as we measure and experience it or create a new experience of time altogether.

MECHANICAL MODULATION OF TIME: SLOW MOTION, FAST MOTION, HIGH SPEED, LAPSED TIME

Just as the camera allows the filmmaker to modify spatial configurations and simulate movement, so too it enables him to regulate the speed at which change and movement take place. Usually, the filmmaker will shoot his film at normal or standard speed, so that action ultimately viewed on the screen will proceed at the same rate as the action taking place before the camera.

Reproduction at normal speed obviously requires that the film pass through the camera and the projector at the same rate, which for sound projection has been standardized at 24 frames per second. However, if one were to project at 24 frames per second action filmed at 68 frames per second, that action would be slowed—or in *slow motion*—on the screen, since it would take the film nearly three times as long to move through the projector as through the camera. Conversely, action filmed at 12 frames per second and projected at the normal 24 will be accelerated—*or in fast motion*—because the film runs through the projector in half the time as was required for movement through the camera.

High-speed photography is a type of slow motion in which the film advances hundreds or thousands of frames per second. In *lapsed-time photography*, a version of fast motion, each frame of the film is exposed after a long interval—seconds, minutes, hours, even days.

Slow-motion, fast-motion, lapsed-time, and high-speed photography have proved very useful for various kinds of scientific studies. By running a film through the camera at the rate of a million frames per second, then projecting it at much slower speeds, a physicist can study at leisure changes that actually take place in a material or structure within a fraction of a second. Lapsed-time photography offers biologists an opportunity to study movements of growing plants that are not immediately perceptible to the eye because they occur over long intervals.

Creative filmmakers always have exploited changes in time for a wide spectrum of filmic effects. Slow motion is used frequently, of course, to suggest dream states or frustration of movement. It can also enhance the elegance of gesture and attitude associated with dancers, divers, horses, and other animals, or lend an artificial grace to movements that would seem awkward and grotesque at normal speed. Fast motion, which produces a sense of jerkiness and frenetic activity, occurs most often as pure visual comedy. It is important to remember, however, that the effect produced by any modification of movement,

whether deceleration or acceleration, is dependent on the context in which it appears.

Gross modifications of speed occur relatively seldom in feature-length films, although in the early days of the medium, when the camera was cranked by hand, operators sometimes overcranked or undercranked to create expressive variations in speed. A feature-length film that makes more than ordinary use of such changes is Gustav Machaty's *Ecstasy* (1933).

The story concerns an energetic and vivacious young woman married to an elderly man of settled habits, whose lethargy, deliberateness, and almost compulsive neatness bore his young bride and whose involvement in his business leaves her lonely and frustrated. She becomes acquainted with an engineer working in the area, they fall in love, and eventually she bears his child.

Throughout the film, modifications in speed evoke a great variety of moods and convey many disparate ideas. Simply by clothing a very ordinary act in slow motion, Machaty expresses the woman's boredom and frustration when her husband is away. The camera watches her standing on a balcony smoking a cigarette. As she exhales, the film slips into slow motion, so that the smoke seems to drift from her lips in endlessly floating curls. For her, time has almost come to a stop. A sequence in which she and the engineer embrace acquires erotic and ecstatic intensity through slow motion (Fig. 485), while the development of their child is symbolized by lapsed-time photography of growing wheat and flowers.

Short films tend to utilize abnormal speeds more frequently than feature-length films. Sometimes this abnormal speed occurs throughout, as in *Football as It Is Played Today* (1962; Fig. 184), in which the events of a whole day are compressed into five minutes: the sun rises, the stadium is prepared, the parking lots and the stadium fill up, the game is played, people leave, the sun sets. Each phase of the activity takes place in a few seconds.

MODIFICATION OF TIME BY EDITING

Mechanical acceleration and deceleration result in a physical modification of time that can be measured in so many seconds and minutes. The filmmaker can also achieve a sense of acceleration and deceleration by the manner in which he edits or assembles the film.

Temporal Units in Film Structure

The basic units of film structure are shots, series, scenes, and sequences.

A *shot* is a unit that exhibits some internal integrity if only because the camera rolls continuously throughout or—in the case of stop-motion photography—*seems* to roll continuously throughout. Whether it comprises one frame or thousands of frames, whether the film is composed of one shot or many, the shot is the basic unit of film structure, the cell of the filmic organism, the building block of the filmic architecture. It is usually, though not always, clearly distinguishable.

A *series* is a succession of shots describing a setting, one continuous action, or the like, examining it from different angles and different distances.

A *scene* refers to a succession of shots that usually occur in the same general setting and develop a distinguishable but secondary phase of the action, narration, or exposition, or reach a minor climax.

A *sequence*, made up of a succession of shots, series, or scenes, completes a major phase of the action, narration, or exposition, or may reach a major climax.

The segment from *Frustration* described in Chapter 3 (Figs. 57–68) constitutes a sequence, which in this instance is devoted to the quarrel between the captain and the sailor. There are four scenes: the interior of the restaurant, the exterior of the park, the interior of the theater, and the interior of the dressing room. The shots concerned with the actual fight make up a series.

Generally, each succeeding unit—shot, series, scene, and sequence—implies a longer period of time than the preceding. As the descriptions may suggest, however, the terms are sometimes interchangeable and therefore loosely applied. A sequence may be a scene or a series. In fact, it is possible to distinguish individual shots that may operate like series or sequences and may be described as series

178–181. *Praise the Sea.* Herman van der Horst. The Netherlands, 1961.

shots or sequence shots, because the changing configurations caused by the movements of the actors and the camera compare to those that might occur in a series or sequence of individual shots.

The lengthy shot that makes up the nightclub scene in *La Dolce Vita* (Figs. 93–106), for example, is constructed much as if it had been made of separate shots from different angles of vision and distances. The hospital scene is filmed in such a way that the movement of the stairway across the screen operates very much like a wipe connecting two shots (Figs. 83–90). So, too, the rhythmic zooming in and out of the countryside in *Praise the Sea* creates an effect that might be achieved through a series of separate shots—long, medium, and close-up (Figs. 178, 179).

The Editing Process

In shooting a film, the filmmaker will usually have made a multitude of shots at different times, under various lighting conditions, and on several reels of film. More often than not he will also have made more than one version or *take* of a particular shot. In the editing process, the filmmaker first selects the shots to be included and the preferred take and cuts them away from the rejected footage. Editing is frequently described as *cutting*, although the terms describe two different operations, editing referring to the intellectual and aesthetic decision and cutting to the physical act. Since the word cutting is preserved in conventional terms like cutting rate, however, it seems pedantic to make too fine a distinction.

Once the selection of shots has been made —and during the process of selection as well— the filmmaker determines when he will move or cut from distance shot to close-up or when he will cut away discursively from the main action to some telling detail, parallel development, or metaphor. He then assembles what is called a *rough cut*, a version of the film in which the shots are arranged in the proper order but in which all sorts of refinements are omitted. When the rough cut is accepted, the filmmaker will proceed to the *fine cut*, at which point the film begins most closely to approximate its final appearance (Fig. 182). In a very literal sense, the film is thus a collage in time, since, as with any kind of collage, the parts are selected, cut away from extraneous material, and glued—or, to use film parlance, *spliced*—together.

Editing does not necessarily take place after the film has been shot. Depending on the filmmaker's method, the film can be at least partially pre-edited in the script or—especially in those types of documentary film incorporating live action that will not be repeated— even in the shooting itself. Whatever the process, the act of editing brings into play most completely the essential characteristics

182. The director and the editor can work together in a cutting room with horizontal editing tables.

of film as a unique medium, for it is in editing that the expressive potentialities of space and time are maximally under the control of the filmmaker. He can select the particular visual image that will appear on the screen at a given moment and also determine the length of time it will remain. His decisions play with the viewer's sense of time to achieve varying pace and intensity.

As suggested at the beginning of this chapter, our subjective measure of time is in large part determined by the number and character of the incidents occurring in a given time span. The greater the number of incidents that excite our attention, the faster time seems to pass. With this idea as an operating principle, the filmmaker can modulate our subjective experience of time by altering the manner and the tempo in which images appear before us. He has two types of control: one involves the mode of transition from one shot to another, the other the actual duration of the shot on the screen. The first method includes such devices as the cut, dissolve, fade, and wipe, most of which were described in Chapter 3 (see pp. 40–46).

Transitional Devices

The *cut* is the simplest and most abrupt method of transition, since it marks the sudden

disappearance of one image and the immediate appearance of something else. It serves to move instantaneously from one aspect of a situation to another, to introduce discursive or related material, and to mark the end of one phase of a development and the beginning of another. Viewed simply as a mode of transition, without concern for the contents of the shots on either side of it, the cut strongly supports the forward thrust of the film. It is the most frequently used method of transition.

Because it superimposes two images, the *dissolve* inevitably takes longer than the cut and allows for a gentler, more gradual transition. Still, the very superimposition of images supports movement of the film through time, though not quite so emphatically as in the cut. The dissolve simultaneously presents two configurations, so it usually makes a transition between segments of material more or less directly related to each other.

The *fade* characteristically retards the forward movement of a film, even though it may take exactly the same number of frames as a dissolve. It is generally used to introduce or terminate a phase of the film's development, although it sometimes appears in an alternation of fade-in and fade-out that imposes a strong rhythmic pulse on the movement through time.

The effect of a *wipe* varies according to the contents of the shots involved. A wipe from image to image is like a dissolve, a wipe from black to image or image to black like a fade.

Such transitional devices are sometimes compared to punctuation, as if the cut had the value and function of a comma, the dissolve of a semicolon, and the fade of a period. In conventional filmmaking, there does seem to be a regular progression in temporal effect, from the slowness of the fade, through the moderate pace of the dissolve, to the immediacy of the cut. But there is no absolute temporal consistency. Josef von Sternberg was known for his long, protracted, almost leisurely dissolves, while Fellini often introduces dissolves so rapid that they are imperceptible and function as softened or disguised cuts. Moreover, the movement and spatial configuration of the shots on either side of a cut or superimposed in a dissolve modify the temporal implications. A cut or dissolve from active to static will retard the filmic movement; a transition from static to active accelerates it.

All these mechanical means incorporate the basic elements of film—light, space, and time—so it follows logically and in practice that by manipulating light, space, and time in other ways, similar effects can be achieved. For example, a sequence might terminate with a fade, but the same kind of temporal effect can be achieved by using the *freeze frame*— that is, by holding the image static for a relatively long period and ending it with a cut. The freeze frame is achieved by printing a single frame over and over.

Both the cessation of movement created in the freeze frame and the loss of light and dark contrast—and ultimately of image—in the fade have the effect of bringing a phase of the development slowly to an end. For all the similarity, however, the two methods do carry different expressive overtones. The fade seems to imply some kind of resolution; the freeze frame does not. François Truffaut, examining the psychology of a juvenile delinquent, ends *The 400 Blows* (1959) with a freeze frame of the child's face (Fig. 183), then a cut, clear indication the boy's problems remain unsolved.

Tempo and Cutting Rate

More important than transitional devices to the development of the film as a whole is the filmmaker's establishment or modulation of tempo. This is accomplished in part by establishing and modifying the cutting rate—the

183. *The 400 Blows.*
François Truffaut.
France, 1959.

relative length of the shots making up a series, scene, sequence, or the film in its entirety. The relative speed at which shots pass before the eyes can set the pace of a film, which may quicken, slacken, or be interrupted according to the expressive exigencies of a particular moment. A film's pace, and modifications thereof, create a rhythmic impulse that carries one through time faster or slower, like the rhythmic patterns and modulating tempi of music.

Two examples of quite disparate cutting rates make immediately evident the effect of differences in the duration of shots. In *Haircut* (1964), Andy Warhol deliberately avoids editing. He points his lens at the barber and at the profile of the client's head and shoulders, lets the camera roll until the film runs out, and splices one roll of film to the next without even eliminating the *leader*—the piece of celluloid attached to the beginning and end of the film proper to protect the ends and allow for threading through the projector. By adopting this procedure, Warhol celebrates film as a material substance and emphasizes the relationship between film and life by making it clear that the live action exists only by virtue of the existence of the film.

In a context in which no major change occurs, each minor change assumes a greater degree of importance, and the observer can discern a formal development. The movement of the barber's hands and scissors as he snips on the far side of the head assumes the character of a spontaneous yet ritualistic hand dance. Then, the transfer of the hands to the near side becomes a moment of dramatic intensity, reinforced by the sudden revelation of a tattoo on the barber's arm. A gradual change in light and dark contrast creates a kind of excitement; shadowed and rather brooding to begin with, the film becomes increasingly dark and contrasty until little is visible but the shiny highlights of the scissors and the client's eyes.

Football as It Is Played Today (Fig. 184) presents quite a different effect, not merely

184. *Football as It Is Played Today.*
Joseph Anderson. U.S.A., 1962.
Six frames in a continuous series illustrate speeding of action in fast-motion and lapsed-time photography.

65

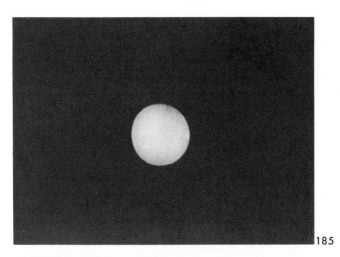

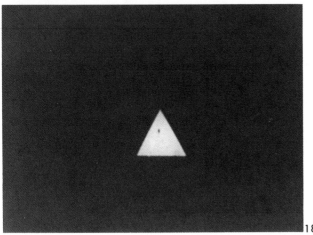

185, 186. *Ballet mécanique.* Fernand Léger. France, 1924.
Alternating shots of separate geometric figures achieve
rhythm.

black ground. If the length of each succeeding pair of shots were regularly reduced from five seconds to one-twelfth of a second and then gradually increased again, the rate of alternation would increase to frenetic rapidity and then slow again. This is essentially what happens in some parts of Fernand Léger's *Ballet mécanique* (1924), a film made up primarily of shots of machines and static objects that have been set in motion by pixillation, plus a circle and triangle in alternation (Figs. 185, 186). Even in the presentation of these fundamentally unrelated objects, there is a rhythmic acceleration and deceleration, with attendant increase and decrease of excitement and tension. One can imagine the use of simple musical tempi, 3/4, 1/1, and so forth, or of the metrical schemes of poetry.

Sequences more directly concerned with depicting normal events demonstrate the filmmaker's manipulation and dramatization of time equally well. A sequence describing the building of a dike in *Praise the Sea* shows relatively routine action—the digging, transporting, and dumping of earth (Figs. 180, 181). Yet the filmmaker injects a sense of drama largely through the continuously accelerating cutting rate, which creates a time existing exclusively in the film.

The sequence begins with shots of the complete operation, following steam shovels as they dig the earth, carry it from one place to another, and dump it to close a hole in the dike. As the film proceeds, one part of the action after another is eliminated and shots become shorter in duration, until at the climax there is only a series of rapid shots showing earth falling from the hoppers. Concentrating more and more on the act of filling, excising larger and larger chunks of time, the filmmaker accelerates the tempo and gives the mundane act a dramatic intensity that in turn expresses the importance of holding back the waters. Thus, by accelerating the tempo the filmmaker contracts time.

Expansion and Contraction of Time

Acceleration and deceleration of the cutting rate modify the pace of a film and the nature of the spectator's experience, but they do not

because the movement within the frame is speeded up—actually it is probably no faster than the snipping scissors—but because the camera constantly changes its position, distance, angle, and point of focus. Had Warhol used a number of cameras viewing the subject from different vantage points and edited his film so that the image constantly and rapidly changed, *Haircut* would have acquired the immediate excitement of acceleration.

The effect of change in the cutting rate can be visualized clearly if one imagines a film devoid of even the hint of narrative content that *Haircut* and *Football* contain, a film perhaps featuring a white triangle on a black ground alternating with a white circle on a

necessarily contract time—as in the dike-building sequence—or expand it. A *Haircut* edited at a rapid cutting rate could still take 35 minutes to run. But the time it takes an event to be completed is often shortened, as it is in *Praise the Sea*, or lengthened.

Sergei Eisenstein seems to use time almost as if it were a rubber band. In a well-known sequence from *Ten Days That Shook the World* (1928), he holds time back and suggests how, in moments of terror or urgency, time can drag. In the course of the October Revolution, a drawbridge connecting two parts of St. Petersburg is raised to sever communications. On the rising roadbed lie a wounded girl and a fallen horse. As the bridge reaches the peak of its ascent, the girl slides down the incline while the horse plummets to the river below. Rather than observing the action from a single vantage point and following it continuously, Eisenstein views it from a number of angles, repeating phases of the action again and again, extending the time required for the bridge to rise and thereby creating excruciating suspense and frustration (Fig. 187).

The contraction of time in *Praise the Sea* could have been achieved by means of fast motion, the expansion of time in *Ten Days That Shook the World* through slow motion. But in both films the overtones and implications would have been quite different, the hard reality of the situations weakened. Fast motion, which almost invariably assumes comic qualities, would deny the seriousness, dignity, even heroic aspect of the work of building a dike; and slow motion would suppress the tension that results from the sight of the bridge beginning to rise and then starting to rise over and over again.

Simultaneity in Sequential Presentation

In each of the preceding examples, the series of shots, however much it may modify time, presents a single action in approximately chronological order. But a series of shots can, of course, describe simultaneous action as well. The transformation of simultaneous action into sequential action occurs frequently in a dramatic development so characteristic of the film as to be considered part of its essential content: the chase.

The most common method of delineating a chase is to cut back and forth from the pursued to the pursuer, so that the rhythm of alternation, especially when combined with a rapid cutting rate, augments the forward thrust of the filmic movement, injects suspense, and enhances the excitement. *Überfall*, a short film made in 1929 by Ernö Metzner, contains a chase that is a model of filmic organization. Although it indirectly raises questions about the relationship between morality and economic or social stress, the film is basically a simple, straightforward narrative of a surprise attack (*Überfall*) on an unassuming man by would-be thieves. The central figure, a man of no particular distinction, might represent Everyman. He finds a coin in the street and, when he tries to spend it on cigarettes, discovers it is counterfeit. Somewhat bemused, he goes into a bar, joins a game of dice, and, using the counterfeit coin, consistently wins. His faith in his luck revived, he leaves the bar, only to discover he is being followed by a thug. When he begins to run, the thug pursues and finally catches him. Just as the thug is about to attack, a young woman approaches the victim and invites him into her house. There, after a series of ominous events, the young woman and an accomplice attack

187. *Ten Days That Shook the World.* Sergei Eisenstein. U.S.S.R., 1928.

188

189

19(

194

195

19(

200

201

20

188–220. *Überfall.* Ernö Metzner. Germany, 1929. Gradual diminution in length of shots and distance from the players, along with changes in angle of vision, accelerate the movement and intensify the excitement of this chase sequence.

the central figure, rob him, and throw him out into the street, where the thug proceeds to beat him with a blackjack. The victim is last seen in a hospital, as the film ends with a shot of the coin and the question: Who is to blame?

Überfall demonstrates how relatively simple narrative ideas can be built into a strong, suspenseful, and significant dramatic structure by the expressive manipulation of space and time. But it is the chase that, for the moment, is of primary interest (Figs. 188–

191 192 193

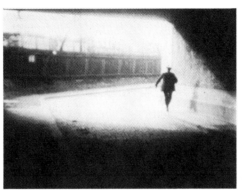

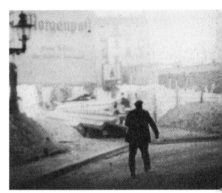

197 198 199

203 204 205

220). The victim leaves the bar and walks away from the camera down the street (Figs. 188, 189). Almost immediately the thug, too, leaves the bar, interrupted in his pursuit by a friend (Fig. 190). The victim looks apprehensively over his shoulder (Fig. 191). As the thug follows, the two appear in the same shot, so that the distance between them can be specified (Fig. 192). Two friends of the thug emerge from the bar and join the pursuit (Figs. 193, 194). Soon the victim breaks into a run,

and the thug scrambles after him (Figs. 195–199). Up to this point the cutting rate has been relatively slow, with the pace further retarded by cutaways to the thug's friends. Now the tempo quickens, and shots rapidly alternate between the victim and the thug (Figs. 200–219). The cutting rate accelerates as the distance closes between them, until, when the thug finally catches his victim, the two appear once again in the same shot (Fig. 220). The sequential presentation of simultaneous action

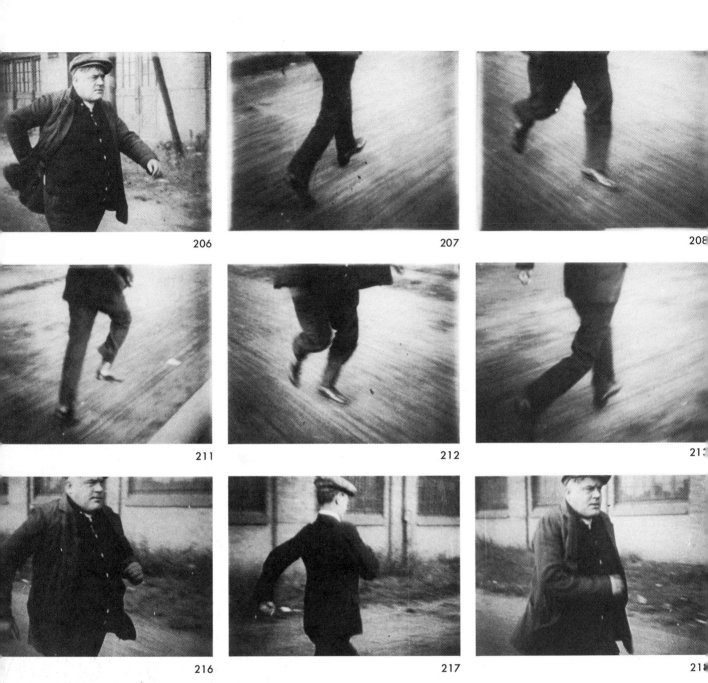

206 207 208

211 212 21

216 217 21

(pursued and pursuer) ceases. Thus, the chase develops an increasingly accelerated rhythm that, in the last shot, comes rapidly to a conclusion and reaches a condition of relative immobility if not of absolute stasis.

Space and Movement in Relation to the Cutting Rate

We have so far considered time as a separate element in filmic expression and viewed the expansion, contraction, acceleration, and deceleration of time and temporal rhythm as if all resulted exclusively from the speed of the film through the camera and the length of the shots. Yet, as we studied each example, we invariably became concerned with the content of the shots and movement occurring within them, so by implication, with the spatial configurations that presented themselves—both of which elements, movement and spatial patterns, affect our experience of filmic time.

209

210

214

215

219

188–220. *Überfall.*
Ernö Metzner. Germany, 1929.

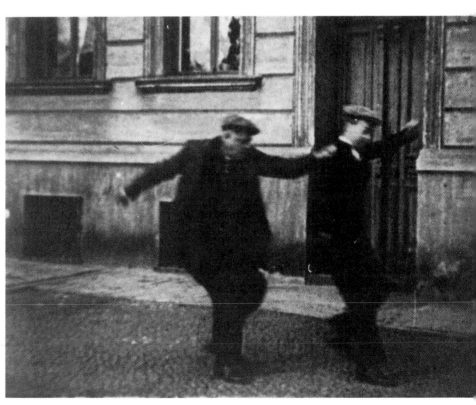

220

The motion of people and things within the frame obviously can establish a more or less slow or rapid pace that is sometimes reinforced by the cutting rate and is sometimes contrasted with it. In *Praise the Sea*, the sweep of the windmills' vanes across the frame, the rotation of the waterwheels, the actions of the people—climbing ladders, pulling on ropes to adjust a vane, milking a cow (Fig. 221), scything a field—assume a rhythm consistent with the camera movement and the cutting rate. Similarly, in the chase sequence from *Überfall*, it is not only the cutting rate that accelerates and decelerates, but the action of the men, who quicken their pace from a relatively leisurely walk to a run and bring it to a halt. Their action as well as the cutting rate imposed by tle filmmaker provides a rhythmic pulsation.

The regular repetition of movement associated with work and play, running or walking, is less apparent in more spontaneous actions that make up our lives. Perhaps more than we are aware we create in our most casual behavior a rhythmic quality—in our gestures as we talk, in the shifting of position, in the movement of head and hands. These, too, will sustain a pace and maintain a rhythm. For example, all the gestures associated with smoking a cigarette—getting out the pack, selecting the cigarette, lighting it, puffing, moving the hand to the mouth, stubbing out the butt—have been especially useful to film-

makers, partly because the relative speed and the character of the gestures may convey moods of tension or relaxation. These gestures also sustain the rhythmic pulse of the film, sometimes almost as if guided by a metronomic beat. Such a device recurs frequently in Josef von Sternberg's *The Last Command* (1928).

In one scene, Natacha, an actress and revolutionary agent, is being interrogated by an army general who is the central figure in the film. He offers her a cigarette, and the movements that follow, filmed in medium close-up, create a strongly accentuated rhythm: she takes the cigarette and puts it in her mouth, his hand extends to light it, she inhales, the hand withdraws, her eyes shift their direction from right to left (Figs. 222–225). Each action maintains the same measured pace. In this shot, although the metrical pattern is clear, the movements flow easily one into another; but even in a relatively static situation they may, of course, be more abruptly articulated for certain effects.

Later, after the general has offered to protect Natacha and she has moved in with him, she decides to murder him. The moment of decision is recorded in a full shot of Natacha seated on a bench, followed by a medium close-up; the decision itself is described in a series of decisive changes in attitude, each held for a moment before the next occurs (Figs. 226–229).

221. *Praise the Sea.* Herman van der Horst. The Netherlands, 1961.

opposite left: 222–225.
The Last Command.
Josef von Sternberg. U.S.A., 1928.
As the general lights Natacha's cigarette, the decisive movements of hands and eyes maintain a rhythmic impulse.

opposite right: 226–229.
The Last Command.
Josef von Sternberg. U.S.A., 1928.
When Natacha decides to kill the general, sharply articulated and segmented movements create a rhythmic beat.

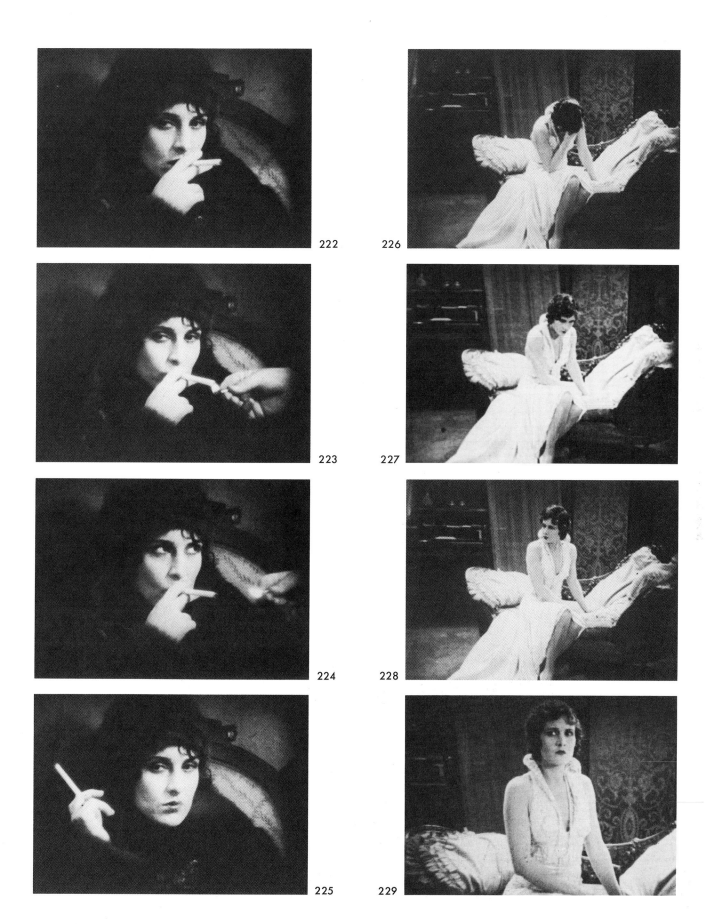

222

226

223

227

224

228

225

229

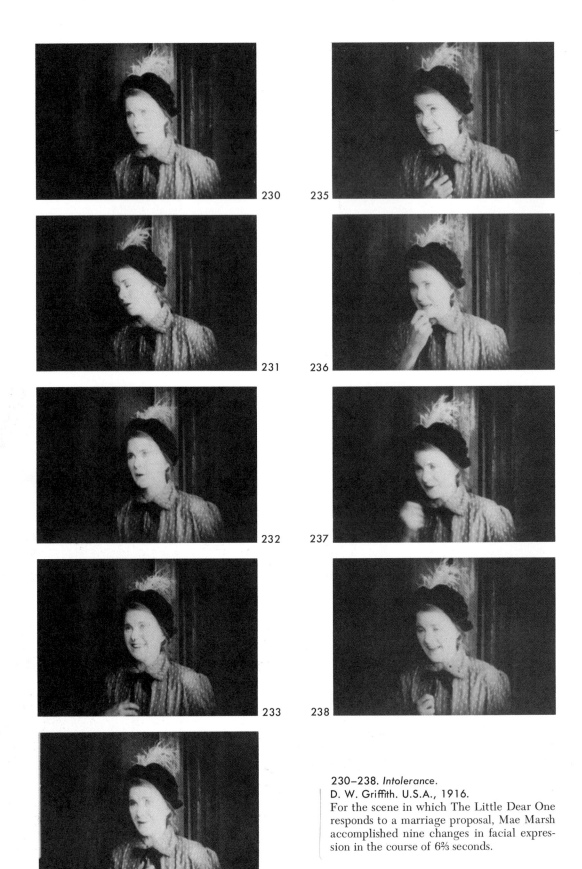

230–238. *Intolerance.*
D. W. Griffith. U.S.A., 1916.
For the scene in which The Little Dear One responds to a marriage proposal, Mae Marsh accomplished nine changes in facial expression in the course of 6⅔ seconds.

Changes in facial expression operate equally well in sustaining a rhythmic pulse and conveying an attitude or mood. Mae Marsh, as "The Little Dear One" in *Intolerance*, produces a tour de force of facial gymnastics in response to her boyfriend's proposal of marriage, which is made through the door of her flat. The shot runs through nine changes of facial expression in 161 frames or about 6⅔ seconds (Figs. 230–238).

All of these examples contain relatively stylized action, but the same possibilities exist in a more naturalistic approach. In *La Dolce Vita*, Marcello and Maddalena leave the nightclub (Figs. 104, 105) and search for new adventures to relieve their boredom. They spend the night in a prostitute's apartment. Their arrival at the apartment is plotted with the same finesse that was apparent in the other passages we have examined from the film. The camera observes Maddalena as she puts on her shoes (Fig. 239), then moves in to a medium close-up of Marcello (Fig. 240). Next, the camera follows Maddalena as she moves from right to left. Seen in medium close-up, she seems to glide through space rather than walk; any rhythmic thrust measured by legs is lost, but the beat is maintained by her crossing through areas of alternating light and dark (Figs. 241–244). When Maddalena pauses mo-

239–245. *La Dolce Vita*. Federico Fellini. Italy, 1960.
As Maddalena glides across the screen, alternating patches of light and dark, together with Marcello's twirling of a flower, create a visual rhythm.

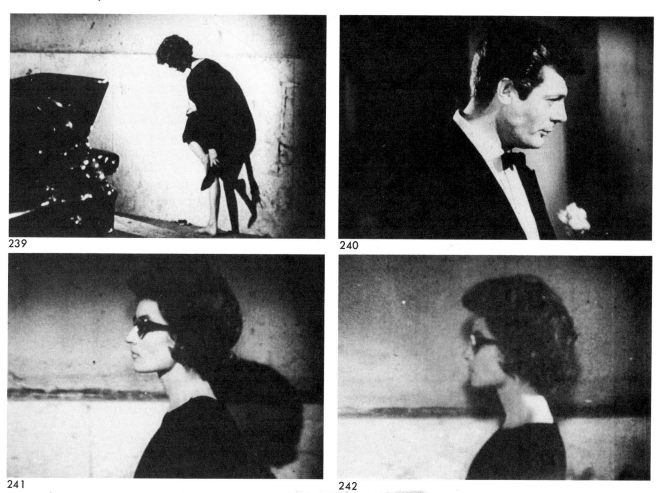

239

240

241

242

243

244

245

239–245. *La Dolce Vita.*
Federico Fellini. Italy, 1960.

mentarily to speak to Marcello (Fig. 245), the rhythmic beat is continued by the movement of a flower Marcello twirls in his hand. Throughout this sequence, actors, objects, and camera all move, and the spatial configuration changes as well.

Überfall illustrates in a somewhat more dramatic way how a change in spatial configuration can reinforce the cutting rate, augment the temporal rhythm, and intensify excitement, for as the chase sequence develops, the patterns change drastically. The principal lines of the composition shift in emphasis from vertical and horizontal to diagonal, the distance changes from long shot to close-up, the close-ups alternate not only between pursuer and pursued but also between legs and torsos. Even the direction of movement alternates, with the thug moving on a diagonal toward the camera, the victim on a diagonal away. The number of contrasting elements increases as the chase gains momentum.

The interdependence of space, movement, and time intervals can be seen with almost paradigmatic clarity in one of the most famous short bits of film history, the "Diving Sequence" from *Olympia* (1938), a documentary account of the Olympic games held in Germany in 1936. The film, directed by Leni Riefenstahl, runs for five hours, of which the diving sequence illustrated in Figures 246 to 272 lasts five minutes.

The opening shots establish the setting, examining in a reportorial manner the pool, the audience, and the action of the divers (Fig. 246). Then follow a series of shots that analyze the movements involved in the act of diving: the diver walks to the end of the board, springs into the air, plunges into the water, climbs out of the pool, crosses to the ladder, and ascends to repeat the cycle (Figs. 247–254). At the ladder the identity of the diver changes, but the series of shots is so cut as to maintain a sense of continuity. At appropriate moments close-ups of the audience are interpolated (Figs. 255, 259, 260) to reveal their reactions; usually, the camera focuses on a person of the same ethnic background or

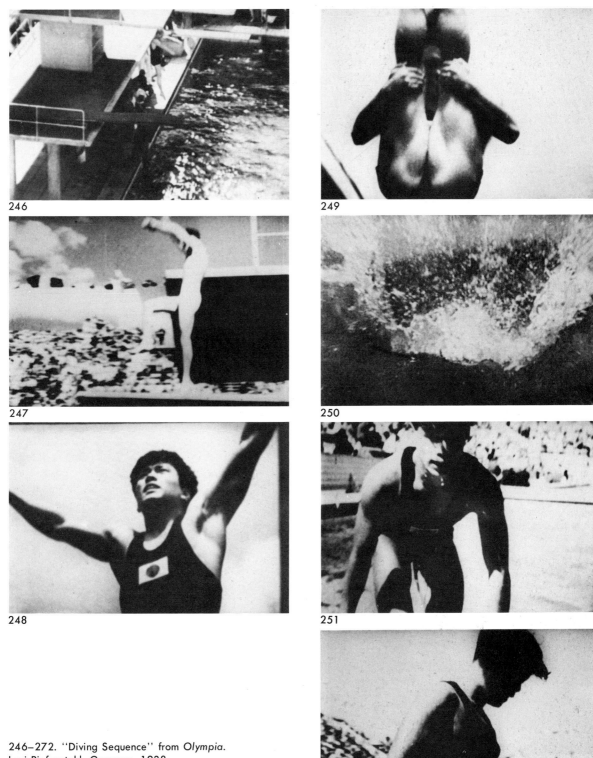

246–272. "Diving Sequence" from *Olympia*.
Leni Riefenstahl. Germany, 1938.
Beginning as a documentary description of the men's diving competition, the sequence, in a crescendo of movement and contrast, becomes a metaphor of heroic aspiration.

nationality as the diver of the moment. Throughout this section the camera maintains a position on a level with the subject, the disposition of forms is generally architectonic, the close-ups of divers and spectators are very nearly frontal, and movements occur horizontally or vertically on the screen. The effect is of journalistic completeness and classical order.

Once this exposition is complete, three changes affect the development of the se-quence. First, the cutting rate is modified as components of the action are eliminated—the diver's climb out of the pool, his crossing to the ladder and climbing up, his walk or run to the end of the board—until there remains only the pause, the dive, and the plunge. Second, normal time is condensed to produce a filmic time more selective and dramatically emphatic. Third, the angle of vision changes regularly and rhythmically: the camera looks

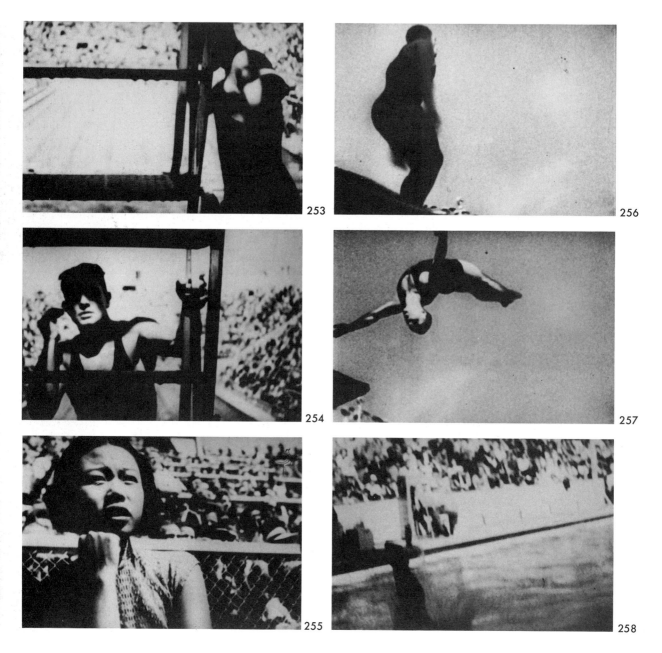

253

256

254

257

255

258

from below, from above, and obliquely; the divers move across the screen not horizontally or vertically but at an angle, defining the space in which they operate by their own movements and shaping it into more dramatic dispositions of forms (Figs. 261–270).

The process of contracting time and dramatizing space continues through the sequence, until at the end all the spectator sees are brief shots of divers suspended in air (Figs. 271, 272), alternating in the direction of their movements, silhouetted against the clouds, soaring in an infinite space that seems unrelated to the earth. Time has been so altered that the divers are as birds coasting on currents of air; similarly, space has been transformed from a view of the arena to an image of the empyrean.

Within this development other transformations occur. Retarded motion for the swan

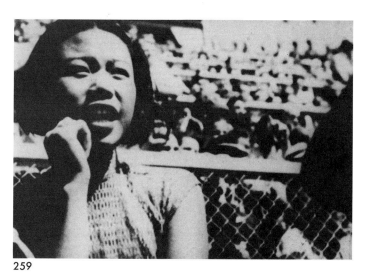

259

260

246–272. "Diving Sequence" from *Olympia*.
Leni Riefenstahl. Germany, 1938.
259, 260. Close-ups of the spectators' faces identify them with divers of the same national origins.

261

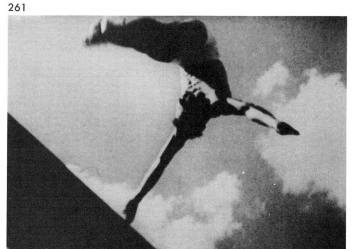

262

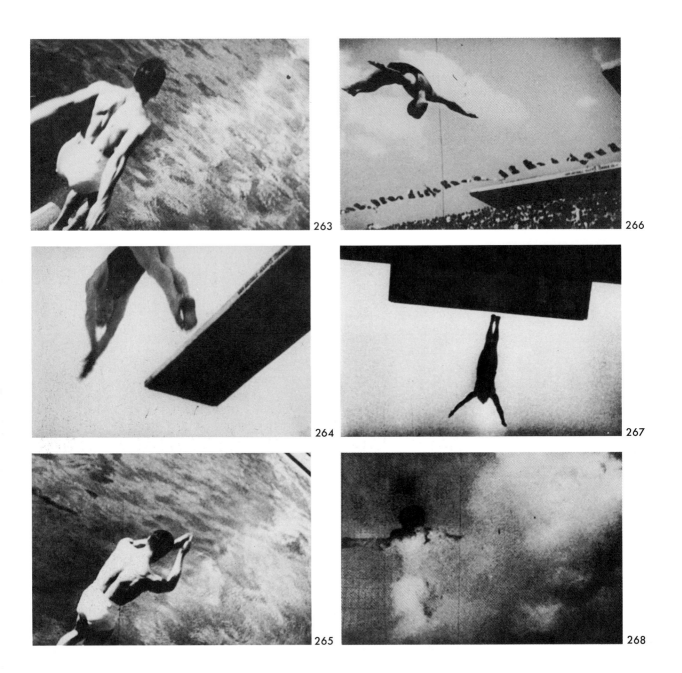

263

266

264

267

265

268

divers makes them seem more than normally to float; and occasionally motion is reversed or the image turned upside down (Fig. 269), perhaps to maintain the rhythm of change in the direction of movement or to inject a subtle, almost imperceptible sense of mystery.

The transformation of space and time embodies a transformation of significance. Of the events in the Olympic games, diving is one of the least dramatic. By contrast, in a race the contest between participants is visible in the distance; in high-jumping or pole-vaulting the measure of the bar is always present to mark the progress of competition. Team sports such as basketball focus on the interplay between athletes, and the announcement of goals takes on a quality not unlike that of a theatrical performance. But in diving, pretty or skillful as it may be, we have no concrete evidence of competition. The basis of judgment is a

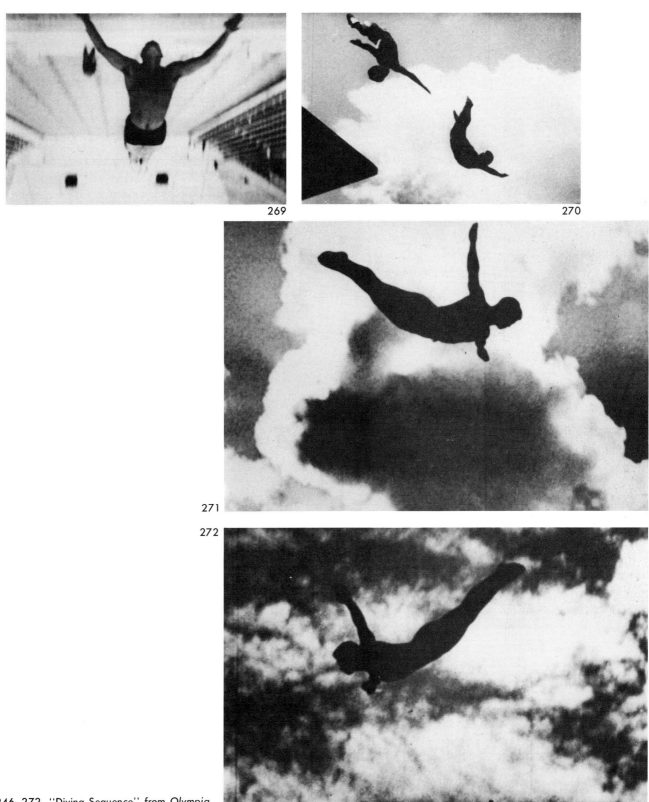

269

270

271

272

246–272. "Diving Sequence" from *Olympia*.
Leni Riefenstahl. Germany, 1938.

matter not of time, distance, or points, but of aesthetic quality. Nevertheless, this sequence develops as drama.

The idea of international competition is suggested early in the film by the simple device of showing close-ups of competitors wearing national emblems on their suits and of spectators who are obviously of different national origins. As the film progresses, the divers are gradually dissociated from the spectators, from the Olympic pool, from any national grouping, and from earth as well, transformed into soaring silhouettes. More than a documentary report, the sequence becomes a paean to physical strength, skill, and human aspiration, a freeing of the spirit through a freeing of the body, a symbolic triumph over the limitations of gravity, an apotheosis of man as a conqueror of space, an appeal to the wish to fly, a glorification of the power of the human. The spectator, like the diver, is released—from the confinement of real time and real space.

The editor's work, then, is not simply a matter of measuring out lengths of film and joining them or even of providing for smooth transitions from shot to shot. In order to propel the spectator through time and to give time both visual form and dramatic force, he must take all aspects of a shot into consideration—space, movement, length of shot, and many other elements that we will examine in the next four chapters.

5

Structures
in Space-Time:
Continuity, Harmony,
and Contrast

The previous chapters considered filmic space, movement, and time separately, as if each were an independent variable. But it has been apparent from the outset that each element is a function of the others, and the total expressive effect—setting aside for the moment considerations of color and sound—results from the interrelationships among them. As we have seen, filmic space is created, described, and infused with import by the real or imagined movement, both within the frame and from shot to shot, movement that inevitably incorporates time. Movement in turn derives its particular expressive quality from the spatial configurations it generates and the amount of time it occupies. And time is modified and modulated, expanded and contracted, accelerated and retarded, or even stopped by the character of the movement and the nature of the spatial organization.

So interdependent are space, movement, and time that it is impossible to consider one without reference to the others. We viewed the "Diving Sequence" from *Olympia* (Figs. 246–272) primarily as an example of temporal manipulation and noted how rhythm was developed and time compressed, transformed, even invented by the modulation of time intervals. Nevertheless, as we examined the sequence we found it necessary to identify the nature of the actions—climbing, walking, poising, diving, swimming—each of which insinuates its own rhythms. We considered spatial factors, like distance, direction, inclusion and exclusion of setting, each of which affects the duration of the shot and is affected by it. In short, what we apprehended is a compound structure incorporating space, movement, and time. Since movement is a concretization of time, we can term the compound somewhat more succinctly as a structure in space-time.

HARMONY AND CONTRAST IN FILM STRUCTURES

The filmmaker's art comes most fully into play and his authority, or lack of it, is most clearly revealed in the way he shapes structures in space-time. Basically he exploits two variables, harmony (or likeness) and contrast, both of which can appear in any dimension of the film—in spatial organization, movement, time intervals, emotional and intellectual content, and, of course, in sound and color.

While harmony lends a unifying force to the material, contrast imposes a disruptive one, and the relative emphasis on one or the other contributes to a particular expressive tone. A comparison between Eisenstein's *Ivan the Terrible, Part I*, with its stress on contrast, and Warhol's *Haircut*, with its overall harmony, readily illustrates this point. As conditions of filmic structure, harmony and contrast are quantitatively measurable by the mind's sensitometer, if not by an absolute scale.

Whether he works analytically or intuitively, whether he follows tradition or avoids all conventions, the filmmaker ultimately confronts the same basic, unavoidable problem in construction: What is the appropriate mixture of harmony and contrast for a particular shot, series, scene, sequence, or film? In order to convey the desired feelings and ideas, introduce specific overtones and accents, develop rhythms, and build to climaxes, he must modulate the various elements in the compound, varying the consonance, dissonance, and tensions among them; in short, he must create varying degrees of contrast. At the same time the filmmaker must establish some kind of relationship among the parts, between one action and another, one shot and another, one sequence and another; that is, he must attend to harmony, if he expects to link the parts into a tectonic or organic whole and achieve some sense of unity.

Unity and Continuity

Because it necessarily involves a continuous sequence of visual incidents, cinematic unity is often called *continuity*. In its simplest and most obvious form it appears as continuous action, a stationary shot of a person walking, for example, which involves a regular repetition of movement and a regular division of time as legs, arms, hips, and shoulders swing along a line, measuring the space and time from one point on the screen to another. Continuity of setting and of action are literally uninterrupted, and the contrasts that appear in the changing positions of the body are so

completely subordinated to the overall continuity as to seem an integral part of it. But if continuity is inherent in the uninterrupted shot, it is not in a series of shots, and the word generally implies the establishment of some kind of relatedness among separate and discrete shots made at different times and in different places or from different angles and different distances, so that the action of a particular thing in space or the movement of the film through time seems uninterrupted.

Let us suppose that in describing a walking figure the filmmaker wishes to bring us closer, to reveal a detail, or to add another contrapuntal rhythm to the rhythm of walking. He may cut from a distance shot to a medium shot to a close-up of feet and legs, so timing his cutting rate that the movement of limbs establishes one rhythm and the cutting—which takes place, let us say, on every third step—establishes a counterrhythm. In this triplet, the spatial configuration will change with each cut. Of course, some sense of continuity will emerge from the fact that all shots depict the same person, but continuity will be given formal substance by the manner in which the cutting is done and the establishment of harmonious spatial relationships between shots.

Unless he wishes to describe a person pacing back and forth, the filmmaker probably will first of all ensure that all shots reveal the person moving in the same direction. And, if he cuts from distance shot to medium shot to close-up, he will no doubt make certain that the shots on either side of the cut show the figure roughly in the same place on the screen. Finally, in order to maintain smooth, uninterrupted action of the legs or feet, he will see to it that their position on either side of the cut is the same. Usually he will make the cut when one leg or foot has reached the extremity of its movement. In sum, then, the filmmaker will endeavor to match the end of one shot with the beginning of another so that the series will embody a harmony in direction, position, and movement in order to unify the action and maintain its continuity.

The cutting in the stalking sequence from *Meshes of the Afternoon* (Figs. 158–171) demonstrates the way in which shots taken at different times and places can be incorporated into a single continuous, fluid movement. In this case a figure rises from a dining room table into the open setting of a beach; a foot rises from the sand, descends on grass, rises from grass, descends on concrete, rises from concrete, descends on carpet, and returns to the house again. Another situation might require that the foot seem to leave the earth in New York and with one step touch down in Paris.

The camera's movement can also be organized to provide a fluid transition from one shot to another. As long as the camera moves in the same direction and at the same speed as the action being filmed, separate shots of quite diverse material may seem to emerge one out of another without any apparent cut. To extend the previous example, the architectural landscape of Paris can merge with that of Manhattan. Michelangelo Antonioni adapted this effect for the opening shot of *La Notte* (1961), in which the camera lens, descending as if on an elevator, views the side of a skyscraper, floor after floor, window after window, rising from the bottom of the screen and disappearing at the top in a seemingly endless repetition. The effect was no doubt achieved by repeating the same shot over and over, with the cuts carefully calculated to occur at a point where there would be no interruption of continuity. Such a method is related to the use of *loops*, which are lengths of film with the beginning and the end joined so that the film plays over and over, a form popular with contemporary independent filmmakers.

The filmmaker may not, of course, wish to maintain smooth continuity in either the movement from shot to shot or the nominally continuous action. For a number of reasons—to provide information, to intensify the visual excitement, to inject a visual shock, to modify the rhythm, or simply to introduce variety—he might reduce or eliminate the harmonious elements. He may, for example, shoot successive phases of an action not only from different distances, as in *Überfall* (Figs. 188–220), but also from different angles of vision, so that the figure or object moves across the screen first in one direction and then in another. Griffith employed this technique frequently in the chase sequences of *Intolerance*, where it was seen by Russian directors like Eisenstein.

273. *Daybreak*. Stan Brakhage. U.S.A., 1957.
Jump cuts here suggest emotional tension.

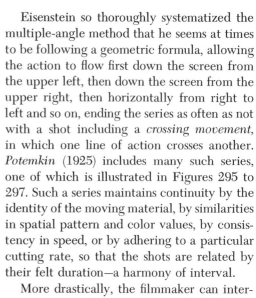

Eisenstein so thoroughly systematized the multiple-angle method that he seems at times to be following a geometric formula, allowing the action to flow first down the screen from the upper left, then down the screen from the upper right, then horizontally from right to left and so on, ending the series as often as not with a shot including a *crossing movement*, in which one line of action crosses another. *Potemkin* (1925) includes many such series, one of which is illustrated in Figures 295 to 297. Such a series maintains continuity by the identity of the moving material, by similarities in spatial pattern and color values, by consistency in speed, or by adhering to a particular cutting rate, so that the shots are related by their felt duration—a harmony of interval.

More drastically, the filmmaker can interrupt action with a *jump cut*, in which frames are excised from within the shot. Generally, the jump cut is used to eliminate dead footage, errors, or accidents, such as when an actor momentarily forgets his lines or stammers over a word or when the camera jiggles. If one can match the frames on either side of the cut, the excision will be imperceptible, but very often this is not possible, and an actor or the setting will seem to shift position suddenly or to jump within the format.

Some filmmakers have deliberately exploited the sudden shift for expressive purposes. Stan Brakhage, in his short film *Daybreak* (1957), has used it as a means of injecting a sense of tension and uneasiness. A young woman is wakened from her sleep by a dream or a shadow moving over her face (or perhaps both). The camera follows her as she rises, dresses, and walks to a park by a river, all the while disturbed and introspective. It leaves her leaning against a railing staring at the water, perhaps contemplating suicide. As the woman walks along the streets and while the camera is in a fixed position, Brakhage makes several jump cuts so that she appears to have shifted position suddenly (Fig. 273). By substituting discontinuity for continuity, he translates psychic disruption into filmic disruption

274–395.
"Odessa Steps Sequence"
from *Potemkin*.
Sergei Eisenstein. U.S.S.R., 1925.

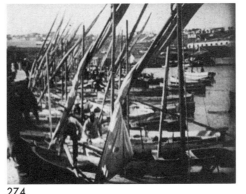

274

275

276

277

and imbues with agitation a scene that would otherwise be ambiguous at best. Though the action is broken, the space of the setting remains unchanged and provides the harmony that makes for continuity.

The examples we have considered thus far have involved a single continuous action of individual, thing, or camera, but the same conditions apply in making the transition from one kind of action to another, from one place to another, or from a shot involving action to a static shot. The corollary is: the more harmonious the shots, the smoother the transition. However, harmony, while a major factor in continuity, is not the only one, as the preceding examples may suggest. Repetition, alternation, and progression in some aspect of the visual-temporal compound also serve to give coherence to the structure. They can provide a means of organizing whole sequences and, for that matter, whole films, as a review of the *Olympia* "Diving Sequence" (Figs. 246–272) or of *Überfall* (Figs. 188–220) makes clear.

The chase sequence in *Überfall*, for instance, is constructed as a repetition of action

and spaces, an alternation not only between pursuer and pursued but also between medium shots and close-ups, and a progression both from point to point and from distance shots to close-ups. Of course, there is an acceleration of the cutting rate as well. The movement of the film as a whole proceeds in a shift between relatively static and dynamic shots, all of them linked by judicious concern for capturing harmonious patterns in space and action and by a sensitive cutting that allows for a constantly changing balance between harmony and contrast.

"ODESSA STEPS SEQUENCE" FROM *POTEMKIN*

The creation of continuity, as well as the control over dramatic intensity and intellectual content through modification in the relative quantities of harmony and contrast from shot to shot, is exemplified magnificently in the "Odessa Steps Sequence" from Sergei Eisenstein's *Potemkin*, one of the most famous and influential pieces of film in history. *Potemkin*

278

279

280

281

282

283

284

274–395. "Odessa Steps Sequence" from *Potemkin*. Sergei Eisenstein. U.S.S.R., 1925.

is a reconstruction of events related to a mutiny that occurred in 1905 aboard a ship anchored in the harbor of Odessa. A small group of sailors complain to the ship's officers that their food is rotting and maggot-ridden. When the captain orders the dissidents executed, the firing squad refuses to carry out the orders, whereupon the crew rebels and commandeers

285

286

287

288

289

290

291

the ship. In the course of the mutiny one sailor is killed. His shipmates ferry his body ashore, where it is laid in state under a tarpaulin on the Odessa quai. The townspeople, hearing of the incident, assemble to pay their respects.

At this point the "Odessa Steps Sequence" begins, announced by the continuity title: "That day the town and the ship were one." People stream to the shore, some carrying food to the ship in small craft, others crowding

292

293

294

274–395. "Odessa Steps Sequence" from *Potemkin*.
Sergei Eisenstein. U.S.S.R., 1925.

295

296

the steps by the quai to watch (Figs. 274, 283, 299). The latter group constitute a cross section of the population: there are people of all ages and economic levels, of different occupations and professions. Some smile and wave, some merely watch curiously, the older people aware of the event's significance, the children not quite certain (Figs. 284–289, 300–309). On the ship the sailors line the rails, returning the gestures of greeting (Fig. 298) and accepting the food.

Suddenly on the steps a legless child, leaping on his hands, pops out from behind the skirts of an elegantly clad young woman (Figs. 303, 304). This is the first premonition of horror and tragedy. A moment later, at the head of the stairs, appears a company of infantrymen (Fig. 312). The people rush down the stairs in horror as the soldiers fire (Figs. 321, 323), driving their victims toward the mounted cossacks who charge from below. Fleeing civilians fall under the gunfire. A small group, led by a bespectacled old woman, implore the soldiers not to shoot (Figs. 324–330). A mother sees her child shot down, carries him

297

298

299

300

301

302

303

304

305

308

306

309

307

310

Suddenly...

311

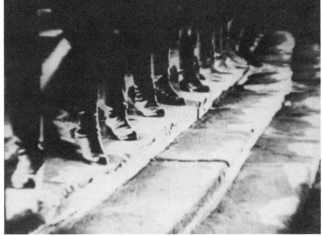

312

274–395. "Odessa Steps Sequence" from *Potemkin*.
Sergei Eisenstein. U.S.S.R., 1925.
313–318. Three jump cuts intensify the response.

313

toward the soldiers to beg them to desist, and is herself shot (Figs. 337–360). Standing confused beside a baby carriage, a young mother falls, clutching at her belly and setting the carriage bumping down the stairs as she does so (Figs. 361–384). The bespectacled old woman is slashed by a cossack's saber (Figs. 385–391). Then the guns on the ship turn in their turrets to open fire on headquarters of the general staff (Fig. 392); ornamental amoretti fall, disintegrated by the blast, and stone lions seem to rise and roar (Figs. 393–395). As sailors and civilians join forces and imperial power and populace meet in bloody confrontation, mutiny for the moment becomes revolution.

314

The sequence is basically concerned with the attitudes, actions, and conflict of forces operating in Russian society—the imperial government, the revolutionaries, and the masses. But Eisenstein is aware that the spectator will find it easier to identify with individuals than with anonymous members of a crowd; accordingly, he singles out a number of persons—like the young boy and his mother or the old woman with the pince-nez—introducing them in close-ups that inspire a sense of intimacy and involvement. He acquaints us with them early in the sequence, showing us the mother as she directs her child's attention to the ship and instructs him to wave, the old woman as she smiles benignly at two children, and a student, whom we see repeatedly, though we never learn his fate. If only slightly and only for a moment before the soldiers come we know these people, the boy's squint, the mother's solicitude, the old woman's smile, and the student's intent stare.

315

316

The soldiers open fire and many people fall. Eisenstein now carefully selects those he will follow in close-ups, those most likely to engage our sympathy and arouse our concern: the mothers, the children, and those who are loving, reasonable, and defenseless. Conversely, the soldiers appear not as individuals but as parts of an implacable, impassive phalanx that moves like a machine. A notable

317

318

319

320

319–320. "Odessa Steps Sequence" from *Potemkin*.
Sergei Eisenstein. U.S.S.R., 1925.
The lowering of an umbrella shifts the dominant
motif from square through triangular to the circle.

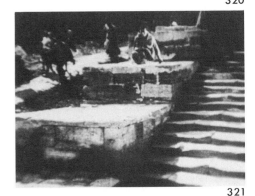

321

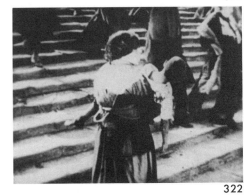

322

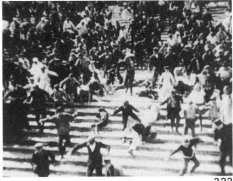

323

exception is the cossack, who opposes us
directly with the full fury and rage of the
imperial government. Joy, compassion, and a
sense of brotherhood are suddenly supplanted
by terror and horror; pathos and tragedy
multiply as the action that began with a slow
and monumental rhythm accelerates to an
overwhelming crescendo of images, finally
dissipating in a puff of smoke. The emotional
response these events elicit may well obscure
for the spectator the intellectual discipline
with which Eisenstein translates ideas, feel-
ings, and even ideology into filmic terms. In
the end the sequence derives its power not
merely from the events depicted, but from the
manner in which they are presented and from
the form Eisenstein has imposed on them.

At this point a word of caution is necessary.
Various versions of *Potemkin* are in circula-
tion, all more or less similar, but each unique
in particulars. Because Eisenstein gave such
extraordinary attention to the most minute
detail, and because the full experience and
comprehension of his work depend on the
precision of his editing, Pier Luigi Lanza has
attempted to re-create an approximation of
the original version by collating seven Russian,
British, and American copies. The results of
his study have been published in a shot-by-shot
description with a frame count for each shot.[1]

274–395. "Odessa Steps Sequence" from *Potemkin*. Sergei Eisenstein. U.S.S.R., 1925.

The version employed for this text and most widely distributed in the United States (similar, with some minor variations, to the shot-by-shot analysis made by David Mayer[2]), differs from Lanza's reconstruction in several ways. Some shots are missing, some appear in a changed order, some are broken up, and most vary in length, although the difference presents no consistent pattern. Therefore, in the analyses that follow, when the divergence between the Lanza and the "American" versions seems important enough to warrant doing so, there is an indication of which version has been used.

324

325

326

327

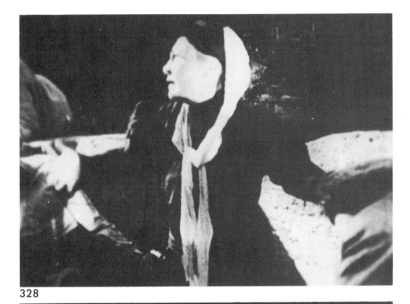

328

329

274–395. "Odessa Steps Sequence" from *Potemkin*.
Sergei Eisenstein. U.S.S.R., 1925.

Such close analysis as the counting of shots and frames may seem at first to be a pedantic exercise having little to do with the pathos and tragedy of the events described. However, it should very quickly become evident that Eisenstein's control of filmic structure does more than merely record a series of events or even the intensity and complexity of feelings involved; rather, it interprets these events and feelings for the viewer.

The Visual Themes

In the "Odessa Steps Sequence" and in the film as a whole, Eisenstein develops three basic visual motifs revealing them sometimes in isolation, sometimes together, sometimes in part, sometimes as wholes. They are the circle, the triangle, and the overall pattern in which no basic geometric figure except a horizontal and vertical substructure is perceptible. The circle or segments of the circle appear over and over again as the arches of a bridge, the arcs of billowing sails, the groups of figures standing on the steps, umbrellas, heads and muzzles of guns, and a host of secondary details. And when a group or individual figures do not describe a desired arc, Eisenstein may create one by vignetting with masks. The triangle appears in the sails of the boats, the yards and rigging of the ship, the massing of figures, and especially in the patterns created by the soldiers and their shadows as they march down the steps. The overall pattern appears most noticeably in the general views of the crowds on the steps and the sides of the battleship *Potemkin*.

By varying the relationships among the geometric themes Eisenstein may stress either harmony or contrast, while at the same time maintaining continuity. In a single shot or series he may stress the overall pattern, the triangle, or the circle, he may alternate two types of configurations, or he may modulate from one to another in a gradual progression.

At the beginning of the sequence, overall patterns of horizontals and verticals appear,

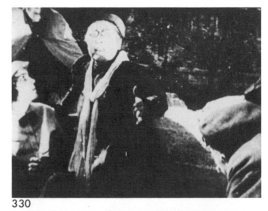
330

331

332

333

334

338

335

339

336

340

337

341

342

343

344

345

274–395. "Odessa Steps Sequence" from *Potemkin*. Sergei Eisenstein. U.S.S.R., 1925.

followed by triangular shapes and segments of circles in a variety of contexts, sometimes in isolation, sometimes interpenetrating. The unifying theme of the completed circle is not yet dominant; the ship and the shore have not yet become one. As the small boats approach the ship and pull up alongside, the shots with circular configurations multiply, especially in views of the people on the steps. Then—in one of the most expressive transitions in the film— at the moment the infantry arrives, an elegantly attired woman lowers her umbrella and, thrusting it before her, walks toward the camera (Figs. 319, 320). As she does, the dominant lines of the composition are transformed, from the rectilinear horizontals and verticals through the triangular shapes of the umbrella as seen in profile to the circle, which, like an iris, gradually fills the screen and then vanishes, disintegrating into the overall pattern that decorates the umbrella's surface. This single gesture summarizes the development of the sequence up to that point, which has moved from unshaped masses supported by verticals and horizontals through conflicting angles and triangles to the circular theme, which disintegrates both immediately and violently.

The development begins again as attention focuses on activity on the steps. First the camera examines the unshaped patterns of running figures against verticals and horizontals (Fig. 323); then in close-ups it picks out predominantly triangular shapes, attitudes, and gestures (Figs. 324–360); and finally, it reveals circular compositions more and more frequently (Figs. 362–384), as if to hint at the muzzles of the guns and the revitalized and

346

347

348

349

350

'Listen to me!

Don't shoot!'

351

274–395. "Odessa Steps Sequence" from *Potemkin*.
Sergei Eisenstein. U.S.S.R., 1925.

352

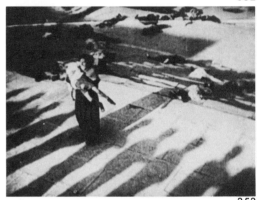

353

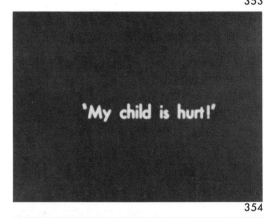

'My child is hurt!'

354

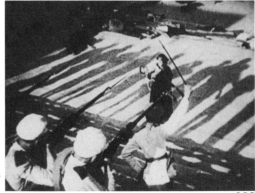

355

transformed union between ship and shore. At the end of the sequence, Eisenstein recapitulates his geometric themes in a succession of shots of the cruiser's gun turrets—first a medium shot combining verticals, horizontals, and circles (Fig. 392), then a close-up of the circular muzzles of the guns as they swing into the center of the screen. As the muzzles of the guns find their targets, the triangular stone lions seem to leap (Figs. 393–395), and the architectural order disappears in the overall pattern of the smoke.

Any such analysis oversimplifies, suggesting an obviousness that the film itself fortunately denies, for in spite of all his attention to geometric themes in *Potemkin*, Eisenstein rarely imposes formal order to the extent that it overwhelms verisimilitude or intrudes on the progress of the action. Moreover, though we have considered the various phases of development as if each exhibited a single configuration or action, few of them do. For example, in the medium shots and close-ups of people on the steps prior to the attack, the dominant circular configuration may be accompanied by

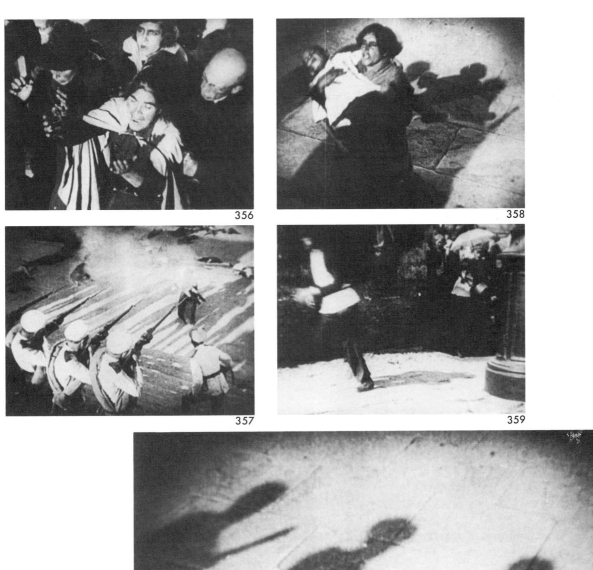

356

357

358

359

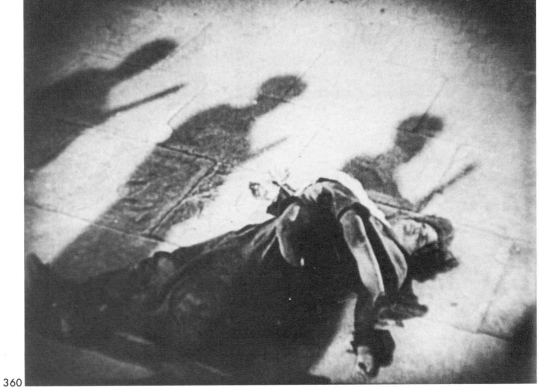

360

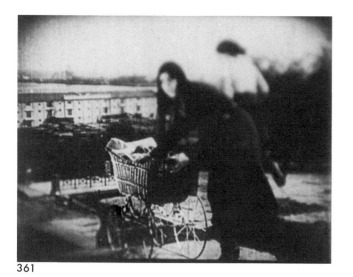

361

362

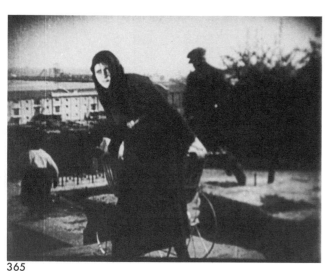

365

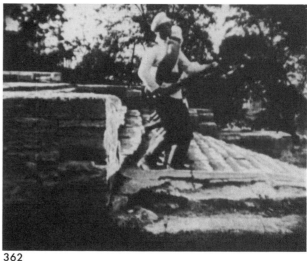

366

274–395. "Odessa Steps Sequence" from *Potemkin*.
Sergei Eisenstein. U.S.S.R., 1925.

a subdominant triangular one, as in the views of the woman with the umbrella. In any one shot we can perceive dominant as well as subdominant configurations and actions, which provide parallel or contrasting overtones and further strengthen the linkage between shot and shot.

While the general effect of harmony and contrast in form is apparent in the larger rhythms of change, the importance of spatial configurations and action in creating continuity is more readily apparent in the relationship

of specific shots. In editing the early phases of the sequence, which depict the movement of the boats toward the cruiser, Eisenstein tends to preserve roughly the same horizontal division of the frame, repeat the triangles suggested by the boats, and, in addition, continue the action in the same horizontal direction in successive shots (Figs. 279–283). However, as this part of the sequence progresses, two important modifications occur: the semicircular arch of a bridge appears (Fig. 283), with crowds of people passing through it in the same direction as the boats, and a circular railing comes into view as a frame within a frame through which the boats can be seen (Fig. 282). The two semicircular motifs lead

363

364

367

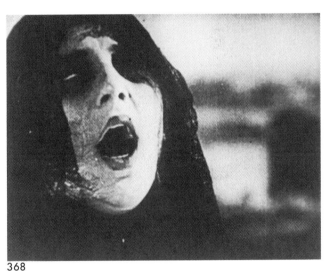

368

gradually to the semicircular configurations of people standing on the steps (Figs. 284–289). The triangular figure and horizontal movement are in successive shots supplanted by the combination of circular figure and vertical movement.

The filmic rhythm now quickens with contrast as shots of onlookers alternate with shots of the boats, the acceleration of the latter reinforced by the manner in which they are presented as moving in different directions in successive shots (Figs. 279–283). However, as ing direction of movement introduces ever sharper contrast, increasing the urgency and creating a visual crescendo that culminates when the direction of movement is doubled

and two lines of boats cross the screen in opposite directions (Figs. 295–297). In short, the sequence has proceeded from shots with many unifying elements to shots with few, and as the emphasis shifts from harmony to contrast, the excitement increases.

The "Odessa Steps Sequence" is full of effective cuts that enhance the sense of continuity. The shots depicting the young woman with the baby carriage bring a number of unlike elements and actions into harmony. When the woman is shot, the camera cuts from her head to the wheels of the carriage to her head and then to her gloved hands and her belt buckle (Figs. 368–371). The forms are unlike in detail but similar in configuration and espe-

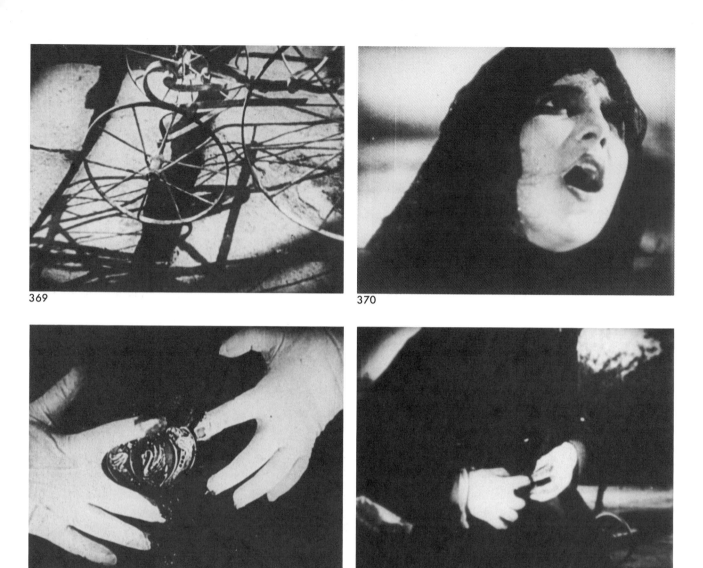

369

370

373

374

274–395. "Odessa Steps Sequence" from *Potemkin*.
Sergei Eisenstein. U.S.S.R., 1925.

cially in their position on the screen. Here, too, very subtle movements become a factor: the carriage moves slightly backward and forward, and in the next shot the woman's head moves back and forth in the same tempo. Alone, the movement of the head suggests a loss of consciousness, but combined with the shot of the carriage it also generates more pathetic overtones, implying simultaneously the woman's now meaningless relationship to the child and her transformation into the inani-

mate object (like the carriage) that death makes of her.

For the shots in which the cossack attacks the old woman (Figs. 385–391), Eisenstein exploits the expressive power of contrast to its fullest, producing a visual shock almost physical in its impact. He does this with extraordinary economy in three shots totaling eighty frames (Lanza 88) or slightly more than 3⅓ seconds, of which the last six frames fade to black (Figs. 385–391). The first shot of thirteen frames shows the baby carriage rolling away from the spectator among the corpses. Eisenstein then cuts to a close-up of a cossack, whose head is to the right of the screen and

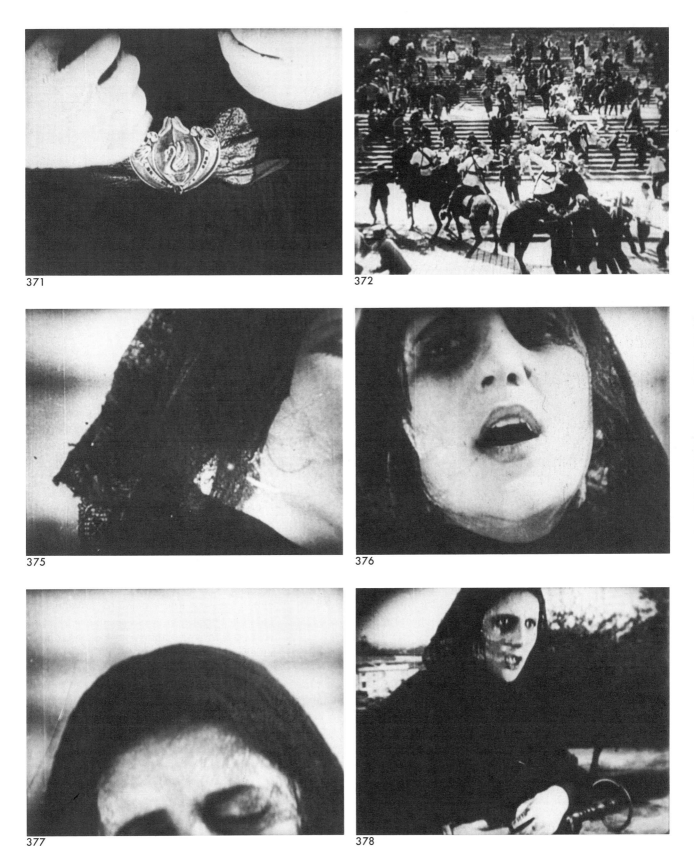

371

372

375

376

377

378

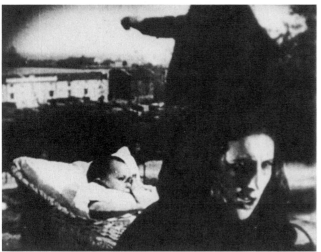

379

380

whose arm slashes down several times in thirty frames (Lanza 31). The shot is broken by jump cuts (American 4 cuts, Lanza 1), which speed the action and intensify the ferocity of the attack as the face suddenly moves forward on the screen and the backstrokes are eliminated. For a moment the spectator might assume the cossack is attacking the baby, an assumption immediately eradicated by the reaction shot of the old woman in the pince-nez (American 47, Lanza 42) seen in close-up, head to left of center, glasses broken and awry, blood gushing from a wound. Throughout, Eisenstein maintains continuity by the similar character of the shapes dominating each shot; at the same time contrast is compounded, appearing in the relative distance, the position in the frame, the direction of movement, and the opposition of mobility and immobility. The effect is of brutal, sadistic, and violent action contrasted with astonished, agonized immobility.

Eisenstein uses the jump cut for a similar effect in the shot of the woman reacting to the sudden discovery of the advancing soldiers (American 3 cuts, Lanza 4). The woman jerks her head back several times, but the forward return is eliminated (Figs. 313–318).

The Cutting Rate

Harmony and contrast, repetition, alternation, and progression appear not only in spatial configurations and action but in the duration of shots in a series, so that the cutting rate is directly related to the spatial configurations and the action, now reinforcing, now modifying their expressive content. Toward the beginning of the "Odessa Steps Sequence," when shots of the small boats running before the wind alternate with shots of the townspeople on the steps, the relative inactivity and the simple spatial configurations of the latter necessitate their being of shorter duration in order to maintain the rhythmic continuity of filmic movement through time. The same applies to the shots of events during the massacre. One might almost be tempted to announce a rule of thumb: The greater the activity, the longer the duration of the shots; the less the activity, the shorter the duration. Actually, the duration is inevitably varied, not simply to maintain, accelerate, or retard the rhythm, but also to create emphasis, develop suspense, intensify a particular mood, or elucidate an intellectual attitude. The lingering view of the injured old woman demonstrates this effect (Fig. 391). That one shot, transforming the woman into a symbol of the whole crowd, encapsulates the horror of the massacre and forces the spectator to contemplate it. At the same time it brings the frenzied action of the central section to an end and leads into a brief, static shot of the cruiser's superstructure that initiates the last segment (Fig. 392).

In all of this, memory plays an important role—memory of action, of spatial configu-

381

382

274–395. "Odessa Steps Sequence" from *Potemkin*.
Sergei Eisenstein. U.S.S.R., 1925.

ration, of content, of tempo, and sometimes,
in a subtle way, memory of clock time. As we
have seen, filmic time is free to conform with,
or deviate from, the last of these. In the
"Odessa Steps Sequence," Eisenstein ignores
the clock and plays with time—accelerating,
retarding, lengthening, and shortening the
amount of time we might expect a particular
action or the event as a whole to require. In
so doing he varies the formal rhythm and dra-
matic impact, but further, he translates into
immediate experience the subjective distor-
tion of time we acknowledge when we say that
time flies or drags.

Toward the beginning of the sequence, as
the boats hurry to the ship, Eisenstein—by
breaking up continuous action and excising
larger phases of it—condenses time so that it
seems to fly in the people's exhilaration of
communion with the rebellious crew. Then,
during the unloading of the boats and the
passing of food to the sailors, he reunites
lapsed time with clock time, since the activity
is more mundane and businesslike. And during
the massacre, by alternating between shots of
mass flight and individual action, and by
breaking individual action into a series of shots
(Figs. 324–343), he extends the filmic time so
that the flight from the steps and the advance
of the soldiers, the fall of a body or the

383

384

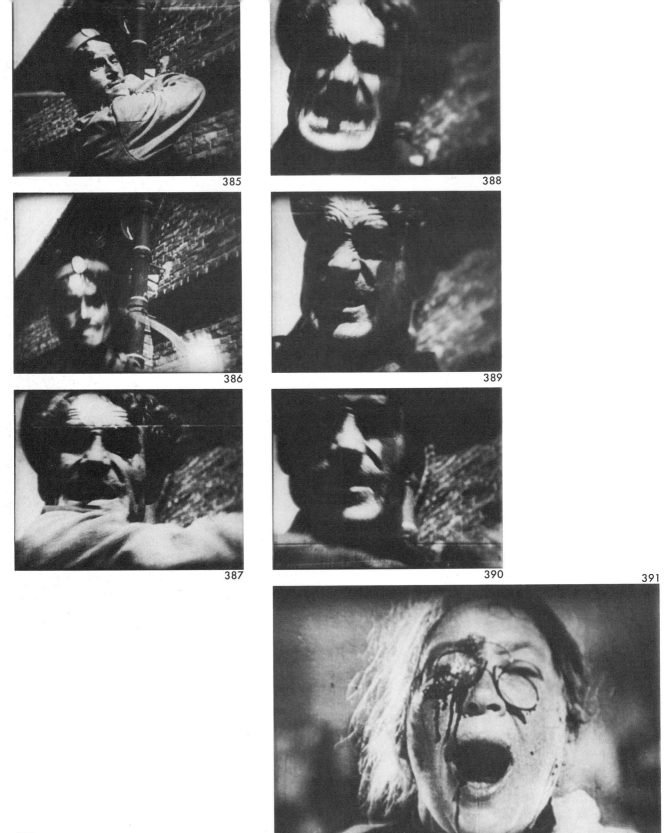

385

386

387

388

389

390

391

392

393

394

274–395. "Odessa Steps Sequence" from *Potemkin*.
Sergei Eisenstein. U.S.S.R., 1925.

395

careening of the carriage, all seem to take much longer than we would expect. The pathos heightens as the camera lingers over accumulating images of horror and frustration.

At the same time Eisenstein accelerates the cutting rate. We can see this effect by measuring the length of shots before and after the appearance of the word "Suddenly," which marks the beginning of the massacre and the change of mood. In the earlier segment (using Lanza's count) the average length of the shots is 88 frames or 3⅔ seconds; in the later section shots average 52 frames or slightly over 2 seconds, and this despite the fact that the later section contains some of the longest shots in the sequence. Thus the organization of time exhibits a curious dualism. While the speed of action and the rate of cutting tend to accelerate as the sequence progresses—not regularly or uninterruptedly, but generally—the incident as a whole and the particular actions it comprises tend to develop more and more slowly, down to the point at which the cossack attacks the old woman. The resulting tension between acceleration and retardation subtly, perhaps at first imperceptibly, augments the dramatic tension of the event, as not only feeling but time too is thrown out of joint.

Eisenstein also used the cutting rate to express aspects of a physical action that a single, extended shot could not convey. Probably the most obvious example occurs in the view of a machine gunner in his account of the Russian Revolution, *Ten Days That Shook the World*. Recognizing that a shot of the gunner at his gun would suggest nothing of the staccato sound, the action of the gun itself, or

396, 397. *Ten Days That Shook the World.*
Sergei Eisenstein. U.S.S.R., 1928.
Alternated close-ups of the gunner and the gun
suggest the staccato rhythm of firing.

396

397

398–403. *Ten Days That Shook the World.*
Sergei Eisenstein. U.S.S.R., 1928.
Visual similes interpret the speakers.

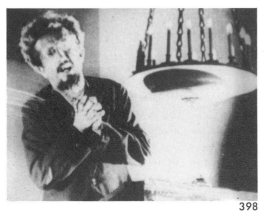

398

399

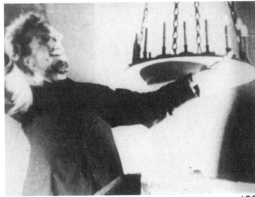

400

401

the dramatic impact of the firing, he rapidly alternated close-ups of the gunner and of the gun (Figs. 396, 397) to suggest these qualities not inherent in the action itself.

DISCURSIVE ELABORATION

So far we have been considering material that is directly involved in the development of the narrative. But the filmmaker need not follow the story line from shot to shot. For a variety of expressive purposes—to elaborate on description, to establish a particular mood, to reveal the thoughts and feelings of a character, to clarify the intellectual implications of the action, to comment on what is occurring, to evoke a reminiscence of something that has occurred earlier in the film or quite outside it—he can interpolate material completely removed from the action. Sometimes these divergences simply provide a kind of decoration, but more often they serve as metaphors and similes. Often they are insinuated so delicately that we are scarcely aware of them, and at other times they are introduced with such intellectual force that we can hardly ignore them.

Eisenstein filled *Ten Days That Shook the World* with metaphorical shots; some are presented frankly as contrast, others discovered in the setting. At one point, observing speakers haranguing a mob at a convention, he cuts to comparisons with angels, harps, and balalaikas, all of which wittily suggest the pious poses, dulcet tones, and strumming on old themes that characterize the speakers' presentations (Figs. 398–403). Again, when Kerensky, the head of the provisional government, orders the bridges connecting one part of St. Petersburg with another opened to prevent mass movements, Eisenstein introduces among the shots flashes of sculptured sphinxes, the symbols of implacable power. And as members of the women's guard bed down in the Winter Palace, he cuts from one of the women to a replica of Rodin's *Kiss*. In doing

402

403

404

405

406

407

so he not only suggests the woman's fantasies, but also compares her weary posture, aging face, and ungainly uniform and boots with the vitality and seductive grace of the lissome young woman in the sculpture (Figs. 404–408). In similar fashion Eisenstein ended his first film *Strike* (1925) with a shot of dead strikers strewn about a field and a slow dissolve to dead cattle, a rather conventional simile but an obvious example of commentary.

More subtle, both psychologically and aesthetically, is a cutaway shot Eisenstein introduces rather frequently in *Potemkin*, notably in the "Odessa Steps Sequence." As the townspeople watch the delivery of food to the ship, he cuts abruptly to a shot of the masts, yards, and rigging of the cruiser, revealing a revolutionary flag fluttering at the masthead (Fig. 307). The shot evokes an earlier scene in which the captain threatens to punish the rebellious members of the crew, and the sailors imagine themselves suspended from the yards.

Descriptive, interpretive, and evocative images need not be presented in separate shots but can be delineated quite simply in the composition of a single shot. Luis Buñuel in *Viridiana* (1961) shows a group of greedy beggars seated around a dining table (Fig. 409) in a travesty of Leonardo's *Last Supper*. Such images can also be introduced by change of focus from one element of the comparison to another or by the movement of the camera.

404–408. *Ten Days That Shook the World.*
Sergei Eisenstein. U.S.S.R., 1928.
A projection of thoughts takes place through examination of the environment.

408

Further, comparative material can be built into a series of movements, changes of focus, and separate shots. The complexity of ideas one can present in this way is illustrated in the extraordinary opening sequence of Antonioni's *Eclipse* (1962), the concluding part of a triology that includes *L'Avventura* (1960) and *La Notte* (1961).

At the beginning of *Eclipse* Antonioni introduces two lovers, Riccardo and Vittoria, who are discovered in Riccardo's living room. Their affair is over. Having talked all night, they are physically and emotionally exhausted and have nothing more to say to each other. Vittoria plays aimlessly with some decorative objects, arranging them behind an empty picture frame. But there is actually little movement except the movement of the camera as it explores the room, looking at the ashtray filled with cigarette butts, the furniture, the decorative objects, the pictures on the wall, and returning repeatedly to an electric fan that drones on through the entire scene. For a long while there is neither dialogue nor action. Ultimately, Vittoria pulls open the drapes to let in the early morning light, walks to Riccardo, and says the first words: "Well, Riccardo?" Up to this point nothing has happened and nothing has been said, yet an incredible amount of information and some profoundly complex attitudes have been conveyed to the viewer.

On the most obvious and superficial level of communication, Antonioni has indicated by the ashtray the time that has passed and how it has been spent; by the inactivity, the silence of the characters, and the concentration on static objects, he has conveyed the psychological state of the lovers. Equally important are other ideas the scene invokes. The concentration on man-made objects, the sense of stifling enclosure from which nature has been excluded, suggest not only inertia but artificiality. Even when Vittoria opens the drapes to the outside world, she reveals a mushroom-shaped water tower set in the landscape like a synthetic botanical specimen, not so much a symbol as a reminder of the ever-present possibility of atomic annihilation. The pictures on the wall are more than decoration or a means of establishing the setting. One is a metaphysical still life by Giorgio Morandi, as silent and static as everything else; the other is an Abstract Expressionist work full of jagged forms, slashing brushstrokes, and extreme contrasts. Juxtaposed with the characters it seems like an expression of their inner conflicts and turmoil. The camera views the lovers framed in architectural elements or furniture, like figures in a painting, so that they seem impris-

409. *Viridiana*. Luis Buñuel. Spain, 1961.
The composition evokes Leonardo's *Last Supper*.

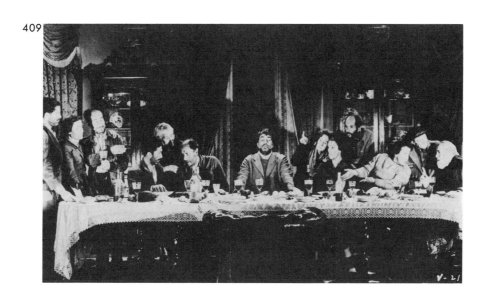

oned in themselves and in modern civilization. The setting in time and place, the mood, the feelings of the characters, the evocation of external ideas, the broader intellectual implications, and the filmmaker's comments—all these coalesce in the examination of the room.

While such discursive material is not directly related to the dramatic action, nevertheless it submits to the formal order of the film, exhibiting the same devices of continuity, harmony, and contrast we have seen in the "Diving Sequence" from *Olympia* (Figs. 246–272) and the "Odessa Steps Sequence" and participating in the rhythmic development as well. When discursive shots and titles are used skillfully, they support the cutting rhythm rather than impede it and thus take part in the total filmic organism. In fact, the duration of the titles in *Potemkin* is determined as much by the cutting rate and the rhythm of development as by length of the verbal statement.

All the examples we have considered demonstrate that the filmmaker is not only describing action that expresses ideas, but also controlling the audience's response through the manipulation of harmony and contrast. Moreover, this control occurs not only in the juxtaposition of shots, but also in the ordering of series of shots and of sequences. In fact, within the larger divisions the filmmaker, in a sense, conditions the spectator to a particular complex of emotional responses and temporal rhythms, and then disrupts the conditioning by injecting a contrasting set of circumstances and rhythms. The spectator on the Odessa Steps is conditioned to joy and suddenly confronted with horror; the viewer of *Eclipse* is conditioned to inertia and then confronted with activity.

EISENSTEIN'S DIALECTICAL APPROACH

Our examination of the "Odessa Steps Sequence" has revealed the way in which Eisenstein manipulated both harmony and contrast to establish continuity and impact. In his theoretical writings, however, the director was more exclusively concerned with contrast —or as he would put it, conflict—and saw the possibility of creating a filmic form inspired by the dynamics of contrast utilized in the dialectic method of Karl Marx and Friedrich Engels. Reduced to a formula, the dialectic method of analysis and description interprets being, events, and history as an interplay in which one state, the thesis, conflicts with another state, the antithesis; the conflict results in a third state, the synthesis. In the dialectic of film form the shot is the basic unit or cell of the filmic organism. Almost inevitably it contains an inherent contrast, conflict, or as Eisenstein put it, collision of ideas, forms, or sensations. If it contains none of these, it presents uniformity. Normally, spatial elements contrast with one another, with the format, and with the surrounding space; action or movement contrasts with the stasis of the setting; and such contrasts within the shot are invested with expressive import. In the motion picture, however, the contrast from shot to shot may be an even more powerful means of expression. Certainly it was for Eisenstein, whose films become models of the dialectical approach.

Returning to the "Odessa Steps Sequence" and to the shots immediately following the turning point, or as Eisenstein terms it, caesura—which is marked by the continuity title "Suddenly"—we can see how the method operates. In the Lanza version, the first shot (883, 106 frames; Fig. 312) introduces the soldiers marching down the steps from right to left at a slight diagonal. Only their booted legs are visible, seen from below. The steps slant off from the lower left to the upper right. The second shot (884, 29 frames) reveals the soldiers in full figure from a slightly higher level as they stop and fire into the mob. The main angles of the composition, which are created by the rifles and the stairs, now slant from lower right to upper left, while the darks and lights, massed into two sharply differentiated sections in the earlier shot, are now diffused over the whole picture space. There is contrast in the length of the respective shots, in the distance of the lens, in the direction of the main lines of the composition, in the massing of lights and darks, and in the depiction of stasis as opposed to movement.

After the volley we see a reaction in the close-up of a woman's head facing somewhat

to the right (Lanza 885–889): she recoils in astonishment, her head moving up to the left several times, her hair falling down in front of her eyes (Figs. 313–318). This action occupies at most a second and a quarter (American 30 frames, Lanza 39) and is interrupted by jump cuts (American 3, Lanza 4). Again there is a contrast in distance, spatial pattern, direction, as well as in the dominance of curved relationships rather than angular ones and in the concentration on an individual rather than a group.

The fourth shot (890, 115 frames; Fig. 319) reveals a large portion of the steps seen from the front, with the main lines of the steps horizontal and the principal movement of the frightened crowd a vertical descent. The shot is transformed from a long one to a close-up as an elegant woman walking toward the camera lowers her parasol and advances it toward the lens (Fig. 320). The views in this shot thus combine the full figure we have seen in the shot of the soldiers with the close-up we have seen in the young woman.

The series develops excitement, advances narrative, and outlines ideology dialectically:

Thesis: The soldiers advance for an unannounced purpose (833)
Antithesis: The soldiers shoot (884)
Synthesis: Brutal, inhuman oppression

The synthesis becomes the thesis:
Thesis: Oppression (883–884)
Antithesis: Surprise and shock (885–889)
Synthesis: Recognition of oppression

Once again the synthesis becomes the thesis:
Thesis: Recognition of oppression (883–889)
Antithesis: Response in terrified flight, disintegration of unity (890)
Synthesis: Suppression of the revolt of the masses

In the American version the second shot is missing, but the sequence of thesis (the advance of the soldiers), antithesis (shock of the woman), synthesis (recognition of oppression) nevertheless operates. What becomes apparent is that the dialectic method follows a cumulative progression in which each synthesis can become a new thesis. Thus, the larger as well as the smaller divisions of the sequence participate in a dialectical development.

The first part of the "Odessa Steps Sequence" makes up a thesis: All movement flows toward the ship or—in the case of the sailors—toward the shore. The people moving toward the quai, the boats scudding into the harbor, and the onlookers' glances all have the same ultimate goal, and the resulting harmony in directional impetus graphically expresses a unity of human impulse, a joy of brotherhood as ship and shore become one. The second part becomes the antithesis: Conflict multiplies, unity dissolves, and the powerlessness of the lone individual is revealed as the repressive force of an uncompromising imperial machine disperses the insurgent crowd. The cannonade in the coda, however, suggests the reemergence of communion and brotherhood in a new contrast: As the townspeople had supported the ship in peace, the ship now supports the townspeople in battle. The synthesis implies, of course, the conflict between the masses and the state and the need for unity.

The spatial compositions in the sequence demonstrate the consistency with which Eisenstein has translated narrative development and theoretical argument into filmic structure; for it is now apparent that he has used the circles and triangles we discussed earlier not for their formal properties alone or merely for their capacity to characterize the dramatic quality of the moment. He also seems to associate them with the ideological content of the film. The triangle, with its abrupt changes in direction, provides an appropriate geometric paradigm of conflict; the circle with its unbroken circumference readily suggests unity, community, and continuity. The triangle is associated with the second part (conflict), the circle with the first part (unity); but except for a brief moment, when the elegant woman opens her umbrella, it is not until the coda, when conflict has been joined, that the complete unbroken circle (the muzzle of the cannon) becomes the dominant motif. Ultimately, when the major geometric forms come together—the triangle and circle appearing

simultaneously—the idea of unity and conflict, thesis and antithesis, synthesize in revolution.

THEORY OF MONTAGE

Eisenstein described his method of organizing filmic material as *montage*. Montage is a French word referring to the act of putting together, assembling, or mounting, as in mounting a gemstone, exhibition, or play, and as applied to motion pictures it implies simply editing. But in the United States, montage came to mean rapid cutting, dissolves, and superimposition of images in sequences intended to summarize the passage of time, to suggest dreams or thoughts, to evoke a milieu like the metropolitan environment, or to suggest some other idea that could be presented in images not directly related to the action. However, Eisenstein uses the term more specifically to connote his particular methods of structuring film through dialectic conflict or contrast. He does not limit his theory to the basic notion of conflict, but suggests five distinct ways in which the shots or montage cells can be related to one another in the filmic organism: metrical, rhythmic, tonal, overtonal, and intellectual montage.

Metrical Montage

In metrical montage the duration of the shots is determined by an essentially arbitrary scheme, and a metered tempo is imposed on the cutting rate without concern for the content of the shots. For example, the filmmaker might determine that all shots were to be of equal duration, or that shots 24 frames in length would alternate with shots 12 frames in length, or that the length of the shots would regularly and progressively increase. While such arithmetical schema may work effectively when applied to purely abstract visuals, especially when set to music, their indiscriminate application to live action may destroy the organic relationship between the content and the form, the action and the cutting rate. Such schema may introduce incongruous emphases that might occur if one were to shift the normal accent of words in order to force them into a metrical pattern.

Among the works considered in this book, metrical montage is exemplified most clearly by Tony Conrad's *The Flicker* and those parts of Léger's *Ballet mécanique* that involve circles and triangles (Figs. 185, 186). Films of live action use the technique primarily for sequences in which the movement has a strong rhythmic character, like the dance sequence in Eisenstein's *Ivan the Terrible, Part II* (1945); or for sequences in which a transformation of the recorded action seems appropriate or desirable, like the series of the woman climbing the stairs in *Ballet mécanique* (which transforms a mundane and banal activity into comedy) or the final section of the "Diving Sequence" in *Olympia* (which transforms an athletic competition into poetry).

Rhythmic Montage

In rhythmic montage the nature of the movement—whether actual movement of figures or implied movement of static forms—is taken into consideration in determining the duration of each shot, so that the cutting rate is related to the action involved rather than forced to conform to an arbitrary schema. Returning once again to the Odessa Steps and the shots immediately following the title "Suddenly," the marching soldiers establish the rhythmic pulse, each of their steps becoming a beat (Fig. 312). (Eisenstein thought of them as entering on the off beat.) The American version contains six beats for the 50 frames in which the soldiers advance, three for the woman's reaction, eight for the 79 frames involving the umbrella—each beat marked by a step or a phase of a movement. Thus, the beat is maintained, though somewhat accelerated in tempo, throughout the series, even though the shots vary in length, just as in music or poetry the beat may be maintained even though the phrases or words are of different lengths.

Also as in music, one note or chord can be sustained over a number of beats without breaking the rhythm, an effect demonstrated in the reaction shot of the old woman attacked by the cossack (Figs. 385–391). The rhythm will not be broken as long as some orderly process is perceptible. In this example, Eisenstein presents a series in which each subject

is on the screen for a slightly longer period of time: the carriage for 13 frames (Lanza 15), the soldier for 30 frames (Lanza 31), the woman for 47 frames (Lanza 42), and the turret for 65 frames (Lanza two shots, 14 and 40). Thus he creates a progression in the length of the shots; but he also alternates between action (carriage and cossack) and stasis (woman), and stasis changing to action (turret), thus bringing the rhythmic pulse almost to a stop before the firing of the guns. In addition, he moves from medium shot to close-ups and back to medium shot.

Tonal Montage

In tonal montage the dominant dramatic, expressive, or emotional tone of the shot becomes a consideration, the sense of joy or solemnity, of calm or agitation, as they manifest themselves in the action, the spatial organization, the light and dark patterns, the sound, or any combination of these. The dominant tone in the shot of the approaching soldiers is a compound of menacing brutality and unswerving, unthinking power—qualities that, in the context, a flash cut would hardly convey. The viewer must see these boots marching on over a somewhat extended period of time, deliberately, persistently, mechanically, if the full force of the threat is to be grasped. The dominant tone of the shot with the soldiers firing combines shock and horror, for which an abbreviated shot seems adequate. The shots of the young woman's reaction have as their overriding tone surprise and consternation, which the quick jump cuts quite successfully convey. And the fleeing spectators express mass terror, which seems to demand an extended shot, at least initially. The cossack's sudden and violent attack on the old woman lends itself to short cuts. As for the reaction shot, a quick cut would have been sufficient to show the wound and the surprise, but the extended shot adds the idea of a woman frozen in fear, pain, and horror, thus forcing the spectator through close-up to contemplate what is happening.

In the examples cited, Eisenstein has edited for strong, sudden, dramatic impact. He organized his material quite differently in the series of shots in which the peasant mother lifts up her wounded son and mounts the stairs to confront the soldiers and appeal to their sense of human decency, only to be shot down (Figs. 345–360). Four separate actions are interwoven: the action of the mother, the advance of the soldiers, the movement of the group of supplicants led by the woman in the pince-nez, and the flight of the crowd. The Lanza version consists of 18 shots: one of the crowd, two of the soldiers alone, three of the supplicants, ten of the mother, and two titles that the mother speaks. What is important for our purposes at this point is the length of time allotted to the mother and the length of the shots in which she figures.

There are 1454 frames in the series; of these, 973, including the two titles, directly involve the mother. The series contains some of the longest shots in the sequence and, for that matter, in the film: they last 113, 217, 141, and 100 frames respectively. In the first two, the mother advances, in the third she confronts the soldiers, and in the fourth she dies. The extraordinary duration of these shots increases the suspense but it is the dominant tone of heroic resolution that seems to govern the length of these shots, which translate the mother's firmness of purpose into terms of temporal duration as she steadily mounts the stairs.

The American version is somewhat different. There are 15 shots: one of the crowd, two of the soldiers, two of the supplicants, eight of the mother, and the two titles. The series includes 915 frames, of which 607 are allotted to the mother; most of the shots are shorter, and only one of the extended shots is present. It lasts 217 frames, somewhat longer than the comparable shot in Lanza, so that essentially the same effect is achieved.

As these scenes actually unfold on the screen, their emotional tone emerges with a clarity and power that words and still photographs can scarcely convey. Something else becomes apparent, too: Tonal montage is not separate from metric and rhythmic montage, but embodies them in emotional accents. The advancing soldiers, their pause to shoot, the woman who discovers them, the rushing figures hurtling down the steps, the group of

410. *Frustration.* Ingmar Bergman. Sweden, 1947.
An example of overtonal montage appears in the fluttering laundry, which injects nervous action into a relatively static shot.

nervous supplicants, the mother with her child stomping up the steps, the cossack and his victim—all these, with every change in attitude and movement, maintain the rhythmic impulse, sometimes accelerating it, sometimes retarding it, but carrying the impulse constantly forward.

Overtonal Montage

Tonal montage establishes the dominant mood; overtonal montage introduces a secondary or subdominant mood or overtone. Just as any dimension or aspect of the film can express the tone, so any dimension, aspect, or combination of aspects can carry the overtone. In those shots we have just considered in which the mother approaches the soldiers, her determination may be thought of as dominant and the threatening shadows of the soldiers as subdominant. In the series as a whole, the tension between the mother and the soldiers constitutes a dominant and the nervous, timid, tentative advance of the supplicants a subdominant.

Bergman uses overtonal devices very skillfully in *Frustration*. The two lovers—the captain's son and the captain's mistress—stand talking quietly near a clothesline (Fig. 410). The composition is relatively static; the lovers scarcely move, their words come in quiet rhythms, the camera is more or less immobile, and the shots are of long duration. But the

lovers' excitement and the rhythmic propulsion of the film as well are conveyed by the clothes fluttering in the wind. Somewhat later in the film the captain and his wife are lying in their bunks discussing his intention of departing for the tropics with his mistress. The cabin is dark, the figures scarcely perceptible, the voices dull, flat, and even. On the ceiling, bright glancing reflections from the waves inject a visual activity, carrying overtones of the nervous agitation that underlies the quiet words and relative immobility.

Similarly, in *Illicit Interlude* (1950), Ingmar Bergman, using a method that has become a cinema cliché, focuses on two people in a cab. Again it is a relatively static shot, the moving lips of the characters and the smooth retreat of the street seen through the rear window providing the only action. But the screen grows light and dark in regular pulsation as the streetlights slant into the cab, introducing a sense of perturbation into the smooth quiet of the scene. The changing light and moving flower in the scene from *La Dolce Vita* (Figs. 239–245) serve a similar function.

Eisenstein exploits waves and smoke for much the same effect at the end of the third part of *Potemkin*, when Vakulinchuk's body is being transported to the quai in a launch (Fig. 411). The lines of the horizon, the horizontality of the boat, the verticality of the honor guard, the smoothness of the progress, the masses of lights and darks all lend an air of dignity, mobility, solemnity, and ceremony. But the white water at the prow, the mobile light on the waves, and the billowing smoke from the stack introduce overtones and broken rhythms and seem almost like the flutter of the pulse in a man who outwardly appears to be quite composed.

Intellectual Montage

As the term itself implies, intellectual montage concentrates on the expression of ideas rather than on affective tones, overtones, and action, although it does not exclude any of these. A series of shots in the second part of *Potemkin* provides a simple example. The crew has been assembled on the foredeck, the rebellious members covered with a tarpaulin,

and the marines ordered to take aim. As all nervously await the order to fire, Eisenstein cuts away from a shot of Vakulinchuk, head lowered in thought, to the marines with their rifles aimed, to a crucifix in the hands of a priest, to the life preserver displaying the name of the ship, to the prow of the ship decorated with the imperial eagle, to a bugle in the hand of a sailor (Figs. 412–416), and then to the condemned men, and finally to the deliberating Vakulinchuk, who, according to a title, makes a decision and goes into action. The triangular and circular themes dominate the screen in clear, unmistakable geometry, while the cuts form an impressive pattern of alternation and progression in length, being

411

411. *Potemkin*. Sergei Eisenstein.
U.S.S.R., 1925.
Predominantly vertical and horizontal lines lend an air of dignity to the composition.

412–416. *Potemkin*. Sergei Eisenstein.
U.S.S.R., 1925.
Metaphors for power are presented as Vakulinchuk contemplates intervening in the execution of the rebellious sailors.

414

412

415

413

416

32, 58, 33, 48, 54, 60, and 34 frames respectively. But what concerns us here is that we are seeing Vakulinchuk's thoughts succinctly summarized in these symbols of ecclesiastical and imperial power, the bugle serving even silently to call Vakulinchuk to arms.

Intellectual montage can exploit a relatively mundane action to convey complex intellectual ideas. Eisenstein employs this technique in a sequence from *Ten Days That Shook the World* in which Kerensky, the new head of the provisional government, enters the palace to go to his new office (Figs. 417–425). In the context of the narrative the important event is Kerensky's assumption of power as dictator, something that could have been revealed quite simply without seriously impoverishing the development of the narrative. Eisenstein, however, uses the occasion to flesh out the personality and biography of the man as well as to provide some sardonic humor. He develops the sequence as an extended metaphor into which he introduces a number of similes.

417–425. *Ten Days That Shook the World.*
Sergei Eisenstein. U.S.S.R., 1928.
As Kerensky ascends to take command of the provisional government, the director comments by introducing shots of the environment.

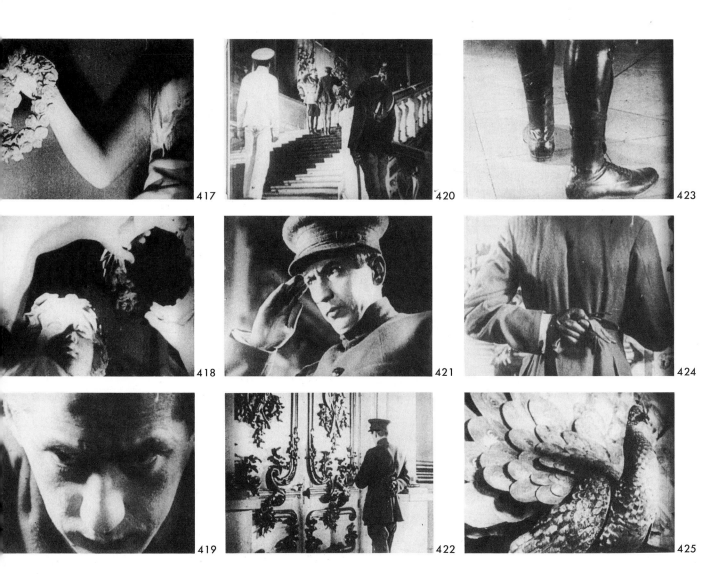

Eisenstein opens the sequence with a long shot looking down a corridor with Kerensky and two aides approaching from the distance. The men are dwarfed by the architecture and unidentifiable in the distance. Then, as the party mounts a monumental baroque stairway, Eisenstein compares his ascent in space to his ascent in rank by intercutting titles that spell out his increasing importance: "Minister of the Army," "And the Navy," "Generalissimo," "Dictator." The angle of vision changes, as views from above yield to views from below; and the lens moves ever closer as Kerensky becomes more and more important and as we gain more understanding of him. At one point Eisenstein cuts away to a sculpture of Victory holding a laurel crown, which seems to encircle Kerensky's head (Figs. 417–419). As Kerensky stands before the doorway to his office, Eisenstein cuts to his polished boots and his gloved hands, then to a mechanical peacock mounted above the door (Figs. 422–425). The personal implications of the comparison are clear enough, and they are reinforced by the similarity between the fanning tail of the bird and the arrangement of Kerensky's fingers. As the door opens, the peacock whirls on its axis, paralleling the movement of the door but also suggesting the revolution of power. Then the bird returns to position and folds its tail with a visual click.

The whole sequence becomes tinged with irony as the contrasts multiply—contrasts between the impressive titles and the simple act of mounting the stairs; between the length of time it takes to ascend the stairs and the grandiosity of the titles; between the small, reptilian man with his constricted military precision and the flamboyant ostentation of the setting; between the suave dictator in whom power is newly concentrated and the obsequious members of his staff. While the intellectual statement emerges in large part from the intercut titles, it is evident that the images operate not simply as sensuous decoration, transitional action, or dramatic illustration. They also perform as intellectual analysis to which even the rhythmic, tonal, and overtonal organization contributes.

The rhythm of the cutting is clearly pronounced in the changing camera position as Kerensky moves at a quick step, absolutely steadily without pause, rising from one flight to another in a circling movement that seems endless. Initially the dominant tone can be felt in the baroque splendor of the setting with a conflicting overtone provided by the prosaic action, drab costume, and small scale of the man. But the dominant tone becomes overtone and overtone becomes dominant tone as the titles grow more inflated and Kerensky rises high and higher, ultimately to blot out the setting completely—an effect that in itself is an intellectual comment.

Metrical, rhythmic, tonal, overtonal, and intellectual montage are clearly all interdependent. For Eisenstein they imply a hierarchy of complexity and value, reflecting the progression of conflicts in the dialectical method that forms the basis of his art. His approach has its roots not only in the philosophy of dialectical materialism, however, but also in literature, as he points out. Eisenstein compares the accumulation of discrete shots in a film to the listing of evocative images in the Japanese *haiku* and suggests that the sequential presentation of ideas in film compares to the sequential presentation of words and phrases in literature. In their repetition of forms and actions, in their clearly defined rhythms, in their expressive use of structure, Eisenstein's films do resemble traditional poetry and music. Some viewers who have seen his films in their silent versions actually speak of the magnificent symphonic scores.

THREE APPROACHES TO FILM STRUCTURE

With its highly structured manipulation of filmic materials and its dependence on the affective power of the composition itself, Eisenstein's montage is clearly distinguished from other modes of editing. This technique is neither the most popular nor the most familiar method of putting a film together. It has been considered at some length for several reasons: it has historical importance; it illustrates the degree of control the filmmaker can exercise over seemingly intransigent materials; its principles either singly or together can be loosely applied to the study of almost any

426

427

426, 427. *The Thunderbolts of Jupiter.* Georges Méliès. France, 1901. Stop-motion photography allows Jupiter to throw down his thunderbolts and immediately materialize a chorus of ladies.

film. Above all, the rigorous clarity of Eisenstein's analysis offers a suggestive springboard for the study of other methods of dealing with continuity, harmony, and contrast.

Tectonic Approach

Eisenstein's method is basically one of fragmentation. He does not simply record objects, figures, and actions; he analyzes them and breaks them down into their respective parts and phases, reconstituting them so the part is related to the whole in a new way. In fact, his method of montage is not unlike the method of the Analytical Cubist painters (Fig. 26). Just as Braque and Picasso broke down solids and voids into geometric fragments and reassembled them—so that theoretically, front, side, and rear, near, middle, and far distance were all interlocked in a single plane—so Eisenstein breaks up time and action into segments, observes his material from various angles, juxtaposes near and far. All the while the director, like the Cubist painter, solicitously maintains a sense of the underlying geometric structure inherent in the physical world. Although Eisenstein considers the film as an organism and the shots as cells, his method is in the end an additive one. Shot is added to shot as, in building, stone is added to stone. The structural process and its effect are in fact more architectonic than organic, so his style will be referred to as tectonic.

Theatrical Approach

Eisenstein's method is both analytical and synthetic. It is an exact antithesis of that man-ner of filming associated with the earliest period of film history and never completely abandoned, whereby the camera takes a vantage point like that of a person in a theater and watches the scene played out uninterrupted from beginning to end. Louis Lumière uses this method in his unpretentious home movie *L'Arroseur arrosé (The Sprinkler Sprinkled;* 1895), which simply turns the camera on a gardener who is sprinkling some flowers and gets sprinkled himself (Fig. 436). It is also the method of Georges Méliès, who, despite enormous technical invention and a magical imagination, never abandons the conventions of the stage, producing vaudeville turns and popular drama in which the camera is stopped only to allow for tricks. *The Thunderbolts of Jupiter* (1901; Figs. 426, 427) exemplifies this style.

The same point of view characterizes Edwin S. Porter's *The Great Train Robbery*

428. *The Great Train Robbery.* Edwin S. Porter. U.S.A., 1903.
The shot is organized by a theatrical approach.

(1903), much of which is presented as if it were a theatrical production. Bandits interrupt a telegrapher at work, attack him, and tie him up (Fig. 428). The telegrapher struggles to the telegraph key, pounds out a message with his fists, and faints. Through it all the camera maintains its fixed position and its distance. Harmony and contrast develop through action within the scene, and continuity in a sense is absolute. According to this method, the length of the scene determines the length of the shot.

Orson Welles revitalized the theatrical approach in some parts of *Citizen Kane* (1941), applying it with a sophistication that achieves in one shot the changing patterns and rhythm of movement that Eisenstein attained by cutting. Welles employed an extremely wide-angle lens to maintain a sharp focus from foreground into distance so that he could plot action in depth; create harmony, contrast, and tension between foreground, middle distance, and distance; and direct the attention of the viewer from one part of the scene to another almost as effectively in a single shot as he could by cutting (Fig. 429).

Organic Approach

The theatrical method *observes* continuity, harmony, and contrast in the action; Eisenstein's dialectical method *imposes* continuity, harmony, and contrast on the action. But there is a third method of construction in which continuity, harmony, and contrast seem to *emerge* out of the action, the narrative, the exposition, or, very often, the dialogue. A film composed by the third method, the organic approach, may exhibit all the resources of materials, tools, techniques, and processes available; utilize the expressive potentialities of editing for acceleration, retardation, mood, and impact; and, in the interrelationship of parts, be very simple or very complex, strictly rationalized or deliberately informal. The ultimate effect, however, will be of flexibility.

The camera lens will not be chained to one place, nor will it change its position from distance to medium to close-up shots with the almost predictable regularity of the "Odessa Steps Sequence." Rather, it will move or remain fixed as the action seems to demand. De-

liberate dramatic pictorialism, conventionally "beautiful" photography, if it appears, will seem spontaneous and discovered rather than calculated. In place of the insistent emphasis on clearly articulated geometric configurations developed in time like musical themes, there will be a tendency toward a more casual and variable patterning in both space and time. However expressive the spatial configurations, action, and cutting, the images and rhythms will tend to be those of prose rather than of poetry—or if poetry, of free rather than rhymed and metered verse. The rhythm will be so intimately related to action and image that this method of construction more than Eisenstein's seems appropriately described as organic.

Because the organic approach is so flexible and is not supported by any highly rationalized theory, it is difficult to grasp from verbal description, but we can derive a clearer understanding by considering a film largely constructed in this third manner, François Truffaut's *The Mischief Makers* (1958). The story concerns a band of young boys who are just beginning to discover the mysterious seductions of sex. Awed by its power and curious about its effects, yet at the same time disturbed and embarrassed, they explore it vicariously by harassing a pair of lovers. Sometimes they submit to the magnetism of sex, while at other times they conceal their ignorance behind ribald jokes and slapstick

429. *Citizen Kane*. Orson Welles. U.S.A., 1941.
A wide-angle lens reduces the need for cutting.

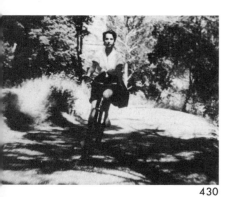

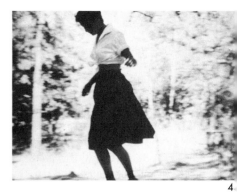

430

431

4

430–435. *The Mischief Makers.*
François Truffaut. France, 1958.
This short film employs the organic or informal
approach to film structure.

pranks. Though fascinated by the strange at-
traction to the opposite sex, they are still very
innocent; the greatest obscenity they can
imagine is the announcement of a wedding
engagement.

For the most part the film is carried by
visual images, since there is very little dia-
logue. The more mature viewpoint of one of
the boys, now grown to adulthood and remi-
niscing on the affair, is provided by a *voice-
over narration*, that is, narration heard over
the dialogue or action of the film. While the
mood of the film remains both comic and ten-
derly lyrical—almost elegiac—and the images
and events take on the color of poetry, the
structure is informal. Image flows easily and
naturally from image according to the
rhythms of prose. The combination of poetic
content and prosaic structure, which may
seem incongruous, has the advantage of lend-
ing mystery to reality and reality to mystery.
This effect is also clearly an example of rein-
forcement by contrast.

The film opens with the camera following
the young Bernadette as she rides her bicycle,
skirt lifting, legs flashing, through the streets
of Nîmes and out into the country, where she
leans her bike against a tree and runs down
the bank of a stream to wade (Figs. 430–432).
The young tribe has followed her and, while
she is gone, they worship at the shrine of her
bicycle seat. When she returns they flee, ut-
terly demoralized. Up to this point they re-

gard her as their own private divinity, follow-
ing and watching her like young satyrs trailing
a nymph, only to discover that they have a
rival, a young man named Gérard. They take
to trailing and harassing the pair, hooting at
them in the Roman arena, chalking their
names on walls, making obscene noises behind
them in a movie theater, tracking them like
Indians on a bicycle trip into the country,
watching them play tennis (Figs. 433, 434),
sending them postcards with suggestive mes-
sages. Ultimately they discover in a newspaper
announcement that Bernadette and Gérard
are engaged. Shortly after, Gérard leaves to
go mountain climbing and, while the boys
continue their attentions to Bernadette, he is
killed in a fall. For the boys, Bernadette and
Gérard become creatures of myth. They turn
to watching other women furtively, drawn
into deeper feelings than they yet understand
by the rise of the breast, the flash of thighs,
and the undulant grace of the buttocks.

Much of *The Mischief Makers* is affection-
ately comic and gently ironic. During the
boys' pranks, Truffaut interpolates a few sa-
lutes to earlier films and filmmakers—to Lu-
mière in a direct parody of *L'Arroseur arrosé*
(Figs. 435, 436), to gangster films as the boys
play in the arena, to Westerns in the boys' at-
tack on the lovers. There are dramatic and
cinematic gags. Gérard asks a man for a light.
The man is furious and refuses to give him one.
One of the boys is "shot" while playing the
part of a gangster and falls to the ground, then
rises again in reverse motion. The usual reper-
toire of familiar cinematic devices is used to
good expressive purpose: when a boy leans to
kiss the seat of Bernadette's bicycle, he moves

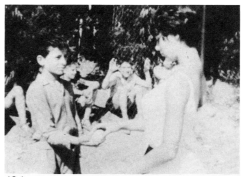

33 434 435

in slow motion in a shot that invests his prankish act with mystery and ritual import; *l'arroseur* jumps along in fast motion, which not only injects a comic effect but also suggests an old film projected at too rapid a speed; and toward the end, when Bernadette and Gérard have been transported to the realm of myth, their heads are superimposed in profile on the sky over the arena, as if they had become ancient constellations.

The Mischief Makers was Truffaut's second film, and in it he seems to be exploring his medium, especially in the scenes just described. Generally, he uses the camera as a substitute eye rather than as an independent instrument, and he takes the vantage point of a hypothetical observer conveniently placed where the action may be most easily and completely observed. He usually aims his lens horizontally and places it on a level with the point of focus. When he tilts the camera, it is to facilitate observation, not to dramatize by introducing extravagant angles of vision.

Just as Eisenstein has a predilection for close-ups, Truffaut has a preference for full, long, and medium shots. He moves the camera closer within the shot or cuts to a close-up only when it is obviously appropriate to do so in order to provide information (the expression on a face) or to suggest a particular quality of behavior (the intimacy of the lovers or the furtiveness of the boys). He seldom closes in for dramatic impact, letting the story itself generate the emotional tone. Much the same attitude is reflected in his editing. A shot continues without interruption as long as there is something important taking place or until a character moves out of range. The tempo is

natural, quiet, and easy; moderately rapid cutting for expressive intensification occurs only toward the end when the boys, in a delirious orgy of voyeurism, watch some young girls dance.

The opening shots provide an example of Truffaut's method. We first see Bernadette riding toward us. Once she has been introduced, the camera retreats, and in the rest of the series of shots depicting her ride into the country we see her from a distance, more or less as the boys see her. The shots are extended until she rides off the screen or changes direction. Again, when the lovers are in the country and Gérard, roaring and shouting, chases Bernadette about a field, Truffaut keeps his distance until the pair fall down in exhaustion. Then, as they converse, he moves to a close-up; when they discover a praying mantis, he moves closer still, so that we too can see it.

When the boys burst in upon them in a mock Indian attack, there are no fast cuts; we simply see Gérard chase them off. Similarly, while the boys watch the lovers playing tennis,

436. *L'Arroseur arrosé.* Louis Lumière. France, 1895. In the theatrical approach, the camera simulates the viewpoint of a person in a theater.

there is necessary movement back and forth between the boys at the edge of the courts and Gérard and Bernadette, but not in a rhythm that attempts to imitate or reinforce the rhythm of the game. The shots are for the most part at medium range until the camera approaches to reveal the focus of the boys' attention, admiration, wonder, and embarrassment—the forms and movements under Bernadette's skirt and blouse as she swings, misses, and pirouettes in mock chagrin. In the scene at the arena, Gérard enters on ground level and calls to Bernadette, whom we first see silhouetted high against the sky from a distance. Next, a closeup reveals her pleasure at his arrival. The camera then takes its distance again.

One of the few places in which the cutting rather than the action seems to determine the effect occurs in the scene at the movie house. After disturbing the lovers with whistles, hoots, and catcalls, the boys, in a medium close shot, scramble out of their seats and make for the door. As the boys rush out, Truffaut cuts to a distance shot of the exterior, with accompanying change in distance, angle of vision, and spatial pattern—all of which convert their rowdy exit into an explosion.

None of this should imply that Truffaut exhibits no interest in pictorial value, that he does not make good use of harmony and contrast, that he fails to translate narrative continuity into formal terms or develop a rhythmic impulse with changes of emphasis and climaxes. Indeed, the pictorial compositions, if in no way extraordinary, have great sensuous appeal, and they reinforce the mood as well as record the action. Shot is linked to shot and contrasted with shot in an effective manner. In the opening series, for example, the verticals and horizontals of buildings and trees, the inclination of the streets, roads, and paths, and the positioning of Bernadette all create harmonious relationships among the various locations. The movement is first toward the camera, then to the left for a long time, then—after the pause in which Bernadette leans her bike against the tree—away from us, so that a perceptible rhythm of change is developed. Similar rhythms emerge from the relative distance of the camera: first relatively close to Berna-

dette, then, during the ride, comparatively distant, at the tree rather close, and finally, as she moves away, distant again. The speed of the action, which seems relatively slow in the first shot because she is moving toward us, becomes more rapid, then slows to a halt, then quickens again.

Much the same observations could be made with respect to the rest of the film. There is filmic order, but it is a different kind of order from that we have seen before. Instead of the strong formal patterns of Eisenstein, there are informal compositions; instead of the deliberate measured pulse that impels the "Odessa Steps Sequence," there is an easy flow of images and actions. Unlike Eisenstein, Truffaut avoids the appearance of artistry, disguising it in his seemingly casual approach.

In *The Great Train Robbery*, the "Odessa Steps Sequence," and *The Mischief Makers*, we see what might be described as the generic approaches to film structure—the theatrical, the tectonic, and the organic. Few films are one or the other in their entirety, however, not even these. But if we were to establish each method at an apex of a triangle, we could probably locate any film within the triangle, depending on the relative emphasis on one approach or another—of course only with respect to the use of harmony and contrast and the film's method of creating continuity.

In Eisenstein's theory the succession of shots, series, scenes, and sequences is often described as *horizontal montage*, a phrase that translates the space-time-action compound into linear terms, interpreting it more or less as the baseline of a chart or graph marked off in seconds, minutes, and hours. Color or visual tone inevitably forms an integral part of the space-time-action complex. But if we think of color as a separate, malleable raw material that the filmmaker can manipulate as freely as he manipulates space, time, and action, we can consider color to be organized in simultaneous or *vertical montage*. While the sound element in film is usually associated with vertical montage and is perhaps more obviously applicable to it than color, we will see in the next two chapters how both are the materials of vertical montage.

6
Color

Eisenstein isolated contrast as the basic element in filmic expression. It is also a fundamental condition of perception. Without the differentiation between one tone and another we would have no way of comparing shape, size, position, direction, texture, and density. The world, normally so luxuriously varied in our eyes, would present itself as an absolutely uniform and hence meaningless continuum.

The perception of color, of course, is the perception of light; any particular tone consists of a certain set of wavelengths of incident or reflected light. These wavelengths can be measured by light meters to determine their intensity or their *color temperature*, which is a measurement of the color value of a light source (light dominated by blue wavelengths exhibits higher color temperature than light displaying a predominance of "cooler" yellow and red wavelengths). The eye, in fact, could be considered a kind of light meter, even though, unlike a photographic meter, it is coupled to no uniform scale, because approximate measurement is brought into play whenever we distinguish one tone from another or try to describe a color by translating light sensations into words—speaking of ecru, beige, pink, maroon, lime, tan, brown, or even red, yellow, and blue—each of which is likely to bring to each listener's mind a different tone.

COMPONENTS OF COLOR

The vague character of verbal description can be reduced by applying one of the many systems by which color is classified, all of which distinguish three basic qualities: the *hue*—that aspect of a color determined by its wavelength; the *value*—the relative lightness or darkness of a color; and the *intensity* (also called *saturation* or *chroma*)—the quantity of the hue present (Fig. 437, p. 133). A fourth quality, luminosity, is sometimes discerned, although it is more properly associated in the case of paint with the materials of which the paint is made—metallic or fluorescent, for example—or, in the case of reflected light such as we see in a movie theater, with the dullness or smoothness of the reflecting surface.

Hues also lend themselves to classification according to their relative simplicity or complexity: the *primaries*, usually identified as red, yellow, and blue, from which in theory all other hues derive; the *secondaries* orange, green, and violet, which are produced by combining two primaries; and *tertiaries* such as yellow-orange or blue-violet, the product of a primary and a secondary. We can achieve a reasonably precise definition of a tertiary hue by referring to the relative quantity of the hues from which it is constituted. Thus, a yellow-orange might be described as 60 percent yellow and 40 percent orange, or perhaps 80 percent yellow and 20 percent red.

Value can be thought of as the amount of darkness or lightness, measurable on a scale between black and white. Theoretically, the number of gradations could approach infinity, but for the sake of convenience we identify seven: high light—a familiar term—light, low light, middle, high dark, dark, and low dark. Compositions dominated by darks are designated low in key, those dominated by lights, high in key.

Intensity can be described in terms of fractions according to the quantity of hue perceived; thus, we think of a hue as having ¼ intensity, ½ intensity, ¾ intensity, or full intensity. Conversely, since it is possible to think of intensity as relative to the fully neutralized or hueless tone rather than to the fully intense tone, we can think of a hue as being ¼ neutralized, ½ neutralized, ¾ neutralized, or of similar proportions.

Reference to the three aspects of color enables us to describe a particular tone with a reasonable degree of accuracy. Many people, however, find it difficult to distinguish between value and intensity. Figure 438 (p. 133) may help to clarify the distinction between them. The hue is blue-green; along the horizontal rows the swatches are all of the same value, although the intensity varies; on the vertical files the swatches are all of the same intensity, but the value differs.

COLOR VERSUS BLACK AND WHITE IN FILM

When there is no hue present, tone can be described as a pure neutral—that is, the values of black, white, or any of the various grays in

between—the gradations we usually think of when referring to black-and-white photography or film. Until the late 1960s it was customary to think of black-and-white film as standard and color as an attractive embellishment. In part this attitude resulted from the conjunction of historical development and a method of advertising. Almost from the very beginning of film history, attempts were made to extend the tonal range of the motion picture. Some films were colored by hand, like the original version of *Potemkin,* in which Eisenstein had a flag that the revolutionaries broke out painted red. Others were printed on tinted stock, including parts of Griffith's *Intolerance,* in which night scenes were colored blue, sunny scenes yellow, and the attack on Babylon red. In both Europe and the United States some of the cumbersome early processes of color photography were occasionally used. But until the late 1920s, when commercially and mechanically feasible color processes became available, motion pictures generally were produced in black-and-white tones, so the presence of anything more was advertised as a special attraction.

While the restricted tonal range of black-and-white film may seem to limit drastically the expressive use of tone, especially in the achievement of some sense of verisimilitude, limitations can often become assets. Actually, the black-and-white image has long been accepted as providing a reasonably accurate rendering of the external, objective world, in large part because it is through value discrimination that the shapes of objects, their limits, and their position in space are perceived. Even the expression of volume through change of hue, which so many artists profess to employ and so many critics profess to discern, turns out on careful analysis to be achieved through changes in value. For that matter, we are not unaccustomed to situations in which neutral tones dominate our field of vision—as in evening, night, or early morning light—or to monochromatic renderings of the world reproduced in newspapers and magazines or in our own photographs.

For many spectators a limited tonal range presents certain advantages: almost automatically it establishes a tonal relationship between one part of the film and another, which enhances the sense of coherence and unity; and while it is capable of producing an acceptable image of the external world, it simultaneously introduces an aesthetic distance between the external world and the world of the screen, which may make the apprehension of formal aspects of the composition a little easier. In some films black-and-white tone seems especially appropriate, for at times the full range of color adds nothing significant to the expressive structure or even becomes a distraction, diluting the visual impact.

Aside from the rather obvious difference in tonal range and its effects, there are other important distinctions between the two types of film. Color film is not as easy to control as black and white. It tends to be slower; that is, it requires more exposure to light to produce a reasonably accurate representation of the subject being photographed, so it is difficult to use when the light is low, as in the evening or at night. Moreover, color film is more sensitive to differences in color temperature and will respond to conditions of light of which the eye is sometimes unaware—the shift toward magenta hues in the evening, for example, or the blue-green quality of some fluorescent light.

Not only the color temperature of light, but the quantity of light will affect accurate rendering of various hues, since films do not all respond in the same way to different levels of lighting. For all these reasons, color film is hard to control, in both the original shooting and the creation of effects like dissolves and superimpositions in the laboratory. These difficulties are compounded by the fact that in films aiming at a more or less objective rendering of the world, the human eye seems less willing to accept distortion and inconsistency of hue and intensity than to accept their total elimination.

In point of fact, the neutral tones of black-and-white film and the varied hues, intensities, and values of color film are simply different dimensions of light, and it is as such that they will be treated in the following pages. Black-and-white film and color film will be considered together, and the term *visual tone*—or tone without qualification—will refer to both.

POSSIBILITIES FOR
CONTROL OF TONE

Tone is recorded on film because the chemical constituents of the emulsion are sensitive to light. The fact that film records light rays reflected from objects suggests a physical link between object and image and reinforces an old and persistent idea that the camera does not lie—one of those attractive notions that is literally true but generally so misunderstood that it requires interpretation. While it is true that film records more or less faithfully the light rays that reach it, the light rays that reach it may not be those reflected from the world outside the camera. For that matter, they may not be recorded in the same configurations they formed when they entered the lens.

Already we have considered how, by selecting particular lenses or angles of vision, the filmmaker can produce images not at all consistent with our ideas about relative proportions and distances or characteristic shapes. Tone, too, submits to the will of the filmmaker, who, in a variety of ways, can determine the quality and quantity of light to be registered in the emulsion. He can: control the actual lighting of the scene to be recorded; control or modify the light at the point where it enters the camera; filter the light entering the camera; use a film of specialized or limited sensitivity, a film sensitive to infrared or black light, for example; or make adjustments in the developing or printing process. What he elects to do will inevitably have its effect on every dimension of the pictorial image.

Setting

Control of light within the scene is achieved by selection, reinforcement, and suppression; that is, *selection* of time and place, *reinforcement* by the introduction of artificial illumination—including reflectors—that will bring light into areas where it is needed and if necessary change its color, *suppression* by the interposition of diffusing apparatus, which reduces the concentration of light, cutting down the sharpness of cast shadows and softening contrast wherever the light falls.

The Camera

The filmmaker can control light entering the camera in a variety of ways. Since the character of the photographic image is determined in part by the *amount of light* falling on the film as well as the *amount of time* it is permitted to do so, both quantity and time must be regulated. The quantity is modified by changing the size of the opening in the diaphragm of the lens element; the length of time is regulated by controlling the speed at which the shutter opens and closes.

In a motion picture camera, such control is effected by modification of the opening or, in the case of the camera having a variable shutter, by changing the angle of the shutter blades. Depending on the amount and quality of light available, there will be a certain opening to provide a more-or-less accurate rendering of the tonal values in a scene. A larger opening would result in too much light reaching the film (*overexposure*), in which case contrast would be reduced by uniform darkening of the negative image and lightening of the positive image, so that hues would be distorted. A smaller opening would result in too little light reaching the film (*underexposure*), in which case contrast would be reduced by a uniform lightening of the negative tones and darkening of the positive tones, so that hues would again be distorted. Such shifts in tonality can sometimes serve a good advantage. For example, by underexposing film one can create an acceptable substitute for night light.

Filters

Filters are thin sheets of gelatin or optical glass containing a dye. When mounted in front of the camera lens or behind it, they reduce in varying degrees the amount of light that reaches the film and may also modify the color balance, whether used with black-and-white or color stock. A great variety of filters are available. *Polarizing filters*, like polarizing spectacles, reduce glare and diffusion by blocking the light rays that vibrate in a single plane to provide a clearer, crisper image. *Neutral density filters* diminish the intensity of light without radically affecting the

color balance. *Colored filters,* on the other hand, modify color balance by screening out or absorbing wavelengths of the complementary tone: yellow filters tend to absorb blue, cyan (blue-green) filters to absorb red, and magenta to absorb green. (The complementary tones differ from those associated with painting, because color in photography operates differently from color in painting.)

In black-and-white photography, filters modify the color value—color as it translates into black and white or gray. For this reason, yellow filters are often used in photographing blue skies: the filter absorbs much of the blue reflected from the sky, lessening the negative density for this area, which consequently passes more light to expose a darker sky in the positive print. The effect of filters on color film is rather obvious, much the same as one experiences in looking through colored glass. All tones are modified by the filter's color.

Selection of Film

The relative sensitivity of a film also affects the tonal quality of the image. Because of the chemical and physical constitution of their emulsions, different types of film can vary in two significant ways: in their sensitivity to the quantity of light—which is usually expressed in terms of the speed at which they will record images—and in their sensitivity to color. The speed of a film is rated in several ways, the most familiar of which is the scale established by the American Standards Association, the *ASA rating.* The lower the rating (25 ASA, for example) the longer the film must be exposed to light to record a reasonable image of the material before the lens; the higher the rating (perhaps 1200 ASA) the shorter the exposure.

Not all black-and-white film is sensitive to the full range of values. *Copy film,* which is preferred for reproducing printed material, tends to be less sensitive to tones between black and white than film for general purposes. Therefore, photographs made on copy film will be highly contrasting. And both black-and-white film and color film can vary in their sensitivity to particular hues. Early black-and-white film was insensitive to red, so the printed image showed reds relatively

darker than other tones. This accounts for the black lips seen in some older films (Fig. 540), rectified in the 1920s with the emergence of *panchromatic film*—film capable of translating all hues into balanced dark and light values.

Color films vary in their sensitivity to particular hues because their chemical-physical makeup is balanced according to the general color temperature of specific kinds of light. That is why film meant to be exposed in daylight differs from film recommended for artificial light. The variation in temperature of the diverse kinds of artificial light has resulted in specialized emulsions for many of these as well. The filmmaker thus has a broad range of films at his disposal and will obviously choose according to his needs, sometimes, for special effects of one kind or another, selecting a film of limited sensitivity.

Processing

Tone can be modified in the processing of film. It can be darkened, lightened, even eliminated or introduced. By *solarization,* or exposure to light during development, a film can be made part negative, part positive (Fig. 439, p. 134). And tonal organization can be altered by more direct intervention. The filmmaker can draw or paint on the film, scratch it, punch holes in it, even, like Stan Brakhage, grow mold on it. The range of control is enormous, and—except in the case of a few experimental filmmakers who have done basic research—the expressive potentialities of tonal manipulation have scarcely been explored.

FUNCTIONS OF TONE

Like the alteration of space, in which it so intimately participates, the modulation of tone affords the filmmaker an expressive instrument of infinite subtlety and variety, one that seems to perform specific, isolable, expressive functions. Tone can define and articulate space; describe the visual character of objects, conditions of weather, time of day, and quality of light; serve as decoration; enhance and establish continuity; intensify action, movement, mood, and meaning; parallel and reinforce the other elements of a shot or

sequence or exist in counterpoint with them; act as an evocative reminder in one shot of material that appeared in earlier shots; even comment on a scene or an action. These functions of tone are not mutually exclusive, of course, and most are related to one another.

Articulation of Space

Chapters 2 and 3 considered some of the ways in which shapes operate in the picture plane. A shape can establish the two-dimensional plane—as does the blue one in Patrick O'Neill's *7362* (1966; Fig. 455); it can define a unique spatial order; it can activate the plane. Its involvement in any three-dimensional order will remain ambiguous unless it is coupled with modeling, light and shadow, perspective projection, or is in some other way related to our customary perception of the world around us. So the blue shape in *7362* may seem to be on the same plane as the red, in front of the red, behind the red, or changing its position in depth. Much the same could be said about the red bedframe in Antonioni's *Red Desert* (1964; Fig. 508), except that as the sequence in which it appears proceeds, Antonioni gradually establishes its identity, and reestablishes it by having Giuliana's hand slide across it and out of the frame.

The earlier chapters also explored some of the affective and constructive effects of spatial organization. Although we ignored the importance of visual tone in articulating space, it is obvious that we perceive spatial organization only through variations in tone. Here it seems necessary to consider a few uses of tone important in the expression of space.

Ordinarily, the sense of three-dimensional void or volume is conveyed through alternations and progressions of tone. A clear example of the former appears in the alternating darks and lights that define the steps at Odessa (Fig. 344). An example of tonal progression is the regular diminution of contrast and reduction of intensity that is evident as one looks through the atmospheric envelope at any landscape, as in Figure 491. Of course, similar effects can be attained in black and white. Sharp focus on an object in the foreground through an aperture that provides little depth

of field produces a diffuseness or diminution of contrast not unlike the effect created when one looks into the far distance (Fig. 76). A more sharply articulated progression from dark to light appears in the dressing room scene from *Frustration* (Fig. 68), which illustrates another popular method of reinforcing the sense of deep space—the technique of clearly defining and separating planes in depth and creating a *repoussoir* or thrust into space emphasized by enclosing the central image with an interior frame in the foreground.

The organization of planes in depth with clear focus from front to rear (as in the *Frustration* shot) has been associated by many students of cinema with Orson Welles, although in fact this method of spatial articulation was frequently employed by earlier filmmakers, including Eisenstein. If we compare any of these examples with a scene from *Red Desert* (Fig. 497) it will be apparent that strong contrasts and regular progressions in tonality tend to enhance the impression of spatial penetration, while uniformity of tone tends to decrease it. Both effects are obviously useful to the filmmaker, paralleling the action and the intellectual content—the brawl in Bergman and suffocation of the individual in Antonioni.

Description

The most familiar function of tone is to describe, not only by articulating spatial relationships, but also by revealing texture, atmospheric density, reflective quality, and intensity of light, thereby indicating the precise nature of the moment or thing. A specific tone can offer a relatively objective record of things as they are or were; it may, by selection or distortion, create metaphors and reinforce action; if carefully selected and controlled, it can even draw from our memories the data of other senses. Whatever is being viewed, however laconic the method of presentation, description is seldom purely physical or sensuous in its implications. The angle of illumination, the artificial reinforcement of intensity, and the modification of hue all imply intellectual as well as physical orientation and suggest a filmmaker's decisions about what is important.

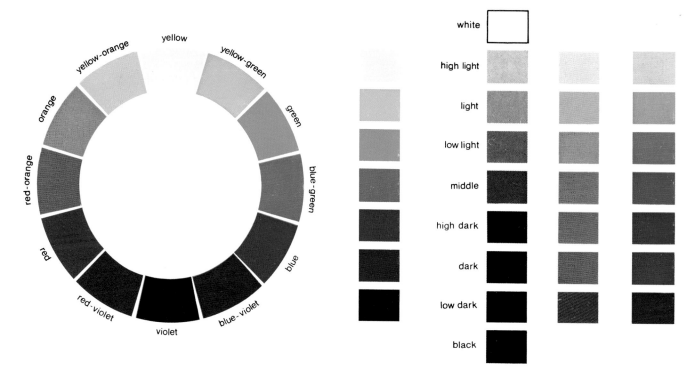

437. Color chart illustrating hue and value.
The color wheel illustrates the relationships among primary, secondary, and tertiary hues. The scale next to the color wheel shows where seven different hues in their *normal values* would appear on a value scale. For neutral tones seven different values of gray are identified between pure white and pure black. Parallel value gradations are identified for orange and blue.

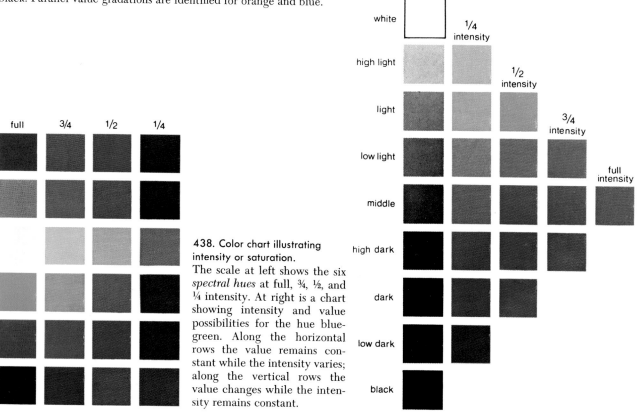

438. Color chart illustrating intensity or saturation.
The scale at left shows the six *spectral hues* at full, ¾, ½, and ¼ intensity. At right is a chart showing intensity and value possibilities for the hue blue-green. Along the horizontal rows the value remains constant while the intensity varies; along the vertical rows the value changes while the intensity remains constant.

439. Edvard Munch, Part II: Paintings. Clifford West. U.S.A., 1967.
Solarization renders the tone part negative, part positive.

We might consider the potential implications of different lighting conditions in photographing a decaying house designated for destruction. A strong raking light heightening the contrast of light and dark and casting dark shadows on doorframes and peeling paint may well accentuate the picturesque qualities of

the building and so overwhelm the senses with abstract patterns that the association with human beings for whom it provided shelter is obliterated. A flatter lighting might catalogue the manifestations of habitation and neglect— the peeling, checking, and cracking of the paint, the layers of soot, the smudges of grime, the lost vestiges of elegance. And a low light, by suppressing details, could suggest a kind of mystery. Very similar effects result from the ways in which actors are illuminated. In Fellini's *Juliet of the Spirits* (1965), for example, the sense of mystery and dramatic tension is obviously enhanced by the darkness of the image and raking backlighting (Fig. 460).

The bedroom scene in Godard's *Breathless* (Fig. 440) demonstrates how backlighting can soften details, investing them with a vague ethereality. When it eliminates detail entirely, as in Reifenstahl's "Diving Sequence" (Figs. 270–272), it may not only dramatize but also generalize figures, suppressing their individual features and elevating them into near abstract symbols of mankind. Diffuse general lighting illuminates a scene with a kind of linear, classical clarity; arbitrary spotlighting without an identifiable source often crowds the lights and darks into conflict as dramatic as the baroque *chiaroscuro* of Rembrandt.

General lighting and arbitrary spotlighting, although they may seem to reveal objective reality with absolute accuracy, will be recognized as insisting on the filmic image as a kind of fantasy. Similarly, the *radiation effects* that became popular in the late 1960s—obtained by shooting at an object against the sun or another intense light—while they project melting sensuousness and mysterious radiance in keeping with the romantic view of nature current at the time, simultaneously proclaim in their geometric configurations that the film is film and not the world it represents. In short, the manner in which tone is used to describe

above left: 440. Breathless.
Jean-Luc Godard. France, 1959.
Natural backlighting softens the details.

left: 441. Breathless.
Jean-Luc Godard. France, 1959.
The effect of glare creates an impression of naturalness.

will vary with the expressive intention of the filmmaker or with his unconscious predilections. Some directors, like Von Sternberg, impose strict discipline to achieve a visual lushness that may glamorize the most banal object; others, including Godard, cultivate such accidents as glare to inspire an appearance of casualness (Fig. 441). Each filmmaker sees the world from a different point of view.

For all its flexibility, the descriptive function generally implies an aspect of tone that relates to the recording function of the camera and connotes some sort of visual objectivity, however limited. There are films, after all, in which tone seems to have no other purpose than to describe—and perhaps to decorate.

Decoration

In a very narrow sense the primary function of decoration, whether applied to buildings or to faces, is to provide sensuous attraction by the enrichment of forms. Greek meanders, Roman rinceaux, the imprint of woodgrain on a concrete plane, nail polish on toes, rings on fingers, mascara on eyes, all work in much the same way: they offer contrast to the form or produce harmonies with it at the same time that they reinforce some of its inherent characteristics. The decorative forms may perform other functions than simple embellishment, of course: wallpaper holds plaster on the wall or expresses the tastes and economic status of the individual; moldings conceal joints; body paint may provide erotic stimulation, identify the individual with a particular clan, or, in some cultures, terrorize an enemy; and forms that compose the decoration often have symbolic significance, as in much religious decoration. However, in considering the decorative function of tone we will be concerned primarily with its capacity for sensuous attraction, whether the tone has another purpose or not.

Joris Ivens' *Rain* (1929) observes a summer shower in Amsterdam (Figs. 442–444). It has long been a popular film whose appeal is due in large part to rich variations in tone, which develop continuously fluctuating patterns as the water beads in droplets, flows in rivulets, collects in puddles, or glazes surfaces with a velvety sheen, cataloguing the differences be-

442

443

442–444. *Rain*. Joris Ivens. The Netherlands, 1929. The film evolves around the decorative patterns of light on water.

444

445. *The Wonder Ring.*
Stan Brakhage. U.S.A., 1955.

tween reflection and cast shadow or the transparency of water and the solidity of wood, brick, concrete, or glass. The minor drama of a passing shower becomes a device for demonstrating how water decorates the world. Similarly, Stan Brakhage's *The Wonder Ring* (1955; Fig. 445), a more or less subjective interpretation of a trip on the Third Avenue El in New York, investigates the various permutations and combinations of dark and light, warm and cool, clarity and obscurity, and the changing modulations of tone as the train passes from sunlight to the shadow or as the lens looks at the world through the imperfec-

446. *Moana.* Robert Flaherty, U.S.A., 1926.
The richness of dark and light values offers a parallel to the natural richness of island life.

tions in the windowpane. In both films the tonal qualities are organized in time sequences to create a dramatic development. In *Rain*, there is the little drama of the passing shower, in *The Wonder Ring* a more artificial and formal crescendo. But in both, the development is largely an abstract one, the sensuous value of the tones providing the primary experience.

Such delight in sensuous attraction can be activated and grow dominant at any moment. In Maya Deren's *Meshes of the Afternoon*, the image of the protagonist looking through the window (Fig. 151), suddenly appearing, almost immediately vanishing, is one of the most haunting and most frequently reproduced images in the film, not so much, one suspects, because of its significance to the film as a whole, but because its sensuous appeal endows it with an independent existence, as if it were a still photograph inserted to provide a moment of clear and crystalline pleasure in a context of mystery and horror. Of course, the film as a whole is remarkable for its involvement with the senses, and this shot, which juxtaposes the unreality of reflection with the reality of flesh and allows the eye to search while the body is confined, might well serve as a symbol for some of the basic themes of the film, a photographic icon meant to imply more than it states. Even its immediate disappearance evokes feelings of elusiveness, loss, frustration, and nostalgia consonant with the film as a whole. Yet these intuitions do not demand decorative quality, and for all its susceptibility to analysis, it is the sensuous appeal that dominates in the end.

If in *Rain* and *The Wonder Ring* the decorative qualities of tone provide the theme and

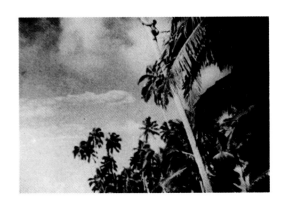

substance for an abstract structure, while in the shot from *Meshes of the Afternoon* they contribute a not indispensible embellishment, in some films tonal decoration is clearly a means for conveying the basic themes of the work. The pictorialism of Robert Flaherty's *Moana* (1926; Fig. 446) suggests the richness of nature and life in a land and among a people as yet untouched by Western civilization, still affording, as Flaherty sees them, a romantic glimpse of the noble savage in idyllic harmony with nature.

In a musical comedy like Jean Renoir's *French Cancan* (1954; Fig. 447) decorative use of tone seems as inherent to the content as it does to the structure of *The Wonder Ring*. Renoir suffused the film with sparkling tonalities derived from the palettes of the French Impressionists and Postimpressionists, which have established for us our notions about color in the last quarter of the 19th century.

Preoccupation with pictorial values or decorative effects can sometimes be an impediment, diverting attention from the main issues and diluting the statement, intruding between the theme and the spectator. Most color films even into the 1960s suffered from these effects, and only during that period did an imaginative and expressive use of color begin to manifest itself in the work of more creative filmmakers.

Continuity

In perception of tone—more than in perception of space—harmony and contrast seem to elicit an immediate affective response in the viewer and under certain conditions can even excite disquieting physiological reactions, notably when complementary tones of relatively high intensity are simultaneously contrasted with one another in space or presented in rapid succession. A painting or weaving may intersperse small units of red and green in a tonal field simply to enrich the surface, enliven it, or cause it to scintillate. But given a dominant role in the composition, contrasting tones may also directly convey a sense of agitation, excitement, and dramatic energy. Freed from association with recognizable objects and presented in pure geomet-

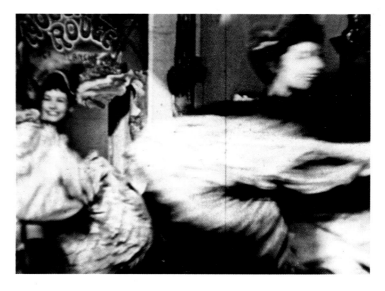

447. French Cancan. Jean Renoir. France, 1954.

ric configurations, such contrasting tones may refuse to hold their place in space or may make it impossible for the spectator to focus. Or, as a result of *successive contrast*—in which the eye perceives in rhythmic alternation first the tone and then the superimposed afterimage—it may even be impossible to retain the identity of the tone's hue, value, and intensity. As a result, the spectator may experience a kind of tonal disorientation, even optical irritation—effects familiar to students of Optical Art. The disorientation seems to be intensified when the contrasts are developed in the temporal organization of the film. Tony Conrad's *The Flicker* presents clusters of black and white frames in alternation to produce accelerating and decelerating rhythms of light with effects comparable to those obtained with strobe lights.

The control of contrast, whether in black and white or in full color, has long been one of the filmmaker's most powerful means of creating particular expressive effects and eliciting affective response from the viewer. It is also one of the most useful and effective means of establishing, modulating, or breaking continuity. A succession of shots harmonious in tone will seem related no matter how contrasting the other elements of the composition. Black-and-white film, therefore, is, at least in its constant and continuous presentation of pure

448

449

450

451

448–451. *Le Bonheur*. Agnès Varda. France, 1965.
Panning back and forth across a tree trunk with regular
changes of focus creates the effect of a series of wipes
and parallels the rhythm of the dance.

neutrals, endowed almost automatically with a degree of harmony and continuity. As we have seen, the sense of continuity can be enhanced by multiplying the incidence of harmonious elements. Therefore, any limitation of the tonal organization—whether it be to neutral tones or to a particular range of values, hues, and intensities—will provide a greater sense of harmony and a more obvious feeling of tonal continuity than an assemblage of shots unrelated in tone. Following this reasoning, Eisenstein could describe *Potemkin* as a basically gray film and *Ten Days That Shook the World* as a film of velvety blackness.

Generally, filmmakers will want to maintain some sense of continuity without sacrificing the dramatic and structural possibilities in variety and contrast. Shots of similar tonality can be grouped together to form rhythmic alternations with shots of another tonality; or the tonality can be gradually altered—from dark to light, from warm to cool, from relatively neutralized tones to relatively intense ones. The "Diving Sequence" (Figs. 246–272) illustrates both types of development: shots of an extended range of values alternate with shots of relatively high key, while the film as a whole progresses gradually from shots with an extended range of values to shots of relatively low key in which the middle tones seem largely to have dropped out and the darks and lights crowded together.

Using a sequence shot rather than cuts, Agnès Varda in *Le Bonheur (Happiness;* 1965) creates a rhythm of tonal contrasts through camera movement (Figs. 448–451). Observing a dance, she stations the camera behind a tree trunk, then pans from the bright, variegated hues of the dancers on one side of the tree across the relatively neutral and uniform tonalities of the tree trunk to the dancers on the other side, crossing again and again, the back and forth movement catching something of the rhythm of the dance. Varda also uses tonal contrast to separate one sequence from another, sometimes showing a panel truck, sometimes a signboard, sometimes storefronts. Each transition is effected by a lateral movement that, like a swish pan, seems to lead the spectator from one space to another and makes of separation a link between one scene

and another, so that continuity becomes a function of contrast.

O'Neill's *7362* presents a more complex tonal development (Figs. 452–459). Using as its basic formal motifs pure geometric shapes —what appear to be machine forms are seg- ments of a human figure—and organizing the composition symmetrically so that the left half of the frame is the mirror image of the right, *7362* develops in four sequences or move- ments that illustrate the basic possibilities for continuity and contrast of tone. The first part

452

453

454

455

456

457

458

459

452–459. *7362.*
Patrick O'Neill.
U.S.A., 1966.
Color has been struc- tured in space and in time.

presents two black circles side by side on a white field. In slow, ponderous, almost solemn rhythm they move horizontally toward one another until their circumferences touch, then separate, repeating the motions over and over again. The continuity in tonal order is simple and obvious.

The second part introduces more complex forms, the movement of which is vertical rather than horizontal. Opening with the simple neutral tones that link it to the first movement (Fig. 452), the sequence develops a tonal progression from black and white to red (Fig. 453) to yellow to red-violet and then to an assemblage of all these tones along with blue (Fig. 454). The movement climaxes with some optical effects exploiting the persistence of vision: frames presenting a red figure on a blue field alternate with frames that are completely blue; frames containing a horizontal blue figure alternate with frames containing a horizontal red figure (Figs. 455, 456). The result is an overlapping of retinal images, an optical mixture of hues and optical combination of forms, a vibrant sensation of flicker.

The third part, retaining a full range of tones, makes use of alternating positive and negative images (Figs. 457, 458). The fourth reverts to the neutral tone again, though in more complex patterns than characterized the first (Fig. 459). The contrasts in tonality exhibit varying degrees of tonal impact: a rather quiet contrast between the first and second sequences, a medium level of agitation in the transitions of the second sequence, a high degree of excitation in the rapid cutting at the end of the second sequence, a barrage of single-frame cuts in the third, and a medium level of tonal action in the fourth. Yet for all the contrast, continuity within and among the sequences is maintained; in the first sequence by tonal harmony, in the second by tonal progression, in the third by tonal alternation, in the fourth by tonal harmony, and in the whole by the progression from neutral tones to high-intensity ones and back again.

Intensification and Deintensification

We have considered tonal progressions primarily as a means of furthering continuity, but it is evident that they also perform a function in building dramatic intensity. Intensification and deintensification of tonal impact operate like the musical crescendo and decrescendo. They can impose order, induce a generalized sense of dramatic development, or convey relatively specific intellectual or emotional overtones, depending on the context.

A study of 7362 demonstrates how effective progression of tonal change can be in building dramatic intensity with essentially abstract forms, for although we identify some forms and entertain powerful associations with others, the forms operate principally on the level of abstraction. The second section, in its progressive change of hues and intensities, seems almost to change temperature and gather strength like a rocket on a launching pad. The third section acquires an even more convulsive life through the manipulation of contrast.

Stan Brakhage in his short film *Loving* (1956) exploits the potentialities of tonal change to express the dramatic and emotional content of sexual intercourse. Using such extreme close-ups of fragments of the landscape and the actors that the precise subject is often not identifiable, Brakhage depends less on action than on cutting and tone to achieve his effects. He opens the film with a full range of naturalistic color, then gradually modulates from the cool greens and blues of the trees and sky to the warm hues of wood, pine needles, and flesh, then cuts from warm to cool and from dark to light in a pulsing rhythm that accelerates to the climax and then retards. As the climax is reached—when the emotional intensity is highest and subjective feeling supplants objective perception—he reduces the range of hues, eliminating first the cool tones, then the warm tones, until all color seems drained from the frames and the physical world disappears in the transfiguring ecstasy of love.

Brakhage's approach is subjective, expressionistic, and semiabstract. For filmmakers who wish to retain a tighter grip on objective reality, even in the expression of subjective states, full color presents a more difficult but not insurmountable problem, as Federico Fellini's *Juliet of the Spirits* (Figs. 460–479) shows.

460

461

462

460–479. *Juliet of the Spirits.* Federico Fellini. Italy, 1965.

460. Mystery, uncertainty, and nervous anticipation combine as Giulietta takes part in a seance.

461, 462. As Giulietta dances with her husband, her joy is suggested by sudden revelation of a brightly colored bouquet.

Giulietta, undergoing psychoanalysis and seeking to understand her withdrawal, her introspection, her frigidity, is troubled by the confusion of dream and desire. Her friend Valentina takes her to visit an Indian seer in a hotel where the latter is holding court. As they enter first the antechamber and then the chamber of the seer, the screen, by a series of shifting camera angles, is dominated by the intense red of a brocaded wall (Fig. 466). Finally, as the seer is revealed and enters his trance, there is another shifting of angles and pulling of curtains so that the screen is filled with white, with even the flesh of the Indian drained of warmth (Fig. 467).

By transforming the tonal environment from dark neutrals to intense reds of middle value to white, Fellini introduces a dynamic, rhythmic development that proceeds simulta-neously in alternation from relatively achromatic to relatively chromatic to relatively achromatic and in progression from dark to light. This tonal transformation parallels the rising dramatic tension and suggests, perhaps ironically, Giulietta's passage from doubt to embarrassed excitement to "enlightenment." The dramatic tension is also heightened by the alternation of light, low-intensity tones with darker higher-intensity tones as the camera pans rhythmically back and forth from the hermaphroditic seer's female attendant to his male attendant, as if suggesting the twofold nature of the old man's sexuality (Figs. 467, 468).

Somewhat later, still exploring her inhibitions, Giulietta visits the villa of her neighbor Susy, whose life and house are so devoted to sensual delight that eroticism has taken the

463

464

460–479. *Juliet of the Spirits.* Federico Fellini. Italy, 1965

463, 464. Sitting on the beach, Giulietta falls asleep, and color leaves the screen.

465. As Giulietta sits contemplating her husband's infidelity, the flowers ironically evoke her earlier happiness.

465

tone of religion. Susy shows her the house, which to a less innocent eye than Giulietta's would obviously seem to be a bordello. They enter a courtyard, in which a uniformed chauffeur stands guard outside a room, then pass through into the room, where a young woman who has attempted suicide is being kept under sedation. Next, they return to the courtyard and mount an open stair to Susy's room. As they proceed, the tonality changes progressively from dark cool neutrals (Fig. 470), to a predominantly white setting with touches of more intense color (Fig. 471), to a full spectral palette (Fig. 472) that expands on the screen (Fig. 473), then becomes increasingly red (Fig. 474–476), creating a coloristic crescendo that echoes the mounting excitement in Giulietta's mind.

A more sudden change has the impact of a shock to eyes and feelings. Beset by visions and seeing phantoms everywhere, Giulietta goes to her closet with its neutral gray shutters (Fig. 477), opens it to reveal a mass of yellow hair and a flash of red (Fig. 478), and then, as the yellow hair falls away, a nude woman appears against an intense red background (Fig. 479), all in a flash.

As these examples will suggest, intensification is largely a function of contrast. It need not involve a change of intensity of hue, can also occur in black-and-white films. The theater sequence in *Frustration* provides a gradual increase in darkness until, at the climax of the fight, forms manifest themselves only in a few highlights, as physical substance gives way to emotional conflict translated into the conflict of light and dark (Fig. 66).

Spatial articulation, description, decoration, continuity, and intensification—the functions of tone we have considered thus far—are rather simple and obvious in application. All of them depend primarily, almost exclusively, on the sensuous apprehension of tones, and all of them seem inherent in the nature of the medium itself. They are found in all films, however ineptly and superficially they may be employed. The functions of tone we are about to consider—metaphor, comment, evocation, parallelism, and counterpoint—imply a more complex order of experience and a more sophisticated comprehension of visual materials,

466. *Juliet of the Spirits.*
Federico Fellini. Italy, 1965.
Physical and psychic excitement are conveyed in an almost static shot of Giulietta waiting to consult an Indian seer.

466

467

below: 469. *Juliet of the Spirits.*
Federico Fellini. Italy, 1965.
Desolation and withdrawal accompany Giulietta as she ascends in an elevator to hire a detective who will follow her husband.

468

469

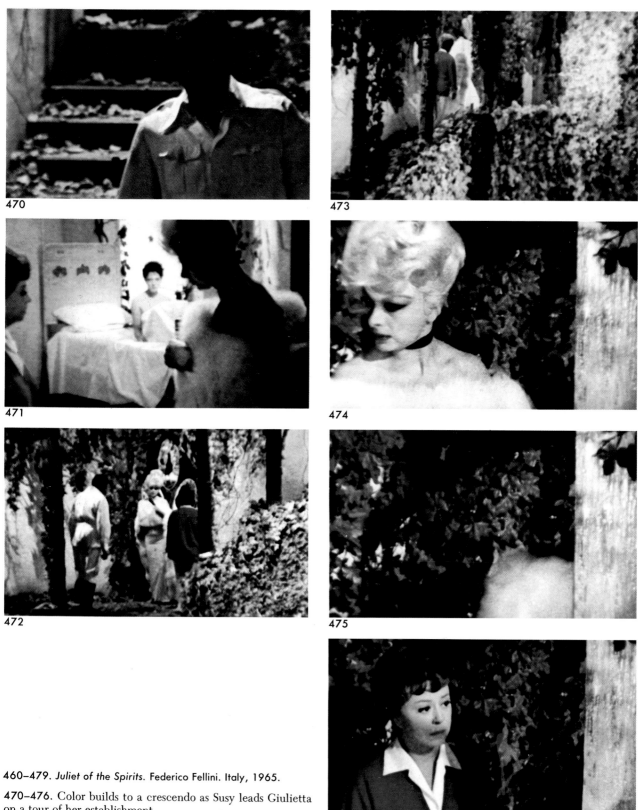

470

473

471

474

472

475

460–479. *Juliet of the Spirits.* Federico Fellini. Italy, 1965.

470–476. Color builds to a crescendo as Susy leads Giulietta on a tour of her establishment.

476

overall a deeper sense of the affective, figurative, or intellectual implications of the selection and organization of tone.

Metaphor

Many of the examples already cited in this chapter suggest the use of tone as metaphor in the delineation of mood, character, or state of mind, in the creation of a particular ambience, or in the isolation of an emotional tone. But it may be useful to examine a few more examples with the metaphorical approach especially in mind. We will revert again to Fellini's *Juliet of the Spirits.*

Giulietta is characterized by her words and her voice (reticent, detached, curious, and amused), by her actions (constrained, controlled, inhibited, limited to functional activities), by her behavior (subdued, almost secretive—she covers her flesh even at the beach) and by the tones surrounding her. The neutral tones of her clothes, whites for the most part, seem extensions of her state of mind. Only occasionally do more decisive hues appear when there is a mood of warmth, excitement, or suppressed daring. Seated at the beach, inviolate under the umbrella, she wears a white hat that matches her white suit (Fig. 463). Dropping her head to study her knitting, she lets the brim of the hat wipe out from the screen the last vestiges of warmth: the still palid pinks of her face (Fig. 464).

Even the settings at times work like tonal metaphors for her interior states, as we have seen. On another occasion, Giulietta calls on a private investigator whom she has hired to discover whether her husband is having an affair. Apprehensive and embarrassed, she ascends to his office in an elevator that seems almost to be constructed of ice (Fig. 469). The setting conveys her feelings here just as it does in the apartment of the Indian seer, in which the red seems simultaneously to be a revelation of suppressed warmth and the projection of an interior blush. There is little in the action that conveys the mood in any of these scenes, and Giulietta's face is a mask, for all its subtle changes in expression. Only the tonal metaphors give concrete expression to the internal state of mind.

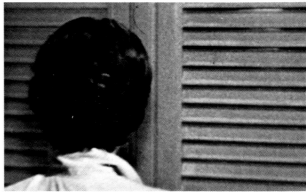
477

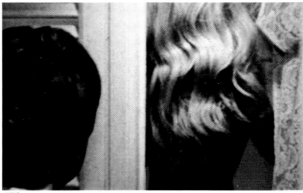
478

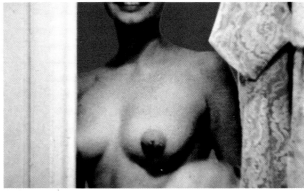
479

460–479. *Juliet of the Spirits.* Federico Fellini. Italy, 1965.

477–479. Beset by visions, Giulietta opens a closet, and neutralized tones are suddenly supplanted, first by yellow, then by red.

In the examples cited, the specific tones do not have fixed associations but gain expressive or metaphorical significance from the context in which they appear. Some films utilize specific tones so consistently to express particular intuitions, feelings, or ideas that the tones assume an allegorical force and seem almost to

480

481

function as members of the cast. In Frank Powell's *A Fool There Was* (1914), which brought the 19th-century interpretation of woman as vampire to the American screen in the person of Theda Bara, light and dark serve not only as reinforcements to a particular mood and as a means of intensifying the dramatic development, but as symbols of good and evil, concrete correlatives of abstractions.

The narrative describes the moral and physical decline of an American financier who falls under the domination of a rapacious woman, the vamp. He is introduced as a happily married, honest family man, highly respected by all who know him. The United States government sends him abroad on a special diplomatic mission. On the ship he is seduced by the vamp. Forgetting all responsibility, he devotes himself to her wishes and separates himself from wife and family. Later, overcome by remorse but unable to break with his seducer, he takes to drink and ultimately goes to a drunkard's death.

At the beginning of the film, when the ambassador and his family are being introduced (Fig. 480), high-keyed tonalities are deployed not only to suggest ease and contentment but also to establish a relationship between the tone and what might be regarded as "good." When the vamp first appears, a strong conflict of light and dark emerges (Fig. 481). And, as the ambassador gradually degenerates, the screen becomes darker and darker around him, until only a few details are highlighted,

like cracks in the walls of hell (Fig. 484). The manner in which tone, while reinforcing the mood and intensifying the dramatic situation, simultaneously operates on the level of allegory is demonstrated succinctly in a sequence during which the ambassador's wife learns that her husband has chosen to remain with the vamp rather than return home to her and the family. The scene opens in a relatively brightly lit dining room (Fig. 482). A storm comes up, reducing the light, and the shutters are closed to cut the light even more (Fig. 483). Light has been supplanted by darkness, good by evil, as the wife's mood changes from happiness to despair.

Comment

In *A Fool There Was*, the tonal modulation—whether reinforcing mood, intensifying conflict, or operating as metaphor—appears nominally within the naturalistic tradition; lighting conditions are ostensibly rationalized, and the tonal range is consistent with our experience and harmonious within the structure of the film. Although the filmmaker obviously manipulates tone to construct his coloristic allegory, the internal uniformity of the structure and the reasonable approximation of experience allow him to do so without revealing his presence in any obvious way, except in one instance, as we shall see.

Yet a filmmaker can interrupt the continuity to interject his own comments and inter-

482

483

484

480–484. *A Fool There Was.* Frank Powell. U.S.A., 1914.
Light and dark become metaphors of good and evil.

pretations of actions, just as the actor can turn to address the audience directly. Eisenstein does just that in *Ten Days That Shook the World* when he compares a speaker cajoling an audience to a harp (Figs. 398–403), cutting away from the main action, time, and place to reveal the presence of someone totally detached from the narrative—himself. Powell intervenes not only in the dramatic development but also in the processes of nature in *A Fool There Was,* when he intimates the ebbing tide of the family's good fortune by making waves reverse as the financier, his wife, and children watch a sunset over the ocean.

The filmmaker will sometimes inject verbal comments in titles, at other times through such devices as advertisements, street signs, or billboards. Godard regularly does this in *My Life to Live.* In the sound film the filmmaker might intervene directly through words, indirectly through music or abstract and miscellaneous sounds. The same sort of maneuver is possible with tone, although the very identification of tone and space makes the use of tone for comment more difficult and ambiguous.

Eisenstein's comment about the public speaker operates to imply analogy with something having a separate identity, space, and perhaps even time; the printed words of a title or sign automatically detach themselves from other elements in the film; and sound involves a different sense, so that separation of comment from other aspects of the film is simple enough. The separation of the spatial from the commentative function of tone is not so easy. Moreover, while we constantly read words and listen to sounds for their emotional or expressive overtones, we are not quite so sensitive and discriminating in our perception of color, so that the isolation of a commentative use of tone from its use as description, decoration, or intensification is sometimes impossible. Except in the work of independent and personal filmmakers, the potentialities of visual tone as a commentative instrument have not been exploited to a significant extent.

An obvious and familiar device is the alternation between sequences in full color and ones in black and white. Used frequently in commercial movies to establish a contrast between the "drabness" of reality and the

"glamour" of a dream, the technique has also been employed for more explicitly commentative purposes, as in Jeff Dell's *Happy Birthday, Felicia* (1968), a short film in which full-color shots of a child's birthday party alternate with black-and-white shots of war. Strictly practical exigencies—like the availability of stock shots of war in black and white only—or purely structural purposes could account for the alternation in tonality. However, implicit in the film is Dell's comment on the difference between a world of life (in color) and a world of death (in black and white).

Dell's presentation of two strongly contrasting tonal schemes makes the commentative function of tone rather obvious. A more subtle procedure, in which tones meant for commentary are integrated into the overall tonal structure, can be found in the works of Antonioni. In *La Notte*, a film concerning the disintegration of a marriage, a continuing reference to silhouettes and to reflections in windows and mirrors (essentially tonal phenomena), not only underscores but interprets the personal relationships being explored. The insubstantiality of the marriage is compared to the insubstantiality of the transparent, reflected images, and the incompleteness and two-dimensional character of an abortive affair to the two-dimensionality of the silhouette. Tonal manipulation then becomes a means not merely of dramatizing or identifying but of criticism.

Evocation

The commentative function of tone implies a relatively explicit intervention of the filmmaker, while the metaphorical application of tone elaborates, expands, and enriches the connotations of an image. Comparable to these two tonal functions is the use of tone to evoke specific associations with material quite outside the film or to relate material in one part of the film to material that has gone before. The former reference we can call external evocation, the latter internal evocation.

Allusion to things, events, ideas, intuitions, and feelings not appearing in the film is so much a part of Luis Buñuel's style that it seems almost as personal as his signature. Sometimes its appearance is serious and commentative, as in the composition of the beggar's banquet in *Viridiana*, with its sardonic reference to paintings of the Last Supper (Fig. 409). In other films it seems to be an amusing intellectual pretension, as in *The Milky Way* (1969), which contains numerous shots based on paintings by Velázquez, Philippe de Champaigne, Bruegel, and other artists. On still other occasions external evocation appears as a relatively personal "in" joke, like the shot of a tall man and a dwarf walking away from the camera on an empty road in the same film, a reference in this "last" film to a shot in Buñuel's first, *Un Chien andalou* (1928). In all the examples, the allusions are made through the subject matter, the action, and the total composition. The use of tone alone for such purposes is somewhat more elusive and indefinite but is not infrequently employed.

Agnès Varda provides a provocative example of internal evocation in the closing sequence of *Le Bonheur*, in which a young man, after the death of his wife, takes his children and his mistress on a picnic. The mistress, who has been wearing cold, bright blue tones throughout the film, now wears the warm tones that have been associated with the wife, evoking her memory, suggesting the mistress' assumption of the wife's role, and raising the question whether she, who was once the wife's rival, will now herself have a rival.

Another example of evocation used for irony occurs in *Juliet of the Spirits*. At a party celebrating their wedding anniversary, Giulietta and her husband dance. At first they are seen in the dark, Giulietta's back to the camera (Fig. 461); then, as they turn, Giulietta appears smiling and a bouquet of flowers is revealed, its intense, varied color acting as a projection of her smile (Fig. 462). Later, when Giulietta has begun to suspect her husband's infidelity, she questions him about the woman whose name he has mumbled in his sleep the night before. He protests ignorance and departs for his office, leaving her sitting at the breakfast table. The neutral tones of the setting parallel her desolation, but the bright flowers recall a happier moment when she was still confident of his love (Fig. 465).

Parallelism and Counterpoint

However else it may be used, the visible tone of the motion picture, like the audible tones of music, can either parallel the dominant theme or serve as counterpoint to it. Parallelism and counterpoint may occur in relationship to the formal organization alone or to the dramatic content of the film. Of course, parallelism implies tonal harmony, and counterpoint tonal conflict. Of these more complex functions of tone, the simpler and more familiar is parallelism, a relationship in which tone is used to reinforce feelings and ideas presented directly in the spatial organization or the action. A relative uniformity of tone might support a sense of endless, changeless void. Composition in a low key is often associated with uncertainty, mystery, and suspense. Strong contrasts of dark and light accompany highly charged situations, such as the confrontation of the mother and soldiers in the "Odessa Steps Sequence" (Figs. 346, 353). Oppositions of light and dark, almost black and white, are multiplied across the screen, reinforcing the conflict and state of tension by means of spatial organization.

As mentioned previously, filmmakers early recognized the possibility of reinforcing a mood by printing on uniformly tinted stock, a method more or less abandoned after the development of color film, although Eisenstein introduced two such color sequences into *Ivan, Part II.* Aware of the boyars' plot to assassinate him, Ivan invites Alexis, the son of a boyar leader, to a banquet, tempts him to don the robes of the czar, and then persuades him to enter the church, where the waiting assassins will kill him rather than Ivan. The banquet sequence, with its enthusiastic drinking, boisterous singing, and wild dancing, is tinted in red-orange tones, which are harmonious among themselves and also conform with the excitement generated in the action, the spatial organization, and the cutting. The sequence in the church, with its aura of solemnity and suspense, is tinted dark blue-green, tones again harmonious among themselves and with the more tectonic spatial organization, the retardation in action, and the slower cutting rhythm. Thus, tones not only bolster the mood of the separate sequences but, by introducing a complementary color relationship, reinforce the contrast in content and extend Eisenstein's dialectical method to the tonal organization.

Today, such uniform tinting appears frequently in film collages and montages as a means of integrating old or new black-and-white film clips with shots in color. William Friedkin's *The Night They Raided Minsky's* (1968) employs a far more sophisticated method of blending the old with the new. The opening sequence of the film contains authentic 1920s footage in black and white of New York's East Side. With this as a model, the filmmakers made new color shots, converted them to black and white, and distressed the film so that it resembled, as closely as possible, the vintage footage. As the film progresses, the amount of distress to which it was subjected decreases and at the same time the black and white is gradually turned back to color. Thus, a static, monochromatic scene becomes animated and filled with color, as if to suggest that a moment in the past is being revived.

While the inclusion of a full spectral palette has generally been rather unsophisticated and perfunctory, providing little more than description and decoration, musical comedies filmed in the full range of color have succeeded in reinforcing the prevailing mood. Examples include Jacques Demy's *The Young Girls of Rochefort* (1967), with its bittersweet gaiety and bright palette, and Renoir's *French Cancan* (Fig. 447), with tones revived from Impressionist painting. More complicated is Renato Castellani's *Romeo and Juliet* (1954), in which yellow-oranges, blue-greens, and red-violets, somewhat indefinite in hue and low in intensity, fill the frames with a tenderness and sweetness consistent with the theme. At the same time value contrasts reinforce the melodramatic qualities, and the tones evoke the tastes of the 16th century, when the events supposedly take place.

Contrapuntal organization is somewhat more difficult to demonstrate. It implies not the simple contrast of hues, values, and intensities that constitute a tonal chord in a particular key—for example, light or dark, warm or cool, neutralized or intense—that may

485. *Ecstasy.* Gustav Machaty. Czechoslovakia, 1933.

contrapuntally opposed with extraordinary consistency, considering the elementary realism of presentation. Somewhat more subtly, the flowers in *Juliet of the Spirits* parallel her mood when she is dancing (Fig. 462) and act in counterpoint at the breakfast table (Fig. 465). The expressive potentialities of tonal parallelism and counterpoint will become clear if we consider some similar bits of action as they are interpreted by different filmmakers in a variety of filmic contexts. Love and death are common enough themes to appear in almost any film. The scenes we will consider are similar in one respect: they all use close-ups and extreme close-ups. But they differ in expressive content, largely because of the use of tone.

Gustav Machaty's *Ecstasy* reaches its climax in a love scene that, despite its discrete selection of details and its analogical shots of plants, still generates an erotic intensity far more powerful than most of the carnally explicit embraces offered to audiences of the permissive sixties and seventies. Camera angles, changes of focus, distortions of perspective, rhythm of movement, and cutting all contribute to the sensuality of the sequence, but most important is the tone, with its forced contrasts of light and dark combined with an extended range of values, that lends softness to transitions and richness to the total image (Fig. 485). An extravagant romanticism permeates the scene. The act of love is here an irresistible force transporting the young

occur in any shot or sequence. Rather, contrapuntal organization calls for the injection into such a chord of more obviously contrasting material, so that the basic chord supplies the dominant theme while the contrapuntal tones act as a subdominant theme.

Contrapuntal tone, like commentative tone, has been applied for the most part in a rather rudimentary manner, most frequently as a method of formally isolating particular objects or persons—a warm figure in a cool setting, for example, or a light figure in a dark setting. A more complex use of counterpoint occurs in *A Fool There Was,* in which the light and dark tones, while performing their various descriptive and decorative functions, are

486. *Breathless.*
Jean-Luc Godard. France, 1959.

woman to ecstatic heights in which she tran-
scends nature and yet is simultaneously united
with it through the analogical images. The
luxurious, baroque diapason of tones at once
tender and bold parallels her joyous transports
and, one assumes, her physical sensations.

Jean-Luc Godard's *Breathless* presents a
similar parallelism of action, idea, and tone,
although in an entirely different context and
with entirely different implications (Fig. 486);
for now the lovers do not melt in apocalyptic
passion but accept their embrace as a part of
life, so that the seemingly casual action of the
camera, the insouciance of the action—only
occasionally touched with urgency—and the
directness of the dialogue create a laconic,
playful mood, for which the naturalistic dis-
tribution of illumination, the incorporation of
lighting accidents, and the relatively high-
keyed tonality seem quite appropriate.

The principal love scene in Agnès Varda's
Le Bonheur, while it resembles *Ecstasy* and
Breathless in its use of close-ups and extreme
close-ups, differs radically in spatial organ-
ization (which transforms anatomy into ab-
stract forms), in action (which takes place
more in the cutting than in the movement of
bodies), and in tone. Toward the beginning of
Le Bonheur a few shots from Jean Renoir's film
Picnic on the Grass (1959) appear on a televi-
sion screen in the home of the principles, and
a few lines of dialogue are heard—among them
the proposition that "Happiness may consist
of submitting to the natural order." Taking
this comment as a motto or text, Varda exam-
ines some instinctive aspects of human psy-
chology as revealed in the relationships among
a man and two women.

As a central figure she presents a man who
responds directly to impulse and instinct.
Without renouncing his love for his wife and
family, he takes a mistress, recognizing that
each of the women fulfills a different aspect
of his personality. When he ingenuously in-
forms his wife of what he has been doing and
how he feels about it, she, more conventional
in her attitudes, drowns herself. After a period
of mourning, he introduces his mistress to his
children. As the film ends they all go on a picnic.

The sequence in which the young man and
his mistress embrace is developed largely
through near static close-ups cut in an almost
metrical manner. The tone is relatively high
in key, with very low intensity flesh tones ar-
ranged against white sheets to create a general
sense of coolness (Fig. 487). While the muted
tonality and suppressed contrast might be
imagined as expressing a kind of tenderness or
even sadness, the effect is so cool, the tonal
arrangement so formalized that warmth, de-
light, and passion implied by the characters'
words and embrace seem denied; the palpable
intimacy of their involvement is countered by
detachment, abstraction, and coldness.

As the sequence closes, the camera retreats
to reveal a bowl of withering flowers that are

487, 488. *Le Bonheur*. Agnès Varda. France, 1965.

487

488

489. *The Naked Night.* Ingmar Bergman.
Sweden, 1953.
This shot from the prologue has the effect of an old silent movie.

happens, without fanfare, leaving only a question about what Michel's last words mean. And in *Le Bonheur* the wife's death occurs, as death so often does, in the bright decorative tonalities of a summer's day, the brightness contrapuntal to the pathos. The attitudes toward dying in *Breathless* and *Le Bonheur* express a more complex understanding of the irony, absurdity, and naturalness of death than the turgid parallelism associated with the death of Kane.

PHOTOGRAPHIC QUALITY

The character of tonal organization is often associated with photographic quality, a subject that has been deliberately avoided until now in order to first establish a framework for its discussion by suggesting the extraordinary variety of possibilities for manipulating and modulating the photographic image. In fact, the quality of an image should be determined not by any fixed criteria but by the expressive appropriateness and potency of the image within the context of the film as a whole. We often hear viewers speak of the beautiful photography in a film. Generally, the phrase seems to imply that the images exhibit clarity, suavity, and richness of tone, and that the arrangements vaguely resemble traditional painting. With the advent of more personal cinematic style in the 1960s, critics complained of camera movement and lack of focus, of grain, glare, blocked-up lights and darks, and flat images—all qualities associated with the fumblings of a beginner. But in the proper context these effects take their place.

In the prologues to *The Naked Night* and *Wild Strawberries* (1957), Ingmar Bergman provides examples of how qualities regarded as deficiencies can become assets. The prologue to *The Naked Night* is a tale told by a clown to the circus owner as they drive a wagon through the night. It concerns an incident that had occurred some years before at the turn of the century. In flashback, Alma, the

dull in tone. There are significant ironies in these tones, not only as they affect the content of the sequence itself, but also as they compare with other scenes in the film. For their pallor is in sharp contrast to the warmth that suffuses the screen when the wife is present (Fig. 488), and to the tones that describe flowers and other objects in her house, which are so bright and intense in tonality they sometimes seem to contain more energy than the people.

As for the subject of death, Orson Welles' announcement of Kane's death in *Citizen Kane* shares a good deal with the love scene from *Ecstasy*, which it follows by only eight years. Opening the movie with the death of its protagonist, Welles shows a light going out in a window of what seems to be a romantic neo-Gothic pile and then moves to an almost totally black image of Kane—as if to say that with the life expired the body has no dimension. He makes the end of life melodramatic by having nature announce it with a clap of thunder and a flash of lightning. For all its visual sophistication, spatial invention, and dramatic intensity, the scene depends on an essentially conventional and romantic parallelism between the situation and the tonal organization. Death is blackness, light is snuffed out, and nature weeps—as nature swells, bursts, and drips in *Ecstasy*.

By comparison, the death of Michel in *Breathless*, with its generalized lighting and apparent indifference to tonal manipulation, is as laconic as the love scene. Death simply

clown's wife, hearing that an artillery battery is practicing on the nearby shore, makes her way to the place, captivates the men with her antics, and cavorts with some of them in the sea. Upon learning of what his wife is doing, the clown goes to the shore and wades into the water to carry her home. His progress is a kind of calvary of love, pathos, and humiliation. The film has the quality of an old silent movie of the period (Fig. 489); it is grainy and lacks definition and contrast, its tones are blocked up, making it appear flat. These qualities set the prologue off from the rest of the movie, evoke an earlier time, and create a starkness that augments the pathos.

Similarly, in the prologue to *Wild Strawberries,* photographic qualities heighten the unreality of a nightmare in which an old man's fear of death and uncertainty about his relationships with other people are expressionistically suggested. Whether photography is "good" or not is a relative matter. Where art is concerned, "bad" photography may in the end evince superb technical control and unquestionable aesthetic force.

RED DESERT

All the uses of color we have just examined are brought to bear in Michelangelo Antonioni's *Red Desert* (Figs. 490–517), a film that exploits tonal functions to their fullest potential and orchestrates them with a mastery that is breathtaking. The film explores as if it were a landscape the psychopathic personality of Giuliana and, through her, the psychic ambivalence and imbalance of contemporary women.

Giuliana, wife of a young industrialist named Ugo, possesses everything that young women are conventionally thought to desire— youth, beauty, a successful husband, a handsome son, friends, wealth and all that it provides, and status in the community. Her untrammeled economic and social position permits Antonioni to examine her psychic condition in its purest state; for although she seems to have everything, she is still unhappy, disoriented, alienated, confused, and overwhelmed by a sense of depression that causes her either to discharge her energy in purpose-

490

491

492

490–517. *Red Desert.* Michelangelo Antonioni. Italy, 1964.

493

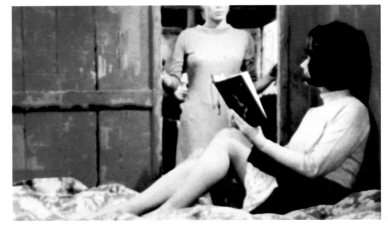

494

495

less activity or sometimes to experiment gingerly with suicide. Now that she has borne her son, she has no purpose in life; her husband has his business, her child is cared for by a maid.

Giuliana tries to discover something significant in her existence, but everything slips away—her husband, her friends, and in a sense her child as well. All is transitory: the patterns in the oily waters of estuaries, the mists that drift across the screen to wipe out the actors and their setting, the ships that glide through the canals, always departing. Even nature, which might provide solace with its rhythmic affirmation of permanence and recurrence, is

490–517. *Red Desert.*
Michelangelo Antonioni.
Italy, 1964.

496

vanishing under the advance of industry, the pure water defiled by oil slicks, the fields and forests displaced by steel concrete and glass, the trees supplanted by gigantic antennae that mock nature while listening to the stars.

Everything seems out of joint. Drugs compounded to ameliorate life produce mutations; war is as close as the journals and television set; atomic destruction waits in the rocket silos on the horizon; her son's toys are machines. Even her friends' talk is mechanical, for when it centers on sex their ideas and jokes turn sex into an artifice and a sport.

Accompanied by her young son, Giuliana first appears wandering near a picket line at her husband's plant. She buys a sandwich from a management representative who is trying to convince the strikers to return to work, then wolfs the sandwich like an animal in the midst of a landscape overgrown with industry and choked by industrial waste. Upon entering the empty factory, she finds her husband and his friend Corrado. After she has gone, Ugo tells Corrado that she has been in an accident and has been hospitalized for shock. That night Giuliana cannot sleep. She rises from her bed and goes to the boy's room to turn off the toy robot that is moving about the floor like a sentry in a horrifying, mechanical parody of modern industrial life.

497

498

499

500

501

502

503

504

505

506

490–517. *Red Desert.*
Michelangelo Antonioni. Italy, 1964.

507

508

509

510

The next day, Giuliana makes her way to the shop she plans to open, apparently to keep herself busy—although she has no clear idea what she is going to sell. Corrado follows her, and the two skirmish with words, testing each other. His intention of initiating an affair is obvious, but as the talk grows personal, she becomes unnerved and begins to retreat. Corrado does, however, convince her to accompany him on a business errand to a nearby village. There they seek to interview a man, first going to his apartment and then to his place of work.

After accomplishing their mission, they wander near a canal, where they find Ugo. The three go to a shack owned by their friend Max, where they have an indoor picnic with Max, his wife, and other friends. The talk turns to love, sexual techniques, sexual perversion, aphrodisiacs, and the like. The staging suggests an orgy, although the activity is verbal rather than physical, and as both the emotional and the physical temperature grow cold, they tear planks from a partition to stoke the fire. A ship glides by the window and ties up at the wharf, its signal flags indicating that it is in quarantine. Giuliana, increasingly attracted to Corrado and annoyed that Ugo is aware of her interest, becomes agitated, runs for the car, jumps in, and drives down to the end of the wharf, stopping only at the edge. The others run after her and lead her home.

When Ugo leaves on a business trip, Giuliana meets with Corrado and they discuss her

490–517. *Red Desert.*
Michelangelo Antonioni. Italy, 1964.

511

illness, which, it is now apparent, is psychic. When she returns home, she finds her son apparently paralyzed, but his paralysis turns out to be only a childish deceit, a demand for attention inspired by some illustrations in a magazine. She tells him a story about a young girl who lived on an island and discovered an isolated beach where everything was calm and blue and pink, where the rocks seemed like people, and all nature sang.

Later Giuliana flees her house and goes to Corrado's hotel, distraught, aware that she is compromising herself but acting by instinct, searching for some solace in a world that has become oppressive, incomprehensible, and meaningless, where even her relationship with her child is artificial. Torn between guilt and desire, she seems simultaneously to offer herself to Corrado and to resist him. He takes her to bed partly by persuasion and partly by force. Waking from her sleep, Giuliana again flees into the dark streets, with Corrado pursuing her. When he finally catches her, she tells him she had sought some way of returning to reality through him but that he has not helped her. She runs to the docks, where she babbles at a Turkish sailor who can neither understand her nor communicate with her. Their impasse epitomizes a central theme of the movie, Giuliana's inability to articulate herself as a person or even to comprehend her problems. Finally, she flees into the darkness.

Giuliana appears for the last time where she was first seen, in the neighborhood of the strikebound factory. Once again the child is

with her. He says that the birds will die if they fly through the poisonous yellow smoke of the factory, and she replies that they would indeed die but that they have learned not to fly through the smoke. The film ends with the mother and son walking across the factory landscape in which the only color appears in a pile of painted barrels.

The film moves from point to point in time, develops rhythmically through a series of climaxes of ever-increasing intensity, and presents a clearly articulated formal structure. Still, it is obviously not a conventional drama of action, conflict, and resolution. Each phase of the development is in some way frustrated, tensions are unrelieved, and the denouement is as inconclusive as life itself. The drama, in fact, is played out in large part through the color, which articulates the space, describes the objects, and decorates the screen. But color is most impressive in its more complex functions, in the way it provides a tectonic structure for the dramatic development, serves as a projection of Giuliana's thoughts and feelings, develops intensity when the action seems almost inconsequential, comments on the states of the mind of the characters or the significance of the environment. Each function is inseparably united with the rest. Color as a whole is so logically related to the objective world that even the most expressionistic configuration seems inevitable, except perhaps in two sequences—an interview between Giuliana and Corrado that takes place in a street in which everything, includ-

512

513

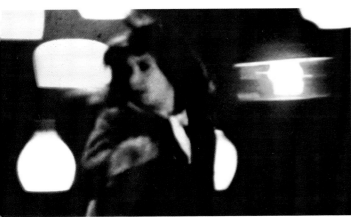

514

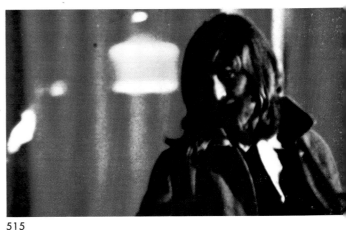

515

ing a fruit vender's produce, is painted gray; and a shot of Corrado's bedroom after Giuliana and he have made love, which is overcast with pink (Fig. 510).

As in any picture—whether it is a drawing, painting, or photograph—contrasts of dark against light, neutral tones against intense or bright hues, and hue against hue clarify the position of forms in space. Not only do they separate significant shapes from their tonal environment (as in the shot of Giuliana devouring the sandwich) but they also establish their relative distance—as in the shot of the entrance to the apartment house, in which the fuchsia plant establishes the foreground plane, while the contrast of values determines the position of volumes or planes receding in space (Fig. 490).

Of the innumerable choices open to him for the creation of tonal order, Antonioni tends to utilize two types: the contrast of intense or bright tones against a neutral ground (Fig. 500) or the opposite (Fig. 497), and the contrast of values in an almost uniform field (Fig. 499). These methods of ordering space are appropriate to the themes of the film, but they are also vehicles for expressing them. The contrast of bright hues against neutral fields tends to suggest the isolation of the characters, as in the example already cited. The more intense fields of tone seem to engulf the characters like the environment in which they move. And the uniform field of tone minimizes the separation of planes in space, thereby emphasizing the two-dimensional composition and the nature of the lives portrayed.

516

Frequently, there is a sequential development reminiscent of Eisenstein's intellectual montage, from isolation through engulfment to uniformity. Over and over again Antonioni moves figures from settings sharply defined in saturated spectral hues (Fig. 498) to areas of uniform neutral tonality (Fig. 499), and finally obliterates them and everything in steam, mist, and shadow. Or he creates ambiguities in position, most obviously when he observes the ships that pass through the canals or beyond the windows, their massive hulks seeming to cross fields and enter rooms, de-

stroying the normal spatial relationships just as the evanescence and ambiguity of life are destroying Giuliana.

Yet, except in the scenes that take place in the gray street and the pink bedroom, nowhere is there a false note. Everything happens in a tonal context that is natural, reasonable, expected; no expressionist distortion of identity jars the viewer. Everywhere the tone describes the surface qualities of the physical world: the bright pink of a feathery flower; the leaden grass, leaves, and earth polluted with industrial waste; the frenzy of polychro-

517

matic patches on the walls of Giuliana's store; the sharp reds and greens and rough, splintering surfaces of the walls in the shack where the outing takes place. The insubstantiality of the mists and shadows that wrap the characters in articulate cotton wool shrouds and obliterate them in funereal darkness remind us repeatedly how they have lost contact with each other, with themselves, and with the flow of life.

For Antonioni, even the oil slicks, the broken timbers, and the sulphurous clouds—despite all the horrors they suggest—have their decorative appeal, although Antonioni's awareness of spatial and tonal harmonies, his perception of the beauty to be found in what is generally regarded as ugly, seldom results in conventionally pretty compositions. His visual structures are reminiscent of contemporary painting and sculpture, like the jagged piece of the bedframe in the climactic sequence (Fig. 508) that breaks up the screen like Pop Art decoration. The decorative quality in the end is not gratuitous; rather it acknowledges the seductiveness of all those aspects of Giuliana's world that she and we find abhorrent. Similarly, in the imaginary landscape Giuliana describes to her son, the anthropomorphic rocks that slide across the screen like fragments of petrified bodies—monumental bellies, buttocks, breasts, and penises—while they sing of some imagined state of grace, also insinuate an undercurrent of sexual turbulence that flows through Giuliana's psyche and the film. Even decorative qualities contain the ambiguities that beset Giuliana or for that matter the contemporary world.

Tonal sequences transport decoration into time. Shot by shot, beginning with the images under the main titles, Antonioni constructs the film as a series of continuously amplified tonal progressions, in each of which the overall tonality or the accentuated hues move from neutrals through blues and greens to yellow to orange to red and then to neutrals again. The progressions in hue are augmented by other progressions, from low intensity to high intensity to low intensity, from light to dark to light, and finally from low contrast to high contrast to low contrast. Thus, a rhythmic

pulsation of color chords, along with the rhythm of action, cutting, and events, subtly enhances the continuity, impelling the spectator through the filmic space and time, imposing an almost symphonic order on what might well seem an accumulation of unrelated incidents (Figs. 511–515).

Following the main titles, the first scene, which establishes the industrial milieu, is composed in neutrals with a slightly bluish tone. Giuliana enters wearing a green coat. She buys a sandwich and is seen eating it in a neutral blue landscape, while behind her the pulsating flame from a smokestack injects an insistent yellow. Shots of the waste-covered earth introduce a return to the neutral blue tones of the opening shots. Then, as Giuliana enters the factory, an intense red-orange appears. The conversation with Ugo and Corrado takes place in a tonal setting of greens, blues, and yellows, and then the full range of tones takes over when Giuliana leaves the factory. As the two men enter the factory yard, a red of very low intensity is introduced in the water tank, only to be obliterated in the final shot of the sequence by a cloud of steam expelled from one of the buildings. Thus, one tone after another is added until the full spectral palette appears (except for purple, which is scarcely alluded to in the film). Quite obviously, the progression of hues is not uninterrupted, but the basic scheme is clearly stated even though broken, in a kind of coloristic syncopation, by an occasional reprise of the palette characterizing an earlier shot. In addition to the progression in hues, progressions in value, intensity, and relative contrast are apparent.

The scheme of tonal progressions is, of course, not a rigidly formalistic one constructed on a strictly metrical basis. Tonal changes do not progress from a particular neutral to a particular red in regular intervals of time; rather, each is adjusted to both the specific dramatic context in which it appears and the overall structure of the film, which, preceded by an introduction and followed by a coda, develops in two major sections.

The film opens with a long out-of-focus pan over a factoryscape, which summarizes the coloristic themes in relatively neutralized

tones. The first major section begins with the strike sequence, reaches a major psychological and tonal climax in the outing at Max's shack, and culminates in the events associated with Giuliana's near death on the wharf. The tonal structure for this first section repeats on a larger scale and over a longer period of time the scheme utilized in the segments, scenes, and sequences, moving from the dominance of neutrals in the first (the strike scene) to a dominance of reds in the second (the outing) to the neutral tones enveloping the third (the near accident).

Each major revelation about Giuliana is accompanied by a significant use of red, but the red becomes increasingly intense or occupies more space as the section proceeds: Ugo's description of Giuliana's problems occurs in the factory yard in front of a tank painted a rusty red of very low intensity; Giuliana's revelations about herself to Corrado occur first in her shop, where there are pink splotches on the wall, then in a worker's apartment, then in the fields. The red assumes an ever more important role, until finally, in the sequence in Max's shack, the screen is filled with red. Once again similar progressions can be perceived in the light and dark values, the intensity, and the relative degree of contrast.

Antonioni's methods of controlling color are much more subtle than painting fruit gray, picking out settings and objects that conform to the demands of a particular shot or sequence, or making complete changes of costume and the like. When Corrado and Giuliana visit a workman's apartment, the man's wife greets them wearing an apron of intense red. When she returns from getting them a drink, she has removed her apron, a natural gesture of courtesy to her guests, but an opportunity also to return the dominant tonality of the scene to neutral. Over and over again, the position and proximity of the movements of camera or characters or both develop the tonal changes.

In the sequence in Max's shack, the opening shot frames a woman's legs, which are stretched out to warm by the fireplace (Fig. 492). Except for a bit of green skirt, the tonality is relatively neutral. The woman swivels her feet slightly and reveals glowing red coals, introducing the tonal theme—the red hue that ultimately will dominate the screen. As the party moves to the bedroom (Figs. 493–497), the shifts in position and the proximity of the camera illustrate the sense of inevitability in tonal change that Antonioni imposes on the film. A return to the main room reintroduces cooler neutral tones, while the gradual destruction of the partition effects a crescendo in red as the walls of the bedroom are increasingly revealed. By stationing characters in front of the window and by intercutting shots of the mist-drenched exterior, Antonioni again achieves a return to neutral, cool tonalities.

Finally, the party moves outside into the hue-suppressing mist (Fig. 499), and in the telephone booth at the end of the wharf where Giuliana's car has stopped, the red makes its last somewhat feeble sound (Fig. 500).

The moving camera and the moving figures come into play simultaneously in the long tracking shot that follows Giuliana's flight from Corrado's dark hotel and brings the film to its major climax in a dramatic recapitulation of the basic thematic development (Figs. 511–515). Giuliana rushes past a wall covered with torn and weathered posters whose faded tones recall the diffused spectral colors of the images under the main title, then past walls that seem dark blue and, in rapid succession, by windows and lights that are green and yellow, finally halting as Corrado catches up with her in front of a brilliant red window.

The sequence in Max's shack and the flight sequence—and, for that matter, the two major divisions of the film and the film as a whole—so obviously illustrate intensification of tonal impact that there seems to be no point in discussing this function further, except to point out the subtlety with which Antonioni increases the importance of red. In such scenes as the one in Corrado's hotel room (Figs. 501–510), he picks up first the low-intensity reds of the wood paneling, moves to the still low intensity (but more clearly defined reds) of a map of South America, then allows the red of the bedframe to play an ever more important role until it suddenly slices across the screen like a bloodstained knife (Fig. 508).

By this time, it must be abundantly clear that in the scheme of the film as a whole the red—as the title suggests—is a major theme, almost another character. The incidence of red and the intensifications of red parallel the rising tensions of the film, making the red in its insistent visual aggressiveness the dominant tonality. Yet neutral tones play an equally important role as a major subdominant, while the cool tones constitute a secondary subdominant that very often has the effect of reinforcing the saturation of the reds by simultaneous contrast. This occurs in the shots involving the woman in the green dress (Figs. 492, 494, 496), or in the shots of the bedframe, which is set against blue. Neutral and cool tones also develop a contrapuntal rhythm—sometimes accompanying the red, sometimes alternating with it—until in the scenes on the dock, warm, cool, and neutral, light and dark seem to balance one another, bringing the tonal development to a kind of resolution.

In the encounter in the hotel room, in Giuliana's flight, and occasionally elsewhere, the changes in visual tone parallel the nature of the physical action of the characters, the rate of cutting, and, of course, the dramatic content of the scenes. But this type of obvious parallelism is not employed throughout the film. Color acts in contrapuntal relationships as well: in the sequence in the shack, for example, the reds accompany relatively static, simply organized shots of rather long duration, while the rapid action and cutting of Giuliana's flight in the car takes place in neutral tones. We might account for the contrast in these two scenes by positing a need for verisimilitude and a necessity of maintaining an established pattern of color progressions, but a review of the film as a whole will make it clear that there is another explanation. The individual tones and coloristic chords are also metaphors for feelings, what Antonioni has called *il colore dei sentimenti*, the color of feelings.

What are the colors of feelings? It is a question many artists, critics, and theoreticians have occupied themselves with in modern times. While there is some agreement that warm tones produce positive, energetic, vital effects and cool tones negative, passive, melancholic effects, more precise, systematic definition of the expressive values of tone would be difficult to achieve, for the variations in hue, value, intensity, and contrast—as well as the combinations and permutations of these that might appear in a photograph or painting—are for all practical purposes infinite, just as the potential variations in feelings themselves are infinite. It would be fatuous to assign particular emotional responses to tones and combinations of tones with the expectation that they would have any validity, especially when as much depends on the context in which the tones appear as on any inherent quality.

A photograph of maples in autumn and a shot from the orgy sequence in *Red Desert* may both be loaded with red, and we may even speak of the landscape as presenting an orgy in red, but clearly we will be dealing with quite different contexts and therefore different meanings. Yet, in a general way, the red in *Red Desert* may suggest excitation, disturbance, and distress and may serve as a substitute for those virtually invisible changes in pulse, breathing, and other metabolic processes that accompany emotional changes. Similarly, the neutrals may suggest the debilitating effects of depression and despair. Almost as if in confirmation, the red in the bedroom of Max's shack reaches its most potent intensity and occupies the greatest space in a static shot in which Giuliana says, "I do not feel so warm, but I want to make love" (Fig. 497). But confirming words need not be present, and these seem primarily a clue to the next expansion of red on the screen, when Giuliana and Corrado recognize their desire for each other and in separate shots are seen motionless against red walls (Fig. 498).

Similarly, the sequence in Corrado's hotel room shifts constantly in tonality in response to Giuliana's steadily shifting moods (Figs. 503–509); she is now attracted, now repelled by what she is doing. When Corrado begins to assert his will, in an almost black-and-white shot he blots Giuliana out (Fig. 504). The red bedframe, in fact, is not simply a piece of furniture but simultaneously the color of Giuliana's agitation. And in a curious shot that seems a more deliberate search for *il colore dei*

sentimenti, the complexity of her feelings is suddenly and briefly projected in coloristic and spatial terms as the almost brutal red band of the bedframe is surrounded by a full spectrum of hues in soft, melting diffusion—tenderness and illusory dream contrasting with violence and reality.

Giuliana's flight from Corrado through the streets and down to the docks is a descent into hell (Figs. 516, 517). Blackness expands on the screen. The position, shape, surface, and identity of things all are lost in the uniform void, hinted at only through the points, needles, and planes of red and white that break the space into patterns as unintelligible as tongues of flame. Giuliana, too, is submerged in the blackness of the night, in the blackness of anguish and despair, when she moves erratically through an incoherent space as incomprehensible as the Turkish sailor's words.

Il colore dei sentimenti is also used to evoke feelings expressed earlier in the film. The red, which has played so many roles, assumes still another in the rosy glow that veils everything in Corrado's room after the lovemaking is completed (Fig. 510); it recalls the rosy rocks in the idyllic landscape of Giuliana's bedtime story. But the rosy warmth is an ironic illusion, for the bedroom was a red desert in the end, as sterile as the rocklike anatomies of the tale. The real place that was to have provided the setting for a rite of passage provided less sustenance than the landscape of her dream, making it a tonal premonition of the words she flings at Corrado later, "I hoped to regain reality through you, but you gave me nothing."

As has been implied earlier, tone as comment is difficult to isolate, but it does seem to occur in the *Red Desert*, not only in the scene we have just considered, but also in the final scene. Here a return to the general tonality of the opening shot—as well as a return to a comparable situation—while it lends a superficial sense of unity to the film, in the end seems to imply that nothing is really changed, nothing resolved, though Giuliana's words to her son, "They learn not to fly through the smoke," may seem to imply a resolution on one level—whether any other resolution has occurred is doubtful or at best ambiguous.

Even though *Red Desert* has been examined at some length, the complexities of structure and of content that it embodies have only been hinted at, and a shot-by-shot analysis would be required to suggest its full significance. What should be apparent is that, even stripped of its objective references, the film, on the level of feelings, would be as comprehensible as a film like *7362*.

7
Sound

Sound has been associated with film from the very beginning. In fact, according to the recollections of William Dickson, Thomas Edison's assistant, the first film he showed to Edison, in 1889 or shortly thereafter, was a talkie he called the *kinetophone*. From the mid-1890s to the early 1930s films were often exhibited in conjunction with recordings both in nickelodeons and in movie theaters. In the latter, the pianist or organist became a familiar fixture (Fig. 518), improvising musical accompaniments or weaving together stock pieces suggested by the distributors to reinforce or establish particular moods, intensify dramatic climaxes, or enhance the sense of continuity. Sometimes vaudeville orchestras provided the underscoring, and occasionally scores were compiled or written for a particular film. For the initial showings of D. W. Griffith's *The Birth of a Nation,* Joseph Carl Breil assembled a score for a seventy-piece orchestra, and for the German showing of Sergei Eisenstein's *Potemkin,* Edmund Meisel composed an original score for large orchestra. Primitive sound effects were often provided, and from time to time actors stood behind the screen to give voices to the players projected on it. But it was not until the advent of the optical sound track that filmmakers were able to manipulate sound with the same sophistication and discipline that were applied to the visual images.

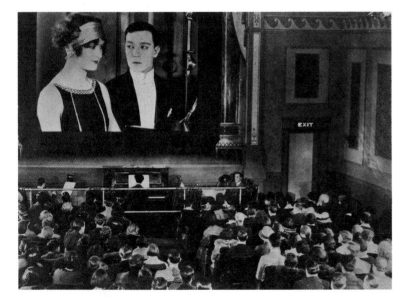

SOUND REPRODUCTION

Various methods of reproducing sound for film are available to filmmakers today. The most popular with professionals and advanced amateurs involves the use of the *optical sound track,* a continuously varying pattern of neutral tones recorded photographically on the edge of the film to serve as a light valve. Just as the valve of a water tap permits control over the amount of water flowing through a pipe, the sound track allows for control over the amount of light passing through the film to a photoelectric cell, which translates the light into electrical impulses. This in turn activates the magnets in headsets and speakers. The same kind of cell turns on streetlights when a certain minimal intensity of natural light is reached and translates light into mechanical action to open a garage door.

There are two types of optical sound tracks in common use, the *variable-density track* and the *variable-area track* (Figs. 519, 520). The former is arranged in striated patterns varying in value from black through gradations of gray to white; the latter carries ribbons of black and white that expand and contract in area. Whichever is used, the effect is the same. Sound can also be recorded on a magnetic track at the edge of the film or on a separate tape to be played simultaneously.

SYNCHRONIZATION

Whatever the medium of reproduction, sound is generally synchronized with the visuals; that is, it is related to the visual track in such a way that certain sounds are unalterably associated with certain images. Usually this is true but not always, for some experimental or personal films employ vinyl records, tapes, and even radios or other noisemaking instruments not meant to be synchronized but simply to fill the silence or generate a propulsion in sound simultaneous with the propulsion of the visuals. Such sound may not be directly related to the image or it may introduce chance rela-

518. In the silent screen era, a small pit orchestra often provided musical accompaniment.

tionships between sound and image that, by their accidental nature, can often operate with unexpected appropriateness. Sometimes the method of introducing sound allows for very little planning: the sound for Barbara Rubin's *Christmas on Earth* (1963) requires two radios tuned to different frequencies. When exhibiting films of this kind, the projectionist or an assistant may become a performing artist, varying the selection, volume, and tone spontaneously as the film unwinds.

While such adventitious and spontaneous relationships between sound and image may seem to be synchronized by definition—that is, presented simultaneously or synchronously—synchronization generally implies a fixed and relatively planned relationship between sound and image. In its most precise alignment, it allows for coherence between the movement of lips and the sound of the voice—called *lip-synch*—between any sound and its visible source, or between miscellaneous sounds like music and the general mood or climaxes in a film.

The invention of the optical sound track not only afforded the filmmaker a more precise control over the relationship between sound and image than had hitherto been available, but it also gave him the means for increased complexity and diversity of expression. From the first it was utilized to offer greater verisimilitude to the images. Even at its quietest, our world is, after all, full of sound, and when any of the noises that form the unattended background of our lives cease, we are often aware of their absence if not always certain about what is gone. In fact, so familiar are we with the presence of background noise that a completely dead passage in a film's sound track sometimes induces a vague disquietude in the spectator. For that reason filmmakers occasionally keep the track alive by introducing recordings of the room noises we scarcely notice.

In the early history of the sound film, the idea of transferring drama to film became a major end for many filmmakers, who abandoned the versatile vocabulary and grammar of movement and editing that had developed during the silent days, immobilized the camera, and choked the film with words. But other

left: 519. Variable-density sound track.
above: 520. Variable-area sound track.

filmmakers saw the possibility of exploiting sound with the same freedom and invention that had been used in constructing the visual track, making sound not simply a means of achieving realistic description, reinforcing drama, or enhancing the sense of continuity, but a more subtle and flexible extension of the filmmaker's expressive means.

SOURCES OF SOUND

Regardless of their ultimate position in the film, the sounds that make up the sound track, like the visual images, can be recorded at a variety of times and places. Some may be transcribed at the time of filming, some when the shooting has been completed, and others, like the visual stock shot, prior to the filming. The latter may have been recorded, perhaps for other films or other purposes entirely, and stored in record libraries, so that theoretically the whole range of known sound, familiar and unfamiliar, is available. Most of the sounds we hear in a film are common enough: the noises of the city or the country; the human voice in all its pitches, modulations, and intensities; and all the varieties of music, whether performed on conventional, exotic, or newly invented instruments. Sound can also be synthesized in a variety of ways, by scratching the sound track, punching holes in it, or drawing directly upon it. Norman McLaren used just such a technique for *Penpoint Percussion* (1951; Fig. 521).

521. For *Penpoint Percussion* Norman McLaren marked directly on both the film (as here) and the sound track.

Sound can be invented by modulating frequency oscillators or by combining familiar sounds in new ways to create what is generally called *concrete music*. Even the human voice can be distorted so inventively as to appear strange, unfamiliar, or even unidentifiable. Stan Brakhage's *Desistfilm* (1954) examines a teen-age party accompanied by atonal and arrhythmic humming that seems hardly to be associated with the human voice and produces an agonizing effect of disorientation. Tom Palazzolo's *O* (1968) is a miscellany of popular entertainments set to Luciano Berio's electronic composition, "Visage," which features a performance by Cathy Bergerian of seemingly unlimited virtuoso inventions of nonverbal and—by conventional standards—nonmusical sounds.[1]

MODIFICATION OF SOUND

Whatever its character or its source, raw sound, like the other elements of a film, can be manipulated to achieve particular expressive effects, the simplest and most familiar of which is the change in volume that allows for the aural equivalent of a visual fade-out and fade-in and may make the normally inaudible —like the pulse—audible. Sounds are changed in pitch, reversed, and excised, overtones added or subtracted, and the succession of sounds in the recording put in any order the filmmaker sees fit to establish. Some of these operations are familiar to anyone who has used a record player or a tape recorder; but others necessitate rerecording from the original tape, which is the standard practice in filmmaking.

The editing of tape, like the editing of film, implies cutting, and cutting into the original could make emendation and alteration impossible without a new recording. In order to facilitate editing, the sound is usually transferred to a sprocketed tape that is the same size as the film being used, so that the tape and the film can be kept in proper alignment in the editing machine to ensure accurate synchronization. Generally, the editor collects each type of sound on a different tape. There may be a tape for music, one for dialogue, another for miscellaneous sound effects, and in some cases more than one tape for any of these. Working from a *sync mark* on the visual track and a *sync tone* on the sound track, the editor splices the various sounds in proper order, inserting blank tape where the sound is not wanted and maintaining a precise alignment between sound and visual image.

Raw sounds, of course, need modulation, and an appropriate balance must be established among the various sounds: for example, the sound of an automobile, the background noises that surround it, the dialogue that takes place within it, and perhaps the sound of music as well. This is accomplished in the *mixing session*, in which the visual track and the various sound tracks are played together, the proper modulation and balance of sounds are established, and what was originally a miscellaneous collection of sounds is put into expressive order, ready for translation to the optical track. If everything has been done with care and expertise, words will seem to emanate from lips, the click of a door will sound at the proper moment, the percussive sounds of footsteps will coincide with the placement of the feet, music will swell and fade as the filmmaker imagined it, and all the artistic and technical strategies that lead to the optical track will impart to the film the expressive power of sound and of silence.

FUNCTIONS OF SOUND

As indicated earlier, the relationship of sound or sounds to the visual images might be thought of as simultaneous or vertical montage, as the addition of notes to a filmic chord written on a horizontal staff representing time. If, in this respect, sound resembles color, it is also like color in the way it functions; thus, it will be convenient to consider sound in much the same way we have considered color.

Articulation of Space

Generally, we do not think of sound as a means of articulating space, although we operate on the assumption that it does so whenever we measure distance or establish position by it, as with an automobile in the street, an airplane in the sky, a voice in a room, or footsteps overtaking us on the sidewalk. Distance, position, direction of movement, openness, and closure manifest themselves directly through sound—distance primarily through the relative volume, position and direction of movement through the relative volume in the separate ears, openness by fullness and naturalness of tone, and closure by echo. All of these aural expressions of space have been given greater precision in film by the introduction of stereophonic equipment, which has become especially important in wide-screen projection and in some circumstances would allow us to close our eyes and still be aware of the position of speakers, the movement of characters, and even at times the general character of the space in which they operate.

The spatial implications of voices and natural sounds are familiar enough, as are the sounds of music emanating from a source within the picture space, but *background music*—that is, music that does not emerge from the action of the film but provides an abstract accompaniment to it—may also suggest spatial ideas in certain contexts. High, thin, brittle, clear sounds seem to parallel our ideas about high altitudes, as if they somehow contained the thinness and coolness of the atmosphere and the clarity of vision, or as if they were simply associated with the idea of high as opposed to low notes on a scale. Similarly,

low, muffled, indistinct sounds are often associated with subsurface depths—caves, mines, cellars, underwater scenes, and the like and perhaps, again, with position on a scale.

No more than in the case of color are the associations fixed, although they do sometimes seem automatically intuited, as Eisenstein has suggested in his description of Sergei Prokofiev's score for *Alexander Nevsky.* Apparently with no conscious intention of doing so, Prokofiev developed a melodic line that in some sections of the film at least follows in its rise and fall the basic lines of the spatial configurations of shots with which it is associated, thus reinforcing the visual pattern by the aural pattern and providing a kind of audible description of space.

Like visual configurations in space, sounds that articulate space may express emotional, symbolic, or intellectual connotations, whether because of their inherent character, their association with familiar experience, or the content of the visual images. The specific implications, of course, always vary with the particular context. In Orson Welles' *Citizen Kane,* the reporter assigned to discover the significance of Kane's last word visits a library memorializing Kane's guardian. As he is admitted through a heavy metal grille and led down a corridor to a librarian, the sound of his leather heels on the stone and the long echoes that follow not only reinforce the sense of imposing monumental scale, but also suggest the building's emptiness, its forbidding formality, its mausoleumlike pretentiousness, and, perhaps, by extension, some of the same qualities in the librarian. The footsteps seem to say that it is a cold and austere place that nobody ever visits, which would be less apparent if the reporter wore tennis shoes.

Description

In its simplest manifestation, descriptive sound duplicates or approximates the sounds normally associated with particular things, actions, or milieus. The sound track of Edgar Anstey's *Granton Trawler* (1934; Figs. 522, 523) is composed almost entirely of natural sounds identified in the action: the quiet, regular chugging of the engines as the boat slowly

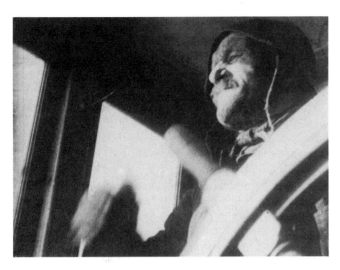

522. *Granton Trawler*. Edgar Anstey. Great Britain, 1934.
The steady chugging of the boat's engines is heard as the captain steers away from the wharf.

523. *Granton Trawler*. Edgar Anstey. Great Britain, 1934.
A fisherman prepares the trawl amid the sound of the wind.

moves away from the wharf, the wash of water and slap of waves, the rush of wind, the creaking of ropes, clanking of chains, clapping of blocks, crying of gulls, and the voices of men. The only abstract or synthetic sound is provided by the thin tones of a mouth organ, which we never see. The description is quite full, and the sounds we hear are those we would expect to hear were we on the boat itself, but in fact the sound track at any one moment may be highly selective, so that the sound of the engines or the waves or the wind

will for a time fade from our hearing. Once a particular sound is established, however, it becomes so much a part of the milieu that we may not notice its absence or rather assume its presence, much as we assume the presence of the harmonica player once he has been heard, even though he may not be seen. In short, the description need not be complete to seem realistic and need not present the actual sounds associated with things and activities at all.

Just as synthetic sounds, abstract sounds, and music evoke ideas about space, so too may they imitate natural sound. The ripping of cloth can be accompanied by the sound of a ratchet, the shimmering of an ornamental glass chandelier by the tinkling of bells, smooth-textured surfaces by extended mellifluous tones, the dripping of water by a plucked string. Some associations between synthetic sound and image have been used so frequently that they have becomes clichés, like the full symphony orchestra—with all its suggestion of density, mass, and power—in repeated crescendos accompanying the crashing of waves. In principle, on an abstract or conceptual level, certain qualities of sound may be identical with qualities of physical materials or of actions; for example, smoothness implies unbroken continuity, which may exist either in space or in sound. Synthetic sound may thus isolate a quality for emphasis and therefore be more effective in a particular context than natural sound.

Decoration

Whatever other function it performs, almost any sound track can decorate or embellish the film by lending audible sensuous delight to the visuals and providing a feast for the ears. In its most obvious usage, decorative sound often accompanies banal travelogues that sometimes fill out the bill in movie houses. The music, although selected to evoke a particular place—"Song of the Islands" for Hawaii, for example—or a particular activity—"Camptown Races" for a scene at the racetrack—and although it may provide a rhythmic propulsion lacking in the action and the cutting, seems mainly to provide sensuous activity for

the ear. As nature abhors a vacuum, the reasoning goes, the human ear abhors silence. Decorative sound becomes a *raison d'être* in musical comedy, of course, with the forward thrust of the narrative halted from time to time to allow soloists, chorus, and dancers to perform.

A more sophisticated use of decorative sound is found in János Vádasz' *Ouverture* (1965), a delightful short film that turns microscopic views of biological processes into abstract art (Fig. 524). The lens discovers a chicken egg, moves forward to penetrate the shell, observes the evolution of the chick, and then withdraws to the exterior to watch the fully formed chick open the shell. The inherent fascination of the subject matter is reinforced by witty and climactic editing that transforms the activity into something not unlike an acrobatic vaudeville turn. There are provocative and instructive relationships between the rhythms of the sound track and the rhythms of the visuals, which sometimes coalesce, sometimes advance, and sometimes retreat with respect to one another. But the music is Beethoven's *Egmont Overture,* and it is difficult not to think that the filmmaker was intrigued by the implications of the words overture and *ouverture* (meaning opening, beginning) and also Eg(-)mont. While another composition might have provided an equally fitting accompaniment to the action, the filmmaker may have selected this solemn music to suggest the solemnity of the beginning of life.

While the examples cited have involved music, aural decoration is not limited to that. Nonmusical sound can have its own sensuous appeal—the whine of a racing car, the clop of hooves on cobblestones, the rustle of skirts. But the decorative use of sound implies conscious and deliberate selection, isolation, emphasis, and ordering, so that the sound is apprehended as something more than the normal accompaniment to an act or milieu or, in dialogue, the normal pattern of speech. In Ingmar Bergman's *A Lesson in Love* and *Brink of Life* (1957), the Swedish actress Eva Dahlbeck exercises a mastery over rhythm, pitch, and pause that, without any artificiality, seems to transform speech into song. Sounds of ordinary speech can be orchestrated—as in the

524. Ouverture. János Vádasz. Hungary, 1965.

overlapping voices of telephone operators and tea merchants in Basil Wright's *The Song of Ceylon* (1934). "Wild" sounds can be built into complex sound montages like those Orson Welles consistently employed in *Citizen Kane.* Even the sound of *Granton Trawler,* descriptive and unpretentious as it is, has a modest decorative appeal in its groupings of sounds, which almost resemble concrete music. In short, it is when the sound has aesthetic integrity apart from its space-articulating or descriptive functions that we can think of it as decorative.

Continuity

The use of musical accompaniment in the days of the silent film was calculated to establish and parallel mood, to support dramatic intensification, to reinforce climaxes, to substitute for sound effects, but, in large part, to enhance the sense of continuity in the visual track by maintaining a continuity in sound. Anyone who has watched a film projected first in silence and then with piano accompaniment will recall that the continuity seemed smoother and the cutting less abrupt when viewed with music, as if aural stimulus somehow synesthetically produced optical response, and the sound of music reduced the visual shock of the cut. Sound has continued to smooth transitions ever since; a comparison

between the sound track and the visual track of the "Diving Sequence" or *Ouverture* makes this readily apparent.

Continuity of the sound track involves something more than creating an aural linkage from shot to shot—as, in all probability, did the continuity of the piano, the organ player, or the pit orchestra. For the rhythmic ordering of sounds lends its own impulse to the film: the drip of water, the beat of the heart, the pulse of the engine, the patterns of speech, the synthesized sounds of music carry the spectator along in varying rates of celerity, sometimes accentuating the rhythm of the visuals, sometimes establishing counterrhythms, sometimes carrying the forward thrust of the film almost entirely and imparting an order the visual track itself may not possess. Thus momentarily and without thinking we may attribute to the visuals a quality of excitement or of unity residing only in the sound. Carefully integrated with the picture and extending the force of the visuals into another dimension, sound can give support to the pulse of the action, varying its meter while holding its beat, investing it with particular emphasis, expanding its import with gross distortions or subtle shadings. When most completely integrated, the sound—whether it is speech, sound effects, or music—will not simply further naturalistic description or, in the case of music, carry on in the background of the spectator's attention but will be united with the picture to form an organic whole in which both elements are indispensible.

The coincidence of visual and aural rhythms can be carried to a point at which the relationships seem mechanical and forced, however, as when the rhythms of action and of music are absolutely matched or synchronized. This effect appears frequently in some of the earlier animated cartoons, from which this method acquired its descriptive term "Mickey Mousing." While such relationships can be used to advantage, especially for comic effects or for reinforcing climaxes, they tend to seem banal and monotonous when carried through the length of a piece.

A more sophisticated integration of sound and image is exemplified in René Clair's *Le Million*, a scene from which we considered in Chapter 1 (Figs. 7, 8). Clair's work acknowledged the mutual interdependence of aural and visual and imaginatively developed the expressive potentialities of the sound-visual chord. The film is a musical comedy, and at no point does Clair permit naturalism to compromise the fantasy. The story is improbable; the characters are all attractive—even the members of the band of thieves who help to resolve the conflict are lovable and benevolent; the settings are frankly sets, sometimes complete with painted backdrops and scrims, although we are never under the impression we are watching a filmed theatrical piece. The acting is stylized, almost choreographic, and the construction is full of witty and elegant relationships between one element of the filmic chord and another, with the continuity established not simply by the plot line but by the interaction of movement, visual pattern, and sound (Fig. 525).

In *Le Million* sound does not simply parallel or reinforce the action; rather, sound and action participate in the same rhythmic development. For example, the opening scene of the narrative introduces the lovers—a young painter and his girl friend, who is a piano student—and establishes the impecunious condition of the young man. It is constructed as a frustrated seduction and ends, as we might expect, in a quarrel. Much of the scene is developed in a sequence of action, natural sound, and dialogue that seems almost metrically composed: the young man leans forward to kiss the young woman (action), someone pounds at the door (natural sound), and a verbal exchange takes place through the door (dialogue). The same sequence recurs again and again as the young man's creditors try to collect what is owing them. Later on, the young man is seen sitting immobile, contemplating the fact that he has tricked his best friend into taking his place in jail. As an interior monologue a voice sings, "Michel, what have you done?" and in the same meter the young man sighs with his whole body. Again the sound track and the action participate in one rhythm, as the burden of continuity is carried alternately by sound and by visual.

As these examples suggest, the same principles that operate in the establishment of visual

525. *Le Million*. René Clair. France, 1931.
Lovers are caught by chance on an opera stage.

continuity apply in the use of sound. Only the terms are different. Likeness in one aspect or another of the sound reinforces the sense of continuity, such as likeness in tone, overtone, pitch, key, volume, or rhythmic pattern. Rouben Mamoulian's *City Streets* (1931) provides an amusing example of aural continuity emerging from a general similarity in the character of the sound effects, rhythmically ordered to move the narrative quickly from place to place and economically planned to establish the milieu. The opening sequence is developed visually in a montage of circular ideas. It begins with a shot of the circular ends of beer barrels on a truck, cuts to wheels of the truck, to the mouths of vats in a brewery, to an assemblage of bootleggers, to the roughly circular hat of a gangster who pays off some racketeers, to a shot of the hat in the water, to cars going along the highway to a city. The sound emerges from the action depicted—the sound of the trucks, of beer bubbling in the vats, of water, of the car, all sounds that are more or less middle in pitch and unbroken by sharp rhythmic accents. By virtue of their continuous extention, the sounds are as similar to one another as the specific forms that carry out the circular motif in the visual portion of the film.

Methods of transition similar to those employed for the visual track can be used in sound as well and with much the same effect. These include the abrupt cut, the fade, and the dissolve. As with the direct imitation of visual rhythms by sound rhythms—and vice versa—such transitional devices may coincide with the effect in the visual: sound may be cut or may fade or dissolve with the visual cut, fade, or dissolve. But as a rule, sophisticated filmmakers will take advantage of the fact that they are using two tracks and, while maintaining a relationship between them, develop each freely so that they reinforce each other in a more subtle way.

As in the meditation sequence in *Le Million*, a shot in which the visual is relatively static might be accompanied by a sound that will carry the film forward on a more rapid beat than the cutting. Or transitions from one sequence to another may be accompanied by a sound bridge or *segue*, in which the sound will be carried over a visual cut, fade, or dissolve, not simply to link one sequence with another, but to urge it forward. Such a bridge may carry the sound of the first sequence into the second or initiate the second before the first has ended, a method frequently used by Josef von Sternberg in *The Blue Angel* (1930) and

The Devil Is a Woman (1935). In the latter, the transition from a quiet dialogue to a noisy crowd scene introduces the sounds of the crowd before the dialogue has ended. The device therefore functions not merely as a means of attaining formal continuity, but also to clarify the narrative, for it expresses in the first scene an idea that the second scene illustrates visually.

The discussions of *Potemkin* and *Ivan the Terrible* considered how particular geometric motifs were used not simply to provide continuity from shot to shot, scene to scene, and sequence to sequence, but also to provide a sense of relatedness among the larger segments of the films and throughout the films as a whole. The recurrence of a particular sound or quality of sounds operates in much the same way as the repetition of visual motifs—the recurrence of racing car sounds in John Frankenheimer's *Grand Prix* (1966), for example, or the limitation of dialogue to children's voices in Phil Lerner's *My Own Yard to Play In* (1959).

The most familiar example of this sort of thing is the repetition of a musical theme. Nino Rota's masterful musical score for Fellini's *La Dolce Vita*[2] beautifully demonstrates how subtly music can be manipulated. Not only is the theme repeated in an astonishing variety of musical contexts, but also preexisting musical materials are adjusted to the theme so that a sense of unity prevails among greatly contrasting musical settings. The theme appears in a wide variety of musical textures and accents, initially with full orchestra, sometimes with solo violin, celesta, organ, piano, horn, or saxophone. At times it makes a straightforward statement, at other times it occurs with overtones of different styles—the blues, Neopolitan, Latin American, Roman oriental, vaudeville-pit orchestra, popular ragtime, cocktail piano, medieval nouveau, Renaissance revival—each variation characterizing the situation and very often commenting on the characters. The conglomeration seems to characterize the city of Rome itself, with its palimpsest of history and agglomeration of races and nationalities.

The theme is a motive constructed on an ascending triad, usually played *legato*, followed by a related motive, a series of repeated notes followed by a turn, and a restatement of the triad, usually played *staccato*. Over and over the other musical material is initiated by phrases comparable to the original triad in some variation or other, whether in Rota's own work, like "Cadillac," or in the work of others, like "Patricia" or "Stormy Weather." The second motive is heard in the nightclub at the Baths of Caracalla, but also in the song "Jingle Bells." Repeatedly a number that begins as one thing, like "The Entrance of the Gladiators," will, with easy elision, slip into the title theme. The theme thus becomes a tonal center around which the other music is made to revolve. Although one piece of music does not necessarily evolve directly out of another, and the particular parts are often adjusted to the context in which they are heard or are separated by silence, dialogue, and natural sound, nevertheless a subtle relationship is established among the musical numbers, and the sense of continuity is enhanced. While it performs many specific functions in varying contexts, the theme serves as a ruminative expression of an aimless wandering interrupted by flurries of activity. As such, it is appropriate to the portrayal of the central figure, a man who has not found himself.

Intensification

The sound track may carry much of the burden, if not the entire burden, of dramatic intensification. Of course, this can occur through the literal content of the narration and dialogue or the descriptive content of action that involves sound. Ingmar Bergman's moving film *The Passion of Anna* (1969) frequently shows its characters delivering long, introspective monologues during which the face fills the screen and the only movement is in the lips and the fleeting, almost imperceptible changes of expression. The voices are subtly modulated and, though the content of the speech may be intensely, even violently emotional, dramatic interpretation is suppressed. Intensification occurs in the meaning of the words—and the events and feelings they describe—rather than in the way they are read, as if Bergman, like Godard in *My Life to Live*, were exploring the

cinematic potency of the word itself. In such passages the sound track becomes primarily a vehicle for conveying the word.

Generally, of course, we are concerned not only with the meaning of words, the identification of natural sounds, and the presence of music, but with their tone, pitch, timbre, volume, continuousness or discontinuousness, and the way in which they are ordered in relatively simple or complex patterns of changing accent or meter, gathering force and discharging it. Even so simple a descriptive document as *Granton Trawler*, with its catalogue of sounds associated with fishing, presents the sound in a progressive order of complexity and intensity, moving from the slow, measured beat of the engine at the beginning to the more complex, continuous, violent ragings of the storm, which may be regarded as the climax of the sound track. Music operates in the same way; the final passages of the "Diving Sequence" (Figs. 246–272) build a powerful crescendo that transforms the simple exhibition of diving into heroic epic.

Intensification may occur in progressive change; it may also occur through simple repetition, as exemplified by *My Own Yard to Play In,* in which the expressive burden is carried almost solely by the reiteration of a single phrase—the title—at the very end. In each instance intensification is the product of contrast, even in the last, when the repetition of the phrase is in direct contrast to the natural flow of language and street noise that preceded it. Contrast can be equally expressive if the progression leads to relative quiet, as in the fighting scene in *Frustration* (Figs. 60–68). The sound of the orchestra dies out raggedly, giving way to murmurs of apprehension and curiosity in the crowd, which in turn yield to the more selective sounds of the fight, and then to silence punctuated by breathing, the silence concentrating attention on the confrontation. The pattern is then reversed as the captain makes his escape: he clatters over the apron of the stage and through the curtain; the performers rush away screaming and chattering; the captain thuds up the stairs in the rush of noise and enters the dressing room of his mistress, announced by the loud cacophony of a pail he has stumbled over as he enters. Then

there is silence again, this time underlining the comic side of the situation, as the captain sits sprawled against the door, grinning (Fig. 68).

Metaphor

Like the visual image as a whole and like color, sound can be used metaphorically, as many of the examples we have already cited indicate. The comparison of the tussle on the opera stage to the rugby game in *Le Million* (Figs. 7, 8) or the musical styles of *La Dolce Vita* suggest not only general ideas about social milieu, the historical moment, and the geographical location, but more specific associations as well. In the latter film, for example, the variation called "Notturno e mattutino" ("Night and Morning") is introduced when nobles, socialites, artists, writers, starlets, and hangers-on, after carousing all night, wander into the palace garden in the early morning light to confront the head of the family, the old principessa, and a priest making their way to a chapel. Through the Renaissance overtones of the music and its vaguely ecclesiastical character, the memory of religious tradition penetrates the revelry, and with it there is a momentary sense of nostalgia for an ancient faith that, even if moribund, somehow survives in the present. When, after an orgy at a seaside villa, the guests make their way into the dawn, the variation becomes melancholy and mysterious, bringing with it all the regret, fatigue, boredom, and emptiness the characters feel and preparing the way for the discovery of a strange monster on the beach.

As we are well aware, there are sounds as well as colors for feelings. Thus in *Frustration,* the island music that acts as a recurrent theme becomes a metaphor for the romantic dreams of the aging captain who is going blind and plans to leave his wife and his business and escape to a more paradisaic life.

Evocation

The island theme of *Frustration* operates in a variety of ways; it evokes images of the South Seas but also, within the development of the film, recalls earlier passages, sometimes for dramatic, pathetic, or ironic effect. The fight

526. *Scorpio Rising.* Kenneth Anger. U.S.A., 1963.

in the theater, to which we have referred so often, simply introduces the captain and his mistress to the viewer. The central conflict is between the captain and his son, whom the captain despises because he is a hunchback. After telling Sally, his mistress, of his own physical condition and his plans, the captain takes her back to the barge on which he, his wife, and his son live. Sally and the son fall in love. The father attempts to kill the son and, when the attempt fails, the captain flees to his apartment in town, where he is pursued and commits suicide by jumping from a window. After a long interval during which the son has been at sea, he and Sally get married and sail off, presumably to the Indies or at least to the earthly paradise that the Indies have come to signify.

The musical theme recurs frequently, but if its recurrence enhances the formal unity of the film, it has a more positive role to play in the development of the narration. It is first heard under the titles simply as a musical theme carrying an indefinite association with the original title, but is repeated so frequently as to establish it in the listener's mind as an almost geographical sign. It also prepares the listener to recognize the implications of the variations. The theme does not recur for some time. When it does, it is in its most important association: the captain is informing Sally of his love for the Indies and his desire to go there. Each subsequent reference provides an

evocation of this moment. The theme returns when the son and Sally make an excursion to a windmill near the barge, where they come to learn about one another and to recognize their love. The music now recalls the captain and metaphorically transforms the excursion into an escape from past and present like the escape the captain has planned.

After the captain has fled to his apartment and in a rage of frustration and blindness has destroyed all the symbols of the islands that meant so much to him, he sits silent in defeat. The theme then returns to contrast his present despair with his earlier hopes. And when, at the end of the film, the son and Sally board the ship, the theme recurs, creating a musical parenthesis for the narration. It recalls the major moments in the film, suggests the figurative and perhaps literal destination of the couple, and underlines the fact that the son has supplanted the father. Perhaps it even implies that good has triumphed over evil or, at least, unselfishness over selfishness. From all this it would seem that the musical theme in *Frustration* operates a little like a flashback, although it is not specifically recreating an earlier event. A true sound flashback occurs in Mamoulian's *City Streets*, when the heroine, in jail, is thinking of her lover and we hear a previous conversation between the two.

Comment

The sound track obviously lends itself to direct verbal comment; probably we think at once of the voice-over narration typical of instructional or documentary films. But voice-over narration is a familiar enough device in film plays as well, sometimes in the analytical reflections of an observer somewhat removed from the events, like the boy-grown-up in *The Mischief Makers*, sometimes in ruminations of one of the main characters, like Diego in Alain Resnais' *La Guerre est finie (The War is Over;* 1966), who often reveals in interior monologue things that are hidden in his face and behavior. In both these films the narrator maintains a distance, speaking as if the audience were not present. But in a film like Sacha Guitry's *Lovers and Thieves* (1957), the narrator may address the audience directly, making

outrageous comments on the action, much as the narrator of a documentary might.

Voice-over narration and music merge, in a sense, in Kenneth Anger's *Scorpio Rising* (1963). Setting aside the astrological references signaled in the title, which undoubtedly enrich the metaphorical connotations but may well seem arcane for all but initiates, we can read the film as a poetic documentary studying the psychology of motorcycle gang members. The film isolates the childlike nature of an intense involvement with machines, the erotic implications of the motorcycles, leather costumes, and accouterments (Fig. 526), the homosexual overtones, the worship of the leader-hero, the pervasive hint of violence that links all the elements together, the ribald games and obscene ceremonies, the drugs, the scrambles, all leading ultimately to death.

The film opens with a shot of a windup toy motorcycle, proceeds to shots of young men tinkering with their machines, invents a quasi-ceremonial investiture in motorcycle regalia, and goes on to a Walpurgis orgy in drag, a Neo-Nazi desecration of a church, a scramble, and the death of the hero. The visuals focus on the action and the paraphernalia of tribal life, introducing material from comic strips, television, and movies. All of this reinforces the characterization and makes provocative comparison between Scorpio and Johnny from Laslo Benedek's *The Wild One* (1954), as well as James Dean, Adolf Hitler, and Jesus Christ, treating the orgy as a parody of the Last Supper and the raid on the church as a black mass.

The sound track enhances the implications of the visuals, utilizing words from pop tunes and having the music itself function as a commentary that—depending on the orientation of the spectator—will seem camp or ironic, realistic or outrageous, objective or blasphemous. As the camera watches a young man working on a motorcycle and its parts, Ricky Nelson sings "Windup Dolly," the combination of visual image and sound suggesting both the childlike involvement of the rider and the erotic symbolism of the bike. When the riders don their regalia, Bobby Vinton sings "She Wore Blue Velvet," and when the camera observes a televised movie of Christ and his disciples, Ray Charles sings "Follow Him."

Similarly, in Dennis Hopper's *Easy Rider* (1969), when Captain America and Billy, after all their adventures, finally arrive in New Orleans and dine on bread and wine, the sound track swells with the "Kyrie Eleison." The filmmaker thus comments on similarities he finds between Captain America and Jesus and between the dinner and the Last Supper.

A more significant use of religious music for commentary is to be found in *La Divina*, made by John O'Conner in 1969. To the sounds of Handel's "Messiah" we observe unidentifiable shapes and movements, gleaming crystalline forms, airy mists, and jetting waters making patterns somehow reminiscent of Gustave Doré's illustrations for Dante's *Divine Comedy*, as well as childhood fantasies of heaven and hell. Gradually, the shapes and materials are revealed to be an automobile going through an automatic carwash. The music suggests that the machine has become an object of religious devotion, that the automobile has been transformed into divinity, an ironic comment on the values of our society and our times.

Parallelism

Like parallel color, parallel sound imitates, reinforces, or intensifies the visual or dramatic content and the formal rhythms of a film. Several films we have considered earlier provide instructive illustrations of parallelism in sound. The sound track Teiji Ito provided for *Meshes of the Afternoon*, with its reedy halftones and its wooden percussion, parallels the mood of eerie mystery and reinforces the climactic moments. Though its long-drawn-out notes and sharp rappings often contrast with the rhythm of action and cutting, they augment the sense of disorientation. The "Diving Sequence" provides another example, at once more familiar in its orchestration and more complex in its application. Initially, the music imitates the action of the dives, changing according to whether the dive is a swan or a tuck, for example; then toward the end it parallels in its tempo, rhythm, accent, and chordal progressions the boldness of the contrasty visual patterns and the accelerating eliptical cutting. Gaining in volume and fullness, it re-

inforces the sense of almost preternatural grandeur as the climax of the sequence is reached (Figs. 270–272). When the lovers row to the lighthouse in *Frustration*, the Indies theme, without coinciding with the metrical pattern of the dipping oars, parallels the gliding motion of the boat and metaphorically the romantic illusion of escape.

But parallelism is not found only in music. In Mamoulian's *City Streets*, the Kid (Gary Cooper) visits his girl Nan (Sylvia Sidney) in prison. At the end of his visit he informs her that he has joined a bootlegging mob. Her shocked response is accompanied by the shrill vibration of a bell announcing that visiting hours are over, the sound paralleling her feelings and bringing the quiet rhythms established by the previous conversation to a disquieting climax.

In all these examples it is apparent that parallel sound supports and makes explicit the content of the visual images. It can be developed to a point where it seems forced, however, as in the paralleling of visual and aural rhythms earlier referred to as Mickey Mousing. Pare Lorentz's *The River* (1937), a poetic documentary that traces the Mississippi from mountain springs to the sea—historically important and impressive as it is—suffers from the correspondence of image, music, and narration. The music tinkles, bubbles, and swells as does the free-verse narration, "poetically"

declaimed in oily, orotund, portentous tones. The combination ultimately becomes cloying, choked on its own richness.

However much parallel sound may embellish, reinforce, and explicate the visuals, it does not radically alter their significance, not in its purely aural character, at least. No matter how they are sounded, words, quite obviously, can in their intellectual content completely transform the significance of the visual image, but in this instance it is the ideas not the sound that work the transformation. When the announcement of the development of the sound film reached Russia, Sergei Eisenstein, Vsevolod Pudovkin, and Lev Kuleshov published a statement suggesting that the most important area of investigation would be the use of contrapuntal sound, an idea that clearly conforms to montage theory in its emphasis on conflict and contrast. Certainly the most provocative use of sound seems to have been developed in sound counterpoint.

Counterpoint

Contrapuntal sound allows for a greater expansion of the filmic statement, for the expression of more complex ideas and feelings, and for the introduction of tones and overtones that the visuals may not convey. It permits the introduction of infinitely varying and subtle shades of meaning, and, in the simple contrast of aural and visual rhythms and accents, it augments the filmic tension. Even the simplest contrast between sound and visual image will have at least the minimal effect of making one the foil for the other and thereby of heightening the effect of the other. A simple but suggestive example is found in the National Film Board of Canada's film entitled *Wrestling* (1961), which examines both the performers and the crowd at a match in Montreal. The massiveness of the figures, the violence of the action—at times the slow motion literally tames it and figuratively intensifies it—the agitation of the spectators, the harsh contrast of the ring lights, and the dramatic energy of the close-ups and camera angles, all coalesce in an image of suppressed human brutality that is released either directly or vicariously at the event. But instead of the

527. *My Life to Live.* Jean-Luc Godard. France, 1962.

528. *The Passion of Anna.* Ingmar Bergman. Sweden, 1969.
While the gaping mouth and staring eyes suggest that Anna is screaming, no sound is actually heard.

shuffling of shoes on the mat, the thud of bodies, the grunts and groans of the combatants, the shouts of the crowd, and all the anticipated attendent noises, the sound track unrolls the light, gracious, elegant notes and rhythms of a Bach-Vivaldi *allegro.*

If the simultaneous presentation of two such disparate collections of ideas and forms has the immediate effect of comedy, the inherent incongruity also intensifies the sense of brutality and violence in wrestlers and spectators alike. Somewhat less directly it suggests the notion that wrestling is an art form rather than a sport and that its social function is the sublimation of violence.

In Godard's *My Life to Live,* a similar but much more subtle contrast is presented in a sequence in which a pimp describes the life of a prostitute to Nana, the central figure. They are driving along the streets and boulevards of Paris, and while there are flash forward shots of Nana's future life (Fig. 527), during most of the sequence the camera watches the center of the city as seen from the car—the Champs Élysées, the Place de la Concorde, the Jardins des Tuileries. The soft, diffuse, evening light combined with the glow of streetlamps, all the lustrous patterns of light and dark, have a sensuous appeal that makes the center of Paris so attractive. But the pimp recites his pitch in a flat, unmodulated voice as if reading from a police report, providing a statistical description of prostitution, the number of people involved, the financial arrangements, the methods of operation. The arid monotone of his long recitative contrasts with the seductive and changing visual patterns, laying bare the methodical operation of vice behind the glamorous façade of the city and transforming the romantic excitements of love, and the dangers and degradations of prostitution as well, into a routine matter.

Silence, too, can act in counterpoint. A shattering example occurs in Bergman's *The Passion of Anna,* when Anna, suddenly overwhelmed by the horrors of her existence,

screams like a wounded animal, over and over, body rigid, face contorted, mouth gaping (Fig. 528). But no sound is heard, and the shock of silence tells more of her anguish than the most searing scream could possibly reveal. The effect is intensified by the fact that she screams silently into a void from which there will come no answer, not even an echo.

INTERNAL AND EXTERNAL, SYNCHRONOUS AND ASYNCHRONOUS SOUND

In the preceding sections we have discovered sound to be operating within the filmic chord in much the same way color does. It can simplify the content, amplify it, increase its complexity, reinforce the structure, take an independent course; but generally it enriches the filmic statement and increases the flexibility of the medium. Color, however, constitutes an integral part of the visual image as it appears on the screen, whereas sound functions as a separable element that may be related to the visual image in quite distinct ways. It can emerge from the space or action described in the visuals, as when we hear and see a person walking, a dog barking, trees rustling, waves breaking, trains rolling. In this case we can think of the sound as *internal.*

Conversely, it may have its source completely outside the space described by the visuals, as in background music or in the words of a person not participating in the action—a narrator describing a documentary, for example. In this case we think of the sound as *external*.

In early experiments with sound, filmmakers like René Clair and Rouben Mamoulian sometimes played with the sound track in such a way as to deliberately confuse the audience about the source of the sound, introducing what seems like background music and then, after a time, surprising the spectator by revealing a source of that sound within the narrative space, as if mocking the more conventional use of musical accompaniment. The opening of René Clair's *Sous les toits de Paris (Under the Roofs of Paris;* 1930) initiates a long exploration of a section of the city. It is accompanied by the title song, which seems initially to be background music, then seems to be sung by a young woman leaning from a window, and then is revealed to be emanating from a phonograph. Similarly, *Le Million* opens with a view of rooftops and chimney pots accompanied by orchestra and chorus. As the camera peers through a studio skylight, it reveals performers singing and dancing at a party. In *City Streets*, Rouben Mamoulian does something very similar, introducing the music and then revealing its source as a radio. In contrast, the theme music in Bergman's *Frustration* is clearly external: we see no orchestra playing, no character singing, and although it may indeed suggest what is going through the minds of the various characters, one is quite aware that it is not the music they are thinking of but the thoughts suggested by the music.

All these examples may seem to imply an inherent ambiguity about the role or the aesthetic locus of the music. Is it, in these instances, external until the source is identified, internal after it has been perceived? In a filmed conversation, when the attention shifts from the speaker to the listener in either a cut or a movement of the camera, does the sound shift as well from external to internal? If we keep in mind that filmic space is not simply the space described by the lens of a stationary camera but the space described by a camera in motion or by separate shots arranged in a

series as well, the problem does not arise. Thus in *Granton Trawler*, when we hear the music of the harmonica, we do not always see the player, but the sound, once it has been associated with him, always establishes his presence on the boat in the space created by the accumulated visuals if not at any particular moment within the picture space itself. It thus serves as a means of expanding the filmic space beyond the visual space as well as maintaining consistent awareness of the human presence.

A similar question may arise concerning the relationship of film sound to film time. Although most of the sound is synchronized with the visuals and therefore is apprehended synchronously with them, the content of the sound may be such that we identify it as taking place simultaneously with the action or as occurring at another time. Sound that is obviously internal—that emerges from the action, words spoken by lips we see, and even words spoken and music played by persons we do not see but know to be present—is synchronous. Although they may be apprehended simultaneously with the visuals, sound flashes backward or forward imply a different period of time and are regarded as asynchronous. Sound bridges that carry sound associated with one scene over into another or introduce the sounds of a succeeding scene before the preceding scene is ended may be synchronous or asynchronous depending on the context. If the bridge or *segue* leads from one scene to another taking place simultaneously, it may be regarded as synchronous; if it leads to events taking place at another time, it may be regarded as asynchronous. But what about background music and the voice-over narration of someone not involved in the action? Should they be considered synchronous or asynchronous? Some theorists, like Siegfried Kracauer, would say that they were asynchronous, although the sound describes the visuals, comments on them, clarifies their meaning, or intimately relates to them in one of the other ways we have considered.

As the full title of his book *Theory of Film: The Redemption of Physical Reality* suggests, Kracauer is thinking in terms of the ordinary day-to-day reality, in which background music and voice are present only in the radio and

phonograph. Perhaps he is also thinking in terms of process, for background music and voice-over are generally recorded either before or after the visuals are shot. But if we think in terms of the aural-visual chord rather than the process, of the reality of the work of art rather than the reality of everyday existence, we can consider such sounds to be synchronous and avoid confusions that have plagued too many students. We can easily describe the distinction Kracauer is trying to make by some reference to the internal or external locus of the sound, so that traditionally filmed dialogue is regarded as synchronous and internal sound, voice-over narration as synchronous and external sound.

Considering sound in this way, we can discover four basic types of relationship between the sound and the visuals. The sound may be:

1. Synchronous and internal (sound emerging from the action)
2. Synchronous and external (background music and voice-over narration)
3. Asynchronous and internal (flashback, flash forward, interior monologue)
4. Asynchronous and external (sound bridges, sound dissolves, segues)

Occasionally, however, as we shall see in the next chapter, sound may be interpreted as both synchronous and internal and asynchronous and external, as in the case of a character who is contemplating events that have already taken place. We must depend on the context to give us the clue.

LISTEN TO BRITAIN

Most of the basic possibilities of sound montage are illustrated in a simple and straightforward manner in Humphrey Jennings' and Stewart McAllister's *Listen to Britain* (1942). Produced by the film unit of the General Post Office during World War II, the piece is frankly propagandistic in purpose. It illustrates how the varying activities of a whole people contribute to the furtherance of the war, exhorts the population to devote their efforts to the common cause, and is intended to reinforce their faith in the ultimate attainment of peace. In its unqualified assumption of rectitude, its undisguised manipulation of traditional sentiments, and its faith in the common cause and ultimate victory, it may in more sophisticated and skeptical times seem naïve, simplistic, and even jingoistic. Still, the film is full of simple humanizing touches and is occasionally indirectly subversive of the appropriateness of armed combat. Whatever our views of its content, it is worth our attention and study as art.

As the title suggests, the basic statement is in the sound, which for the most part is so explicit in reference and so clearly articulated in structure that the visuals, while never mere illustrations, seem extensions of the sound, a reversal of the more familiar relationship. The film opens with the camera viewing Leonard Brockington, K.C., who reads a verbal paraphrase of the film's message. It is an afterthought, one suspects, dictated by some functionary who lacked confidence in the ability of the film to speak for itself. The film proper encompasses a day in the life of Britain at war, beginning in the late afternoon of one day and ending in the afternoon of the next.

At the outset we see fields of waving grain, women harvesting, air-raid observers in watchtowers, birds settling to roost in trees, a servicemen's dance in the great ballroom at Blackpool, riflemen guarding the coast, and the multilingual broadcasts of the British overseas radio service. As night progresses, firewardens are on duty in what seems to be the basement of a church, and there are shots of a railroad yard where a troop train momentarily halts and then departs. As dawn begins to break, we first see birds (Fig. 529), then workers going to mines (Fig. 530), factories, offices in the cities, women operating machines, and entertainment at lunchtime—popular singers at the factory, Myra Hess at the National Gallery (Fig. 531). Then a mother is seen watching children dancing in a schoolyard, tanks and infantry march through a narrow village street, and an aircraft factory and a steel mill are shown (Fig. 532). The visuals thus provide a cross section of the occupations of the country and the social classes associated with them, proceeding from agriculture to communications to industry and commerce to

529

530

531

the popular and fine arts to education and finally to the industry in which, by implication, all these activities coincide—aircraft production, a central symbol of modern war.

A contrapuntal theme is developed in references to the military. First, at a distance, planes are shown flying over fields, although their pilots are never glimpsed; then we see military men dancing, traveling, listening to a concert, performing in concert, and finally marching. The amount of time devoted to military activity increases as the film progresses. A second contrapuntal theme reveals civilians pursuing wartime activities as air-raid wardens, firewardens, or troop entertainers, and women are shown engaged in men's traditional work.

The constant shifting from one to another of these themes provides a structural expression of their interdependence and contributes to our recognition of a nation of individuals totally devoted to a common cause. The highly rationalized structure is relieved of oppressive didacticism, however, by the selection of faces, expressions, gestures, and attitudes that allow for involvement and sympathy, while depicting a wide range of feelings—apprehension, boredom, humor, and pathos. The harsher realities of war are introduced only with the most deliberate understatement—a bandaged head in a crowd, an empty picture frame in the National Gallery, barrage balloons floating above the city, a woman glancing at a photograph of a man in uniform, a man in a business suit carrying a helmet and gas mask (Fig. 533).

If the visual images provide a varied and comprehensive view of the island at war, the sound in the end brings the message into focus, giving the film a point the visuals merely adumbrate and introducing comments the visuals ignore. The primary function of the sound is to describe—to catalogue the characteristic sounds of activities and times of day, to catch the nuances of the human voice. Because the sounds and activities are for the most part so ordinary and familiar, they are rich in

associative content, evoking whatever spontaneous response we may have to the susurrus of the breeze, the whine and sometimes the miss of an airplane motor, the noises of birds coming to roost, the chimes of Big Ben, the clop of horses' hooves on cobblestones in the dawn, voices of children singing, a sudden suppressed laugh, the confidential tones of a man reminiscing about a date, and so on. The selection is calculated to enmesh the spectator in the familiar and offer assurances of the continuity of ordinary life in extraordinary times. And yet along with these there is a poignant reminder of transitoriness, of arrival and departure, as sounds swell and fade.

Volume and overtones are carefully controlled for their potentialities as spatial expression: the airplane is established as being at a certain distance, as are the birds, the singing children, and everything else. The volume changes as a train approaches and retreats or the camera changes location with respect to the source. The volume of the band at Blackpool is adjusted to indicate whether we are placed outside or inside the ballroom. Only occasionally does the sound require reinforcement by the visual to suggest spatial ideas, notably in the cheerful, professional tones of the overseas radio announcer and the man who conducts the morning exercise, whose voices we recognize as projected through wide expanses of space, largely because they are accompanied by views of the ocean and the city. The very emphasis on the sound and the selection and isolation of particular sounds transforms noise as well as music into decoration, suggesting how the ordinary constitutes the aural ornament of our lives. Moreover, the decorative quality is enhanced by the methods of creating continuity.

For the most part, continuity is developed by relatively simple methods. Sounds more or less similar in quality are arranged sequentially: in the beginning, for example, we hear the breeze, the airplanes, the sound of Morse Code, the twitterings of birds; later, the shifting of switches in the railroad yard, the chugging of the engine, the clanking of gates in the head of the mine shaft, the sound of dray horses; and finally, the music of the morning program followed by the music in the factory,

532

533

the music of the lunchtime break, and the sounds of singing children. The arrangement is not simply mechanical, however. The sharply differentiated noises and rhythms of the night sequence are interrupted by conversation and singing soldiers on the troop train; but a general similarity in the character and rhythm of the sounds prevails. And there are sound fades, dissolves, and segues as the film moves from one activity to another. Within the sound sequences, augmenting the rhythm of the sounds themselves, there is a rhythmic change from one specific sound to another, so that the spectator moves easily from place to place and moment to moment.

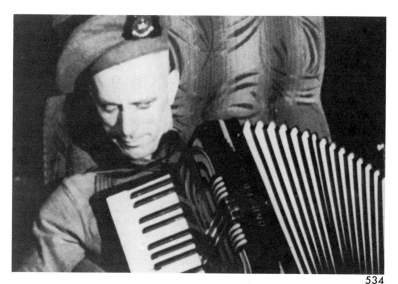

534

529–534. *Listen to Britain.* Humphrey Jennings and Stewart McAllister. Great Britain, 1942.

The forward movement is reinforced by an increasing complexity and volume of the sounds in each of the major sequences and in the film as a whole. The opening afternoon sequence, which begins with the soft, continuous breath of the breeze, adds the whine of the engine, introduces voices, and ends with seemingly hundreds of chirping birds. The film as a whole, which began with the almost imperceptible wind, gradually expands its range of sounds to end with a grand diapason that combines the roar of the factory, a full symphony orchestra, a massed chorus, and marching feet, a development that not only gives order and continuity to the track but also expands and intensifies the expressive content.

Until the very end of the film, the sound for the most part is internal, synchronous, and parallel. The sound of the airplanes carries over the continuously waving grain and the relatively immobile field workers; the unstructured chirpings of the birds accompany the unstructured silhouettes of the trees; the rhythmic clank of the changing switches par-

allels the action and the cutting; the rapid rhythm of the music and the incisive counting of the announcer on the morning program parallel the forward movement of the lens in its rush through space. In a particularly effective shot of a soldier playing an accordion on a troop train (Fig. 534), a rising shoulder nicely parallels the ascending arpeggio of sound. The parallelism is interrupted from time to time, however, so that a subtle alternation of parallel and contrapuntal sound is introduced. The quiet of the night in the static shot of the firewardens in the church basement is countered by the operatic voice of a singing firewarden.

Occasionally, sound functions as humorous comment: during the gymnastic instructions of the morning program, the announcer says, "Chest out and turn," and the camera watches a man on his way to work parallel this pose and action. The sound is also ironic, as when the song "Yes, My Darling Daughter" is played in a factory where the workers are all women. More profoundly, when the noise of tanks, marching feet, and the military band drowns out the songs of the dancing children, the sound comments, indirectly and subtly, and in a way counters the primary message of the film.

For the most part, whatever sympathy, pathos, humor, or irony it may evoke, the film proceeds in an essentially straightforward way until the final sequence, when, as the point is driven home, the whole method of dealing with sound is changed. Then, over a shot of the interior of a factory with its industrial sounds is added the sound of a symphony orchestra, the chorus, and the marching men mentioned earlier. In contrast to the rest of the film, the sound becomes external, asynchronous, and contrapuntal, evoking the major divisions of British culture examined in the preceding footage—the industrial, cultural, and military—and bringing them through the overlapping sound into undissolved, and by implication, indissoluble unity.

8

Structures
in Space-Time:
Tenses in Film

For the most part, we have considered time as the ineluctable element of the film medium—capable of expansion and contraction but arranged chronologically, as if our experience of time necessarily corresponded to our sequential viewing of the film's segments, with the present, once grasped, converted into the past, the future never glimpsed, and time simply a series of events arranged along a line to be wound up on a reel. Critics and theoreticians frequently point out that the motion picture exists in the continuous present, that there are no tenses in film. This observation, like so much of film criticism, reveals the verbal obsessions of western critics. It is true that the language of film is not inflected. There is no standard way of adding a suffix like -ed to the image of a man walking in order to suggest that this walking took place in the past. But the notion that film exists in the continuous present requires some examination.

In English or in any inflected language we might say something like this: "A long time ago on the Ides of March in 44 B.C., Julius Caesar went to the Senate. Conspirators were waiting for him. At a signal from one of them, they fell upon him and stabbed him. Before Caesar's supporters could act, Caesar had lost consciousness." The various forms of the verbs clearly indicate time relationships of particular kinds: action continuing in the past, a sequence of actions completed, and one action completed before another began. Each of the modifications of the verb, however, acts simply as a repeated adverb establishing the time and therefore may, with some reason, be regarded as redundant. It is possible, after all, to tell the tale in a different way: "A long time ago on the Ides of March in 44 B.C., Julius Caesar goes to the Senate. The conspirators wait for him. At a signal from one of them, they fall upon him and stab him. Before Caesar's supporters can act, Caesar loses consciousness."

We could also say (although admittedly we would hardly be likely to): "A long time ago, on the Ides of March in 44 B.C., Julius Caesar will go . . ." The adverbial phrase "a long time ago," the date, and "before" establish the time relationships clearly enough, and inflection adds little but verbal subtlety. In short, if we

are concerned with temporal relationships rather than with grammatical elegance, we have no difficulty recognizing, in a continuous series of connected events arranged chronologically, that they have taken place in the past, are taking place in the present, or are expected to take place in the future.

Nor does the filmmaker have difficulty in presenting them. The localization of time implied by "a long time ago" or the date, if it is crucial, can be indicated verbally in titles or in voice-over narration, as Truffaut does by means of a continuity title in *The Wild Child* (1970) or as Stanley Kubrick does in the main title of *2001: A Space Odyssey* (1970). Calendars, newspaper materials, news commentary on radio and television, or similar devices may also be used to indicate a particular time. When the specific time is not crucial, the spectator will infer a time from the context, action, costumes, setting, or speech.

FLASHBACK AND FLASH FORWARD

A problem arises when the filmmaker wishes to establish a relationship in time between two series of events taking place at quite different times. He may wish to imply, for example, the kind of relationship expressed in such structures as: "Before Antony became emperor, Caesar went . . ."; or, "By the time Antony assumes power, Caesar will have . . ." But the problem is not insoluble, and the solution is not unfamiliar. The filmmaker establishes a moment in time—whether it is historically in the past, the present, or the future is immaterial—and then introduces a flashback or flash forward. These may be projections of the thoughts of one of the characters, commentative interpolations by the filmmaker, or, in an extended form, primarily a structural device adding interest and complexity to a narrative that might also have been presented in simple chronological order.

The flashback can be *external*, something not directly related to the events of the film; or it may be *internal*, directly related to the events of the film and explaining or accounting for them. A simple flashback appears in Von Stroheim's *Foolish Wives*. As Mrs. Hughes sits on the veranda of the hotel in Monte Carlo,

surrounded by military personnel of various nations and ranks, the imagery flashes to shots of an American charge on a battlefield during World War I. We can read the flashback in at least two different ways: as a comment by the director, establishing the time and reminding us that many of the people staying at the hotel had been enemies not long before (in which case we might consider it as external); or as an insight into Mrs. Hughes' thoughts and perhaps as a clue to the romantic element in her personality (in which case we could consider it as internal). However we regard it, the flashback does little to advance the plot or our understanding; it is dissociated from the main theme and operates like an aside. Its temporal implications are comparable to the past perfect: when the events in the story took place, the war had already ended.

Alain Resnais, who—along with a number of filmmakers of the 1950s and 1960s—has been exploring temporal relationships in the film and the significance of time in human psychology, gives the flashback a quite different meaning in *Hiroshima, mon amour* (1959). The film concerns an actress who is in Hiroshima making a movie about peace. She has become involved with a Japanese architect (Fig. 535), a native of Hiroshima whose parents and friends were killed in the blast or by the atomic fallout that followed. The architect wants her to stay on in Japan after the film is completed, but she insists she must return to France. Whether she stays or leaves we never learn, and the scriptwriter and director are no help, because they themselves do not agree about the outcome of the affair. In any case, this is of little importance in comparison to the psychological attitudes revealed and the philosophical questions raised.

As the film progresses, we learn that the young woman is married and has children; that as a young girl in Nevers she had fallen in love with a German soldier who died in her arms; that when she subsequently suffered a nervous breakdown, her parents imprisoned her in a cellar; and that at the war's end the townspeople shaved her head as a collaborator. She has had other affairs, perhaps in a futile attempt to recapture the passion of her first love, perhaps in unconscious defiance of

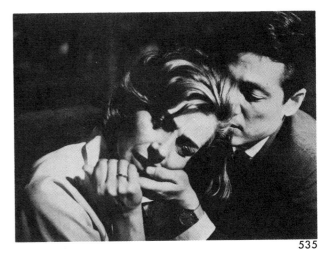

535

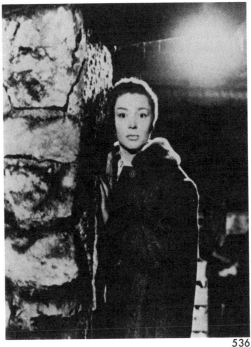

536

535, 536. *Hiroshima, mon amour.*
Alain Resnais. France, 1959.
The film plays with time by showing first the present and then the past in the form of flashbacks.

the society that imposed its guilt upon her and humiliated her. Both the movie in progress and a visit to the memorial museum at Hiroshima revive her memories of her past, and she relives it, identifying the architect with the soldier. As the two talk in one place or another, there are flashbacks to her life in Nevers (Fig. 536), first in fleeting images, then—as

memory becomes more insistent and present and past interpenetrate to finally coalesce—in extended passages that describe the earlier affair. Then it is time for her to leave Hiroshima.

The film opens with the actress and the architect in bed. She tells him she has seen Hiroshima, and flashbacks reveal what she has seen—fragments of remains, photographs, charts, models, newsreels, and motion picture reconstructions at the museum. He tells her she has not seen Hiroshima. The film proceeds almost as a debate: when she says she has seen, he says she has not; when she says she has known, he says she has not; when she says she must leave, he pleads with her to stay. But this personal conflict simply provides the framework for a more philosophical one, for the film draws parallels between the mass horror of Hiroshima and the personal horror at Nevers. The comparisons become explicit in the association of the two themes and in references to specific details, such as the tufts of hair from a woman at Hiroshima preserved in the museum and the hair shorn from the actress' head in Nevers. The film raises the question whether in the end there is a difference between personal tragedy and mass tragedy. Parallels between the two, however, reinforce the differences. More importantly, the film deals with memory and the tendency of the individual to remember personal tragedy and to forget the tragedy of others, so that the horrors of Hiroshima are forgotten while the "threepenny novel" of our individual lives is remembered. The film is, one might say, a reminder to remember.

The flashbacks are clearly internal, essential to the exposition, and part of the personal drama. The tense they imply is the present perfect: the action has occurred in the past, but somehow has a relationship to the present, in this case affecting present behavior. Resnais' method of introducing the flashbacks is traditional and familiar: he cuts from the film's present to the past, presenting the past for the most part objectively so that we see the girl, and the flashbacks become not so much her recollections as Resnais' illustration of her recollections.

In *Wild Strawberries* Ingmar Bergman employs a more unusual method. His central character, an elderly doctor on his way to Uppsala to receive an honorary degree, recalls events of his earlier life. Rather than watching himself from outside like some benign Scrooge, however, the man enters the space of the past and participates in events as a child, a youth, or a young adult in the form of an old man (Fig. 537). The narrative point of view is thus subjective. Even more subjective is Emlen Etting's *Poem 8* (1932), in which the spectator does not see the central figure but only what the central figure sees (Figs. 538, 539). Still, Bergman's film is more

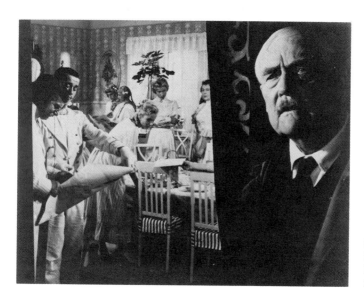

537. *Wild Strawberries.*
Ingmar Bergman. Sweden, 1957.
Present and past coalesce as an old man enters the spaces of his past.

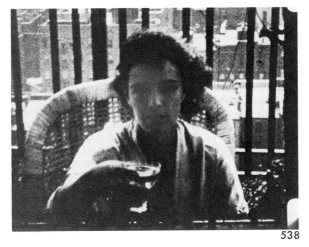

<center>538</center> <center>539</center>

538, 539. *Poem 8.* Emlen Etting.
Great Britain, 1932.
Subjective narration appears in two forms. In first-person narration, the narrator is offered and accepts a martini.

subjective than Resnais' and perhaps even more effective in suggesting how the past can haunt the present. Once again the tense appears to be the present perfect, although Bergman actually creates a compound tense in which past and present exist simultaneously.

At times the flashback may simply be implied or induced in the viewer's mind. In *La Dolce Vita* Marcello, the journalist who is the central figure, attends a soirée at the home of his friend Steiner, who at one point takes Marcello to see his children sleeping in their cribs. Later, Steiner kills his children and commits suicide; Marcello, attending the police investigation, wanders into the children's bedroom and looks at the beds. A recapitulation of the earlier visit is implied as being in his mind and is induced in the spectator's. More especially there is a recollection of Steiner's fears for modern society.

Unlike any of the examples we have been considering, Jacques Demy's *Lola* (1960) creates the sense of the flashback and the flash forward while remaining in the present by associating his central figure, Lola, with two others—Cecile, who stands for Lola when she was young, and her mother, who stands for Lola as she will be.

The flash forward is illustrated repeatedly in Resnais' *La Guerre est finie.* The film explores the philosophical and psychological predicament of Diego, a Spaniard who works as a liaison between exiled popular front leaders in Paris and underground cells in Spain. We first see him after the police have initiated a series of raids in Madrid as he is fleeing to Paris to warn others who are about to return to Spain. As he sits in the dining car of the train, his attention oscillates between the people and the sounds around him and speculations about what he will do in Paris. We see flashes of his arrival in the Gare Austerlitz, of his attempts to track down his friend Juan, of pretty girls in the street, of his mistress.

Sound may carry the burden of the flashback or flash forward. Truffaut introduces an extraordinarily complex and provocative flash forward in *Mississippi Mermaid* (1969) when his central figure, a wealthy manufacturer, returns from work to discover that his mail-order bride has decamped. Immediately suspecting that she may have absconded with all his cash, he drives into town to check with his bank. As he speeds along the twisting road, with the landscape reeling around him and the sunlight flashing in blinding reflections from the windshield and the chrome, we hear a voice-over dialogue in which the bank manager informs him that his wife has indeed withdrawn the money. We can read the scene in a number of ways. The dialogue could be the manufacturer's projections of what will happen—which in fact later does happen—and

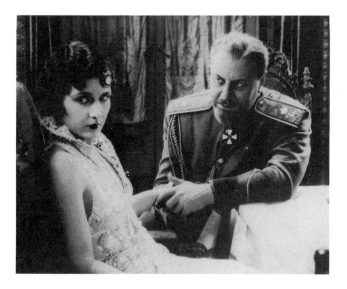

In an extended flashback, the general recalls his love for an actress, whom he has arrested as a revolutionary agent.

pair set out for Moscow by train but were attacked on the way, and the general was forced to serve as a fireman. The actress then made her way to the cab and seduced the engineer in order to divert his attention while the general escaped. As he lay recovering from his fall, he watched in horror as the train blew up.

Once these events have been recounted, the film returns to the Hollywood studio, where the general is put in command of an army of extras. He exhorts them to charge and, carrying the Russian flag, falls dead. Although the Hollywood sequences at the beginning and end could, with little change, stand on their own as a narrative sketch, they constitute the end of the general's story and serve as formal temporal parentheses located in the filmic present. They embrace the events that occurred in the filmic past, which in this case perhaps implies the past perfect tense.

Absolute correspondence between filmic and verbal construction obviously does not exist; but the notion that the tense of the film is exclusively and continuously the present must be qualified. Those who insist on such an interpretation of filmic time seem to be more concerned with grammatical convention than with temporal content. There is no question that any shot, series, scene, or sequence in a film, viewed in isolation as a separate and integral unit, seems to take place in a time that corresponds with the present tense of an inflected language. A similar passage excerpted from literature may designate whether the time is past, present, or future and may indicate complex relationships among actions taking place at different times as well. Because of the nature of the respective media, in filmic construction temporal relationships seem to emerge from the general context rather than from a specific form, while in verbal construction temporal relationships can be expressed directly in a verbal form. Linguistic inflection undoubtedly provides a more precise, economical, standardized, and often even more subtle method of establishing relation-

therefore be internal and synchronous. Or we might think of it as creating an overlap in time, the filmmaker simultaneously narrating the present in the visuals and the future in external and synchronous sound. We can also regard the scene as a combination of the two types of relationship. However we interpret it, the future is implied.

The extended flashback is exemplified by *The Last Command*, in which Josef von Sternberg rearranges the events of a narrative that could just as easily, though not as effectively, have been presented in chronological order. The film concerns a former general of Russia's imperial army who escapes from his homeland during the Revolution, makes his way to Hollywood, and there becomes a film extra. In the first scene, a director is conferring with his staff about casting the part of a general in a certain film. The Russian general's photograph turns up, the studio calls him, and he goes to the costume department. As he is pinning a medal on his costume, he recalls the events leading to his exile.

While on maneuvers, the general had interrogated an actor and actress arrested as revolutionary agents. He had the actor imprisoned, but installed the actress, with whom he had fallen in love, in his palatial quarters (Fig. 540). At first she planned to kill the general (Figs. 222–229), but seeing his love for Russia was as deep as hers, she could not bring herself to do it. When the Revolution broke out, the

ships in time than film does. But film is capable of conveying the ideas of tenses other than the present, even though it does use different methods from those of verbal language.

There are ideas one can verbalize for which it is difficult if not impossible to find an equivalent in film. Dealing only with particulars, the filmmaker can illustrate but cannot express concepts without using words. Nevertheless, by reiterating a variety of illustrative materials, he can provide the viewer with the evidence from which to construct a concept. A film entitled *Relativity* (1966) by Ed Emshwiller relates man to his prehistoric past, to other forms of life, to inanimate matter, to subatomic structure, to machines, and to the universe as a whole through a series of visual comparisons, which suggest the concept implied by the title.

It is difficult to express customary action without employing words—that is, to find an equivalent for a phrase like "They used to take a walk every evening in the garden." Still, the idea is not impossible to convey in filmic terms, as our examination of Resnais' *Last Year at Marienbad* later in this chapter will suggest. Even more difficult is the expression of ideas inherent in verbal moods, such as the conditional—for example, "If the Sheriff rides to Red River Gulch he can head off the rustlers." Resnais at least approaches such a verbal tense in *La Guerre est finie* when he has Diego momentarily, in a flash shot of the train for Perpignan, contemplate the possibility of going to Perpignan rather than to Paris to warn his colleagues of the dangers that confront them. From that flash shot we infer that he is thinking something like, "If I went to Perpignan, I could head them off."

Methods such as these affect form, but they also determine content. Thus in film, time is not just continuous present, nor is it simply past or future. It can be at once present and past or present and future. Such ambivalence —sometimes even multivalence—inherent in the medium, may seem to impose severe limitations on the filmmaker, but in fact can do just the opposite. Whether the filmmaker has intended it or not, the ambiguities in filmic time reveal time not as a chain of events in which future becomes present and present becomes past, but as a continuous field in which past and future shape the present, and present shapes past and future, much as in daily life.

METHODS OF EXPOSITION AND NARRATION

We have seen how the filmmaker can modify space and time physically, can modulate space-time rhythmically, and, in a general way, can introduce ideas of tense. But for the most part we have been concerned with general principles and have illustrated them with selected fragments. In the following sections we will consider the way in which the filmmaker deals with time and space in the larger structure of the total film, that is, his methods of exposition and narration. We will discover that there are basically four types of narration: continuous, simultaneous, parallel, and involuted, each of which we will consider in turn.

Continuous Narration

As may be inferred from what we have seen already, narration or exposition can be developed in two ways: continuous or discontinuous. Continuous narration simply presents incidents in chronological order. Strictly applied, it adheres unwaveringly to the classic unities of time, place, and action. In its most primitive and most elementary form it has been used by early filmmakers like Méliès, who frequently viewed the action from a single vantage point until it was completed, and by independent filmmakers of the 1960s, who often discovered new adaptations for old usage. Andy Warhol, for example, in his early films like *Sleep* (1963), *Empire* (1964), *Haircut*, and *Blow Job* (1964), simply turns the camera on his subject and observes it almost as if it were a scientific specimen, varying the distance, camera angle, and exposure only, it would seem, by accident when changing reels.

Filmmakers have found more sophisticated methods of adjusting to the unities. Alfred Hitchcock in *Rope* (1948), tried to create the effect of a feature-length film made in a single shot while retaining the expressive potentialities of varying spatial organizations and editorial rhythms by making the camera highly

left: 541. *Rope*. Alfred Hitchcock. U.S.A., 1948.
Hitchcock carefully blocks out the actors' gestures before filming.

below: 542. *The Connection*.
Shirley Clarke. U.S.A., 1960.
The film is constructed in a single setting, which seems to participate in the action.

mobile. Since movie cameras do not hold sufficient film for a complete feature-length film, Hitchcock planned the action carefully so that the change from one reel to another would take place when the back of a character appeared in close-up before the lens. To achieve mobility and the sense of editing provided by the sequence shot, he carefully blocked out camera movements and arranged for not only actors but also furniture and walls to move out of the way of the camera as it rolled from place to place to take up different distances and assume different angles of vision (Fig. 541). Thus *Rope*, was in effect pre-edited, and the result is a tour de force.

Few filmmakers have been willing to relinquish the flexibility that post-editing allows and operate more like Shirley Clarke in her filmic translation of Jack Gelber's play *The Connection*. The play studies a variety of personalities assembled in a drug addict's pad as they first wait for their connection to arrive

with heroin, then react to the drug. The setting is a single room (Fig. 542). There is very little action: a strange, silent derelict enters carrying a phonograph, plays a record, and departs; a "salvation sister" turns up and disappears; there are occasional scuffles; and there are musical interludes, since a number of the characters are jazzmen. But the significance of the play really resides in the words, as the characters analyze themselves and each other and speculate about their lives and life in general. All this is fit material for theatrical production but—viewed superficially at least —unprepossessing material for film.

Like Hitchcock, Clarke maintains the unities and the mobility of the camera, but she also exploits the potentialities of editing. With an uncanny awareness of the play's filmic possibilities, she transforms the theater into film, perceiving not only how to use the film to reinforce the actors' performances, but also how to use the material environment to extend the action of the play and how to develop rhythms that invest the work with an additional, purely filmic, energy. While one of the characters is speaking, for example, she moves her lens slowly away from him to follow a cockroach as it aimlessly wanders about a wall, creating a symbolic dimension the theatrical producer could not. In one of the musical interludes, she simultaneously develops four contrapuntal rhythms, the rhythm of action, of sound, of moving camera, and of cutting, creating a tension among them that maintains the tension of the drama through the music.

Another filmmaker might have been tempted to introduce flashbacks as the characters reveal their lives, or to illustrate their comments on society and thereby risk a sentimentality and diffusion of attention that would dilute the solid strength and concentration of the play. But Clarke has recognized that a small space is as adaptable to cinematic

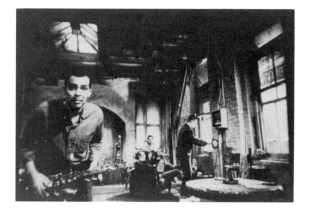

observation and exploration as a large one, and that part of the play's strength and the personality of the characters is to be found in the almost unreal claustrophobic isolation from the external world, which continuous narration and strict adherence to the unities help to express.

Simultaneous Narration

Simultaneous narration involves the presentation of two or more events occurring at the same time or at approximately the same time but in different places. The events may be narrative or dramatic, or they may be anything that is happening in the film. The place could be the space of the narrative or simply different places on the screen. Simultaneous narration is the most common method of describing that classic film situation, the chase. *The Lonedale Operator* (1911) by D. W. Griffith is an early example of the form.

As the film opens, we see a young railroad engineer talking with some associates. A messenger boy arrives with his assignment. He sets off to the train yard and meets his girl friend. They talk, look lovingly at one another, sigh a bit, and then part, he to take a train down the line, she to take her place at the telegraph key in the Lonedale Station. While she is working, two tramps who have been riding the rails appear from under a train. As they make their way to the station, their stealthy manner betraying their intentions, the operator spies them. She bolts the door to the office as they enter the station and, while they are attempting to break it down, telegraphs the next station for help (Fig. 543). The telegrapher there is asleep—causing suspense—but he finally wakes up, takes down the message, and alerts the operator's boyfriend, who sets off to the rescue on his engine. Before he arrives the robbers break down the door, and the resourceful young woman, discovering a weapon, tells them to put up their hands. At this point the engineer arrives and the weapon is revealed to be a monkey wrench, much to the consternation of the robbers and the amusement of the engineer.

The film is worth studying from every point of view—for its photography, its acting styles,

the manner in which space is analyzed and continuity established—but it is of interest to us at the moment primarily for its method of narration, which is continuous until the lovers part (Fig. 544). At that point the thread of the story separates into two strands, the first following the engineer, the second the simultaneous activity of the young telegrapher. With the entry of the robbers, a third strand begins to unwind, and the appearance of the sleepy telegrapher provides a fourth. Then, step by step the number is reduced: the sleepy telegrapher is eliminated; the bandits and the girl come together; finally the engineer joins them to rewind the threads into a single strand.

Simultaneous action is described by means of sequential shots presented either in alternation or in cycles of three or four, depending on the number of strands the story is pursuing at any given moment. It is an important factor in creating the suspense that accompanies the race against time to the last-minute rescue and

543, 544. *The Lonedale Operator.*
D. W. Griffith. U.S.A., 1911.

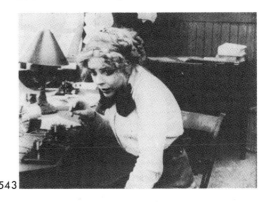

543

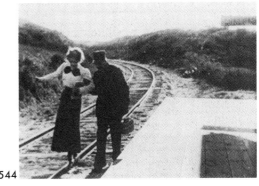

544

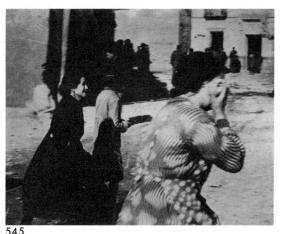

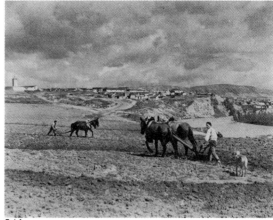

545

546

545, 546. *The Spanish Earth.* Joris Ivens.
U.S.A., 1937.
Two themes are interwoven and at times coincide.

in accelerating the cutting rate that augments the excitement.

A more generalized kind of simultaneity can be observed when the various strands of a story are not so obviously and intimately interrelated, as in *The Spanish Earth* (1937), a documentary concerned with the civil war in Spain. Directed by Joris Ivens, the film develops two major themes: the outbreak and progress of the war and the planning and construction of an irrigation system (Figs. 545, 546). The two tales are interwoven and sometimes, by implication, coincide, as the crackle of rifle fire is heard while the farmers work on their ditches. But the basic relationship is one of ideas rather than of action, the film pointing out that life continues its ordinary course during the war, that there is hope for the future, that the agricultural revolution and the political revolution are related, and that there is a community of action between the worker and the soldier and presumably a common goal—a good life on the Spanish earth.

In both *The Lonedale Operator* and *The Spanish Earth* simultaneity is expressed by disjunctive cutting, that is, by the interruption of temporal continuity. True simultaneity manifests itself through the interruption of spatial continuity, which may appear in any of the forms we mentioned in Chapter 3—the inset or vignette, the superimposition of images, the split screen, or multiple projec-

tion—any of which can be described as a kind of polyvision (see pp. 44–46). Like disjunctive cutting, all of these methods of multiplying images developed relatively early in the history of the film. Edwin S. Porter's *The Dream of a Rarebit Fiend* (1906) uses superimposition of images to show the dreamer and the dream simultaneously. In the shot illustrated, the dreamer floats over the city (Fig. 547).

Among the directors working prior to the advent of sound, Abel Gance was especially attracted to the fragmentation of the picture space. In *Barberousse* (1916) he split the screen into three parts to cover the two ends of a telephone conversation and a bandit intercepting the call as well. He used three projectors in *Napoleon*, sometimes to carry a single panoramic view, sometimes to create a triptych of images, at one point, for example, showing François Rude's sculpture *La Marseillaise* in the center panel and images of the popular army in the flanking panels (Fig. 117).

Split screen, multiple projection, and superimposition of images gained increasing vogue in the 1950s and 1960s. Charles and Ray Eames have frequently employed multiple projection in films for international fairs and exhibitions, like *Glimpses of the U.S.A.,* shown in Moscow in 1959; *The House of Science,* shown in the Science Pavilion of the Seattle World's Fair in 1962; and *Think,* exhibited in the IBM Pavilion at the New York World's Fair of 1964. Multiple projection is a common feature of Francis Thompson's *We Are Young* (1967; Figs. 548, 549), which was presented at Montreal's Expo '67.

Directors of commercial entertainment films introduced sequences in split screen during the same period. John Frankenheimer breaks the screen into nine images in *Grand Prix* to reveal the action in the cockpits; Norman Jewison makes a mosaic of 64 pieces in *The Thomas Crown Affair* (1968), presumably to capture the excitement of the polo match, although in the end producing primarily a decorative effect. Inevitably the personal, independent, avant-garde, and underground filmmakers have employed all manner of spatial fragmentation and displacement. Storm de Hirsch in her semiabstract film poem *Third Eye Butterfly* introduces the whole panoply—insets, split screen, superimposition, dual projection—combining and recombining natural images and artifacts with magical fluidity.

The ultimate effect of such adventurous excursions into polyvision is almost always generalized. In *Glimpses of the U.S.A., The House of Science*, and *To Live* the multiple imagery functions impressionistically, building up a general sense of the visual environment or human behavior. The snowball fight sequence

547

Above: *547. The Dream of a Rarebit Fiend.*
Edwin S. Porter. U.S.A., 1906.
This shot reflects the very early use of superimposition of images.

below: *548, 549. We Are Young.*
Francis Thompson. U.S.A., 1967.
The split screen became a very popular device in the 1950s and 1960s. The production of *We Are Young* entails an elaborate procedure to achieve the final result.

from *Napoleon* and the cockpit sequences from *Grand Prix* operate more expressionistically, heightening the excitement and tension and translating action into subjective terms that suggest how it feels to sit in the cockpit of a racing car or participate in a snowball fight. Multiple imagery in *Think* explicates intellectual generalizations like the concept "two." By contrast, *Third Eye Butterfly* seems to transform the eye into an organ of feeling rather than seeing or reasoning, as if Storm de Hirsch, like Abel Gance, counted on the senses to grasp what the intellect does not consciously measure. The complex of images moves so precipitously across the screen that the viewer is often unable to catch them; instead, he himself is caught in the movement, immersed in the flow of life, occasionally glimpsing images and objects that by their similarity suggest the unity of being.

548

549

Porter's *Fireman* and *Rarebit Fiend,* Gance's telephone conversation and his triptychs contain so few elements and the relationships among them are so explicit that the filmmakers maintain control over the spectator's response, selecting the significant details, directing the viewer's attention to them, and determining the order in which he will see them. The fireman, the sleeping rarebit fiend, the popular armies, once established, become like parts of the setting in which the action is played out; the participants in the telephone conversation call attention to themselves by their movements or their words.

In the other examples cited above, the filmmaker allows the spectator to move more freely in the picture space, to concentrate on particular images in whatever order he wishes, or to ignore the specific and open his mind to the whole complex. As a result, the spectator becomes more directly engaged in the film and an active participant in the creative process, though chance can play a role as the viewer shifts his attention from one screen to another or from one image to another. While every frame of the film may be imprinted on the spectator's mind like the inactive data in a computer memory bank, the capacity for conscious absorption is limited, so filmmakers chary of calling attention to the medium or those intent on directing the spectator's attention and conveying specific, concrete, and limited information have tended to express simultaneity by interrupting time rather than by breaking up space, using polyvision sparingly to depict relatively simple and self-evident relationships—like the telephone conversation—and to convey general impressions, suggest abstract ideas, enhance visual excitement, or immerse the spectator in sensuous experience.

Parallel Narration

Parallel narration, parallel cutting or editing, and parallel time are terms frequently used to designate methods here referred to as simultaneous narration, involuted narration, and narration in indefinite time. A more specific differentiation among the various methods of structuring time seems useful; for that reason, the concept of parallel structure will be limited to narration or exposition that develops two or more stories, themes, or series of events associated with different times. While extended forms of the flashback and the flash forward are employed in parallel narration, they appear not as subjective reminiscence or anticipations like those of *Hiroshima, mon amour* or *Mississippi Mermaid,* but as subjects for comparison, which are related ideologically or metaphorically, most often through similarity or contrast; there is no direct or immediate interaction among them.

Griffith's *Intolerance* is the most monumental and the most influential example. In a grand epic rhythm, Griffith develops four episodes widely separated in time: the conquest of the Babylonians by the Persians, the Crucifixion of Christ by the Romans and Jews, the massacre of the Huguenots by the Roman Catholic French state, and, in the modern story, the exploitation and persecution of the poor by people of wealth and social status. He narrates the stories cyclically, bringing each one to a particular point and then turning to the next, creating what has sometimes been described as a filmic fugue, in which one theme after another gains dominance and all four parts are brought to a climax in an avalanche of images. The episodes are related in their dramatic structure, which in each case lends itself to a general exposition of milieu, an increasing concentration on action, and a constantly augmented emotional intensity. The four episodes also have a basic intellectual theme: the persistence of intolerance in the history of western man. This idea is reinforced and given formal substance by the fugal organization, which has the effect of minimizing historical differences and treating three thousand years as virtually undifferentiated, at least as far as intolerance is concerned. But action in one episode clearly does not affect the action in the others, except to the extent that the vagaries of human nature are transmitted from generation to generation—an interpretation suggested by Griffith's interpolation of a recurrent motif, the rocking cradle.

Alain Resnais uses parallel development in *Nuit et brouillard (Night and Fog;* 1955) but unlike Griffith builds a structure of contrasts.

The explicit subject matter of the film is the Nazi concentration camps of World War II (Fig. 550), and the German for night and fog (*Nacht und Nebel*) was a term used to designate prisoners. In the context of the film the term takes on symbolic overtones, seems to whisper of secrecy, and reverberates with horror. Resnais contrasts shots of the camps as they appear today—quiet, empty, neat, and seemingly innocuous—with shots of the planning and building of the camps and the obscene and inhuman uses to which they were put, underlining the contrast by using color for the filmic present, black and white for the past.

Superficially viewed, the film is a recording of history, and its observations of the past are almost a postscript to *Intolerance*. Resnais' film however, is built not of fictional reconstructions but of actual documents that confirm the pessimism of Griffith's film without offering its ultimate optimism. While both works are constructed on the parallel system, the manner in which parallelism is expressed, along with other aspects of the films, results in two different kinds of statements. Griffith proposes his pessimistic thesis directly and immediately (if not clearly), recovering in the end the basic optimism implied in the very structure of the familiar theme of last-minute rescue and the triumph of justice. Alain Resnais and Jean Cayrol proceed to their major theme slowly and deliberately, almost by indirection. Describing and illustrating laconically and sometimes with bitter irony, but certainly not explicitly, they ask, "And who does know anything? Is it in vain that we in our turn try to remember? What remains of the reality of these camps—despised by those who made them, incomprehensible to those who have suffered here?"[1]

Resnais' constantly mobile camera, always advancing purposefully through the now silent and impassive spaces, and Cayrol's rehearsal of past events, continuing over shots of past and present alike, seem not only to suggest the subjective viewpoint of a visitor and the recitation of the tour guide, but also to awaken some dormant presence, some secret, unseen, threatening animus that continuously prowls from past to present, an invisible link between the two worlds. As the last of the

550. *Nuit et brouillard.* Alain Resnais. France, 1955.

dead are buried and the prisoners are released, as the film changes from black and white to color and there is a scene of green fields and waving flowers, the questions are raised, the doubts exposed, the fears insinuated of the bestiality that may still be living beneath the placid masks of men, the inhumanity that may be all too human. In *Nuit et brouillard* the narration, running over past and present, may seem to inject an overtone of involuted structure in which, as we shall see, the past or the future exerts an active force on the present; but the only active link between the horror, shown in black and white, and the calm, filmed in green and red, is the moving camera.

The distinctions among the various types of narration are not necessarily clearcut. Gillo Pontecorvo's *The Battle of Algiers* (1966) may be interpreted as the interweaving of two narratives—one concerning the activities of the revolutionaries, the other the efforts of the French authorities to penetrate the revolutionary organization, identify the leaders, and capture them. The film shifts its attention from one group to the other so that a drama of revolution is intertwined with a drama that appears almost to be a detective story, either of which could have been developed separately. The resulting structure seems to illustrate parallel narration. Actually, however, Pontecorvo organizes the narration in such a way that the action of one group responds to the action of the other, which in turn provokes a response; thus, the narrative is a single one of action and response comparable to dialectical montage, and the film is seen in the end to be structured in continuous narration, with groups as well as individuals in conflict.

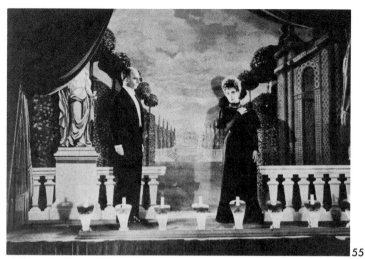

551, 552. *Last Year at Marienbad.*
Alain Resnais and Alain Robbe-Grillet. France, 1961.
Ambiguities of identity are suggested through similarity in pose.

Involuted Narration

Continuous narration strings events along in chronological order; simultaneous narration reveals two or more events taking place at the same time in different places; parallel narration presents events taking place at different times. Involuted narration not only brings the past and sometimes the future into the filmic present—at times making the distinction among them impossible to determine—but also gives them present force. The past is not simply a moment recalled and then forgotten (like Mrs. Hughes' recollection in *Foolish Wives*) or merely the cause of an effect in the continuous narration of events (like the delayed confession of the murderer in the modern story from *Intolerance*) but a continuously active influence. Whereas in other forms of narration the images or sounds of the past emerge in the present for the moment and then return to the past and remain there, in involuted narration they persist in the present, not as if they had happened once upon a time, but as if they had happened and are happening still. We have seen a number of examples in progressive degrees of complexity: *The Last Command, Hiroshima, mon amour, Wild Strawberries,* and *La Guerre est finie.* The most profound and provocative exploration of the tenses, however, is manifest in Resnais'

and Robbe-Grillet's *Last Year at Marienbad* (Figs. 551–564).

Alain Robbe-Grillet, who wrote the script, describes *Last Year at Marienbad* as the story of a persuasion.[2] A woman, A, and a man, M—who may be her husband, her lover, or perhaps even her guardian—are staying at a hotel. A second man, X, attempts to persuade the woman that they have met before, that they have been in love, that she begged for a period of separation but promised to meet him in a year, and that now the year is up. At the outset she resists, denying that she has ever met him before. Then, as he produces more and more circumstantial evidence and ultimately concrete proof in the form of photographs and a bracelet, she yields, at first reluctantly, even hysterically, projecting fantasies of rape, murder, and suicide, then more willingly, until in the end she goes off with him. Summarized in this superficial way, the narrative seems relatively simple, but in fact it is not, for the subject matter is not only seduction, but the enigmas and ambiguities of time. Past, present, and future become so intricately intertwined that we cannot separate one from the other, and the structure of the film seems to substantiate one description of its creation: the filmmakers had set out with the idea of making a conventional mystery film and then had deliberately mixed up the time sequences so that the work itself became a mystery. We, like the woman, are seduced, perhaps by truths, perhaps by deceptions—we cannot be sure. Robbe-Grillet, on the other hand, describes *Marienbad* as a film in which the images appear as they appear in a mind, without necessarily perceptible con-

right: 553, 554. Last Year at Marienbad.
Alain Resnais and Alain Robbe-Grillet. France, 1961.
Ambiguities of time are developed by a cut in
which the only significant change is the costume.

below: 555, 556. Last Year at Marienbad.
Alain Resnais and Alain Robbe-Grillet. France, 1961.
As the camera pans away from a character only
to find him elsewhere, ambiguities of place are
insinuated.

553

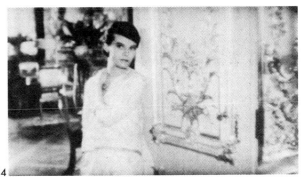

554

nections. This description seems more likely.
Probably the simplest way to view the film is
as a continuous flow of images representing
what A is seeing, hearing, imagining, recol-
lecting, and anticipating.

Toward the beginning of the film, an anon-
ymous man tells a story to a group of people
including A and M: "It was all anyone talked
about last year. Frank had convinced her he
was a friend of her father's and had come to
keep an eye on her. It was a funny kind of
eye, of course. She realized it a little later: the
night he tried to get into her room But
his presence here has no connection, my dear,
absolutely no con . . ."[3]

Near the end of the film—at approximately
the same distance from the end as the anony-
mous man's anecdote is from the beginning—
M discovers a photograph of A, which X
claims to have taken, and asks A who took it
and when. She replies that she doesn't know;
perhaps it was Frank, the previous year. But
Frank wasn't there the previous year, he says.
And we wonder: Is X Frank? Is A the woman
of the anecdote? Was the narrator of the story
unaware of her identity? Did X meet A the
previous year, enter her room, and take her
by force? Did she perhaps suffer a breakdown,

suppress the memory, and is she now through
X's words recovering her past? Or are we now
back in last year? We cannot know because
the filmmakers do not consistently distinguish
past, present, and future, illustrations of dia-
logue, actual events, and fantasies. Occasion-
ally there is a clue in the action or tonality.
Sometimes as he tells his story of last year, X
makes corrections, and corresponding correc-
tions are made in the visual image: when he
describes how A was standing, for example, A
changes her position to conform to his de-
scription. Shots associated with the so-called
rape scene are so underexposed that they seem
set off as fantasy (Fig. 562), although X's im-
mediate denial that he took her by force again
causes us to wonder whether the scene is real-

555

556

557

558

559

557–559. *Last Year at Marienbad.*
Alain Resnais and Alain Robbe-Grillet. France, 1961.
The continuation of a scream carries a character and the
spectator from one time and place to another.

although there is no cut, discovers members of the first group now forming part of the second in a different place (Figs. 555, 556). Or, as X continues his speech uninterrupted, there are cuts from a shot of A in one costume to a shot of her in the same place but in a different costume (Figs. 553, 554). Or there are cuts from A on the terrace to A in the bar wearing the same costume and facial expression, the sound of her scream bridging the cuts (Figs. 557–559).

Through most of the film we hear X talking, sometimes as if in a dream, first quietly insistent, then more and more intense, and impatient as A persists in denying that she has known him, that she had agreed to meet him. As he tries to produce more circumstantial evidence by describing her room, her costume, and her action in detail, he falters, as if his memory were failing or as if he never knew. Once he seems clearly to be inventing facts, apparently molding events to suit his will. And as his voice drones on, slurring over hours and days, other ambiguities arise. His sentences are completed by someone else or his ideas are pursued and his questions answered by anonymous passersby. More often than not, his words and dialogues with A have little relation with what is happening on the screen.

Events seem to occur without apparent connection to what precedes and follows them, while action that seems continuous is interrupted: A, leaning against a bar with X a short distance away, suddenly becomes transfixed with horror. The camera advances for a close-up. There is an abrupt cut, and a number of unrelated incidents occur. Then there is another close-up of A and she begins to scream. There are more unrelated shots, and then again a return to her scream and her collapse. Are the scenes interspersed between the shots of her screaming actually images of what she is thinking? Perhaps, although they seem innocuous enough. Time is amiss, now present, now past, now, in a way, timeless. We are caught in a whirlpool of tenses that sucks us into a center of either no time or all time.

Despite the fact that we are not always sure when things are happening, there is a dramatic development—in the changing character of X's arguments, in the increasing inten-

ity, memory of reality, or unbridled fantasy, whether he is Frank and whether this is the incident described in the anecdote.

M's murder of A is presented in a normal range of tones (Figs. 560, 561), and that surely is a fantasy of what M would do if A left him. Or is it? Illustration, memory, fantasy, present action, all seem to have the same reality. Over and over again the movement of the camera and the sequence of the cuts fuse different times—recognized by changes in A's dresses—and different places. The camera leaves one group of people to search out another and,

right: 560, 561. *Last Year at Marienbad.*
Alain Resnais and Alain Robbe-Grillet. France, 1961.
The possibility of murder presents itself.

below: 562. *Last Year at Marienbad.*
Alain Resnais and Alain Robbe-Grillet. France, 1961.
The underexposure may express memory, fantasy,
possibility, certainty, or ecstasy.

560

561

sity of his voice, in the rising tension that culminates in the shooting and rape, in the gradual acceptance of X's arguments by A and by us. The suspense is heightened by the recurrent introduction of a mysterious game M and X play against one another with counters. And underlying the seeming confusion and the drama there are other almost imperceptible patterns, subtly woven and delicately advanced. But in the end they are perhaps as significant as anything we have considered.

When first heard, X's monologue—or dialogue, as the case may be—is concerned with repetition and endlessness. "Once again—I walk on, once again, down these corridors, through these halls, these galleries, in this structure—of another century . . ." It is a theme to which he returns again and again, although with decreasing frequency and finally only by passing allusion. As the film proceeds, X becomes more and more concerned with the specific events of the past, bringing them into the present in generalized terms, then in more and more concrete words, and finally by producing the material proofs—the bracelet and the photograph. At this point, a curious coalescence of past and present occurs: A begins to add details to X's descriptions of places and events, and X begins to talk as if A had agreed to go off with him the previous year. Then, in one scene, present and past are fused as the still photograph X claims to have taken seems to come to life, and in the same setting the two appear together.

When it is apparent that A concedes the past relationship but resists departing with him, X begins to describe her departure as if it had already happened. The images and the descriptions of events begin to coincide; miraculously, events that in the context of the movie will take place in the future but are described as if they had already happened are actually occuring in the present. Simulta-

neously A *will leave, is leaving, has left* with X, during a performance of a play to which all the other guests, including M, have gone.

Clearly, it is in the tension among tenses as well as in the act of persuasion and in the individual incidents that the drama exists. We are in a maze of time searching our way out, but, as some of the characters are made to say, there is no escape. The theatrical performance occupies a provocative position in the film. Like the references to Frank mentioned earlier it appears at roughly the same distance from the beginning of the film as from the end, so that a certain symmetry in time scheme arises. Time, however, if it progresses, cannot have symmetry, which implies a beginning and an end, a fixed axis, and a balancing point.

562

563

left: 563. *Last Year at Marienbad.*
Alain Resnais and Alain Robbe-Grillet. France, 1961.
A assumes a pose and appears in a setting that evokes the actress on the stage in Figure 551.

below: 564. *Last Year at Marienbad.*
Alain Resnais and Alain Robbe-Grillet. France, 1961.
The stasis of the final shot suggests an escape from time.

At the beginning of the film, after his initial description of his return to the hotel, X, whom we have not yet seen, asks "Are you coming?" And the actress on the stage says, "We must still wait—a few minutes more—no more than a few minutes, a few seconds more," And after a continuation of this kind of interchange, the actress says, "Very well. Now I am yours."[4] She falls into a position with her head turned toward her left and her right hand touching her left shoulder, a position A adopts repeatedly during the rest of the film. At one point A is placed in a spatial configuration that evokes the stage (Fig. 563).

Near the end of the film A speaks very much as the actress did, "A few hours more is all I'm asking for," to which X replies, "A few months, a few hours, a few minutes. [A pause.] A few seconds more. . . as if you were still hesitating before separating from him . . . from yourself . . ."[5] The play on the stage and the play of the film seem to converge, as if one were an extension of the other, as if time were finally captured in the work of art, which exists inside and outside time at once.

For a moment it is as if the whole cycle of events were going to begin all over again; but the final shot and the final words stop short of any possibility of further development. In contrast to the mobile shots at the beginning, there is a final static shot of the hotel, quiet, horizontal, symmetrical, classically disposed (Fig. 564), and there are the words, "you were now already getting lost, forever, in the calm night, alone with me."[6] As quickly as it does in our lives, the future has become the past.

What has happened? In Robbe-Grillet's words, A "seems to accept the identity the stranger offers her, and agrees to go with him toward something, something unnamed, something *other:* love, poetry, freedom . . . or maybe death"[7] The separation of the last phrase seems provocative, for the end of the film is, like death, still. Perhaps it is in death as well as in art that all becomes static, while past and present and future are locked together "forever."

NARRATIVE IN INDEFINITE TIME AND PLACE

Metaphorical cutaways from principal theme to material not directly related to it—the orator and the canary in *Ten Days That Shook the World*—generally can be thought of as existing in indefinite time and place and as serving as discursive comment by the author. Agnès Varda, exploring some of the possibilities in relationships between male and female and considering the proposition that happiness consists of submitting to the will of nature, at one point cuts away to a lion and lioness in the zoo.

564

9
Modes

We have so far been concerned with the materials, methods, and processes of the film medium, with space, time, color, and sound as well as the ways in which they are presented and modulated, combined into filmic chords, and organized into space-time structures—that is, with the way the materials are given form. From the beginning it has been apparent that form conveys content. We should be entirely clear in our definition of content, however, for the word inevitably has different meanings for different people. Often the content of a film is identified with verbal paraphrases, with summaries, descriptions, and analyses such as appear in this book. Screenplays, which are essentially no more than transcripts of dialogue, or scripts, which provide precise information about sound and image, are also thought to represent a film's content. But none of these, no matter how detailed, contains more than a skeleton. The configurations of light and shade, the specific quality of gesture, the peculiar timbre of voice, the precise movement of the camera, the sound of the music, the tempo of cutting, and the reciprocal relationships among them —all the elements that express, define, and circumscribe the content—are absent. Summaries, descriptions, screenplays, and scripts may serve as orientation for the reader or as a guide for the filmmaker, but their function is limited; they can identify the subject matter, but they cannot convey the content.

Only in the experience of seeing a film, in the direct confrontation with the tectonic or organic whole, which is the form, do we discover the content. Content and form are inseparable, and although we may distinguish one from the other for the sake of discussion, they are not even so separate as two sides of the same coin; rather, they are the identical material, the same side, seen from two angles of vision. Together, as form-content, they constitute a filmmaker's style.

Discussions of style often appear to suggest that it is a set of personal or traditional mannerisms applied to preexisting content; a means of translating from one state or medium into another; a method of interpreting one mode of being, thinking, or feeling by another. Such expositions proceed, that is, as if style

were form imposed on content. So Cézanne, painting his favorite mountain, Sainte Victoire (Fig. 45), can be said to interpret objective reality in pictorial terms, to translate his perceptions into pictorial structures, or to impose aesthetic order on the seeming chaos of nature. As descriptions of Cézanne's method, statements of this kind are not entirely without validity and seem at times to be substantiated by his own comments about his work. But they do ignore some obvious facts— that the Mont Sainte Victoire of the painting does not exist until Cézanne has painted it, that Cézanne's perceptions include not only the existing mountain but also the painting he is creating, that Cézanne is not imposing order on nature but creating order on canvas, that the meaning is not discovered until the picture is painted.

Indeed, the act of creation can be thought of as an act of discovery, as Picasso maintained when he said "I do not seek, I find." Chance, the unexpected, the unforseen, and the compulsive play their roles in even the most carefully planned work of art; in the 20th century, artists have conceded their inescapable presence and have accepted and cultivated them. Filmmakers have seized upon chance from those early days when, for example, the makers of Mack Sennett comedies dashed off at the spur of a moment to build films around current happenings. In more recent times, Bob Rafelson could not decide how *Five Easy Pieces* (1970) should end until he filmed the ending.

The mountain, the current event, or the script are no more than the nominal subject matter, the pretext, or as Cézanne would have said, the motive. The meaning is in the form-content, the style. Style is, thus, not an extra added attraction, but the matrix of meaning. It is present in any film, whether the maker is an amateur recording the family, an inventive genius, or an imitative hack. The differences in the end are not of kind but of quality and quantity, for we are all artists, a point we tacitly acknowledge when we talk about life styles. In fact, whenever we use language we engage in artistic activity; some of us simply have less to say and less adequate means of saying it than others.

There are historical, national, regional, and personal styles in film as in any other art, and each is a compound of historical precedent, contemporary attitudes, and individual predilections. To examine them in all their variety would carry us far beyond the scope of this book, but we can begin to comprehend the nature of style in film if we consider a number of basic modes of filmic expressions discernable among the myriad of individual styles: the formalist mode, the realist mode, the fantasist mode, and mixed modes.

In dealing with a medium as complex as film, any such classification is likely to seem an unsatisfactory and misleading oversimplification, especially when the categories are not mutually exclusive as these modes are not. A realist, after all, may make excursions into fantasy, and a fantasist may try to give dreams the authenticity of reality. The line of demarcation between the two may seem tenuous in fictional film in any case, as descriptions of Hollywood as a "dream factory" suggest, although the reference here is more to subject matter than to style.

Since the early 1950s, the distinction between reality and fantasy has frequently been obliterated, as in Fellini's $8\frac{1}{2}$ (1963). In one scene, Guido, the central figure, sits in a terrace restaurant with his wife and contemplates what might happen if his mistress appeared and the wife and the mistress became friends. The daydream is enacted. But there are none of the traditional clues to distinguish the dream, no change of light, blurring of focus, distortion, dissolve, or vignetting, only an ultimately ambiguous action: Guido settles back in his chair and smiles enigmatically. Objective realism and fantasy thus may seem at first to be indistinguishable. However, in this case fantasy is simply the subject matter. The mode of presentation is realist and the form-content very precise. Fellini interprets the dream as fact, as operating within the context of reality, as having as much reality as what we normally label reality, and as deserving the same claim to examination, evaluation, diagnosis, and acceptance as do the various other dimensions of Guido's life.

The mode of presentation, then, fleshes out the skeleton provided by the subject matter, and further develops the overtones and undertones, the specific coloration that give meaning to the scene or the film as a whole. It is style in its most general manifestation. The mode is not always so easily circumscribed as it is in $8\frac{1}{2}$, however. Fantasy and realism sometimes do coalesce in a more ambiguous way. (An example is Jean Vigo's *Zéro de conduite* [*Zero for Conduct;* 1933], which we will consider shortly.) And both may be limited by the controlling force of the formalist approach, as realism is limited in *Praise the Sea.* But if specific films, scenes, and personal styles do not lend themselves to easy classification, and if the method of classification seems at times ambiguous or arbitrary, it is all to the good. For our purpose in discussing the modes is not to impose rigid schemes of classification, but to initiate a concern with style and to establish a framework for considering aspects of the film that we have until now either taken for granted or ignored.

Since this book has been concerned so frequently with form, and since any film exhibits some formal qualities, even though it may strive to avoid them, it will be appropriate to consider the formalist mode first.

FORMALIST MODE

Whatever the subject matter of the film, whether it be geometric shapes, documentary reportage, or film drama, the method of presentation in the formalist mode generally exhibits most of the following characteristics. Spatial configurations tend to be clearly defined, reducible to simple geometric shapes, and arranged in architectural relationships. Action, camera movement, sound, and cutting display easily perceptible rhythmic patterns consistently throughout the shots, series, scenes, sequences, or the entire film. The development from exposition to climax is usually regular and deliberate. Shots, series, scenes, and sequences are clearly distinguishable from one another. In fictional film, acting and dialogue are relatively stylized. The overall effect is of rational control and imposed order, even in the most dramatic and emotionally intense subjects like the "Odessa Steps Sequence" from *Potemkin.*

left: 565. *Rhythmus 21.*
Hans Richter. Germany, 1921.

right: 566. *Lichtspiele.*
László Moholy-Nagy. Germany, 1925–30.
This light requisite machine was especially designed for the film.

Many films are simply studies in form, the visual equivalents of musical compositions in their abstraction. An early important example of the abstract film, *Rhythmus 21* (1921) by Hans Richter, illustrates the basic character of the genre. Simple geometric shapes glide about the picture space animated by a variation of standard techniques in which different-sized cards are substituted for drawings of phases of action (Fig. 565). Every aspect is carefully controlled. The tones tend to be dark, medium, or light in value. The shapes are squares and rectangles that echo the shape of the frame. Whether they advance or retreat, expand, contract, or slide across the screen, they move in directions harmonious with the format—that is, horizontally and vertically. The rhythm of action is as clearly articulated as the patterns of movement, and the tempo is slow, deliberate, and studied. The total effect is of calculated harmony, balance, logic, solemnity, and, in a way, mystery.

The materials and structure of *Rhythmus 21* are rather simple. László Moholy-Nagy's *Lichtspiele (Film; 1925–30)* is much more luxurious in its patterns of tone and shape, more varied in its movement, and more dramatic in its overall structure. *Lichtspiele* takes as subject matter the patterns of light and shadow created by a machine especially designed for the film, an abstract mobile construction of perforated plates and rods called a light requisite machine (Fig. 566). From varying angles and distances and under different angles of illumination there are shots of the machine itself, the cast shadows, and the two together. The dominant shape is the circle; and since the construction moves in eccentric revolutions, the forms seem to swim across the picture space in arclike trajectories, so that spatial configurations can hardly be called tectonic. Nevertheless, the film is extremely formalized, not only in its geometric subject matter but in its temporal structure. The regular revolution of the machine produces a steady metrical beat; the change of illumination, distance, angle of vision, and subject is systematic; and the cutting rate—now conforming to the insistent metrical pattern of the machine, now contrasting with it—accelerates and decelerates in logically established order, injecting a sense of organic vitality into the sterile world of mechanics and plane geometry.

Rhythmus 21 and *Lichtspiele* exemplify formalism in its purest manifestation. Fernand Léger's *Ballet mécanique* (Figs. 567–578), which we have discussed earlier (p. 66), is a classic example of a film using already existing objects and people as the raw material for a construction. Here the primary concern is neither information nor narrative but form, as the title itself may suggest. Opening with a simple, slow, regular movement of a pendulum, a woman on a swing, and a swinging reflecting ball similar to a Christmas tree ornament (Figs. 567, 568), *Ballet mécanique* builds formal rhythms by an astonishing variety of means, sometimes simply presenting the

movement of machines (Fig. 569), sometimes multiplying and complicating the movement by viewing it in reflecting surfaces or through refracting lenses (Fig. 577), sometimes animating immobile forms (Figs. 575, 576).

The tempo accelerates in the action of the machines or the rate of the cutting or both, at times following a single beat, at times developing complex polyrhythms. As in Léger's painting and sculpture, the human is revealed in its most mechanical aspect. The young woman in the opening sequence swings back and forth; eyes open and shut and lips smile in automated rhythms (Figs. 570, 571). A woman viewed from above as she climbs some stairs is transformed into a robot by the simple

567–578. *Ballet mécanique.* Fernand Léger. France, 1924.
Using animate and inanimate objects, the film assumes a dynamic, rhythmic form.

567

568

569

570

571

ON A VOLÉ
UN COLLIER DE PERLES
DE 5 MILLIONS

572

573

576

574

577

575

578

567–578. *Ballet mécanique.* Fernand Léger. France, 1924.

repetition of the shot, which—since she is never allowed to reach to top—carries with it overtones of humor and frustration (Fig. 578).

Everywhere Léger's wit comes into play, even in the shots of objects, among which he discovers surprising and amusing similarities, so that non sequiturs assume an absurd logic in form. There is a hint of expressionistic nar-

rative in a sequence involving the announcement in bold-faced type, "A pearl necklace worth $5,000,000 has been stolen" (Fig. 572). Shots of the individual zeros become like shouting mouths, a reference, perhaps, to the attempts of some silent filmmakers to create a sense of increasing volume of sound in their titles by enlarging the type

size (Fig. 573). But wit, comedy, and narrative are purely visual and formal; any irony we may discern in the identification of man and machine is free of sociological overtones.

In none of these films is there a significant narrative content, although the accelerating and decelerating rhythms and the development to formal climaxes give the works a structure that corresponds to narrative development. The three films, in fact, are primarily studies in formal orchestration of the visual track, but even the documentary can be structured in the formalist mode. *Praise the Sea,* a lyrical interpretation of the environment of the Netherlands, examines the setting and the character of the Dutch people (Figs. 178, 179, 221) and transmits its ideas for the most part through formal relationships, eliminating narrative—except for the shipbuilding sequence—and dialogue—except for the words of a hymn.

In subject matter *Praise the Sea* moves from wheat fields to windmills to canals to dike building to the cityscape with its dwellings, commercial buildings, and churches, to sailing, shipbuilding, and ship launching. It develops its theme by allusion and proposes not only a comprehensive view of the different aspects of Dutch life, but also a symbolic history in the change of emphasis from agriculture to industry, always relating the material to the sea. At the same time, the film alternates in attention from things—the landscape, cityscape, boats, and the like—to the people who use them, control them, build them. In each sequence, camera movement and movement within the frame is directly related to the central theme.

In the agricultural sequences, the sweep of windmill vanes (Figs. 178, 179), the rotation of the mill wheels, the rippling of the grain in the wind, the movements of a farmer adjusting the vanes, the action of scythes, and the milking of a cow all are harmonized in spatial configuration and action, while the lens tends to zoom in and out of the space and to pan smoothly in a rhythm and at a speed harmonious with the action it records. The sequence concerned with operating boats and building dikes, in which the movement of boats and steam shovels is characteristically lateral and horizontal (Figs. 180, 181), is developed by

panning and by lateral tracking. The views of architecture, with its rectangular structures, are accompanied by abrupt cuts and alternating lateral and vertical movements of the camera, which punctuate time as the windows and other structural elements punctuate the space. With the shipbuilding sequence, which observes the slow, deliberate, and suspenseful operation of putting a sheathing plate in place, the movement of the camera is stopped, the duration of the cuts is lengthened, and the rhythmic impetus is carried by the delicate movements of hands, the chuffing of the engine, and the staccato sounds of machinery. Transitions from one shot to another are carefully plotted in spatial composition and action, while the repetition of movement and images provides rhythmic pulsation and a kind of visual rhyming. The whole becomes as formally ordered as an oratorio in praise of the sea.

The effect that the formalist approach produces is quite different from the effect that would be created by a more laconic, reportorial presentation. Formalism elevates the themes above the ordinary, invests them with a certain nobility and grandeur, and bestows on them an almost epic and heroic quality that no straightforward illustration would quite achieve. In the filmplay it is the work of Eisenstein more than anyone else that is consistently characterized by its attention to formal organization, as our comments on *Potemkin* and on Eisenstein's methods of direction have perhaps suggested. Eisenstein's theory of montage (see pp. 116–121) seems to imply a formalistic approach with its concern for dialectical organization based on conflict and tension. In fact, the theory may be utilized with varying degrees of concern for the niceties of formal structure, and, if one thinks of the cell or shot as being essentially a means of conveying an idea, it may exhibit no formal structure other than contrast from shot to shot. In Eisenstein's work, however, the attention to each aspect, dimension, and detail of the film is extraordinary. Formalistic structure in the screenplay achieves its most complete expression in *Ivan the Terrible, Part I* (Figs. 579–599).

The film examines Ivan's personality, his consolidation of power within Russia, his con-

579

quest of the neighboring Asiatic state of Kazan, the expansion of his power within the European sphere, and his conflict with the boyar princes at home. It opens with the coronation of Ivan, a ceremony of high pomp, the description of which is interrupted regularly to reveal the varying reactions of those in attendance—awe, joy, delight, amusement, cynicism, indignation. Then, in his first speech as czar, Ivan announces his policy: an end to the power of the boyars, the establishment of a national army, taxation of the monastic orders and the wealthy aristocracy, and the retrieval of Russian lands under foreign domination. Among those affected, the reaction is of barely suppressed outrage. One of the major conflicts is established.

After the coronation, the scene shifts to the wedding banquet of Ivan and Anastasia, who are seated on a dais between Ivan's two closest friends. While one announces his intention of retiring to a monastery, the other, Kurbsky, reveals that he is in love with Anastasia. As the festivities proceed, the hall is invaded by representatives of the people, who demand protection from the Glinsky faction of boyars. No sooner has Ivan won the confidence of the people than he is confronted by emissaries from the neighboring Kazan, who threaten the destruction of Moscow. Ivan responds by declaring war on Kazan. All the major conflicts of the narrative have now been established.

The scene then moves to the arrival of the Russian armies in Kazan, the seige of the city, the preparation for dynamiting the fortifications, and the explosive destruction. Returned to Moscow, the czar falls ill and is apparently at the point of death. In the palace corridors, Euphrosyne Staritsky, Ivan's aunt and a boyar leader, rounds up support for the election of her feeble-minded son Vladimir to the throne, enlisting the aid of Kurbsky, who has become jealous of Ivan's powers. In Ivan's bedchamber priests celebrate extreme unction. The ritual completed, Ivan pleads with the boyars to support the succession of his infant son. When they refuse, he flies into a rage and falls to the floor unconscious. Thinking Ivan dead, Kurbsky attempts to consolidate his position with Anastasia, then, discovering from Anastasia that Ivan is still alive, hastens to take an oath of allegiance just as Ivan appears.

In the next scene Ivan instructs his ambassador to England, scheming to extend his power to the west. Anastasia falls ill and dies, poisoned by Euphrosyne. While Ivan mourns by her cenotaph in the cathedral, there is a running commentary on his defeats and frustrations. Ivan summons friends he has made among the common people and creates the Oprichniki, a personal guard. Then he announces his intention of withdrawing until the people seek his aid, which they do. In the final scene Ivan accepts their plea to resume his role.

While there are a great many shifts in locale, it will be evident that Eisenstein has constructed the film in five acts:

580

581

I. The assumption of power and clash with the priests and boyars
II. The wedding and the conflicts—personal with Kurbsky, political with the Glinsky, international with Kazan
III. The siege and the destruction of Kazan
IV. The illness of Ivan, the disagreement over the succession, and Ivan's recovery
V. The expansion of Ivan's power abroad and consolidation of his power at home as an isolated figure, bereft of wife and friends, but with a private army and the will of the people to support him

The structure of the narrative is thus symmetrical. The first two acts begin in celebration and end in conflict. The third act presents Ivan as a triumphant ruler with an almost mystical power. The last two acts begin with conflict and end with triumph, the procession of the people at the end corresponding to the court celebration at the beginning. Contrasting with the symmetry of structure is the linear progression in the development of Ivan's personality and the change in his relationship to the court and the people, which evolves logically out of Ivan's nature and the position in which he finds himself.

Each act is announced by an emblem that symbolizes both a phase in Ivan's development and an aspect of his personality, further establishing a geometric shape that will dominate the spatial configurations throughout the act. The coronation ceremony emphasizes the crown (Fig. 579), an obvious reference to the event and to Ivan's regal position and commanding personality. The clearly domical shape dominates the sequence just as Ivan dominates the situation, the princes, and the populace. This shape recurs in the cathedral interior (Fig. 580), in the patterns of light and dark (Fig. 581), the massive volumes of the individual figures, the paths of much of the action—whether of heads, hands, or whole figures—and even the line of the music.

The second act is associated with the arc. It is introduced in the arches of the entrance to the palace and the halberds of the guards (Fig. 582), is carried into the decoration around the wedding couple (Fig. 583), the profiles of the utensils (Fig. 584), and the weapons of those who interrupt the feast (Figs. 585, 586). In its association with halberd, sword, and knife, the arc symbolizes military power; but its relationship to the arch is not without implication as well. Like the arch, Ivan in this sequence bridges the gaps between persons and groups, and, like the arch, he is possessed of physical—as well as psychic—strength.

The third act centers on radial patterns. These first appear in the wheels of guns and wagons as Ivan's army journeys to Kazan (Fig. 587). They reappear in the main lines of the *tableau vivant* in which Ivan is seen standing like an icon on a hillside before his tent (Fig. 588). Then radial patterns are formed by the fuses leading from dynamite charges fixed in

582–586. *Ivan the Terrible, Part I.*
Sergei Eisenstein. U.S.S.R., 1944.
A joyous wedding feast is suddenly interrupted.

587

589

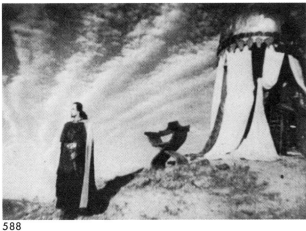

588

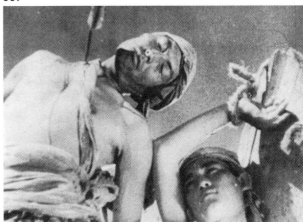

590

the tunnels the sappers have been excavating under Kazan (Fig. 589). Finally, they characterize the forms in which Kazan's captives are arranged (Fig. 590), and in the configurations, smoke, and debris created by the explosion (Fig. 591). As a symbol the radial patterns suggest the expansionist policy of Ivan's regime, his driving will to power, and his explosive personality.

The fourth act focuses on the eye, which is present at the outset in a mural depicting the eye of Christ (Fig. 592). One of Ivan's eyes is seen peering out from under a Bible on what was to have been his deathbed (Fig. 593), and Alyoshka, Ivan's watchdog, spy, and informer, is shown with one eye covered by hair, the other visible (Fig. 594). Similar lozenge shapes recur in subtle ways throughout the act (Figs. 595, 596). The reference to Christ reminds the spectator of his betrayal, death, and resur-

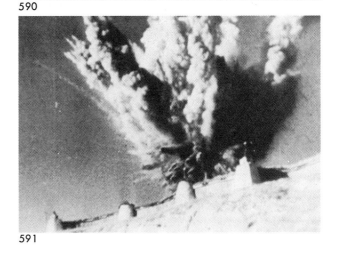

591

587–591. *Ivan the Terrible, Part I.*
Sergei Eisenstein. U.S.S.R., 1944.
Ivan goes to Kazan to seize and destroy it.

rection, which Ivan seems to reenact, the allusion reinforcing our awareness of Ivan's transformation from earthly saint to religious mystic, and—a more modern touch—suggesting a canny watchfulness that has approached paranoia. In addition, much of the action involves looking and seeing.

The fifth act is associated with the silhouette of the eagle, which Ivan has come more and more to resemble (Figs. 597, 598). Its ragged contours seem appropriately expressive of the torn character of this phase in Ivan's life, when Anastasia has died and most of his followers have defected, but it serves primarily to evoke the idea of a man as solitary, courageous, and strong as the eagle, a man driven by the spiritual force the eagle has come to symbolize in the Christian tradition.

In their association with Ivan, all five motifs—the crown, the arc, the radial pattern,

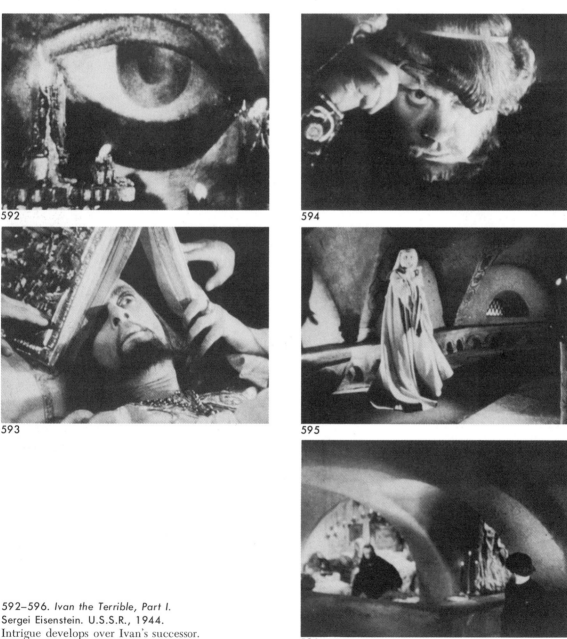

592

594

593

595

592–596. *Ivan the Terrible, Part I.*
Sergei Eisenstein. U.S.S.R., 1944.
Intrigue develops over Ivan's successor.

596

the eye, and the eagle—evoke the Christian representation of Christ in majesty, which depicts Christ in a mandorla surrounded by a man, a lion, an ox, and an eagle—symbols simultaneously of the four evangelists, Matthew, Mark, Luke, and John; of the books they wrote; and of the aspects of Christ they stressed (Matthew the human qualities, Mark the regal lineage of the King of Kings, Luke the sacrificial victim, and John the divine nature). Viewed in slightly rearranged order, they suggest the ancestry, incarnation, death, and resurrection of Christ, just as Eisenstein's symbols suggest the assumption of power, the consolidation of power, the expansion of power, the transformation of Ivan, and his final isolation. If particular shapes dominate the successive acts, once they are introduced they are never dropped but become subdominants until, in the last scene, crown, arc, radial pattern, lozenge, and eagle operate with equal force as the concrete manifestation of Ivan's total image (Fig. 599).

Like *Potemkin, Ivan* is edited with solicitude for spatial harmonies and dissonances. The composition of each shot either harmonizes with the preceding one or clashes violently with it, depending on the situation. There are changes from tautly organized tectonic arrangements to freer baroque compositions. Costuming facilitates the use of human beings as plastic forms, the long robes giving the figures the appearance of Renaissance chessmen and creating a consistent monumentality and harmony that links them with the architectural settings.

Ivan's physical shape changes as the film proceeds. Initially, it is similar to the shape of the other characters, but ultimately, as Ivan grows more amd more isolated and individualized, his body becomes elongated and, at the end, is as gaunt and ascetic as a Byzantine hermit saint. The tonal organization, too, is modulated to reinforce and intensify dramatic content and to create a parallel rhythm of change both within the acts and throughout

597

598

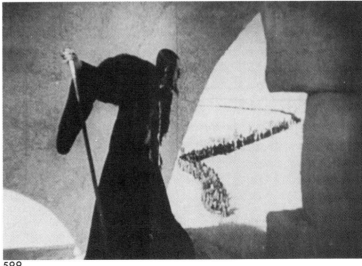

599

597–599. *Ivan the Terrible, Part I.*
Sergei Eisenstein. U.S.S.R., 1944.
Once again power is consolidated in Ivan.

the film as a whole. Apparent is a tendency to exploit the dramatic potentialities of strong contrast between light and dark, as is consistent with Eisenstein's dialectic approach. Yet each act, and each sequence within the act, exhibits a distinctive character in the organization of tones depending on whether they tend to utilize a full range of values, to multiply the darks and lights, or to encompass a progression from one kind of emphasis to another.

The first act generally presents a full range of values, although the dramatic contrast of crowded lights and darks appears as Ivan's speech concentrates on a clash of wills. The second act opens with a shot of the guards standing in the courtyard. The low key of this setting provides a transition from a dark screen to the light tonalities of the wedding feast. However, the principal characteristic of the tonal organization is a transition from high key to low key as the wedding celebration is interrupted and the sense of conflict becomes more and more intense. The siege of Kazan reverts back to the relatively full value range of the first act, thus introducing an alternation in tonal character from act to act. The fourth act, concerning Ivan's near death and the struggle for power, is generally of a low key. The fifth act, beginning with a relatively full value range—although with some crowding of lights and darks—moves to a low key when Ivan visits the cenotaph, and then to a high key at the end. The changes thus summarize the basic possibilities in tonal composition and at the same time reflect in reverse the tonal development of the second act and directly conform with the dominant mood of the action. The visual tonality thus mirrors the expressive tone of each act. The full value range of the first act provides a coloristic richness consistent with the luxuriousness of the setting and the pomp of the ceremony. The lightness in tone at the wedding ceremony parallels the lightness of mood, and the developing contrast stands as a metaphor for the conflicts in the state. The full range of values apparent in the third act is appropriate to the range of Ivan's power. The low key of the fourth act reinforces the narrative mood of melancholy and distrust. And in the fifth act the transition from

a relatively full value range in the earlier section to the dark of the middle and the light of the end conveys the emotional change Ivan experiences—from authority to melancholy to exaltation.

Even in the acting the dialectic approach is evident. The players move in a highly stylized manner that contrasts action with inaction, movement in one direction with movement in another. Static, operatic posturings give way to slow and deliberate movements that are calculated to describe expressive patterns in the picture space and to provide accentuating foils to more abrupt, vigorous, fluid motion.

In the first act, for example, a series of close-ups describe the investiture. Ivan's left hand moves in from the right to grasp the orb, his right hand enters from the left to grasp the scepter, and the attendant priest lowers the crown from above to his head. As he delivers his speech, Ivan, seen in close-up, regularly and abruptly turns his head to the left or the right, punctuating his announcements by his movements. A series of shots of the audience shows ancient members of the aristocracy turning their heads also, first one to the right, then one to the left, and so on. In a bedchamber scene from the fourth act and again in the scene with the ambassador in the fifth act, Ivan rises to cross the room, but rather than moving from point to point, he strides first in one direction, then in another, describing a zigzag path through the space. Such action introduces a strong rhythmic pulsation while reinforcing the expressive content of the gestures.

The rhythm of movement is accompanied by a rhythm of cutting that augments the intensity of the mood and gives emphasis to the character of the action. In the coronation scene, the shots of the actual ceremony tend to be relatively long in duration while the action is restrained, enhancing the impressiveness of the ceremony. The cutting of reaction shots, on the other hand, is more rapid, suggesting the agitation and, in the end, the conflicts.

The sound track is carefully integrated with the visual images: the dialogue is similar to verse, as even the translation of Eisenstein's

script suggests, while the music, for the most part, parallels both the spatial pattern and the rhythm of movement. This synthesis of musical sound, action, and spatial configuration is exemplified by the rising sounds of the bass soloist at the coronation, which is accompanied by rising and falling gestures of his arm, and, reading across the frame, rising and falling spatial accents.

Eisenstein's shaping, controlling, creative will manifests itself in every dimension of the film, interposing a significant distance between the film and reality, elevating the narrative to epic import, enlarging the elements to heroic proportions, and transforming biography into symbol. As a result, although the introductory titles maintain that the film is about Ivan the man, not Ivan the legend, the czar emerges as a legendary figure.

Ivan the Terrible, Part I is a monumental film, overwhelming in its dramatic power and also in its control over filmic materials. It is perhaps not inappropriate at this point to recall that the formalist mode may be applied to less epic themes, like the abstract and documentary films we considered earlier. It can evoke comic, lyrical, and romantic moods as well as operatic and heroic ones. The form may be more loosely structured than our examples have suggested. The films of Josef von Sternberg are a case in point.

Von Sternberg's plots tend to be comparable to those one would have found in the popular novels of the period. They are contrived in their development, superficial in their analysis of character, and endowed with spurious profundity and implications of elevated symbolism. With their interpretation of woman as temptress, vampire, and destroyer, they sometimes appear more in tune with the 19th century than with the 1930s when they were made. But Von Sternberg's genius, with all its baroque extravagance, redeems the romantic narrative and superficial interpretations of character, investing them with a lyricism and power largely dependent on the formal structure.

The formalist mode does not necessarily imply the tectonic approach characteristic of Eisenstein's methods of montage. Von Sternberg found many ways to maintain and modulate the rhythmic pulse without resorting to cutting, some of them dependent on the careful planning of action, some on the potentialities offered by the moving camera. In extended shots he was able to obtain effects comparable to those associated with cuts, wipes, fades, and dissolves, in much the same way Agnès Varda did in the dance sequence from *Le Bonheur* (Figs. 448–451).

A tour de force of this kind of structuring is Miklos Jancsō's brilliant and powerful film *Red Psalm* (1972). The film is concerned with a peasant revolt during the 1890s, in which socialist tenant farmers strike against feudal landowners, the state, and the army. It interprets the incident as a drama of ritual and symbolic confrontations in a manner that seems to fuse folk opera, dance, and pageant, while the structure of the film beautifully supports this interpretation. Although 88 minutes in length, *Red Psalm* contains only 26 shots, of which about half a dozen last roughly 20 seconds, the rest an average of between 4 and 5 minutes.

Jancsō apparently shot the film in a single location, a broad plain, and choreographed the movement of the camera and players with all the care one would expect of Eisenstein. In fact, the film might illustrate how Eisenstein's ideas of rhythmic, tonal, overtonal, and intellectual montage can be employed in long takes. The camera's movements are arranged in regularly recurring patterns to provide a basic rhythmic structure against which the more varied action of the players is built. As the camera moves, the field of vision may shift from close-up to long shot; people, horses, and objects—like trees and haystacks—may intervene between the camera and the principal players; and the dominant hue and intensity of light may change, so that the flexibility, the variety, and the rhythmic order afforded by an assemblage of separate shots is maintained.

REALIST MODE

From its very beginnings, film has been associated with the realistic rendering of the objective world. Science has used it as a tool; newsmen, documentary filmmakers, and amateurs have employed it as a record of immedi-

ate experience; theoreticians like Kracauer have interpreted its primary function as the investigation of physical reality. Although we may have abandoned the notion that a photograph cannot lie, we may still find it easy to think of the camera as capable of performing like a somehow neutral eye and regard film as the record of that eye's vision.

To be sure, similar apparatus is involved in both photography and vision: in both there are lenses and irises and in both the response to light is registered—on the film in the camera and on the retina in the eye. We call the scientific principles involved in the operation of both *optics*. But the photographic image is not the image of the eye. Its field of vision, its rendering of space, its capacity to resolve detail over large areas and distances result in a different type of image. While the film may record varying intensities of light rays that reach it with approximate accuracy, by the time they do reach it they may very well be distorted, and in the processing they may be distorted even more. The camera is not an eye and in any given situation may see either more or less than an eye.

Even in its most objective recording of visual data, film does not provide a neutral field in which the eye can operate freely as it operates in the neutral field of vision that normally surrounds us. Film may be truth 24 times a second, as Godard describes it (although he is obviously concerned with something more than literal, visual truth), but it is also art 24 times a second. What is caught in the frame of the picture is the product of recognition, selection, and isolation, and these processes impose an order that, however minimal, is already art. Even the most objective reporter recording the news of the day must inevitably modify the character of the event if only because any occurrence involves more than the camera can see—or the tape recorder hear—so that the record is partial and highly selective. More importantly, the angle of vision, the proximity, the point of focus, the configuration of lights and darks, the proportions of the various elements in the picture, the particular details selected for emphasis—all are subject to the will of the cameraman. Once he has selected particular aspects of an

event for the record—perhaps in a split second—and once he has established his exposure and taken his position, the cameraman produces an image that is as subjective as it is objective, however dispassionate his intent. The resulting image tells almost as much about the man behind the lens as it does about whatever is happening in front of it.

In his early films—like *Sleep*, which observes a man sleeping for six hours; *Empire*, which focuses on the Empire State Building for eight hours; *Haircut*, which records just that for thirty minutes—Andy Warhol seems to transfer the neutral and objective lens of the scientist into the realm of art and to record for the length of each reel exactly what occurs before the lens. In *Haircut*, the camera is stationary, the camera angle and distance are calculated to provide a clear view of the operation, and the lighting is arranged more or less like traditional portrait lighting to bring into sharp relief the essential character of the subject. The film is set in motion and rolls uninterrupted to the end of each reel, and the leader with its markings at each end is retained. In one reel the camera seems to have moved slightly closer to the subject and the light and dark contrast is reduced. Whether the opening was changed, whether a light blew out, whether someone forgot to turn a light on, whether it happened by accident or design is impossible to say, although one suspects it was not calculated.

Curiously enough, what seems to be an almost amateurish recording of a mundane event cannot escape the appearance of art. The isolation and framing of the participants, the bold if uncalculated chiaroscuro, the movement of the cutting blades and the hand, the probably inadvertent changing in light and distance, the loose formal rhythm introduced by the retention of the leader all give form to the formless. Toward the end, the sudden appearance of the hitherto concealed tattooed arm of the barber introduces a sense of drama. Artlessness results in art, partly, no doubt, because Warhol, by retaining the leader, insists on the reality of the film as well as the reality of the event and thereby, whether deliberately or accidentally, insists as well on the transformation of reality into film.

All of this tells us much about Warhol, his fascination with the banal, with repetition, and with boredom, his predilection for slight almost imperceptible deviations from the expected, his exploitation of the vulgar, and perhaps even, in the sudden appearance of the tattooed arm, a hint of the sadism that enters some of his other films. About the haircut itself or the participants it tells little, except, perhaps, that sensuous delight and a sense of drama may reside in the most mundane events. The very concentration on reality ultimately produces a sense of unreality, and the simple act acquires the solemnity of religious ritual.

Two conclusions seem inescapable: it is difficult to eliminate the appearance of art, and it requires art to present a convincing image of reality. It follows, too, that in viewing films that purport to offer the image of reality—especially information films—we should be aware of how the filmmaker has either deliberately or inadvertently intruded, for his particular method of presentation can alter totally the character of an event.

Filmmakers have tended to employ clearly recognizable and not unexpected conventions in their presentation of reality—and it is presentation that we are concerned with, not subject matter or ideological orientation. The realist mode can be employed in almost any filmic context, in fantasy (as in science fiction), in psychological drama (as in *Hiroshima, mon amour*), as well as in documentation. Generally, these conventions recreate the visual experience of a hypothetical observer, subtly reinforcing the sense of reality by duplicating the familiar conditions of seeing.

Certain features characterize the realist mode of presentation. The illumination, even when reinforced by artificial lighting, appears natural; often the filmmaker will use only available light without resorting to artificial reinforcements like kliegs and spots. The apparent distortions of space associated with the long-distance and wide-angle lenses will usually be avoided. Camera angles and distance will be those of the hypothetical observer. Spatial configurations will seem informal rather than deliberately contrived, although it is apparent that shots as tightly structured as those we found in Eisenstein may appear by chance. The action will seem natural rather than stylized. The cutting rhythm and the overall structure of the film will be determined by the exigencies of the material rather than by the kind of abstract scheme we found Eisenstein employing in *Ivan, Part I*. The sound track will most often be composed of live sounds, natural sound, or sounds that seem live or natural even if simulated.

Deviations from the ordinary and familiar will usually be justified or rationalized. For example, in Shirley Clarke's *The Connection*, the patent use of artificial lighting is rationalized by the fact that the narrative involves the making of a film. The *cinéma vérité* style, which insists on the total reality, often includes the presence of the filmmaker. The lighting may be frankly artificial and the lighting equipment, along with microphones, camera, and tape recorders, appear in the film.

Like artificial lighting, music will be justified and seem to emerge from the scene itself, as in the sound of the harmonica player in *Granton Trawler* or the use of the radio in *City Streets*. Spoken narration will be associated with a personality whom we may see or at least identify rather than appearing as the utterances of a disembodied oracle. The difference in effect that the two methods achieve is remarkable. When the speaker is not identified, narration may acquire a subtle air of omniscient authority. This is true not only for the stentorian solemnity and pomposity of the narrators in *The March of Time* series (1935–51), but also for more straightforward or humorous narrators. On the other hand, a text that might easily be judged as dry, abstruse, or boring can take life from the visual presence of the narrator. *Corn and the Origins of Settled Life in Meso America* (1961) deals with the technique used to recreate an extinct type of corn, presenting its information in the context of conversation. On one occasion the dialogue takes place in an automobile speeding through the countryside, with the movement of the car as well as the conversational tone injecting a vitality that a more traditional narration would lack. The importance of seeing a speaker is singularly well illustrated by what happened when the hearings before the House Unamerican Activities Committee in-

600. Senator Joseph McCarthy covers the microphones for a private word with Roy Cohn during the Army-McCarthy hearings before the House Unamerican Activities Committee in 1954.

stigated by Senator Joseph McCarthy were televised. As many observers convincingly maintain, McCarthy was discredited by the television camera, which made transparently clear his triviality and chicanery (Fig. 600).

All these aspects of the realist approach seem to imply regulation as stringent as that associated with the theory of montage, but in actual practice the realist mode is likely to be relatively free and even improvisational in any aspect of its structure. Few films that can justifiably be described as realist exhibit all these characteristics at once. Various considerations may lead a filmmaker to depart from absolute consistency—peculiarities of location, exigencies of exposition, the requirements of personal taste. For the documentary filmmaker, there is frequently the necessity of using material that happens to be available, sometimes a unique shot.

Some sense of what may operate in deviation from a strict realist canon appears in Truffaut's *The 400 Blows*. The film examines the situation of a young boy in an unstable family and an authoritarian school system, as well as the effect of the interrelationship between them. His mother had become pregnant before she was married, wanted an abortion, but was convinced by her mother to have the child. She married a man who was not the father and left the child with a grandmother

until the latter became too old to take care of him, at which point she and the stepfather took him. But the child is obviously an intruder in their lives, and his mother, as he later tells a reformatory psychologist, doesn't really like him very much. She is having an affair, and the stepfather, who seems the more sympathetic and responsible of the two, is nevertheless incapable of dealing with the situation. The boy becomes an instrument through which the mother and father attack and placate each other, attempting to reinforce their own egos. The boy is continually getting into trouble and is finally sent to a reformatory. He runs away to look at the sea, and it is there, in the solitude of the empty sky and ocean, that the film leaves him in a freeze-frame shot (Fig. 183). Staring at the audience, he reminds them of the economic, social, and political conditions, and the personal inadequacies that have placed him alone, unloved, rejected on this strip of sand.

While Truffaut is sensitive to the expressive power of formal relationships in space, tone, action, movement, and cutting, he seldom forces them or causes them to intrude, but rather firmly imbeds them in reality. There are no tricky camera angles, lighting effects, or movements. The camera seems a sympathetic but neutral observer, but it occasionally assumes an active role, as when the boy, Antoine, is allowed to run out of camera range and then is caught again in the lens, the shot succinctly summarizing one of the themes of the film, for Antoine is constantly running toward freedom and always being trapped. If the camera dollies, tracks, and zooms, it generally projects a sense of ordinary vision, only occasionally deviating from the kind of pattern that Truffaut has established throughout the film.

In one sequence an athletic instructor leads his charges on a brisk heel-and-toe through the city streets, and the boys peel off to leave him with only two followers. Once the situation has been established, the camera, shaking free of consistency, retreats to a station point high above the street to survey the action in its entirety (Fig. 601). Like the freeze frame at the end of the film, the shot seems isolated as a set piece, a parenthetical interpolation in

which the form is governed by considerations external to the development of Antoine's story. There is little question that the inclusive shot is the most economical and perhaps the most comically effective way of encompassing the incident. But it is probable that in this case other considerations dictated the angle of vision, for the sequence recalls a similar passage in Jean Vigo's *Zéro de conduite* (Fig. 602), and is a sort of homage to Vigo. The drastic change in angle has the effect of putting the scene in parentheses. Similarly, the long freeze-frame shot at the end has a special function, or at least a special effect. Not only does it bring the action of the film to rest, but it encourages the spectator to contemplate the boy's position and to question what his ultimate fate will be.

Truffaut's editing is consistent and is determined by the action, but in one sequence in which a reformatory psychologist interviews the boy, the director obviously imposes an external form. The scene has been much admired because it focuses on the boy throughout, never cutting away to the interrogator or to the setting. It is not an uninterrupted shot, however, but a cycle in which shots of the boy listening to the questions and shots of the boy speaking are connected by dissolves, which maintain continuity, introduce an easy cutting rhythm, and also suggest an almost abstract unreality in the situation. It seems more than probable, however, that the segmenting of the scene was in large part determined by the fact that Jean-Pierre Léaud, who played Antoine, was improvising, and that Truffaut selected

601. *The 400 Blows.*
François Truffaut. France, 1959. Truffaut pays homage to Jean Vigo in this outing with the gym teacher.

602. *Zéro de conduite.*
Jean Vigo. France, 1933.

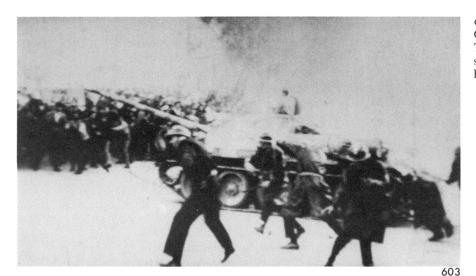

603, 604. *The Battle of Algiers.*
Gillo Pontecorvo. Italy, 1966.
The realistic approach is suddenly
shattered as the camera reveals a
hiding place behind the scenes.

603

the shots from a number of separate takes, shots he then had to find a way to put together.

The examples cited show slight departures from consistency, but in no way are they strictures against the quality of Truffaut's film. Rather, they are indications of the kind of latitude the filmmaker may exercise and the kind of situation that may dictate a deviation from the norm he establishes for himself. A more serious relaxation of the realist mode occurs in Pontecorvo's *The Battle of Algiers,* an extraordinary and exemplary recreation of documentary realism (Fig. 603). The effect of this realism is suddenly shattered, if only momen-

tarily, when the leader of the resistance is tracked to his hiding place, a hole behind the wall of an apartment, and the camera is suddenly within the black hole, recording the fugitive in Rembrandtesque lighting (Fig. 604). The sense of authenticity, so conscientiously maintained up to this point, evaporates.

The mode of realism appears in its purest form in documentary reportage like Dan Drasin's short film *Sunday.* It records an incident that occurred in 1961 in Washington Square Park, New York City, when a group of young people and their sympathizers, who had been assembling in the park to sing folk songs, met

opposite:
605–609. *Sunday.*
Dan Drasin. U.S.A., 1961.

604

605

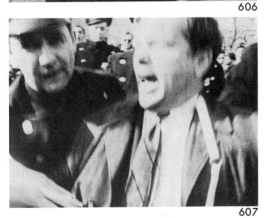

606

607

to challenge an injunction issued by the local authorities and in effect to defend their constitutional right to free assembly. There is no voice narration; the action tells the story. Shots of the square establish the location (Fig. 605). It is almost empty except for a few children playing on the walks and a few mothers watching from benches. Shots of crudely lettered signs calling for a protest meeting establish the situation. The young people assemble and begin to sing. The police arrive, and the leaders of the two groups confront each other to engage in a relatively calm debate (Fig. 606). Then the police begin to clear the park, and incidents of violence result (Figs. 607, 608). Reinforcements arrive. The protesters raise an American flag and sing an American hymn, the heroic words swelling ironically over the conflict as the square is cleared (Fig. 609). The last shots contrast with the situation established at the beginning, except that now the square seems isolated from the human use for which it was intended, a vacuum sealed off by walls of patrolmen.

Inevitably chance comes into play, its presence welcomed in the editing. The camera jiggles and swings, the lens goes out of focus, images pale in the glare of the sun, people step in front of the lens, sounds become confused (Figs. 606, 608). All these accidents enhance the sense of the immediate experience. Despite the immediacy, however, the film is something more than a mere recording, and what seems disordered is ordered. The cameramen anticipate the coalescence and dispersal of forms as the scene changes or the action moves from place to place, and they seize the ephemeral patterns in their lenses.

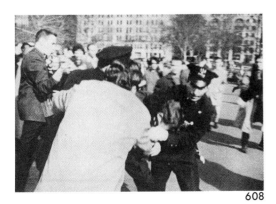

608

609

Their selection—of subject, angle, distance, and movement—transforms and shapes reality, so that what we see in the film is quite different from what we would have experienced on the spot. The multiplication of close-ups creates a physical density that heightens the drama, the compression of time intensifies the ideological conflict, and the choice of views develops a point of view. One can imagine

610–612. *Moana*. Robert Flaherty. U.S.A., 1926.

610

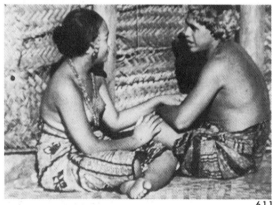

611

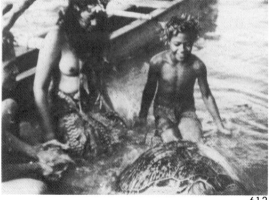

612

another version in which a larger number of long shots would diffuse the intensity, where shots of the police would not menacingly crowd the frame, instruments and incidents of violence would be eliminated, one would not see a young woman dragged off screaming, and the youthful folksingers would appear as the villains.

The content of *Sunday* emerges from physical action, facial expressions, and sounds; but the reality it explores is the reality of ideological conflict and emotional response, the spontaneous flux of human relationships in the immediate present, when the subtle textures of life, both physical and psychological (and, for that matter, aesthetic) are forgotten, as reality is caught on the run.

A quite different approach is apparent in Robert Flaherty's *Moana*. Flaherty spent two years on the island of Savaii studying the people and the physical environment. With time at his disposal and predictable activity to record, Flaherty could plan camera setups, wait for light, reshoot—except in the tattooing scene—when necessary. The result is apparent in the film. Seemingly casual shots are carefully composed for picturesque effects (Fig. 610); figures fall into attitudes almost classical in their composure (Fig. 611); the surface textures of the natural world are explored with a caressing lens—the patterns of bark, foliage, and light on water; contrasts of skin and fiber; fluid, solid, and insubstantial air (Fig. 612). The film is a hymn to the sensuous luxury of nature and to the "natural man" in Eden before the Fall. All the events that the film records happened, but, like *Sunday*, it is only a partial view; Flaherty has created a romantic idyll that obscures the truth.

Like *Sunday*, *Moana* exemplifies the characteristics we have described. What is apparent in both films is that, while the mode may be realist and the subject an actual event, the image of reality is the construction of the filmmaker. Also evident are two basic approaches to the mode of realism: *Sunday* is filmed from the point of view of the participant, and its images are limited to those a participant could see; *Moana* is filmed as seen by an unfettered omniscient eye free to move at will through space, sometimes as a partici-

613

614

613, 614. *The Great Train Robbery.* Edwin S. Porter. U.S.A., 1903. The painted sets contrast sharply with scenes shot on location.

pant, sometimes as a distant observer. The effect is almost inevitably a sense of involvement in the former, a sense of detachment in the latter.

In reportorial and documentary films the realism is generally inherent in the conditions of the shooting. Fictional film and documentary reconstructions obviously give the filmmaker more latitude for manipulation, especially in his choice of locations. He may choose to shoot in an already existing setting or to construct a set that simulates actuality, two methods applied early in the history of the film. *The Great Train Robbery,* for example, was shot partly on location and partly in sets constructed in the studio; one of the latter, the dance hall scene (Fig. 613), with its painted background and stove, scarcely qualifies as an example of the realist mode and destroys whatever illusion of reality the rest of the film achieves (Fig. 614).

The desire for verisimilitude coupled with a need for aesthetic control has led at times to extraordinary measures, a famous example of which is Erich von Stroheim's reconstruction of the casino at Monte Carlo for *Foolish Wives* (Fig. 615). During the 1920s German producers became famous for the illusionistic quality of sets built within their studios, like the hotel and street scenes in Murnau's *The Last Laugh,* the artificiality of which is not apparent except under close examination (Fig. 616). In both *Foolish Wives* and *The Last Laugh,* the solicitude for illusion

above: 615. *Foolish Wives.* Erich von Stroheim, U.S.A., 1921. A concern for authenticity was the overriding factor in this elaborate reconstruction of the casino at Monte Carlo.

below: 616. *The Last Laugh.* F. W. Murnau. Germany, 1924.

617. *Foolish Wives.* Erich von Stroheim. U.S.A., 1921.
Patterns of the environment convey a mood of intrigue and menace.

618, 619. *The Last Laugh.* F. W. Murnau. Germany, 1924.

618

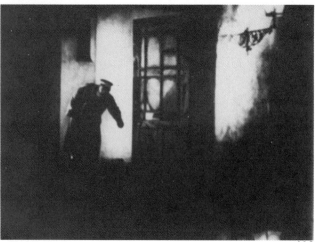

619

yields to exploitation of the expressive potentialities of form. Space and light, while rationalized, are shaped to give concrete expression to character, personality, and feelings. Spatial patterns and light patterns in *Foolish Wives* often seem baroque in their luxuriousness, romantic in their subjectivity, and expressionistic in their deliberate distortion.

If Von Stroheim, in his search for authenticity, occasionally lets the screen go almost black, he also utilizes the light and dark patterns created by Venetian blinds to convey the internal corruption, menace, and disorder of his principal character (Fig. 617). Similarly, Murnau uses the shadows from a streetlamp to convey the feelings of his central character, the old doorman of the Hotel Atlantic who has just been demoted to the lowly position of washroom attendant. The doorman has lost not only the position he enjoys but also his status in the neighborhood and his self-respect. As he creeps back to the courtyard where he has a flat, his shadow tentatively precedes him, wavering on the wall, a thing of no substance but larger now than he is—an image of his past glory and his present apprehension (Figs. 618, 619). The result is a mixed modality—characteristic of much fictional film since the beginning—that we will consider at greater length subsequently.

From the early 1940s, increasing numbers of filmmakers have attempted to transfer to the film the appearance of life as it is generally known. Especially significant are the achievements of those filmmakers associated with the Neo-Realist tendencies of the 1940s and early 1950s. Disenchanted with the dream world fabricated by the major studios—in their romantic comedies, costume melodramas, war films, crime films, and adventure tales—concerned with the problems of man in contemporary society, and inspired perhaps by the rise of the documentary film, the Neo-Realists saw a need for films that would provide a more honest interpretation of contemporary life and a direct confrontation with current social problems. Some explored social mores within the familiar modes of filmic presentation and dramatic structure, which not infrequently weakened the impact of their films by reducing their authenticity and by associating them

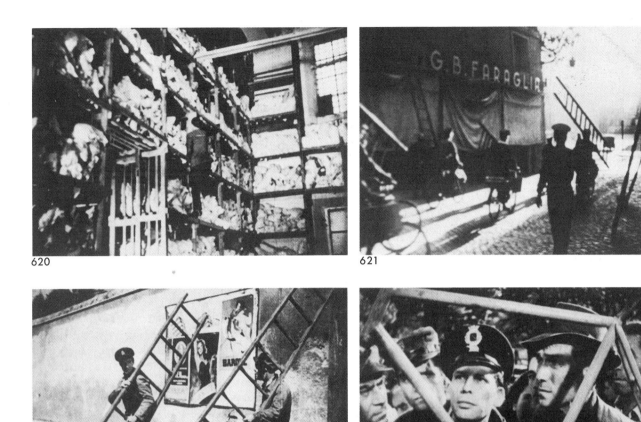

620

621

622

623

620–629. *The Bicycle Thief.* Vittorio de Sica. Italy, 1949.

with conventional fiction. Others, like Vittorio de Sica, developed a mode of presentation consistent with their subject matter and, without sacrificing the expressive potentialities of the medium, achieved a verisimilitude that augmented the seriousness and poignancy of their themes. De Sica's *The Bicycle Thief* (1949; Figs. 620–629) is one of the masterpieces of this Neo-Realist approach. Analysis

The Bicycle Thief concerns an unemployed worker who gets a job as a billposter on the condition that he provide his own bicycle. He and his wife pawn their bedding to get the money, and he sets off happily to work, secure in the knowledge that he can provide for his family (Figs. 621, 622). While he is posting a bill, a thief makes off with his bicycle. The rest

of the film follows him as he, sometimes in the company of his young son, searches for the bicycle and the thief, following up clues that lead him to various parts of the city, becoming increasingly discouraged, and finally giving up all hope. The basic plot, at least until the end, parallels many a heroic quest and adventurous chase, with each new development offering new hopes and foundering in new conflicts.

The search takes the man into a second-hand bicycle market (Fig. 623), a soup kitchen, and a restaurant (Fig. 627), where he goes to make amends with his son after he snapped at him and temporarily lost him (Fig. 624). Even in the restaurant, where there is the hope of forgetting for a moment, the presence of a more affluent family at a nearby table re-

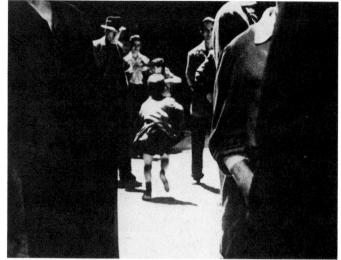

624

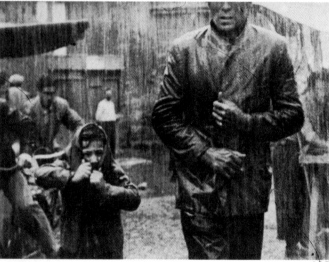

625

626

620–629. *The Bicycle Thief.*
Vittorio de Sica. Italy, 1949.

minds him of his impossible situation, and he goes off to a bordello to make irate charges against people who look like the thief. Finally, surrounded by bicycles that belong to others, he gives up (Figs. 628, 629). Each phase of the action reveals another aspect of the man's personality and his plight, and by projection the helplessness of the unemployed poor.

The approach is scrupulously realistic, the effect documentary. De Sica employs nonprofessionals for actors, shoots on location in the streets with whatever lighting is available, keeps his camera at eye level, and generally observes his subjects in close-ups and medium shots. He allows action to develop in the midst of crowds, with people (Fig. 624) and sometimes bicycles stationed between camera and subject. All these devices are calculated to eliminate aesthetic distance and bring the spectator into the space of the film.

The appearance of observed reality is consistently maintained, as is an awareness of the expressive possibilities of spatial and tonal patterns. When the couple go to pawn their linen, the slow movement of the camera over stacks of unredeemed articles emphasizes the quantity and suggests that the two are not unique but part of a pattern of economic failure (Fig. 620). As the billposter reports for his first job, the light of early morning caresses everything and throws it into sharp relief, reinforcing the man's sense of joy (Figs. 621, 622). Ladders slung over the billposter's shoulders fall into natural patterns, their open order contrasting with similar diagonals that appear in the second-hand market when the triangle of the bicycle frame seems to confine the man like a prison (Fig 623). From that point on, the spatial patterns often hem in the billposter. Distance shots are associated with the estrangement of the man and his son, intensifying the poignancy of their separation. In the end, as the man and his son sit dejectedly on the curb (Fig. 628)—almost inevitably recalling Charlie Chaplin and the Kid—they are engulfed by bicycles of pleasure-seekers (Fig. 629). For a moment, as in the restaurant,

we glimpse how the world may look to the destitute, how the sight of relative affluence may incite not ambition but despair. De Sica sustains the sense of immediate experience while maintaining an aesthetic control that is ever present if unobtrusive.

In the late 1950s, the New Wave filmmakers in France cast up a new approach to realism, new at least in feature filmmaking. Those originally designated as the New Wave shared no common aesthetic. They emerged from the ranks of critics, documentary filmmakers, scientific workers, and the establishment. Some were young Turks, others were old hands. They worked in a great variety of styles, some traditional, some innovative; and they were linked only because they produced their first feature films within a particular time span. In spite of the divergences of style, certain attitudes and practices became associated with the group—a frankness in dealing with taboo subjects, a point of view paralleling the existential philosophical orientation of the period, and especially methods of handling the camera and editing that for a time were disorienting to many critics and viewers but that have now become, with certain modifications, standard practice.

Like de Sica in *The Bicycle Thief*, the New Wave filmmakers who established the approach left the studio and went into the streets and the countryside. They often worked with very small crews, sometimes only the director, cameraman, and actors, taking advantage of the lightweight equipment and more sensitive film that had become available during World War II, which allowed them to carry camera in hand and to move with it freely. Sometimes they shot in 16mm for enlargement to 35. They often employed improvisation, dispensed with synchronous recording of sound, and depended on post-dubbing, a practice relatively popular in Europe, in any case.

Films made in this way look different. In Jean-Luc Godard's *Breathless*, actors walk in familiar streets and people turn around to stare (Fig. 630). Sometimes the actors are lost in the glare from a window (Fig. 440) or an electric lamp (Fig. 441), or are hidden in the dark. The camera often is unsteady, the focus uncertain. There are long sequence shots, but

627

628

629

630. *Breathless.* Jean-Luc Godard. France, 1959.
When New Wave directors shot scenes in familiar streets, people inevitably turned around to watch.

the editing, too, seems new. This approach to filmmaking assumed that an audience that had grown up watching films regularly did not require some of the conventions like establishing shots and explanatory transitions, so the narrative as a whole was likely to begin in the middle of things and end without resolution. Some critics found the films amateurish, incomprehensible in structure, ambiguous in content, and lacking the slick, professional polish that had almost become a sign of aesthetic value. Others saw them as fresh, free, and close to life. If a character was sometimes not fully developed, motivations not clear, situations not rationalized, this, too, was like life. De Sica's *The Bicycle Thief* seems like a well-tailored film compared to some of the New Wave products.

MODE OF FANTASY AND EXPRESSIVE DISTORTION

If film by its very physical makeup is capable of recording the visual appearance of reality with a precision unparalleled in the plastic arts, it is also by its physical nature capable of transforming reality, as we have repeatedly seen. In fact, the capacity for transformation is as inherent in film as the capacity for recording. Because film translates three-dimensional relationships into two-dimensional images and segments, because it condenses and extends time, we should go further and see a transformation of reality as the inescapable condition of even the most objective filmic art. In considering fantasy and expressive distortion, however, we are concerned with radical transformation, transformation beyond that implied by the medium itself and, for that matter, beyond what we have described in other contexts as expressive intensification.

The term fantasy, as used here, implies the creation of images that deviate in significant ways from our usual experience of the world around us, images that modify or ignore the immediate data of customary experience, images that are invented in dream, imagination, or play. Expressive distortion implies transformation of the materials of film so as to give concrete and physical form to feelings. Of course, any film is the product of imagination in one way or another, and the materials of film are usually manipulated to convey feelings, so that it could be said we are dealing simply with the nature of filmic reality and expression. But in fact we are concerned with *radical* and *deliberate* distortion, dislocation, and divergence from customary experience.

The description may seem at first to involve two different types of experience, even two different modes with different functions—one the projection of an internal world without concrete existence, the other an interpretation of the external world and, within the terms of film, existing fact. But in the end they are both products of the imagination, and the means by which they are conveyed are identical and, by now, familiar enough.

Specific aspects of these modes include the following. Settings, costumes, makeup, surface textures may be distorted, action stylized, and incongruous juxtapositions established in the scene to be shot. Spatial relationships, perspectives, proportions, and shapes may be distorted by lenses, prisms, extraordinary camera angles and movements, while separate spaces may be combined by superimposition of images or by fragmenting the screen. "Foreign" shapes may be introduced by masking, scratching, perforating, drawing on, and otherwise modifying the image. Normal

tonal relationships may be distorted by lighting, by filters, by overexposure and underexposure, and by processes like solarization and printing out. Time may be modified by slow and fast motion, jump cutting, and stop motion, or frustrated by repetition of shots. The inanimate may be animated. Sound may play its role in much the same way: extraordinary or unexpected sources may be used, the frequency or tone may be changed, the speed modified, incongruous mixtures created. Animals and things may be made to speak.

Since all these possibilities have been explored earlier in other contexts, there is little point in examining them individually in detail here; rather, we will consider a number of films in which fantasy and expressive distortion play a major role in order to see some of the common ways in which they have been employed in filmic presentation.

Once again it seems useful to recall that we are considering methods of presentation rather than intellectual or narrative content. Fantasy, which implies an antirational approach, can be used to explicate perfectly rational ideas, as has frequently been done to explain complex scientific or mathematical ideas in films like Frank Capra's *Hemo the Magnificent* (1957), a visual treatise on blood for the young. As subject matter, fantasy generally is presented in more or less realistic terms, which lend their credibility to the incredible in science fiction and horror movies. Occasionally these are constructed in the formalist mode, like Fritz Lang's *Metropolis* (1926), which is conceived and developed almost like a dance.

Albert Lamorisse's *The Red Balloon* (1956), exemplifies in a simple and straightforward way fantasy made real. A balloon takes on anthropomorphic qualities, becomes the pet of a young boy, and after a number of relatively plausible adventures, is destroyed by a bully, whereupon it is resurrected and carried away as if in a funeral by hundreds of other balloons, the boy floating away with it. The realistic terms in which this modern myth is presented invest it with a peculiar tenderness, pathos, and authenticity that a more deliberately fantastic method of presentation might well have destroyed.

Denys de Daunant's *The Dream of the Wild Horses* (1960; Fig. 694), operates in the opposite way. It views wild horses in la Camargue in southern France, fighting, running, cavorting over the marshland and the sand, wading in the water, fleeing from a fire. A long distance lens (which seems to compress depth), rather soft-focus images, a grainy surface, and especially the slow motion transform reality into dream. These elements are joined with an imaginative sound track to enhance the grace of movement and the nobility of bearing that characterize these wild creatures. Thus, film can make fantasy real, reality fantastic, and the relationship of the two ambivalent.

Many of the methods, dimensions, and ambiguities of fantasy are illustrated in three more complex films of considerable historical importance: *The Cabinet of Dr. Caligari, Entr'acte,* and *Zéro de conduite.* As Siegfried Kracauer has pointed out in his book *From Caligari to Hitler,* Carl Mayer and Hans Janowitz, the authors of the story on which Robert Wiene's *The Cabinet of Dr. Caligari* (1919) is based, intended it as a political allegory of corrupt leaders and submissive subjects. In its finished form, presented with a framing device, it loses its political implications and becomes a tale of hallucination. A young man named Francis, sitting in the garden of a mental institution, tells a companion of an adventure he has had, he says, with another inmate, a young woman named Jane. The two lived in the town of Holstenwall. A fair came to the town and with it a strange old man, who called himself Dr. Caligari and had in his charge a somnambulist named Cesare, whose usual resting place was a box like a coffin. When Caligari applied for a license to exhibit Cesare, the town clerk was so arrogant in his manner that Caligari was offended. The next morning the official was found murdered. Francis and his friend Alan attended Caligari's performance, and Cesare, answering questions in a trancelike state, told Alan he would die before morning. Alan did die, stabbed like the official before him, whereupon Francis, suspicious, prompted Jane's father to assist him in an investigation. Spying on Caligari, Francis saw what he took to be Cesare in his box. Actually, Cesare had been dispatched to kill

631

632

633

631–633. *The Cabinet of Dr. Caligari.*
Robert Wiene. Germany, 1919.

Jane and was at that moment entering her bedroom. As Cesare was about to kill, he was overcome with love for Jane and gathering her up in his arms fled with her, pursued by Jane's father. Ultimately he dropped Jane and died of exhaustion. Meanwhile, Francis, discovering that Cesare had been in two places at once, called on the police for aid, entered Caligari's van, and found a dummy in the box. In the ensuing uproar Caligari escaped. At this point the film returns to the framing narrative. Francis accompanies his companion to the asylum, fancies the director is Caligari, and attacks him. After he is subdued and examined, the director says that now he understands the nature of Francis' delusions, he will be able to cure him.

Although inspired by a murder that actually took place near an amusement park in Prague, the tale offers little resemblance to a real occurrence and is completely transported into the realm of fantasy by the settings, costumes, makeup, and action. The settings are grotesque. Stabilizing horizontals and verticals are suppressed, jagged patterns fracture the space, buildings and trees twist in contorted shapes, normal perspectives and proportions are distorted, openings become eyes and maws, elongated shadows slice the solid shapes, and light and dark contend in brittle contrast (Figs. 631, 632). The world is out of joint, each part animated with evil, madness, foreboding, and terror. The costumes are linear and jagged, too, and stark makeup

obliterates the subtler conformations of the faces so that they seem like masks (Fig. 633). Except for rapid changes of scene, shifts in distance, and the use of vignettes to alter the shape of the format, there is little that is filmic about *The Cabinet of Dr. Caligari.* While the actors move with the same angularity and abruptness that characterize the settings, they are unable to disguise the discrepancy between their own actuality and the artificiality of the milieu in which they move. Overall, the film takes on the appearance of a photographed stage play, but a play lacking the compelling power of words to compensate for the unreality of the sets. So conscientiously do the sets imitate the rectilinear facets of Cubism and the disquieting distortions and emphatic simplifications of Expressionism, that *Dr. Caligari* has been described as a filmed painting. For all its avant-garde sophistication and its importance as an experiment, it is not so far removed in its method of presentation from Edwin S. Porter's frankly theatrical *Uncle Tom's Cabin* (1903), which today seems naïve and quaint (Fig. 634). Wiene's film suggests why so many makers of science fiction and horror films have chosen to embody their tales with approximate realism.

If in *The Cabinet of Dr. Caligari* fantasy resides in the theatrical aspects—the setting, costumes, makeup, and acting—in *Entr'acte* it emerges in large part from the use of the film medium. Written by Francis Picabia in 1924 to be shown between the two acts for the ballet *Relâche,* provided with a musical score by Erik Satie, and directed by René Clair, *Entr'acte* outraged its first public audience, which was ill-equipped to recognize the charms of a film that so radically broke with social traditions and artistic conventions to substitute instead the attitudes of Dada and Surrealism.

Dada is often described as a nihilistic movement devoted solely to the destruction of traditional attitudes, methods, and values. It was, in fact, a regenerative movement dedicated to establishing new foundations for art and society that would be more relevant to the contemporary human condition than the assumptions currently in operation. Convinced that reason, logic, objectivity, and science provided inadequate methods for the interpretation of man and the conduct of life, and certain as well that these elements could serve immoral as well as moral ends, the Dadaists deliberately cultivated an antirational approach and spawned an imagery of fantasy that was to provide inspiration for generations of subsequent artists. They were especially fascinated by the operation of what they called the laws of chance in the affairs of men and insofar as possible attempted to abdicate con-

634. *Uncle Tom's Cabin.*
Edwin S. Porter. U.S.A., 1903.

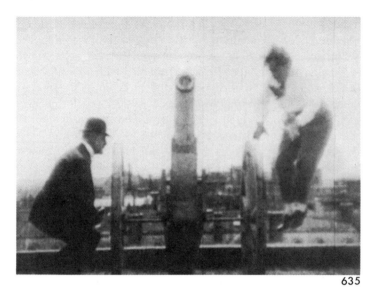

Illogical and irrational imagery
marks this Surrealist fantasy.

635

636

637

scious control over their imagery and at times even the execution of their works. They fostered a free association of forms and ideas and the spontaneous generation of images, experimenting with methods and materials that would allow chance to play a greater role in the creative process.

When some of the Dadaists, inspired in part by Freud's interpretation of dreams, recognized that their works often elucidated unexpected meanings apparently released from the subconscious, they perceived the possibility of creating a new kind of realism that would combine the reality of the objective world with the reality of the dream and would express a more comprehensive or higher reality, a *sur*reality. Dada then became Surrealism. The two movements, usually distinguished from one another, are actually two phases in the development of a new creative consciousness, two manifestations of revolt against dead values, two steps in the search for a new world of the mind. Together they created a unique imagery of the incongruous and a new source of imagery in the unconscious. But if their images deny the validity of traditional interpretations and superficially logical relationships, these same images possess the logic of poetry, the logic that allows one to say, "Her cheeks were like apples, her neck like a swan's."

Entr'acte (Figs. 635–657) was created at the time when Dada became Surrealism. Because its imagery, superficially at least, is antirational and its ideas expressed in metaphor, the film is difficult to summarize. Part of its meaning, its magic, and its outrageous charm lies in the relationship of one shot to another in what seems at times almost a rain of unrelated images. *Entr'acte* opens with a sequence in which two men on a roof dispute the positioning of a cannon (Fig. 635). The cannon, almost as if exasperated by their indecision, finally whirls on its own and threatens the men, who run off. There follows a sequence of seemingly unrelated views: rooftops, doll-like targets in a shooting gallery (Figs. 636, 637), boxing gloves fencing, the night lights of a city (Fig. 638), a dancing ballerina seen from below (Fig. 639), a man's head seen from above. Matches fall on the head and are ignited. A

638

639

640

641

642

635–657. *Entr'acte.* René Clair. France, 1924.

643

hand scratches at them. Next come shots of architectural columns, a chessboard, and two men playing chess on the cornice of a building (Fig. 640). As they argue over their game, a torrent of water wipes out the pieces, spilling over the city of Paris (Fig. 641), carrying a paper boat along on its current (Fig. 642). The ballerina reappears, seen first from below, then in details at eye level. The camera picks up her waving hands, then follows her arms to the top of her head and finally to the face, which turns out to be bespectacled and bearded (Fig. 643). A ballerina dances, is superimposed on water, and dissolves into two eyes staring from beneath the surface. The shooting gallery reappears, this time with an extraordinary target, an egg supported by a jet of water (Figs. 644, 645). A man in hunting costume, poised on a cornice, sights on the target and fires (Fig. 646). The egg explodes releasing a pigeon, which flutters to the brim of the hunter's hat. As the hunter plays with the bird, another figure appears silhouetted on

a cornice, takes aim and fires (Fig. 647). The hunter falls to the ground below.

The camera takes up position before a church. A funeral is in progress, and the mourners are departing (Fig. 648). They form a procession behind a hearse, which is drawn by a camel (Fig. 649) and is decorated by delicacies that the mourners eat (Fig. 650). The cortege begins to move (Fig. 651). Scarcely has it started before the hearse becomes detached from the camel and proceeds on its own at an increasingly rapid pace through the streets of the city (Figs. 652–654), over a roller coaster (Fig. 655), into the suburbs, and across the fields. As the mourners run to catch up, more and more people and vehicles become involved in the chase. At last the coffin falls out of the hearse and rolls into a field. The half dozen remaining members of the procession gather round. The lid of the coffin opens, and the murdered man emerges dressed as a prestidigitator (Fig. 656). As he waves his wand at each of the spectators in turn, that

644

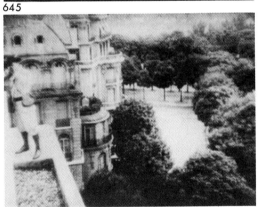

645

646

647

648

649

650

651

652

653

654

635–657. *Entr'acte.* René Clair. France, 1924.

person disappears. Finally, he turns the wand on himself and vanishes. There follows a title reading "The End." The victim emerges through the title shaking his head "No." His murderer comes on saying "Yes." After they have disputed briefly, both fly back in reverse motion through the paper title (Fig. 657), which reconstitutes itself to announce once again and finally, "The End."

Quite obviously *Entr'acte* involves us in a totally different world from that we enter in *The Cabinet of Dr. Caligari.* In the latter, fantasy, as far as presentation is concerned, is in the setting, which, viewed as originally written without the framing device, embodies the concrete and static symbol of social disorder and personal horror. When viewed with the framing device, it becomes the concrete expression of a demented personality. Whichever way it is considered, *Dr. Caligari* develops with conventional concern for the motivation of action and the traditional respect for the relationship between cause and effect. In *Entr'acte* the whole notion of motivation, cause, and effect is sabotaged. As far as the spectator is concerned, there is no motivation for the murder. A perfectly rational cause like the shot at a target produces an absurd effect, the release of a pigeon. A reasonable effect, the accelerated pace of the chase, is initiated by an absurd and impossible cause, the animation of the inanimate hearse. In almost every shot or sequence of shots a nonsensical juxtaposition of some kind occurs. Events take place in extraordinary places. What are these men doing playing chess on the cornice of a building? Why is the hunter on the rooftop firing into a shooting gallery? Why are these mourners forming a cortege in an amusement park around a miniature replica of the Eiffel Tower and detouring to go over roller coasters and sliding boards? Properties, costumes and characters are extravagant: the hearse, in addition to being drawn by a camel, is decorated with sporting scenes and hung with meats, vegetables, and pastries that the distracted mourners devour. The cortege is a motley assembly of mourners in formal dress, men and women in street clothes, long-distance runners, bicyclists, oarsmen, and an amputee on a pushcart. There is, as well, the bearded ballerina with the holes in his or her bloomers.

The action is quite mad: the two men disputing over the cannon go off using their umbrellas as pogo sticks; old women departing the church in voluminous dresses find their skirts blown up around their necks; the amputee, unable to keep up by pushing his cart, gets up and runs; the heads of doll targets swell up

and shrink like the balloons they are. Details of setting, costume, and action and the tempo or general mood are forever at odds with conventional attitudes toward the nominal content of a scene. If the dancer moves with the (slightly travestied) grace we associate with the classical ballet, and if her skirts undulate like the petals of a water lily, the image of grace and beauty is destroyed by the beard and spectacles and moth-eaten drawers. The way the soles of her feet flatten grotesquely as they strike the glass on which she dances is a persistent reminder of weight and the attraction of gravity that the dancer traditionally denies. The funeral scarcely treats death with customary solemnity and dignity, but lampoons it from beginning to end, almost as if it were the ultimate absurdity.

Many of the shots are filmed in a straightforward manner, but the effectiveness of the film results from the brilliant use of filmic means. Some sight gags result, exploiting the magical possibilities of the medium. The cannon is animated, as is the hearse. The disappearance of the mourners, the victim, and the two principles at the end is accomplished by similar cinematic tricks—in the first instance by stopping the camera while the character walks off, in the second by reversing the direction of the action in printing. But in addition to such examples of cinematic magic, the film exploits a great variety of other devices and becomes almost an encyclopedia of contemporary filmic possibilities. There is superimposition of images (Figs. 641, 645, 653, 655), overexposure and underexposure, negative printing, upside-down printing, odd angles of vision, slow motion, fast motion, reverse motion, and split screen (Figs. 652, 653), as well as more standard operations like panning, tilting, and tracking.

Many of these devices appear in the chase, which becomes the most exciting part of the film. As the cortege forms, there is very little movement. Then as the procession begins, everything is in slow motion. When the hearse accelerates, the people break into a run, first in slow motion, then in normal motion, and finally in fast motion. The tempo is further accelerated by increasingly rapid cutting coupled with drastic changes in angle and also

655

656

657

ultimately by the introduction of a split screen, with people running toward the spectator on one side and away from him on the other (Fig. 654). The rapidity of the tempo and the sense of excitement are enhanced by imagistic interpolations as well, especially in the sudden vista from the seat of a roller coaster (Fig. 655), which seems to carry the spectator through space at a dizzying speed, the effect

increased by the superimposition of views and ultimately by the appearance of an upside-down image.

The speed, excitement, and absurdity of the situation are not simply observed but are translated into terms of subjective experience that draw the spectator into the action, just as the earlier sequence of the hunter and the target, with its multiplication of the egg (Fig. 645), forces the spectator to share the marksman's difficulty in holding the target in his sights. Fantasy becomes a metaphor for the character of the action, the states of mind, and the conditions of being.

While *Entr'acte* is perhaps associated with a narrative involving the rivalry of two men for a woman, as well as a death, a funeral, and a resurrection, it seems basically to be an absurd, incoherent, and extravagant *mélange* of gags, most of them calculated to enrage and puzzle the bourgeoisie, all of them strung together with a persistently creative exuberance and a constant delight in exploring the possibilities of the film medium. Picabia himself wrote:

> *Entr'acte* ne croit pas à grande chose, au plaisir de la vie, peut-être; il croit au plaisir d'inventer, il ne respect rien si ce n'est le desire d'*éclater de rire* . . .
>
> (*Entr'acte* does not believe in much of anything, possibly in the good life. It believes in the joy of invention or creation and respects nothing but the desire to burst out laughing . . .)

But earlier in the same passage he says:

> L'entr'acte de *Relâche* est un film qui traduit nos rêves et les événements non matérialisés, qui se passent dans notre cerveau . . .[1]
>
> (The entr'acte of *Relâche* is a film that gives form to our dreams and to incidents that never occurred, events that take place in our minds . . .)

What goes on in the head is perhaps a little more orderly than it appears. As one reviews the images, they seem imbued with sexual energy. There is an insistent phallicism in the beginning sequences, with their guns, columns, umbrellas, dancer's legs emerging like stamens from the petal-like tutu, and tum-

escent and detumescent dolls' heads. All of these establish a metaphoric bias that the following sequences develop—the caressing hand in the incendiary hair, the dancing egg on its foamy jet. Even the hunter's shot and the emergence of the bird seems a transparent symbol for fecundation and birth. The character of the movements and their accelerating rhythms elaborate the theme and transport the beholder toward that climactic release so often compared to death.

Viewed in this way, *Entr'acte* as a whole becomes an image of life, an extended metaphor of birth, copulation, and death in their essential absurdity. It is a bit reminiscent of the Dada definition of beauty as the chance meeting of an umbrella and a sewing machine on a dissecting table—another potentially erotic symbol, given the phallicism of the umbrella, the movement of the needle, and the bedlike character of the table.

The Dream of the Wild Horses translates reality into fantasy; *The Cabinet of Dr. Caligari* gives fantasy plastic reality; both types of transformation occur in *Entr'acte*. In all three, fantasy, although it may reflect, express, interpret, or comment on ordinary reality, exists independently, remaining parallel to the world of familiar experience but never becoming a part of it. Fantasy and reality exist simultaneously, each interpenetrating and thereby modifying the other, in Jean Vigo's *Zéro de conduite*.

A far more subtle, sophisticated, and sensitive film than the others we have been considering, *Zéro de conduite* (Figs. 658–663) interprets life at a French boarding school. It is constructed in a series of vignettes, each of which makes a complete and integral unit in itself. While there are no specific narrative links joining one unit with the next, the content of the successive units does result in a narrative and dramatic development. The early sequences describe various aspects of life at school—the arrival of students, the old and the new teachers, the activity in the classroom, schoolyard, and dormitory, the boredom of Sunday. The succeeding sequences intensify the conflict between the administration and four of the boys, who for one reason or another are always receiving zero

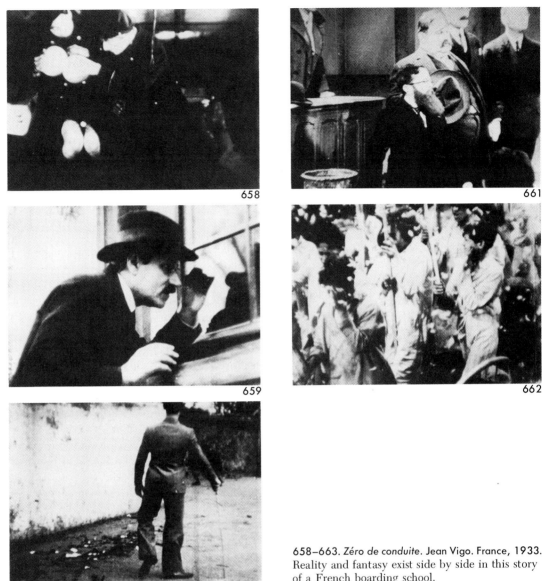

658–663. *Zéro de conduite.* Jean Vigo. France, 1933.
Reality and fantasy exist side by side in this story
of a French boarding school.

for conduct. The final sequences describe a
series of gestures of rebellion, each larger,
grander in scope, and more public than the
preceding.

The film is firmly grounded in reality, ap-
parently so firmly grounded that the Paris
censor saw fit to forbid its exhibition. The boys
are credible in personality and behavior, set-
tings are authentic, and the incidents that
occur are in themselves not extraordinary. But
from beginning to end there are deviations
from strict realism in presentation that turn
this very believable world askew, sometimes
almost imperceptibly, sometimes obviously.

The teachers are caricatured in both ap-
pearance and action. One is a sort of Presby-
terian Groucho Marx, who tiptoes mincingly
about, constantly looking for something to
confiscate or for some deviation from the rules
(Fig. 659). Another is the "good Joe," who
walks like Charlie Chaplin and does acrobatics
and magic in the classroom (Fig. 660). The
principal is a dwarf, a menacing grotesque
who squeaks and screams in a fluty voice (Fig.

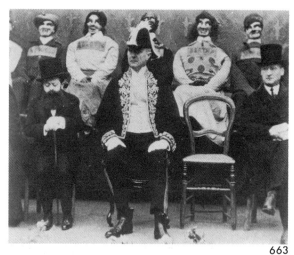

658–663. *Zéro de conduite*. Jean Vigo. France, 1933.

661). The notables who gather on the podium on Speech Day, when a rebellion is publicly expressed, are dummies (Fig. 663).

Settings are occasionally transformed by the sound track. The opening sequence shows two of the boys in a railway compartment on their way to school (Fig. 658). They vie with each other in producing toys and performing tricks. Then as they decorate themselves with feathers and light up long cigars, the music transforms the compartment into a wigwam and the boys into sachems. The new teacher makes a drawing that becomes an animated cartoon. A priest "lady" skitters away from a crowd of schoolboys in fast motion. A pillow fight (which provides diversion while one of the students raises a skull and crossbones on the roof) turns into a mock religious procession, shot in slow motion to express the nearly mystical ecstasy of the participants (Fig. 662).

All these deviations from ordinary, observable actuality modify the world and the events, as the students modify them with their instinctive tendency to travesty, burlesque, and satire. Their thoughts, through the methods of fantasy and expressive distortion, become as real as physical facts.

MIXED MODES

In each of the films we have considered, one mode seems to dominate and, with minor ex-

ceptions like the framing device in *The Cabinet of Dr. Caligari* or the Sunday sequences in *Zéro de conduite*, to govern the presentation from beginning to end. Obviously, not all films exhibit quite such overriding consistency. Many present a mixture of modes, moving abruptly or casually from one to another.

The story of Jean Vigo's *L'Atalante* (1934; Figs. 664–674) is a rather simple one. It concerns the captain of the barge *l'Atalante* and his new wife, a young peasant who, still in her wedding gown, joins him on the barge. They are to embark on what seems to the bride at first an adventurous life that will take her away from her tiny village to all sorts of exotic places and especially to Paris, whose glamorous enticements she experiences second hand on the radio. She soon becomes bored with life on the barge and after an evening ashore, slips away to explore Paris. The captain, after waiting a while for her to return, is forced to go on. He becomes more and more embittered and despondent while she becomes lonely and destitute. Ultimately, the two are reunited, both of them presumably having learned something from their separation.

This is a direct, romantic tale, and while it is somewhat sentimental in its faith in enduring love and tender in its interpretations, its basic approach is realistic. The film opens with the church bells tolling the end of the wedding ceremony. The wedding party makes its way through the quiet and somewhat desolate streets of a village to the river, presenting a vignette of village life so plain and dowdy, simple and solemn as to appear documentary (Fig. 664). At the outset Vigo's sharp perception and sense of the comic are already apparent. The bride in her ceremonial dress seems incongruous beside the awkward group accompanying her, and her solemn and intense expression contrasts with the patent satisfaction of the captain. Nevertheless, the scene appears quite authentic. The bride is swung aboard the barge at the end of a sweep like a piece of cargo (Fig. 665), welcomed by the mate, and presented with a bouquet by a young, simple-minded assistant. Her voyage aboard the dream boat begins (Fig. 666).

Vigo describes life aboard the barge in some detail, the progress through the country-

side day and night, the lifting of the barge through the locks, the sleeping, cooking, eating, cleaning. There are tender moments when the captain and his bride embrace on the deck and begin to know one another; but there is also boredom and the radio rasping the lures of the big city. The mate attempts to provide diversion with tricks, jokes, and gymnastics, finally taking the bride to his cabin to exhibit his collection of souvenirs and his tattoos (Fig. 667). Discovering them together, the captain becomes furious, smashes dishes, and then withdraws (Figs. 668, 669).

The pervasive gloom is relieved when the captain takes his bride to a dance hall. There, however, she is captivated by a flirtatious performer—a combination one-man band, magician, acrobat, dancer, and traveling salesman. The performer's attentions enrage the captain, who picks a quarrel with the salesman and then leads his wife back to the barge. The next day the performer bicycles to the barge to convince her she should join him in the city (Fig. 670). That evening she leaves.

Angry, the captain sails without her but then becomes increasingly despondent. Acting on the superstition that if one ducks one's head under the water, one will see one's beloved, he dives overboard and imagines her floating before him wearing her wedding gown (Fig. 671). The wife wanders in search of the barge and then looks for work. At night the two are seen dreaming of one another in a series of alternating shots that dissolve into one another and unite them on the screen if not in fact (Figs. 672–674). The mate tries to divert the captain with games and with an old phonograph he has repaired, but the captain becomes more and more withdrawn. Finally, the mate discovers the wife working in a shop where customers pay to hear phonograph records. The wife and the captain are reunited and go sailing off down the river.

The characters are interpreted to a considerable extent as types—the captain as the honest, unpretentious, convention-bound workman; the wife as the innocent, inexperienced girl; the mate as a childlike old man; the helper as a congenial fool; the performer as a Pan in modern dress, a sort of vocal Harpo Marx—and all of them are essentially good.

664–674. *L'Atalante*. Jean Vigo. France, 1934.
In subtle ways—as in the artificiality of the lighting or the settings—there is a shift from reality to fantasy.

664

665

666

667

668

664–674. *L'Atalante.*
Jean Vigo. France, 1934.

While the style of acting is rather broad, the method of presentation conveys sufficient realism to lend authenticity to the absurdity of some events and characters. But it is through fantasy that Vigo invests his tale with its lyrical overtones and probes the psyches of his characters, revealing the depth of their passion and the strength of their erotic drive, which their superficial behavior seems to mask. On the first night of the marriage, the bride, still in her wedding gown, stands on the prow of the barge (Fig. 666), gliding through the darkness like a phosphorescent figurehead. She seems an unreal, mythic creature, reminding one of ancient sculpture and that other Atalanta, who was diverted from a race by the glitter of a golden ball and who also ran away from marriage. The simple image tells us much—of her romantic dreams, of her apprehensions, of her feelings about herself as

a woman, and of the way a rather plain girl may be transformed in her husband's eyes.

The mate's cabin is a Surrealist environment, a conglomeration of bizarre, incongruous, provocative trophies that transforms the place into a magician's cave and simultaneously instills a barely hidden tortured sexuality, which suddenly becomes more explicit when the mate, to divert the young woman, takes off his shirt and shows her his tattooed torso with its crude drawings of naked women (Fig. 667). Subjective fantasy is projected when the captain imagines he sees his wife under the water and again when the husband and wife dream of one another.

Fantasy enters this otherwise realistic world, then, in a number of different ways: in the artificial lighting of the bride on deck it is a comment by the filmmaker; in the exploration of the mate's cabin it is the setting itself;

669

670

671

672

673

674

and in the dreams of the captain and his wife, it is a projection of their subjective feelings.

The manner in which fantasy penetrates reality, gives meaning to reality, and even in the end becomes reality is the motivating force of the film and one of the principal themes. The young woman dreams of excitement, the captain dreams of an ideal love, the mate puts faith in fortune telling. Ultimately the dreams are realized and the fortunes fulfilled. At one point the film forces the audience to participate in the fantasies. When the mate

is repairing the phonograph, he pauses to run his fingers over a record, and he and the audience hear music. He stops and the music stops. He touches the record once again, and once again the music begins. Then the young assistant is discovered to be playing the accordian as a joke.

In its spatial organization and editing, *L'Atalante* is for the most part relatively informal: spatial configurations seldom appear studied, and editing is generally determined by the action. A more formalistic approach appears from time to time, usually at a point of more than ordinary significance. When the captain discovers the mate entertaining his wife, he throws dishes about, scattering the mate's family of cats (Figs. 668, 669). Cutting for accent and impact, Vigo develops a metrical pattern of action that has little to do with simple description but does convey the explosiveness of the moment and the speed of the action. For similar expressive purposes he introduces a more formal approach in his interpretation of the captain's underwater search, finding slow-motion rhythms of love and frustration. And when the husband and wife dream of one another, he dissolves metrically from one to the other, making the dreams concrete.

In examining the modes, we have treated the dominant mode of a film, sequence, scene, series, or shot as if it were the exclusive determinant of the modal content of the work. Considering each example in the light of what we have learned from the others, it is apparent that few if any can be interpreted as examples of pure formalism, realism, or fantasy. For all its submission to formal order, *Potemkin* is close to actuality and includes a bit of fantasy in the shot of the sailors hanging from the yards or in the series of shots of the awakening lions (Figs. 393–395), some expressive distortion in the cutting and juxtaposition of shots. Even a single shot or frame may contain elements of all the modes. What is important in the end is our discrimination of the overtones or undertones that each contributes to the filmic chord, and our awareness of the latent content of the style.

As suggested at the outset, the modes constitute only the most general manifestation of filmic style; for style, whether it emerges from deliberate plan or unconscious predilection, whether it represents the individual or a group, permeates every dimension of the film. To grasp its full content, we must be aware also of the manner in which the filmmaker utilizes or ignores the capacity of film to articulate space, to describe, decorate, intensify moods, and the manner in which he achieves continuity, creates contrast, invents metaphor, makes comments, and develops ideas in parallel or contrapuntal relationships. Since we have already considered these functions of filmic structure at length, there seems little point in further consideration here beyond recalling that it is through a filmmaker's preferences for one way or another of handling these aspects of filmic composition that he imposes his personal vision on his material and reveals his individuality as an artist or, as some would have it, as an *auteur*.

10
Genres

Film seems capable of dealing in one way or another with the entire range of human experience. Filmic expression is embodied in a countless variety of styles, and film performs an extraordinary diversity of functions. For all its variety of subject matter, form, and function, however, it is still possible to discern in film a limited number of genres or types that subsume the entire range of filmic production. These are the *factual film*, the *fictional film*, the *film poem*, and the *abstract film*. Obviously, as a group these categories are not consistently or exclusively concerned with form, function, or, in any specific sense, subject matter, but in a general way each one of them does have to do with content, just as the modes, in a general way, have to do with form.

In a book concerned primarily with the enjoyment and interpretation of film, consideration of film genres may seem principally of academic interest. To be sure, a system of typology provides a concise means of description and reference and may serve those who make catalogues and those who use them; it may perhaps offer a reminder that some of the criteria by which we judge one type of film do not necessarily apply to another. A study of type has other purposes as well. What we call anything has a great deal to do with how we judge it, so it will be of some use to know what we mean when we apply some of these terms. Even more important, the consideration of various genres, like the consideration of modes, will allow us to examine aspects of the film not yet touched upon.

FACTUAL FILM

As the term suggests, factual film is concerned with the truth, what is thought to be the truth or offered as the truth or, at the very least, with an interpretation or hypothesis capable of being supported by material evidence. Such a film deals with verifiable reality, although it does not necessarily take its shape in the realist mode. The general category includes several types of film: *record film*, *instructional film*, *informational film*, and *documentary film*.

Record Film

Record films exploit the most fundamental and primitive function of the medium, which is to preserve transitory events—the growth of an organism, the behavior of an animal, the response of a model aircraft to the blast in a wind tunnel, the inauguration of a president, a fire in a warehouse, a family reunion, the events of a vacation. They are the tools of science, industry, and commerce, the visual enactment of the news, the souvenirs of personal life. Record films are only incidentally or accidentally preoccupied with aesthetic values, and they would not concern us at all

675, 676. *Cosmic Ray.* Bruce Conner. U.S.A., 1961.
The flag raising on Mt. Suribachi and the explosion of the hydrogen bomb are among the most familiar shots in film history.

675

676

except that they frequently provide the raw material for other types of production. Scientific footage was welded together to create *Ouverture;* news shots have been interpolated into informational films, documentaries, experimental and fictional films. Some of these records have become as familiar as highway signs. The burning of the dirigible Hindenberg, the dance of Hitler on his arrival in Paris, the raising of the flag at Mount Suribachi (Fig. 675), the explosion of the hydrogen bomb at Bikini (Fig. 676), all have appeared so often they exist as symbols carrying an accumulation of associations that allows them to stand for eras in time and complex states of mind. They may be used in certain contexts so unimaginatively as to seem banal clichés, but in skillful hands they are still capable of evoking a powerful and significant response.

Instructional Film

Instructional films are concerned with process, with how certain operations are performed, how particular events occur. They constitute a large number of the films used for training and teaching and may range from the canned lecture and demonstration, which makes use only of the camera's primitive capacity to record, to more imaginative and complex structures, which exploit the full potentialities of film and explore aspects of a process or operation that simple lecture-demonstration may inadequately describe.

A New Way of Gravure (1950) demonstrates how skillful use of film can reveal aspects of a process not inherent in the manual operations themselves. This film by Jess Paley is simple enough in its scheme: it watches Stanley W. Hayter, a British artist whose innovations in printmaking and teaching have had a profound effect on the history of modern graphic art, as he makes a print. It would have been possible simply to line up the steps in the process and explain what was happening, but the film goes far beyond description. Using very few words, all of them spoken by Hayter, it conveys the struggle to find form, the sensuous delight in the materials as the gleaming orange copper flashes from the green acid bath, the concern for dirt and grime as the

artist cleans his plate or inks it. Patience and the measure of time are evoked when Hayter says, "There will be time, time for a cigarette." Finally there is the physical labor, the suspense and apprehension of waiting for the first proof, the excitement of discovery, and the recognition of the need for modification. The film examines the printmaking process not simply as a technical operation, but as a complex of psychological attitudes as well, so that the spectator in some measure shares in the act of creation and comprehends its various dimensions. Like many imaginative instructional films, *A New Way of Gravure* might just as well be described as an informational film.

Informational Film

While instructional films provide information, their subject matter is limited and clearly defined, their purpose operational and utilitarian. They are directed at a specific audience that needs to perform the operations or to understand them. Information films have no such immediate purpose or limited audience. They encompass the entire spectrum of the world. They may explore the structure of a cell or the universe, describe exotic or familiar places, recount history and biography, investigate the arts, and observe current events. They may be descriptive, analytical, critical, polemical, or propagandistic. An information film may use any or all of the modes (including fantasy), may develop ideas by lecture and panel discussion, interview, or illustration. It can even employ the full dramatic possibilities of the medium. A particularly fine example of the type, which suggests how film can be used to convey information and to make a critical examination of a subject with the most sparing use of words, is Herbert Matter's *Works of Calder* (1950).

In discussing film, we have been especially concerned with the expressive potentialities in configurations of space, light, and color. The objects within the configurations have been viewed not for their intrinsic qualities but for their participation in the formal order or for their association with human activity as parts of a setting. These objects have also been seen

677

678

677–681. Works of Calder.
Herbert Matter. U.S.A., 1950.
Through an exploration of the natural world, the filmmaker reveals a source of inspiration for the artist.

ing a rhythm in certain passages, when the frame becomes somewhat static, or acting as a substitute for dialogue. Only once, when Calder is indirectly quoted, does the narration serve an explicitly critical function.

In the beginning, the film explores the natural environment—the trees and leaves, the dappling light on the ground, milkweed seeds scattering in the air (Fig. 677), the flicker of light on water (Fig. 678), the action of waves and clouds. All these geometric shapes lift, float, and dance in air until finally the disk of the sun appears. A small boy walks on the beach, absorbed in his surroundings, watching the sun. He discovers Calder's studio, where the reflections in the glass wall move, shift, and slide in space like the jellyfish in water (Fig. 679). Inside he finds Calder at work, surrounded by mobile structures that constitute what he describes as his own private universe

It is now apparent that Matter's exploration of the natural world has set up one part of a simile, of which the other part is Calder's oeuvre. The parallels in shape and sometimes in color between the art objects and the natural objects are clear. Also clear is the conceptual nature of Calder's imagery, for while his works do not make specific references to leaves, reflections, or dappled lights, they do reveal the common qualities that tie them all together and link them also with the machines Calder uses, which in their operations they resemble.

As the boy watches Calder work and the spectator glimpses various tools and procedures, a sense of the physical labor required to make these flighty, floating objects is created. It is a labor as abstract as the works themselves, since it is devoted to the production of nonutilitarian objects—labor almost for its own sake.

The sound track is largely descriptive of the visuals, but as the scream of the machines, the scraping of tools, the thunder of sheet metal,

as metaphors for some aspect or quality of human feeling or behavior. But in Matter's film objects, works of art, are the subject; they are treated as significant and expressive in themselves, apart from any context in which they appear. They are mute, fashioned primarily of wire and sheet metal. Some are mobile, that is, driven by motors, the touch of a hand, or the breath of the air; others are stabile, solidly planted but poised as if for action. They exist as geometric shapes of varying regularity or irregularity, and for the most part they bear no immediate resemblance to anything in the world around us, but look like strange, purposeless machines or bits of scrap left over from the purposeful cutting of a sheet-metal worker. Any critical interpretation, it would seem, would require a heavy barrage of words, but words are used sparingly, and the narration is simple, quiet, and direct, serving only to reinforce the mood or provid-

679

680

and the clank of falling bits and pieces describes the noise of work, the composition of the sound becomes expressionistic. The stabiles, black silhouettes against white planes, appear briefly in rhythmically punctuated and contrasting static shots (Fig. 681), which, with the percussive staccato sound, suggest the force and vigor of their shapes, the metallic quality of the material, and the solidity of the structures.

Words have not been necessary. Through the content of the shots and the structure of the film, the idea of abstract art as conceptual metaphor, the notion of art as work, craft, and play, and the characterization of the expressive content of the forms have all become clear without them.

Documentary

According to tradition, the word documentary was first applied to film by John Grierson in a review—published in the New York Sun in February 1926—of Robert Flaherty's Moana. Grierson wrote, "Moana, being a visual account of events in the daily life of a Polynesian youth, has documentary value." His application of the word is thought to have been derived from documentaire, a French word that described travel films. As applied to Moana it has had far-reaching consequences that could scarcely have been imagined at the time, creating confusion about its meaning among filmmakers, critics, and public, and little agreement about what the word connotes.

In Grierson's original use, the word documentary was simply an adjective derived from the noun document, which designates proof or evidence and in turn derives from the Latin docere, to teach. Both definition and derivation are significant in Grierson's subsequent interpretation of the documentary, the function of which, he thought, was to teach by offering evidence derived from direct observation of the subject. As his ideas developed, however, he attached certain additional connotations to the word, defining the documentary as "the creative use of reality" and restricting its scope to films concerning the interaction of humans with other humans or the human with his environment. The interaction with which he was concerned was one that shaped the human being or the environment in some particularly distinctive and sig-

681

nificant way. So he questioned whether *Berlin: A Symphony of a Big City* (1927) ought to be called a documentary when the only noteworthy action people perform in it is to get out of the rain; and he criticized *Granton Trawler* for its lack of human content.

Most critics would probably accept the notion that the documentary film involves the creative use of reality; and there seems to be in common parlance some justification for insisting that the documentary film be one concerned with people, since what we usually mean by documents are items such as bills of lading, marriage certificates, licenses, leases, wills, treaties, and similar contracts, each of which implies a kind of human transaction.

Both Walter Ruttman's *Berlin: A Symphony of a Big City* and Anstey's *Granton Trawler* exemplify the creative use of reality, and both deal with human behavior. But there is reason to question whether these films ought to be considered documentaries, a reason once again related to common parlance and implicit in much of Grierson's commentary on the genre. We customarily speak of documenting an argument, thesis, or interpretation —that is, of presenting verifying evidence. When we do so, we are referring to method or process. If we think of documentary film not simply as a film that could be used as a document, but as film using the method of documentation—that is, a film advancing a thesis, interpretation, or argument by presentation of documentary evidence—we find a more cogent reason why *Berlin*, *Granton Trawler*, and a host of films often described as documentaries may not really belong in that category. While they describe, provide information, and could in themselves serve as documents, they offer no thesis, argument, or interpretation. *Granton Trawler* might be called an information film; *Berlin*, as the subtitle suggests, could be designated a film poem.

The function of the documentary film is not simply to *be* a document, but to *use* a document to a particular end; not simply to display human behavior, but to interpret it and to expand our consciousness and our understanding thereof. While the documentary film constitutes a discrete genre, it does not take a particular form, for the form is determined pri-marily by the content and the filmmaker's particular or peculiar attitudes to it. It therefore manifests itself in almost infinite variety. There are, however, some especially popular approaches that give some idea of the range of documentary film production: the eyewitness account, the case study, the comprehensive analysis, *cinéma vérité*, and fictionalized documentary.

Eyewitness Account From the beginning of its history, film was employed to record events of varying importance, and ultimately the recorded incidents became part of the newsreel. Such films were made on the spot, were assembled as quickly as possible, and generally exhibited no more creative force than standard newspaper reporting. The documentary treatment of eyewitness accounts, however, is characterized by a creative manipulation of the medium and gains its strength as much from the manner in which it is presented as from the event itself. Already we have seen an especially instructive example of the eyewitness account in Dan Drasin's *Sunday* (Figs. 22, 23, 605–609).

Clearly, *Sunday* is not simply a compilation of record shots assembled by a disinterested spectator. It recreates the experience of someone involved, analyzes human behavior in a moment of stress, and takes a particular point of view toward legal and social problems. While at its climax it exhibits something of the diffused and kaleidescopic shifts of attention that a participant might experience, the film is carefully structured to build tension and to reveal the manner in which peaceful confrontation may trigger violence. *Sunday* isolates some of the problems that arise from conflicting interests of different groups in an urban environment during a period of cultural change and suggests one way of resolving the conflict. Like any eyewitness account, however, it is colored by the personal attitudes of the witnesses, in both its selection of details and its overall structure. In short, it provides a good deal more than information, using documents to advance an interpretation or thesis.

The eyewitness account concentrates on a particular instance of human action or behav-

ior, often on an event that is especially news-worthy or unique, sometimes on an event that is primarily of personal interest. Whatever the subject matter, the scope of the action is limited to the event itself; the material included is that a bystander might witness; and the intellectual or ideological content, the interpretation, or thesis emerge from the event itself.

Case Study Like the eyewitness account, the case study focuses on individual or group behavior, on an event or a complex of events, whether typical or unique, but it differs from the eyewitness account in the scope of its observation and inquiry. The case study provides a broader and deeper description and analysis of human behavior, examining not only the immediate action but the context in which it occurs. Often, it creates a sense of direct involvement with a particular individual or group of individuals and, in the broadest sense, conveys a feeling of identity, community, or sympathy.

Robert Flaherty developed the genre in such films as *Nanook of the North* (1920), *Man of Aran* (1934), *Louisiana Story* (1948), and *Moana*, all of which explore the interrelationship between man and the natural environment by following the activities of an individual or a relatively small group. In *Moana* (Figs. 610–612), Flaherty investigates life in a rich tropical environment through the activities of Moana, his family, and his fiancée, showing how they hunt, fish, gather fruit, prepare meals, make tapa cloth, play, dance, flirt, joke, and participate in ceremonial functions. The film reaches a climax in the tattooing of Moana, a rite of passage that Flaherty presents as a major symbol of the cultural ethos of the islanders, implying that since the Samoans enjoy a life of untrammeled tranquility, they seek artificial means to demonstrate masculine strength, courage, and endurance. By the end of the film the spectator has become acquainted with an exotic culture as well as another human being through observing him in a variety of activities and moods. *Moana* is thus unlike *Sunday*, from which we learn little about the people involved, except how they behave in a particular situation, and little about the background

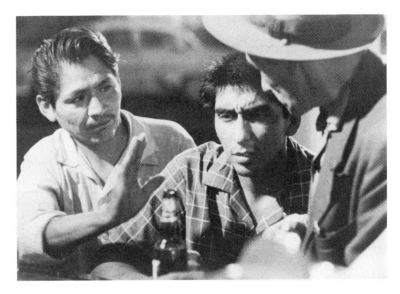

682. *The Exiles*. Kent Mackenzie. U.S.A., 1959–61. The Indian is caught between the tribe and contemporary urban society.

of the event, except what is revealed in the actual confrontation.

With much the same approach as Flaherty's film, Kent Mackenzie's *The Exiles* (1959–61) investigates a small group of American Indians who wander back and forth between a reservation and the city of Los Angeles, alienated from both worlds, exiles from the tribe and from contemporary urban society (Fig. 682). They are caught without identity between ancient tribal custom and the mores of the 20th century, their plight summarized in the final sequence when they dance with melancholy joy on a hill overlooking the city. Both *Moana* and *The Exiles* introduce the spectator to individuals, to the environment in which they live, and to the way they conduct their lives. But they tend to treat the individual as a symbol of the group and to concentrate on overt behavior rather than on internal feelings—that is, on those aspects of personality and activity that are representative rather than on those that subtly differentiate individuals.

With another aim in view, *Good Night, Socrates* (1962), produced and directed by Stuart Hagman and Maria Moraites, uses the threatened destruction of a Greek enclave in the heart of Chicago as an occasion for focusing

683. *Good Night, Socrates*. Stuart Hagman and Maria Moraites. U.S.A., 1962.

on personal sentiments. It examines the setting itself, the street with Greek signs in the storefronts (Fig. 683), communal life on the stairwells leading to the apartments, the mementos of the homeland in furnishings and decoration, the cafes with their old-fashioned wire tables and chairs, the vacant lot with its one tree where the children play. Routine activities of the people who are soon to be displaced, scattered, and absorbed into the mainstream of American culture are surveyed—the old men sitting at their tables in the cafe, the women shopping, the children playing, the casual social life of the stairwell, street, and shop, the

684. *Lonely Boy*. Wolf Koenig and Roman Kroiter. Canada, 1962.
The pop singer Paul Anka is closely observed in this psychological study.

expectation with which a package from Greece is opened. Bit by bit the film builds a sense of the dignity, serenity, security, and continuity this fragment of a foreign land provided for all age groups. Through it all, since the narrator speaks in the past tense, there is a sense of nostalgia for a quality of life that can be no more.

Good Night, Socrates resembles *Moana* in its concern for the manner in which the individual is shaped by his physical environment and cultural milieu. A similar sense of dignity, warmth, and security is generated by both. But there are basic differences between the two: *Good Night, Socrates* builds its central theme, for the most part, by evocative suggestion; *Moana* does so by explicit illustration. In *Socrates*, there is a narrator who recounts his memory of the past and acquaints us with his intimate thoughts and feelings. In *Moana*, on the other hand, we gain understanding of the characters only through their actions.

Wolf Koenig's and Roman Kroiter's *Lonely Boy* (1962), a study of the pop singer Paul Anka produced by the National Film Board of Canada, concentrates even more than *Socrates* on the psychology of an individual, penetrating below surface appearances to the troubled psyche they mask. Outwardly, Anka seems to possess all the attributes of success. He has the adulation of masses of admirers (Fig. 684); he is very much in demand and plays in the best showcases; he is exceedingly well paid; he is a skilled performer who writes and records hit songs. Yet, no more than the Indians in *The Exiles* does he seem to have found an identity. Surrounded by admirers, Anka remains a lonely boy in the midst of the crowd, wondering if the image into which he has been molded by his profession and which he presents to the public has anything to do with the image he has of himself. The method of presentation in *Lonely Boy* is quite different from those we have been considering. We see the subject at work, hear what others say about him, see how he acts with people, and draw our own conclusions.

Comprehensive Analysis Like the case study, comprehensive analysis investigates the complex texture of the human condition; but

it is distinguished by the relative anonymity of its players, by its emphasis on large, diverse groups rather than on individuals, and by its interest in the effect of political, social, economic, or religious forces on large segments of the population or on humanity in general. *Listen To Britain* (Figs. 529–534) exemplifies the type simply and directly. While the film is sympathetic toward individuals, it introduces us to them only momentarily; its overriding concern is the population as a whole and the manner in which the country may—or perhaps should—respond to war.

Joris Ivens' *New Earth* (1934), like the dike building sequence in *Praise the Sea* (Figs. 180, 181), is concerned with reclaiming land from the ocean. But unlike van der Horst, Ivens does not limit himself to lyrical description. Working during the depression, he explores social, economic, and political implication, the despair of the unemployed, the hopes engendered by a reclamation project that will allow for greater production in wheat, the physical labor involved, the frustration of the workers when the grain is destroyed to maintain the price of American wheat. *New Earth* becomes a revelation of how society, economics, and politics are interrelated, a plea for humanity and social justice.

Cinéma Vérité *Cinéma vérité*, direct cinema, or living camera emerged in the decades after World War II. Though it had its roots deep in the past, it represented a new emphasis on arriving at truth through direct involvement with people and events. It was characterized less by any common style than by a method which, like the New Wave's, took advantage of technical advances that permitted filming in conditions in which it would earlier have been impossible. In *Primary* (Time-Life, Inc., 1960) the camera followed the movements of John Kennedy and Hubert Humphrey so closely it sometimes seemed attached to them. Alan King, in *Warrendale* (1966), similarly participated in the lives of the disturbed children he was viewing.

Cinéma vérité frequently depends as much on words as on images. Sometimes the filmmaker simply records spontaneous dialogue. Sometimes he interviews. Sometimes he es-tablishes a topic and the respondents discuss it. The emphasis on the spoken word could perhaps nullify the role of the visual images, but in the hands of a sensitive filmmaker the visuals retain their importance, revealing gestures, facial expression, bodily attitudes, and aspects of the environment that modify or extend the meaning of the words, providing supplementary illustrations and confirmatory or contradictory material. The best examples of the approach exploit all the expressive potentialities of the film, all the abstract means with which we have been concerned, to convey feelings, attitudes, and ideas.

Like any other documentary approach, the method of *cinéma vérité* may distort, falsify, and express prejudice. Its truth lies less in the interpretation of its subject matter than in its frank admission, even insistence that what the spectator is witnessing is a film. While the other documentary methods tend to reinforce the sense of actuality or truth by presenting their material as if the camera, recorder, and filmmakers were not present, *cinéma vérité* not only admits the presence of the filmmaker and his equipment (sometimes showing both), but recognizes them as a factor in the situation, a participant that can modify what is revealed.

Whatever other truth it may reflect, the essential truth of *cinéma vérité* is the existence of the film itself, a fact that has long been advanced by filmmakers of the avant-garde to parallel the once-popular notion that a work of art should be truthful to its materials. This idea is not exclusively associated with the documentary but is implied in other genres as well, as the frequent appearance of Academy leader in films as diverse as Bergman's *Persona* (1966) and Warhol's *Haircut* will attest.

Two films by Chris Marker, *Le Joli Mai* (1963) and *The Koumiko Mystery* (1965), suggest the methods and potentialities of *cinéma vérité*. *Le Joli Mai* refers to May of 1959, the first year in some time that France was not at war. The film opens with a series of general views of Paris (Fig. 685), most of them showing crowds of people and automobiles. Lyrical, redolent of spring, yet touched with a wry irony, the shots convey a traditional idea of springtime in Paris, recalling popular songs.

685

686

685, 686. *Le Joli Mai.* Chris Marker. France, 1963. In this film Marker searches for the individual truths behind the statistics.

Over the visuals, two narrators, a man and a woman, cite a long series of statistics about the city and its inhabitants. Then the film turns to some of the individuals who compose the population (Fig. 686)—a housewife who has just moved into a housing development, a young soldier and his bride, an inventor, an artist, a group of engineers, an Algerian, and people at the stock exchange. Each interview or discussion carries the spectator into a different district as the film moves across Paris, finally reaching the women's prison. The viewer suddenly realizes that the confrontation with strangers, the babel of ideas, and the flood of information are what a prisoner might experience when first released. The camera then withdraws, looking at the city in long shots as the narrators recite the dizzying statistic of what happens during one day. Finally, as the camera moves in to look at some of the people passing in the street, the narrator questions how one should feel when there are people who are hungry, disturbed, alienated.

At first the film appears formless, a series of incidents and interviews strung together without relationship, but gradually it becomes apparent that it has been developed like a sonata or theme and variations. The spectator is carried along not only by the interviews but

by the camera, which records, takes stances, and moves in rhythms independent of the speakers—at one point taking off after a fly. The editing creates another rhythm, and in the end, as the statistics are recited, there is an acceleration to fast motion, which seems to summarize a day in a few minutes so that the people lose their identities and become visual personifications of the statistics. The structure itself carries a message the words only elaborate. Showing us first anonymous members of the crowd, then introducing us to some of them as individuals—so that we become acquainted with their personal problems, their views about the state, their hopes, joys, tragedies, triumphs, uncertainties, ambiguities— then reminding us of what it is to see not individuals but masses, and finally bringing us into visual contact with only some of the faces in the crowd, the film seems an exhortation to remember the individual within the mass, the personalities behind the statistics, to choose humanity rather than abstractions.

The Koumiko of *The Koumiko Mystery* is a Japanese girl whom Marker met while filming the Olympics in Tokyo (Fig. 687). He photographed her and, upon his departure for France, left her a series of questions, which she answered on miles of tape. The questions referred both to the way she thought, felt, and acted and to the way Japanese people in general thought, felt, and acted. The visuals include shots of Koumiko at home or in the

streets, shots of the Japanese setting with its mixtures of tradition and modernism, and shots of the subject matter of Koumiko's monologues—cats when she talks of her fondness for them, a stick fight in a gymnasium when she considers whether there is an inherent strain of violence in Japanese culture.

We see Koumiko first as a charming but still unknown young woman watching the Olympic games, our psychic distance from her established by the fact that Marker himself provides the initial narration. Bit by bit we become acquainted with her, a personality still in the process of formation, now childish, now sophisticated; now forthright, now speculative; now confident, now wistful; now superficial, now penetrating. Gradually the subject matter becomes more personal, more encompassing in scope, and more universal in its application. A dramatic development of ideas comes to a climax at the end when Koumiko considers herself as a woman in relation to events in the world as a whole. We see her riding a monorail as she speculates and finally concludes that someday she is sure the world will inundate her like a big wave. The magnitude of the question takes shape in the vision of the monorail, which seems to stretch to the horizon. The meandering dialogue and the innumerable facets of her personality come into focus in the vanishing point of the perspective. Koumiko becomes any young woman anywhere wondering who she is, what it is to be, and what her role is in the infinitely extending universe.

For all its appearance of objectivity, *cinéma vérité* serves as a vehicle for personal expression, partly through its formal structure and partly through the subject matter. Paul, a public-opinion pollster in Godard's *Masculine Feminine* (1966), decides that the questions he asks convey an ideology and predetermine the answers. Marker may not be able to control the response to a particular question, although he can lead the respondent, Koumiko, in certain directions, but he can select among the responses he receives from her and order them in such a way as to express a particular point of view. In both films the specific statements are less important than the cumulative effect—the sense of an individual isolated, alone, shaped by forces impossible to comprehend. At the same time, these films convey a sense of human interdependence, of the need for sympathy and understanding.

Fictionalized Documentary The documentary is by definition concerned with the actual. However, like the documentary novel, which treats actual events in a novelistic fashion, there are several types of film in which the distinction between the documentary and the fictional film blurs.

Authentic documentary material, that is, records of actual events, may be linked together by fictional scenes that provide a narrative thread. *The Savage Eye* (1959), a compilation of newsreel and television shots of Los Angeles presented on a fictional framework, takes this approach. The film, directed by Ben Maddow, involves a young woman who has gone to Los Angeles to try to find herself and regain her equilibrium after a divorce. Instead, she becomes depressed and attempts suicide. Discovered and hospitalized, she ultimately achieves some reconciliation with herself and her situation, regains her courage, and at the end faces the world with some hope. As she wanders aimlessly about the inner city searching for distraction and a remedy for depression, she is confronted by bars, strip joints, bingo parlors, devotees of faith healing, automobile accidents, and derelicts.

687. *The Koumiko Mystery.* Chris Marker. France, 1965.

The loneliness, isolation, poverty, infirmity, and disease she witnesses overwhelm her. While the documentary aspect of the film is impressive, the fictional part is not, largely because of the disembodied voice that addresses her as a sort of invisible guardian-angel psychoanalyst, mouthing pompous platitudes in pretentious phrases and unctuous tones. The young woman's personality is inadequately realized, and the narrative plot offers merely a schematic means of bringing some coherence to the series of visual probes of life in the city, which give the film its strength.

Reconstruction of an event that occurred in the past is another subject in which documentary and fictional film often merge. Depending on the degree to which the filmmaker succeeds in simulating the conditions of the event, as well as the extent to which he recreates the appearance of filmic records, the film will emphasize either the documentary aspects or the fictional. As we have seen, Pontecorvo in *The Battle of Algiers* manages to create a sense of authenticity in almost every dimension of the film. Finally, film that is fictional in its plot may be constructed with such concern for reproducing actuality that it takes on the character of documentary, like de Sica's *The Bicycle Thief*.

Whatever form they take, documentary films are the instruments of human awareness and social change, continuing public education of a most important kind. They bring into focus lives, activities, attitudes, and problems the viewer might otherwise never confront, revealing to him the common ethos of the human race and the dependence of man on man. Whether comic, fantastic, serious, or pathetic, documentary films insist on man's confronting reality; they are sometimes not chary of his conventional sensibilities, forcing him to take cognizance of what he would perhaps prefer not to see: the stacking of bagged bodies in John Huston's *The Battle of San Pietro* (1944), the slaughter of cattle in Georges Franju's *The Blood of the Beasts* (1949). But for all their concern with actuality, we should be aware of their bias as it appears in the use of the filmic means.

Each subgenre we have discerned under the general category of documentary suggests a particular method for developing the intellectual content of the film. We distinguish such categories with a kind of aesthetic hindsight, for the filmmaker may have made no deliberate choice among them. There is no reason for him to be concerned with such matters; his purpose is to produce a film that will illuminate actuality, and the method of dealing with the material may well seem to emerge from the content itself.

What is clear is that any of the films we have described might have been constructed in a different way: *The Exiles* could have been approached in a comprehensive study or through the methods of *cinéma vérité*, for example. In the end, it is the filmmaker's habits and preferences that come into play. Flaherty tended to prefer the case study of an individual; Ivens preferred a more comprehensive approach. And Marker chose the method of *cinéma vérité*. The preferences of the filmmaker also inevitably determine the mode or modes he will use. Ivens works in the realist mode and Marker moves occasionally into fantasy, as in the fast motion of *Le Joli Mai*.

FICTIONAL FILM

Fictional films are what most people think of when they consider the film as an art form. Even critics and historians tend to stress the fictional film—or screenplay, filmplay, screen drama, film drama, or story film, as it is sometimes called—as if literature were to be identified only with the novel and short story or visual art only with drawing and painting. This point of view, however limited, is understandable, for it is the fictional film on which the greatest time, money, and effort are expended, and it is to the fictional film that creative filmmakers more often than not seem to turn. Of all the categories of film, the fictional is the most difficult to define in closely circumscribed terms. Its limits and characteristics are as elusive, inconstant, and sometimes as inconsistent as those of the novel and short story with which it is often compared and from which it is often derived. Like the novel and short story, it seems capable of absorbing all the other genres of the medium and sometimes of other media as well.

688, 689. *Nobody Waved Goodbye.*
Don Owen. Canada, 1964.

688

689

Orson Welles in *Citizen Kane* utilizes the form of the newsreel as a means of exposition; Truffaut borrows the epistolary method from literature to advance *Jules and Jim* (1961); Resnais develops *Last Year at Marienbad* as if it were a film poem; Godard in many films adopts documentary techniques—the interview method of *cinéma vérité* in *Masculine Feminine* and *My Life to Live*—and more than any of the other celebrated directors incorporates literary forms, lectures, poems, short stories, and advertising. In *A Woman Is a Woman* (1961) Godard absorbs the form of musical comedy; the familiar attributes of musical comedy are absent—the meditative solos, the duets, the ensemble dances—but the stylized movements and attitudes are there, as are the rhythm of action, the gags, the comedy routines, and film tricks in slow motion.

The most obvious overlap is in fiction and reconstructed documentary, which can dissolve into one another so that they are indistinguishable. Don Owen's *Nobody Waved Goodbye* (1964; Figs. 688, 689), a production of the National Film Board of Canada, traces the progressive alienation of a middle-class boy growing up in an environment in which understanding has been replaced by convention, love distorted by selfishness and indulgence, and honesty supplanted by meretricious rationalization. He proceeds from truancy to petty theft to stealing a car, in which we see him for the last time, sobbing, totally isolated in a world that seems to have no use for him. Is this a fictional treatment of fact or a documentary treatment of fiction? The film does not tell us, and in this instance it is of little concern.

In a film like *The Battle of Algiers*, however, the form is important, for the filmmaker has selected a recent historical event and reconstructed it with such conscientious verism that for the most part it seems to have been shot by participants on the spot at the time. Yet the film offers not only the fascination of reality, but also the excitement and suspense of the detective story, the espionage film, the psychological thriller, and the romantic tale. Truth, of course, can be stranger than fiction and more exciting or provocative as well, but in an instance like this we want to know where fact leaves off and fiction begins, because the film goes beyond history to confront important historical problems.

Another difficulty in defining fictional film emerges from changes that have taken place in content and method of construction. Earlier in this century, if one ignored experimental or avant-garde works, one might have defined the fictional film as one that told a story invented by the filmmaker or by someone else. It might have been developed more or less chronologically, in flashbacks, or in two or

690. *Masculine Feminine.*
Jean-Luc Godard.
France, 1966.

more parallel narratives, but its basic structure would be a linear one with a beginning, a middle, and an end. It would have had an exposition that developed tension, a climax, and a resolution. The relationships between part and part would be based on simple or sometimes naïve principles of continuity and causality. The sequence of events would be clearly articulated, one action would follow another with explicit narrative logic, and transitional passages would explicate and ease the movement from scene to scene.

A situation that exemplifies traditional cinematic construction involves Mr. A calling Mr. B to summon him to a conference. We see Mr. A take up the phone and dial the number, then Mr. B pick up the phone and the ensuing conversation. Next we see Mr. B put on his coat, leave his apartment, hail a cab, drive through the street, pay the driver, leave the cab, enter a building, ascend an elevator, ring a bell, and so on. The filmmaker explains, in short, why Mr. B is in Mr. A's apartment and shows how he got there.

In some situations this kind of development serves a useful purpose by increasing suspense, presenting a necessary lapse of time, introducing important information about the characters and the milieu in which the action takes place, or keeping informed an audience unaccustomed to making leaps in space and time.

When the thieves in Griffith's *The Lonedale Operator* are attempting to break into the telegraph office and the operator telegraphs the next station for help (Fig. 543), the sudden appearance of the rescuers would have seemed implausible; therefore, there is some justification for our being informed how the hero got the message and made his way to Lonedale, although even Griffith's time scheme stretches the bounds of plausibility. Scenes in which an officer reports to his superior—as so often happens in war films such as John Frankenheimer's *The Train* (1964)—may show the officer's progress through the headquarters to his superior, informing us of the orderliness or confusion of the situation.

For the most part, such transitional sequences are unnecessary, however, and toward the middle of the 20th century, filmmakers more and more frequently eliminated expository passages, assuming the spectator would comprehend. Even more important, they suppressed the narrative, plunging into the middle of the situation, examining it, exploring ideas, feelings, and attitudes inherent in it, and leaving it without neatly tying up the ends in a conclusion. Godard's *Masculine Feminine* (Fig. 690) is based on two stories by Guy de Maupassant. In one, entitled *La Femme de Paul*, a wealthy young man who is a senator's son becomes madly infatuated

with Madeleine. On an excursion with her at a hotel and restaurant frequented by licentious types, Paul is incensed at the presence of a quartet of lesbians and outraged to learn that Madeleine is familiar with one of them. He threatens to have them arrested and forbids her to have anything to do with them. When he learns that Madeleine and her friend Pauline have obviously arranged a meeting in the evening, Paul suggests that he and Madeleine retire early. She refuses and goes off with Pauline. Overwhelmed by despair, he searches for her. When he discovers her in the company of Pauline, he drowns himself.

Godard retains very little of the Maupassant story except the names of the two central characters. Paul is a working-class young man who ultimately takes a job as an interviewer with a public opinion survey; Madeleine is a pop singer. While she lives with two other girls, any suggestion of a lesbian relationship is quite ambiguous. Godard retains Paul's death, but neither we nor anyone else can know whether it is by suicide or by accident, because it does not explicitly emerge from the earlier action. We see Paul seated in a cafe and hear him, voice over, reflecting on his experiences as an opinion sampler. He concludes that the questions he has asked in actuality convey an ideology and by implication elicit contrived answers. His ruminations end with the conclusion that "Wisdom would be if one could see life, really see, that would be wisdom." In the next scene Paul is dead, and the police are questioning Catherine, one of Madeleine's roommates, to find out what happened. She tells them that Paul had just received an inheritance from his mother and that he had bought an apartment in a not yet completed building, where he and Madeleine were going to live. He had taken Madeleine and Elisabeth, the other roommate, to see it. Madeleine wanted Elisabeth to live with them, but Paul objected. Catherine then says, "I think he wanted to take a moment for some pictures. And then he surely stepped back too far, and he fell. It can't have been suicide, it's not possible. It was really a stupid accident." At the end, nobody knows why Paul died, not the characters, not the audience, and possibly not Godard.

As in conversations overheard on an elevator, through the walls of a hotel, or, for that matter, interrupted when we arrive among friends, we grasp only part of the story. A more conventional filmmaker might have had Paul reach the conclusion that life is absurd—that there is no truth, that people manipulate facts to suit themselves—and then kill himself. Following Maupassant's tale, another filmmaker might have had Paul suddenly realize that Madeleine was in love with Elisabeth and commit suicide out of frustration. In either case, a filmmaker would probably have made more of the death by allowing us to watch it, with Paul, camera in hand, backing step by step toward the edge of an unfinished balcony, the women suddenly realizing he was moving into danger, and Paul stepping off before they could warn him. But for Godard the events themselves are less important than reactions to them, answers less important than questions. Telling a story with all the loose ends neatly tied up is of less consequence than viewing a situation, in this case a sampling of what for him are "the signs" of the younger generation. As a result, we become aware of the illogical character of life. The filmmaker doesn't necessarily know what has happened. The author no longer pretends to be omniscient, and the film maintains the uncertainty of life itself.

In such films, the story no longer exists as a linear development from point to point. A comprehensive definition of fiction, then, might be a work that examines the behavior of characters who are more or less invented. We should emphasize the word *characters* as distinguished from *persons*, for characters may be animals, animals provided with anthropomorphic traits, or things made to behave as if conscious. For example, *Orange and Blue* (1962), a film by Peter and Clare Chermayeff, features an orange ball and a blue ball animated in such a way that they suggest human relationships.

FILM POEM

The various genres we have been considering may resist absolute definition and as categories may seem elusive, indefinite, and overlapping.

Attention only to those aspects of a film that associate it with one genre or another may cause us to ignore other significant aspects and interpretations. It is useful to consider, for instance, that any film can be thought of as documentary or informational or that any film may be regarded as abstract or fictional. But whatever relationships we discover among the various genres, we do have a notion of what we mean when we refer to any one of them.

There are innumerable films that do not fit into any single category, but present a different kind of form and content, demand different perceptions, and engender different expectations. Like any work of art, they may be records of a particular experience, or they may provide information, serve as documents, or even use documents; however, they cannot be thought of as record, informational, or documentary films. Such films may be fictitious and even depend on narrative, but they do not conform to our ideas about fictional films. They may be abstractions in the sense that they show only images, but we cannot call them abstract films. Some of them describe the familiar, visible world, like Charles Sheeler's and Paul Strand's *Manhatta* (1921); some resemble abstract films in their isolation of patterns in nature, like Ralph Steiner's H_2O (1929); others use a narrative framework, like Maya Deren's *Meshes of the Afternoon*. There are films that take the form of mysterious case studies, like Jean Cocteau's *Blood of a Poet* (*Le Sang d'un poète;* 1930). Some incorporate documents, like André Michel's *La Rose et le réséda* (1945). Divergent as they are in subject, method, form, and content, such films can all be described as film poems or *cinepoems*.

More often than not a sense of poetry in film is informally and casually identified with a lyrical quality—which can be mere prettiness, with an intensity of feeling—or with elegance—which in the end is economy and grace. Generally, the word poetry is used to describe an elusive quality we are too lazy to elaborate; or possibly when the particular quality we perceive is ineffable, so visually rooted, so complex that we can find no simple way in which to isolate it. So we speak of the poetry of motion in *Ivan the Terrible*, perhaps, meaning the organization and control, the

dancelike measure, and the epic elevation. Or we refer to the poetry of color in Bo Widerberg's *Elvira Madigan* (1967), with its soft harmonies and light-filled hues, which seem to tell of tender, evanescent love.

Still, poetry can be harsh, rugged, and obscene as well as pretty; it can howl as well as move in mellifluous cadences; it can be convoluted, involuted, and dense, as well as simple, direct, and clear. There is no set content, attitude, or form; it seems to resist definition. Yet one characteristic does link the varied subjects, methods, forms, and moods and that is an emphasis on image or figure, on metaphor, on an evocative and illuminating conjunction of disparate and independent ideas or forms, a condensation or mingling of dissimilarities, a dissolution of separate identities, ideas, or feelings. We may find poetry anywhere, in a single frame, shot, or sequence. For that matter, we can think of any work of art in its entirety as being a metaphor. Even nonrepresentational, nonfigurative works, which seem to be only images, imply ways of thinking or feeling, however abstract they may be. In the film poem, the whole is metaphor.

The metaphor may involve any of the dimensions or elements of the film—the formal structure, the action, a narrative framework, an ideological point of view, an emotional response to the subject matter. *Manhatta*, one of the earliest American film poems of importance, examines the architectural landscape of New York, isolating the rectilinear austerity of the modern setting man has built for himself and discovering an almost Cubist world of line and plane. While the subject matter might seem more appropriate for an informational film or a documentary, the strict formal structure implies something more than a casual record. The visual material is translated into a simple, descriptive poem. In shot after shot the position of the camera and the angle of vision reiterate the vertical and horizontal lines and parallel recession of planes in the buildings, creating a harmony of shapes and directions very like rhymes and assonances in words (Fig. 691). Even more important, the movement of the camera gives movement to the forms, echoing the buildings themselves in its vertical and horizontal exploration. The

691. *Manhatta.*
Charles Sheeler and Paul Strand.
U.S.A., 1921.

movement of the camera and the cutting not only isolate and enhance the harmonies but also instill a metaphorical life into static forms, tracing the energy within them.

Ralph Steiner's *H₂O* interprets its theme in much the same way as *Manhatta* does, but the subject matter is more varied, the filmmaker's perception more subtle, and his organization more complex. In the beginning, water appears in its familiar settings—gushing from spouts, flowing between river banks, eddying around pylons (Fig. 692). Gradually, the camera moves in closer, the topographical context disappears, the contrasts of light and dark are reinforced. The water loses its identity, becoming changing patterns of light and dark

reminiscent of the dripped and poured paintings of Abstract Expressionism, the abstract images of the ductile quality of water (Fig. 693), rather than of water itself.

Each of these films—in the relative proximity of the object from the camera, the angle of vision, the movement of the camera, and the ordering of shots—structures our visual experience and deviates from our normal way of seeing, imperceptibly distorting it. Daunant's *The Dream of the Wild Horses* employs more explicit distortion. By means of slow

692, 693. *H₂O.* Ralph Steiner.
U.S.A., 1929.

692

693

694. *The Dream of the Wild Horses.*
Denys Colomb de Daunant. France, 1960.

695. *Desistfilm.* Stan Brakhage. U.S.A., 1954.
The insistant gaze directly into the camera lens
establishes contact with the viewer.

motion, the depth compression inherent in the telephoto lens, the graininess of the print, and the selection of shots and cutting rate, fact is transformed into dream, while the grace and elegance of motion that monumentalizes the animals is distilled (Fig. 694). The images that result from this distortion are not merely two-dimensional reproductions of animals but represent ideas about them.

All three films select limited aspects of the world for examination; in all three, drama, narrative content, and poetry reside in the abstract manipulation of forms. Much the same can be said of Stan Brakhage's *Desistfilm,* a study of a teen-age gathering in which nothing much happens. The participants alleviate boredom by engaging in a variety of time-consuming activities that are not especially

extraordinary in themselves: a boy picks lint from his navel, another builds a tower of cards, a third lights matches, two of the boys reveal a repressed attraction for one another, a number of them run through a repertoire of facial and bodily contortions, some scuffle, a boy and girl retire to another room, the rest harass them and pursue them when they try to flee. The action is a kind of social busywork, and one can imagine that if it were filmed in a documentary manner and viewed from a greater distance, it might provide a mildly amusing and fairly typical view of adolescent behavior. But Brakhage goes to a higher level of reporting than mere observation to invest the film with an expressionist intensity, exploiting a broad range of purely filmic devices. He takes advantage of the distorting effects of extreme close-ups, involves the spectator by having some of his subjects peer directly into the lens (Fig. 695), focuses on activity to dramatize and monumentalize it out of proportion to its actual significance, moves his camera in an almost drunken vertiginous manner, illuminates in such a way as to create visual drama where there is none, and attaches a sound track that is a disjointed, arrhythmic, atonal humming rather like grinding teeth. Through these strategems Brakhage evokes a sense of internal loneliness, a sexual ambivalence, an uncertainty and disquietude, and the feeling of clumsiness attendant upon efforts to assert individuality. The cumulative effect is not a series of observations but a metaphor for a state of mind.

Each of these films alters our normal way of seeing—through a different approach toward spatial configuration, as in *Manhatta;* toward tonal pattern, as in *H_2O;* toward movement, as in *The Dream of the Wild Horses;* and toward proportion and rhythm, as in *Desistfilm.* In each case, the metaphor manifests itself in the use of the filmic means rather than in the subject matter. An example of metaphorical content in the subject matter is *Un Chien andalou,* a major work in the history of film that has affected much of the experimental and avante-garde work following it. Produced by Salvador Dali and Luis Buñuel, the film breaks down linear development, overflows with interior metaphor, and intro-

696

697

698

duces a new method of analysis and comment that seemed outrageous in 1928, when it was made, and is still intensely disturbing.

Un Chien andalou (Figs. 696–723) is divided into sections that develop no coherent narrative line and seem unrelated to one another. Each is preceded by a title referring to time. The prologue is introduced with the words "Once upon a time." The vagueness of this phrase removes the film from any specific temporal reference and in its association with children's stories acquires overtones of irony if one considers the startling content of the ensuing sequences. A man is seen standing on a balcony, sharpening a razor (Figs. 696, 697). A young woman stares out at the spectator. A cloud passes over the moon (Fig. 698). The razor slices the woman's eyeball (Figs. 699, 700).

Introduced by the words "Eight years later," the first scene reveals a young man riding a bicycle down a deserted street (Fig. 701). He is dressed in a curious costume—a gray suit, a maid's cap, a cape, and a short skirt. From a tape around his neck hangs a striped box. As he pedals along, he becomes transparent and vanishes. The camera enters an apartment and finds a young girl reading. Suddenly she tosses the book aside and goes to the window. In the street below, the cyclist comes to a stop and falls into the gutter. The girl rushes out and kisses him feverishly. The camera closes in on the box that has been suspended around his neck. A pair of hands opens it and removes striped paper and a striped necktie.

696–723. *Un Chien andalou.*
Luis Buñuel and Salvador Dali. France, 1928.
The film is a tribute to the poetry of the surreal.

699

700

696–723. *Un Chien andalou.*
Luis Buñuel and Salvador Dali. France, 1928.

701

In the room the young woman stands contemplating a bed on which the man's outlandish accessories are laid out as if he were lying there. She looks around to discover the man. He is staring intently at the palm of his hand (Fig. 702). From a hole in the center a colony of ants is emerging (Fig. 703). A series of dissolves follows: to the armpit of a young woman who is sunbathing (Fig. 704); to a sea urchin (Fig. 705); to another young woman who is standing in the center of a ring of people poking with a stick at a severed hand lying at her feet (Fig. 706). A policeman picks up the hand and puts it into the striped box and hands it to the woman, who stands as if enraptured in the middle of the street. A car runs over her.

The couple in the apartment have been watching the episode. The man, his face distorted with passion, attacks the woman, caressing her breasts and buttocks (Figs. 707–709). The woman escapes into a corner. Looking about him as if for a weapon, the man spies two ends of rope, which he picks up and hauls over his shoulders. Attached to the ends are a grand piano draped with a bleeding, suppurating dead mule (Figs. 710, 711), a cork, a melon, and two priests (Fig. 712). Horrified by the spectacle, the woman flees through a door. The man drops the ropes and runs after her, managing to get one hand through the doorway, the hand covered with ants. The woman looks toward the bed and sees the man lying there dressed as we first encountered him.

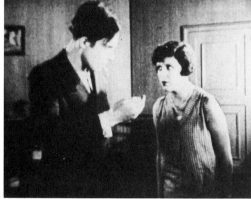
703

702

The second scene opens with the title, "Toward three o'clock in the morning." A man appears and rings the doorbell. Admitted, he goes to the bed, forces the first man to get up, rips off the accessories he is wearing, throws them out the window, and sends the young man to a corner, where he stands like a schoolboy being punished (Fig. 713). We now see the second man's face and recognize that he is an alter ego of the first.

A third title appears: "Sixteen years before." The intruder walks to a school desk,

704

705

709

706

710

707

711

708

712

713

714

715

picks up some books, returns to the first man, and orders him to put his arms up and hold a book in each hand. The first man turns on the second and, as the books turn into revolvers, shoots (Fig. 714). The second man falls, not in the room, but in a field. Beside him is a naked woman. As he falls he scrapes her back (Fig. 715). She disappears (Fig. 716). Some passersby and park guards rush to the man's aid. Two men, one tall and limping, the other short, almost dwarflike, watch the incident and then walk away.

Back at the apartment the door opens and the young woman enters. Everything is the same as it was before all these events occurred. On the wall she spies a moth. On closer examination it appears to have the pattern of a death's head on its back. Suddenly, the first man puts his hand to his mouth. When he withdraws it, the mouth is gone (Fig. 717). The woman applies lipstick furiously (Fig. 718). The man suddenly acquires a beard (Fig. 719). Horrified and revulsed, the woman looks at her armpit from which the hair has disappeared (Fig. 720). Sticking out her tongue at the man (Fig. 721), she opens a door leading to a beach. A third man waits for her. They walk up the beach together, the waves tossing up at their feet the accessories of the first man (Figs. 722, 723).

Dali and Buñuel filmed *Un Chien andalou* in accordance with the antirational principles of Dada and Surrealism—repulsing reason, welcoming chance, cultivating incongruity, multiplying shock, and hoping to force a complacent audience into a new awareness of aspects of themselves and their culture that it consistently avoided. According to Buñuel, they were initially inspired by dreams, and when developing the script they discarded anything that seemed to make sense, retaining what appeared to be good gags. But the film is something more than a string of jokes, whatever the intent of its authors.

The prologue is disquieting even today, when we have become familiar with visions of violence. It constitutes a deliberate reversal

716

of sentimental tradition and familiar expectation, since the *mise en scene*, with its balcony, night sky, shifting clouds, and moonlight, provides the trappings associated with a romantic incident, but the image of the smooth-shaven man stropping his razor, a cigarette dangling from his lips and illuminated like a villain in a horror movie, immediately introduces a sense of apprehension. As the cloud slides across the orb of the moon and the knife slices the orb of the eye, a traditional symbol of tender yearning, amorous passion, and lunatic dreaming becomes a simile for sadistic dissection. The succession of images is more than a reversal of sentiment, however; it is a kind of defloration, exposing the raw nerve ends of the spectator, sensitizing him to the events that are to follow, and insisting, by the destruction of the physical eye, on penetration to a world behind appearance. It also insinuates a basic theme that recurs many times in the film, the identification of love and violence, attraction and repulsion.

717

Throughout the film, objects and actions evoke other objects and actions, sentiments and associations, symbolic and metaphorical relationships. At times the imagery acts like a simile: the colony of ants recalls the moustache of the armpit which looks like a sea urchin's spines which in turn look like a crowd of people. In the context, all perhaps evoke images of pubic hair. At other times the imagery acts like a metaphor: the ecstasy of the young man caressing the woman becomes the ecstasy of the martyred saint (Fig. 709); his attitude when standing in the corner is the attitude of Christ on the cross. More conventional imagery includes books becoming guns. More frivolous imagery occurs when the second man rings the doorbell and hands, which are shaking a cocktail shaker, become the sound of the bell; when the young woman is cornered and she brandishes a tennis racket in defense; and when the young man, frustrated, goes searching for a weapon and takes up the yoke of conventional marriage.

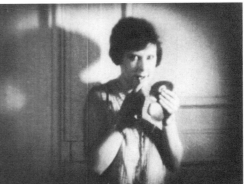

718

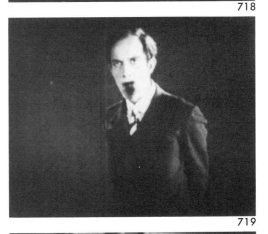

719

Un Chien andalou parodies middle-class attitudes toward religion, society, and love, making asses of the clergy, suggesting an ambiguous identity between religious and sexual ecstasy, linking love and violence, reason and

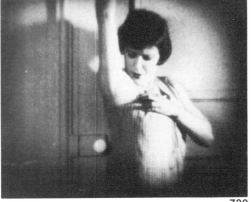

720

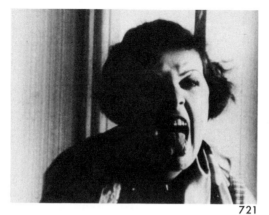

721

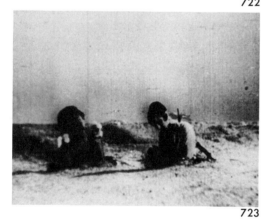

722

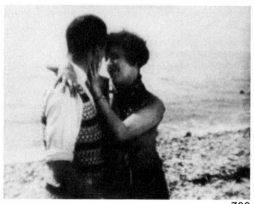

723

696–723. *Un Chien andalou.*
Louis Buñuel and Salvador Dali. France, 1928.

right: 724. Salvador Dali.
The Persistence of Memory. 1913.
Oil on canvas, 9½ × 13".
Museum of Modern Art, New York.

instinct, and death and life as poets have for centuries. The film also mirrors a particular interpretation of human psychology, which is embedded in the objects and actions, as well as in the peculiar time sequence they follow. It is hardly without significance that the young cyclist wears babyish clothes and carries a necktie—associated with adulthood—in a box, that the elder alter ego punishes him for wearing them, that the flashback to sixteen years before introduces a schoolboy, that there is a conflict between the infantile-adolescent young man and his mature other, and that the flashback, without any interruption by title, slips easily into the present again.

Each incident makes a persistent reference to another time. Dali's painting *The Persistence of Memory* (Fig. 724) provides a clue to the scheme, for in that painting time is suspended, as the limp watches are literally suspended over a branch of a dead tree. In that moment of suspended time we can see an egg; a prenatal form decorated with the moustache, eyes, and lips of the mature man; and a dead tree. Thus, the man's total life seems captured and crystallized in the instant—conception, prenatal state, adulthood, and death.

In Buñuel's film, past, present, and future merge as they do in Resnais' *Last Year at Marienbad* (Figs. 551–564). The difference between the two lies in the attitude toward the narrative. Even though we may at first have difficulty in grasping it, the narrative framework is always implicit in *Last Year at Marienbad;* but in *Un Chien andalou,* although one is tempted to look for narrative, none seems to exist. Any journey we make is

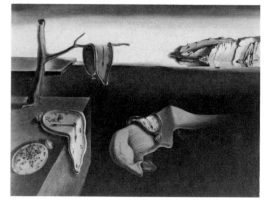

not horizontally through time, but vertically down into the subliminal depths of the psyche, there to discover the secrets of the soul and recognize the past, present, and future are simultaneously existent at the moment the razor makes its incision and at every other moment that follows. The film in the end is not simply a string of metaphors but a single metaphor as well.

Narrative can operate in a film poem as it does in a verbal poem when the narrative itself is not the point but serves as an image for something else. Jean Cocteau's *Blood of a Poet* (Figs. 725–749) illustrates this point. Like *Un Chien andalou*, Cocteau's work is an examination of the psyche that condenses past, present, and future into the present. As Cocteau confesses, it is a very personal and autobiographical film as well. To explore all the implications of Cocteau's imagery would take us far beyond the limits of this book, but we can examine how the author makes of his plunge into the well of the mind a literally horizontal odyssey.

The film opens with a view of the author in a studio setting and a doorknob twisting as if someone were trying unsuccessfully to enter, after which a tall factory chimney is seen. Suddenly, the chimney begins to crumble, but before it collapses to the ground, there is a cut (Fig. 725). The completion of the collapse occurs only at the very end of the film to make a frame or parenthesis around the body of the piece and thereby suggests that all that has occurred is simultaneously present.

In the first episode, the hero, a young painter dressed in 18th-century breeches and peruke, works at a drawing of a head reminiscent of Picasso's antique style (Fig. 726). The mouth of the drawing takes on three-dimensional form and begins to move (Fig. 727). Horrified, the painter tries to erase it, only to find that he has transferred it to the palm of his hand (Figs. 728, 729). He kisses it, caresses his body with it (Fig. 730), and collapses. The next morning he awakens to find it has not left him but remains like an animated wound. He goes to a plaster statue, a female Muse, and claps his hand over its face, transferring the mouth to the sculpture (Fig. 731). A modern Pygmalion, he brings the Muse to life.

725

726

727

725–749. *Blood of a Poet.*
Jean Cocteau. France, 1930.
A moment in time is extended to 55 minutes.

728

729

730

731

In the second episode, the sculptor's Muse encourages him to pass through a mirror into the world beyond (Figs. 732–735), where he finds the Hôtel des Folies-Dramatiques. Sliding down a corridor, he passes four rooms, pausing to look through the keyhole of each. In the first he sees a Mexican, who resembles him, standing against a wall next to a rock fireplace on the mantel of which stands a statue of the Virgin. There is a volley of shots. The Mexican falls and the statue is shattered (Fig. 736). By reverse motion everything is restored to its former appearance, only to be shattered again, resurrected again, and shattered again. In the second room he sees an old woman teaching a young girl to fly (Fig. 737). The girl gets stuck to the ceiling, refuses to descend, and sticks out her tongue at her teacher. The third room contains a Chinese preparing opium (Fig. 738), the fourth a hermaphrodite with its male and female aspects arguing (Fig. 739). As he leaves the corridor, a saleswoman hands him a pistol, instructs him in its use, and tells him to kill himself. While blood flows from his wound, a crown of laurel appears to grow from his head (Fig. 740). He returns through the mirror and in a fit of rage destroys his sculptured Muse.

The third episode is quite different in style from the rest. A group of boys engaged in a snowball fight destroy a sculpture of a poet, which is standing in the courtyard (Fig. 741). One of the boys hurls a snowball at another, who falls to the ground and dies, blood gushing from his mouth. The courtyard becomes a theater with an audience in the boxes (Fig.

725–749. *Blood of a Poet.*
Jean Cocteau. France, 1930.

732

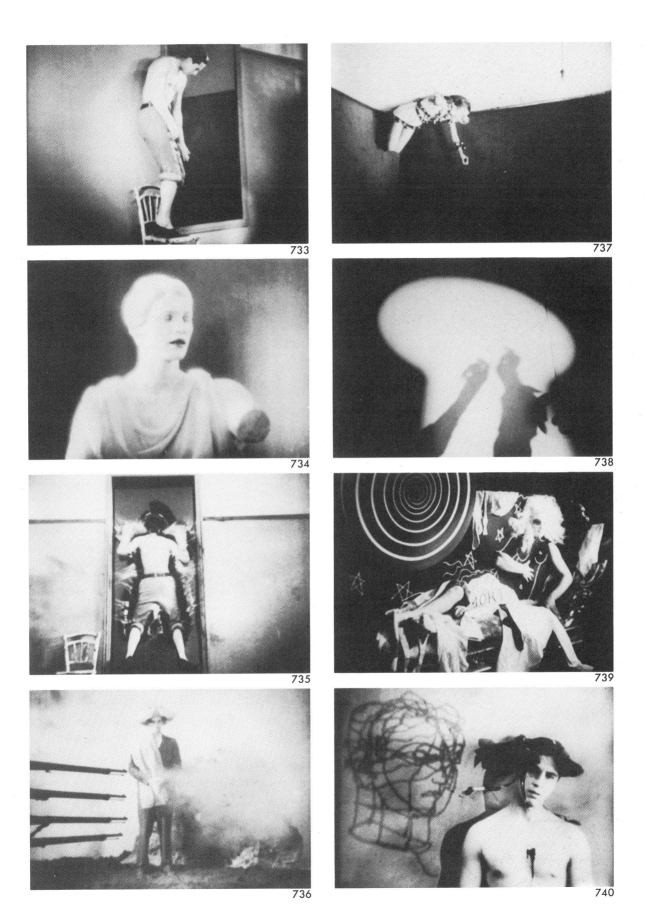

733

734

735

736

737

738

739

740

273

741

742

745

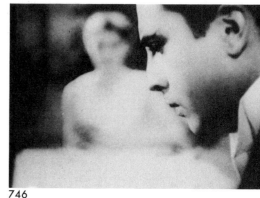

746

725–749. *Blood of a Poet.*
Jean Cocteau. France, 1930.

747), and the poet and his Muse are seated on a terrace playing cards, like actors on a stage (Fig. 742). The young boy lies at their feet, and the poet reaches down to take a card from the boy's pocket. The boy's guardian angel descends to absorb him (Fig. 743) and carry him away (Fig. 744). Then the Muse informs the poet that if he does not have the ace of hearts, he is lost (Figs. 745, 746). After inspecting his cards, the poet pulls out a revolver and shoots himself. The audience applauds (Fig. 747). As the Muse leaves the scene, she discovers a bull with the map of Europe plastered on its side (Fig. 748). The camera retreats, the Muse becomes a drawing, the bull's horns become a lyre, and the map turns into a globe. Then the parts form into a constellation (Fig. 749) while the poet, voice over, says, "The mortal tedium of immortality." The factory chimney we had seen at the beginning completes its fall.

Between shots of the falling chimney, Cocteau defines himself as an artist or poet in a series of images that refer both to his interpretation of a poet's personality and to aspects of his own biography. The first episode, through its 18th-century costume, associates him with the French classical tradition and, through the style of the sculpture and the allusions to myth, to the traditions of classical antiquity. The mouth that attaches itself to his hand recalls Philoctetes, the Greek hero who possessed a bow capable of sending arrows unerringly to their mark and who suffered an incurable wound that caused him great pain and made him repulsive to others. The bow may be likened to the pencil of the artist or the words of the poet enamating from that prodigious mouth in the palm, which in turn is the wound that tortures the artist-poet, distinguishes him from others, and causes them to reject him. The caresses associate the poet-artist, obsessed with the art that is a part of himself, with Narcissus, who was metamorphosed into a flower as the poet is ultimately

743

744

747

748

749

metamorphosed into a constellation. Of course, the sculpture that comes to life is a rather obvious reference to the myth of Pygmalion, whose figure of Galatea became animate, and to the idea that the poet instills life into his art.

In the second episode, the visit to the Hôtel des Folies-Dramatiques elaborates the definition. The Mexican in the first room recalls the Emperor Maximilian, who died before a firing squad. It can be taken as a symbol of a nationalist tradition, just as the Virgin may stand for a religious tradition, from both of which elements the poet dissociates himself. Both Maximilian and the Virgin die as the poet will die, and both are resurrected as the poet will be resurrected through the survival of his work. Both attain greater power after death than they had in life as the poet will through his poetry. The events in the second room imply a revolt against his teachers, a poet's tendency to take flight in the face of traditional constraints and perhaps a masochistic self-indulgence as well. The opium den in the third room refers directly to Cocteau's experimentation with the drug, and indirectly to the poet's cultivation of dreams. And the hermaphrodite arguing with itself recalls Cocteau's sexual ambivalence, as do all the preceding incidents in a somewhat less obvious fashion. There is also perhaps a reference to the scope of the poet's sensitivity. The final scene with the pistol introduces the thesis that the poet must die a physical death to gain

immortality in his poetry. Although the implications of the suicide are not entirely clear, they become explicit in the third and final episode, which is partly a metaphorical exegesis of the preceding two episodes and partly an elaboration.

While the third episode comments in passing on the indifference and scorn of contemporary society, it concentrates on the poet's wound, death, and final apotheosis, as well as on the poet's sacrifice of his physical and social self to his poetry. The scene with the bull and the map is a reference, of course, to the myth of the rape of Europa. The bull, which is Jupiter in disguise, takes on implications of divine inspiration and, since it is a traditional sacrificial victim, implies once again the sacrifice of the poet to his art, while the map suggests the expanding influence of his poetry.

The three episodes, then, can be seen as three metaphorical deaths—the first as the automatic and instinctive (masturbatory) surrender of identity to the work of art in the creative act; the second as the deliberate destruction of the self in favor of the work of art; and the third as the martyrdom of the artist by the public—all of which figuratively lead to the release of the art from the artist and the assumption of life by the art itself. The narrative substance of the film in this instance serves only as a means of developing a metaphor about the relationship of the artist to his work and to his history.

Manhatta and *H₂O* are lyrical interpretations of the physical world; *Desistfilm* is an examination of a seemingly demented, almost paranoiac group ethos; *Un Chien andalou*, however submissive to the laws of chance and the cultivation of the irrational, is a revelation of the human psyche; and *Blood of a Poet* is an autobiographical analysis of a creative personality. Stan Brakhage's *Prelude: Dog Star Man* (1961) treats larger, more abstract, and even conceptual material. By selecting views of earth, air, fire, and water and exhibiting them in isolation as well as in multiple superimpositions, Brakhage creates a sense of cosmic unity. Through rapid camera movement and cutting, he introduces a vertiginous energy that captures in each fraction of a second the totality of the universe—from the dance of

atomic particles to the cosmic explosion of the sun. It is a dazzling, pyrotechnical display, a modern equivalent to the ancient Brahminical "Hymn to the Sun," although it must be said that after a while the unchecked energy becomes fatiguing and the weight of the cosmos heavy.

Ed Emshwiller in *Relativity* deals with much the same kind of material, but with quite different methods and metaphorical overtones. Emshwiller compares and contrasts human and animal bodies with rocks and flora, considers love and death as well as form and life, explores the animate and the inanimate, the natural and the manmade, stars and computers. Unlike Brakhage, however, he uses sequential juxtaposition rather than superimposition and moves over vast distances in space and eons in time. His slowly gliding lens takes the spectator through centuries and millennia back into the prehistoric past and forward into the future, exploring matter, instinct, and reason, establishing man's place in the cosmos. With each of the separate images, he evokes the likeness among all things, and when all forms are absorbed in the larger image, he comments on the essential oneness of existence implied in the title.

The film poem can also be used as an instrument of social criticism and may take on something of the character of a documentary. It may even employ documentary material, although its structure as metaphor distinguishes it from any purely factual film. Bruce Conner has pieced together *A Movie* (1958) from snippets of news and information films depicting some of the activities of technological man—bicycling, flying, racing speedboats. Through his selection and ordering of the shots he sets an insidious trap for his audience, for the shots he has chosen invariably end in absurdity or failure; the spectator, seeing the film for the first time, is likely to laugh at the follies and frustrations exhibited. But as failure follows failure, as the accidents become more serious, as the casualty lists grow longer, and as the date of the shots approaches ever closer to the present, the laughter trickles away. By the time the dirigible Hindenberg crumples in flames, there is embarrassed silence. Well aware now that the follies pre-

750

sented are not simply those of other times, places, and people, but their own, the viewers confront the explosion of a hydrogen bomb and a final poignant shot of a scuba diver making his uncertain way through the sea to glide finally into a dark hole as if returning to the primordial mud. At this moment the film reveals itself as a metaphor of the suicidal impulse of mankind, a warning of doomsday.

A more complex social comment is developed in *Oh Dem Watermelons*, which Robert Nelson produced for the San Francisco Mime Group in 1965. The film proper opens with a rendition of the old spiritual "Massa's in de cold, cold ground." A static shot of a watermelon sitting on a field of grass appears, then an animated drawing of a watermelon is superimposed on it and, voice over, there is an exhortation to follow the bouncing watermelon as it marks the time over the printed words of the song. The lens holds the static watermelon, set like a football, long enough for the spectator to deduce that this is no ordinary fruit. Then a cleated shoe enters and punts it out of a stadium into the street, where it breaks into pieces like bloody flesh. In the remainder of the film the watermelon is stepped on by the passengers of a bus, crushed by an earth mover (Fig. 750), flushed down a drain, cut up and eviscerated by a butcher, and subjected to a number of torments and embarrassments, all calculated to exemplify the condition of the blacks and to travesty some familiar and conventional attitudes toward them: that the black male is gifted with extraordinary physical equipment (Fig. 751) and sexual prowess, that white women lust after black men, that blacks are "getting in"

everywhere (Fig. 752), that Negro women are all mammies, and, of course, that Negroes by definition are fond of watermelons. While the attitudes and conditions exemplified are real enough, both the shots of live action and the animated collages that make up much of the film are metaphorical and enable a serious subject to be dealt with through boisterous black humor.

A Movie and *Oh Dem Watermelons* come close to being documentaries, at least in con-

750–752. *Oh Dem Watermelons.*
Robert Nelson. U.S.A., 1965.
Live action and animated collages combine to make a social comment.

751

752

753

754

755

756

tent if not in method. Conner's *Cosmic Ray* (1961; Figs. 753–756) from time to time approaches the abstract film, which we will consider next. Not only does it employ near-abstract light patterns (Fig. 755), but it is also composed of frenetically cut shots of marching soldiers, the raising of the flag at Suribachi, a sequence from a Mickey Mouse film, and some unusually attractive go-go dancers (Figs. 753, 754). These shots may seem at first to have no rational relationship with one another and to serve simply as a visually rhythmic accompaniment to the driving aural rhythms of Ray Charles' "What'd I Say?" But the sequence of images turns out to be a series of metaphors equating war and sex in audio-visual and visual puns that are immediately comic but ultimately serious (Fig. 756).

ABSTRACT FILM

Like the history of film, the history of abstract painting and sculpture began at the end of the 19th century. From that time on, increasing numbers of artists, some of them inspired by theories of universal dynamism, explored and exploited the expressive potentialities of nonfigurative, nonrepresentational forms that—whether geometric, biomorphic, or freely invented—were not related to existing objects. It was almost inevitable that some of them should recognize film as an appropriate medium for instilling life into their static material, and that the history of film and the history of abstract art should merge in a genre of film designated variously as *pure film, absolute film,* and *cineplastics.* The last term, with its connotations of spatial manipulation of form, might well be applied to filmic composition of any kind.

The purest and most basic form of filmic abstraction is the *flicker film,* in which each frame is completely uniform in tonality, filmic movement is restricted to changes in tone, and tempo is governed by the rapidity of change. The change may involve an alternation of two tones, a progression from one tone through a series of graded steps to another, or some

combination of alternation and progression. In a sequence of alternations the rapidity of change is determined by the number of frames of the same tonality that are presented in series: a sequence in which two white frames alternate with two black frames will proceed at a more rapid tempo than one in which twenty white frames alternate with twenty black frames. In a sequence of progression, the rapidity of change is determined by the number of frames included in the progression.

While the underlying principle is simple enough, the effects may be surprisingly varied and complex. Depending on the tones used, the color field may seem to grow larger or smaller, advance or retreat, be uniform or varied; persistence of vision may result in the optical mixture of two quite discrete tones; rhythmic patterns may be as regular as the pulsations of a strobe light or so complicated as to resist analysis; and the changing lights may caress or assault the eyes as music caresses and assaults the ears, eliciting a wide range of emotional responses, even affecting changes in metabolism.

Léger used the flicker technique for the sequences involving the circle and the square, legs and clock, hat and shoe in *Ballet mécanique;* but filmmakers did not begin to develop the full potentials of the method until the 1950s and 1960s. Peter Kubelka produced *Arnulf Rainer* (1960) and Tony Conrad *The Flicker* (both achromatic in tonality), and Paul

Sharits constructed *Ray Gun Virus* (1966) utilizing the whole chromatic range and describing his film as a "striving toward blue." Just as painters like Robert Rauschenberg, Yves Klein, and Ellsworth Kelly reduced painting to its lowest common denominators— presenting uniform fields of color unmodulated by anything but light changes in the environment or accidental cast shadows—these filmmakers reduced filmic experience to filmic essence: space, light, time, and perception.

Such extreme reduction has been relatively rare. Most filmmakers concerned with abstraction have chosen to construct more complex compositions within the individual frames and have devised a great variety of methods to set them in motion. Some have utilized conventional and direct photographic processes, filming objects or lights in motion. In *Anemic Cinema* (1926), Marcel Duchamp photographed spiraling forms rotating on a machine, the spirals seeming to expand, contract, advance, and retreat according to the speed of rotation (Fig. 757). The changing patterns of shadow cast by his "light requisite machine" and the machine itself are photographed in Moholy-Nagy's *Lichtspiele* (Fig. 566). And in *Emak Bakia* (1927), Man Ray filmed patterns created by objects revolving in a sharply raking light (Fig. 758).

Generally, however, filmmakers have employed some technique of animation—that is, they have synthesized movement and change

757. *Anemic Cinema.* Marcel Duchamp. France, 1926.
Abstract forms seem to expand, contract, advance, retreat.

758. *Emak Bakia.* Man Ray. France, 1927.
A sharp raking light animates these revolving forms.

from static material by shooting each frame separately and making whatever changes were needed to suggest movement in an image. This would seem to imply that in animating drawings or paintings the filmmaker would produce 24 drawings for every second of film, 1,440 for every minute, and 14,400 for every ten minutes. In practice, however, filmmakers use a variety of shortcuts, the most familiar of which (in commercial studios, at least) involves transparent acetate sheets called *cells*. (The method can most easily be visualized by reference to animated cartoons like those produced by the Disney studios.) To avoid the necessity of making a complete drawing for each frame, the filmmaker uses a single cell for the exterior or interior setting. Over this master cell he places transparent cells on which moving elements—humans, animals, or objects—are drawn in opaque ink, so that only the moving parts in each frame need to be redrawn. Other methods reduce the labor of reproduction even further. If, for example, a cartoon figure simply stands and speaks, it is possible to draw the figure on one cell and basic lip positions on a series of cells, which can be combined and recombined to simulate the position of the lips in forming particular sounds. In addition, the camera can pan, zoom, cut away to another portion of an image, and perform as it might in filming live action.

Filmmakers have used similar methods in the construction of abstract films, but they have also explored various techniques based on the same principles. Len Lye drew directly on the film, frame by frame, in making *Colour Box* (1935); Norman McLaren painted on the film without considering the frame in making *Begone Dull Care* (1949); Douglas Crockwell cut thin slices off a block of varicolored wax, shooting the change in pattern that occurred after each slicing, so that the areas of color flow as they would in molten wax; and Stan Vanderbeek and James Whitney have used a computer to manipulate their forms.

A filmmaker need not always invent his materials, as the title of John Arvonio's *Abstract in Concrete* (1954) implies. He may discover patterns in the world about him, remove them from their familiar context, avoid recording them completely, and disguise them

by a softened focus, reduction printing, or other processes. He may follow a line down the middle of a highway, trace a tube of neon light, or flash a field of color on a billboard. Already we have seen how in *7362* (Figs. 452–459) the human figure provides a formal motif, although its identity is so completely disguised that only a tantalizing hint remains, and how H_2O, beginning almost like another version of Pare Lorentz's *The River*, becomes more and more abstract until nothing but shifting and flowing patterns of light and dark are visible (Figs. 692, 693). In *Cosmic Ray*, the blurred lines of streetlamps and automobile lights provide a visual, rhythmic accompaniment like a drumbeat to the vocal and instrumental.

The sound track of abstract films often includes familiar, traditional, or popular music; it may have been added to the visuals because of some felt correspondence or because it provided the possibility of establishing an aural counterpoint; it may provide the initial impetus for the film, with the visual conceived as a translation of the sound. A relatively well-known example is the Bach *Toccata and Fugue in D Minor* sequence from Walt Disney's *Fantasia* (1940), consultant for which was Oskar Fischinger, one of the pioneers in setting abstract forms to existing music (Fig. 759). Canned music, of course, allows a considerable saving in time, money, effort, and—too often—imagination. The filmmaker who uses it runs the risk that the spectator will bring to the music associations possibly inconsistent with the film as a whole. A great many filmmakers—concerned with the total structure, sensitive to the relationship of sound to image, cognizant of the value of the planned relationships—have chosen to provide original

sound tracks, using original scores or improvisations on traditional instruments, or electronic or concrete music, sometimes drawing the sound track or introducing sounds in other ways. Paul Sharits, in *Ray Gun Virus* instructs the projectionist to play the sprocket holes.

What are these flashes of light and jiggling or gliding forms and colors about? Viewing factual or fictional films or film poems, we can usually intuit some content, even though we may not be able to specify it in verbal paraphrase. But how can we interpret abstractions? We may let the changing patterns bathe or assault our eyes as we sometimes let music bathe or assault our ears, giving ourselves over to pure sensuous experience. We may recognize and analyze the relationships among the forms in space and time. Or we may search for, and perhaps discover, correspondences with states of mind evoked by other kinds of stimuli, perceiving associations with other kinds of experience. It is here that we may run into difficulty, for the abstract forms, working like mobile Rorschach blots, offer an opportunity for free association that may leave us floundering in self-deception, a possibility examined with devastating humor in Ernest Pintoff's animated abstraction *The Critic* (1963).

On the screen we see an assemblage of abstract film clichés (Fig. 760). We do not see the critic, but we hear him. He may be a hypothetical member of the audience, sitting beside us perhaps, ready to give us a nudge, or behind us, poised to lean forward and breathe down our necks. He speaks loud and clear with the insouciance of the aged or the unconsciousness of the deaf. He is at first curious, then confused, then frustrated, and finally exasperated by the dancing forms. At last he decides that the shapes, which are rubbing and interpenetrating one another, are having sex and that the movie is dirty.

One of the lessons, of course, is that pornography, like beauty, is in the eye of the beholder. This point is also illustrated by Parker Tyler in his book *Underground Film,* in which he describes how a young woman watching *Ballet mécanique* giggled and remarked that it was like making love. One might easily make a case for interpreting *Ballet mécanique* as a metaphor for love. The body of the film is framed by shots of a young woman swinging back and forth toward us and away from us, turning her head from side to side in what seems to be simple sensuous pleasure (Fig. 567). The shapes, actions, and rhythms of the machines, the joyous if frustrating strivings of the woman climbing the stairs (Fig. 578), the optical superimpositions of legs and clocks, hats and shoes (Figs. 575, 576)—with their potentially cunniphallic implications—all could be associated with making love, especially when one considers Léger's penchant for interpreting human beings in terms of machines and the Dadaists' interest in love machines. But there is a difference between the attitude of "The Critic" and the attitude of the young woman. "The Critic" ultimately concludes that the forms *are* making love; the young woman observes that it is *as if* the forms *were* making love. Obviously, the woman is being more cautious, for there are insufficient clues to enable us to identify *Ballet mécanique* with lovemaking as opposed to some other activity. In a film like Willard Maas' and Ben Moore's *Mechanics of Love* (1955), which describes lovemaking by showing household objects (Fig. 761), the association is appropriate, not only

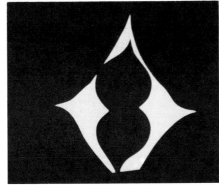

Opposite: 759.
Film Study No. 6.
Oskar Fischinger. U.S.A., 1929.
An abstraction set to jazz.

right: 760. The Critic.
Ernest Pintoff. U.S.A., 1963.

far right: 761. Mechanics of Love.
Willard Maas and Ben Moore.
U.S.A., 1955.

762. *Yantra*. James Whitney. U.S.A., 1950–60.

763. *Fiddle-De-Dee*. Norman McLaren. U.S.A., 1947.

because of the title, but also because the film introduces human lovers before it moves on to the inanimate.

Neither *Ballet mécanique* nor *Mechanics of Love* can be considered absolute film, nonobjective film, or abstract film. *Mechanics of Love* is a witty film poem, and *Ballet mécnique* might be described as a hymn to mechanical action whether in human beings, in engines, or in static objects that have been animated. But the two films do illustrate the problem of categories. If we strive too hard to find a symbol or allegory, we may end only by discovering ourselves.

The danger, in a sense, is of mistaking abstract films for generalizations of a particular rather than as particularizations of the general. A violent clash of tones need not imply a clash of personalities, nations, or sexes; a dynamic change of accelerating rhythms mounting to a climax and subsiding need not imply sex; and two lines intersecting at right angles need not imply a crucifix. To the extent that they may be said to refer to anything, abstract films refer to situational concepts such as complexity and simplicity, stasis or energy, tension or relaxation. Just as we may find in music grandeur and triviality, agitation and calm, intellectual rigor and uncertainty, disquietude and exhilaration, so may we in ab-

stract film. The film can be structured like music, the color and shape operating like musical tones and arranged like music in patterns as strict as a fugue or as free as a tone poem. But in addition to our intellectual perception of the formal structure and our sensuous response to the forms and tones, we may discover other effects—that *Rhythmus 21* moves in solemn, deliberate, even stately rhythms; that *7362* gathers force like a rocket launching; that James Whitney's *Yantra* (1950–60; Fig. 762) seems to capture the pulse and surge, the ebb and flow of life; and that McLaren's *Fiddle-De-Dee* (1947) is a comedy of incongruity.

While a scraping country fiddler travesties "Listen to the Mockingbird," lines and forms painted on the film rush by at a furious rate. The combination of cacophonous sounds and contrasting visual rhythms is in itself mildly amusing, but the high point of McLaren's comedy occurs when a black speck attempts to swim, fly, and flutter against the stream of bright color but is constantly frustrated in its movement (Fig. 763). Described in this way the situation seems scarcely matter for comedy, but spectators invariably laugh. One suspects there is an identification with the speck, a recognition of frustrated efforts, an anthropomorphism taking place.

11

The Filmmakers

Since this study has been concerned with the film as a completed work of art rather than with the manner in which it has come into existence, we have considered processes only in order to suggest the limitations, potentialities, and flexibilities of the medium. We have avoided consideration of the people who make the film beyond referring to a vague, collective character called the filmmaker or, sometimes, to a specific director. But just as it is useful to know something about the limitations and potentialities of the process when evaluating the finished product, so it is useful to be aware of the roles of the various people who bring the film into existence, especially when the director is so frequently described as the author, if not the sole begetter of a film.

The production of any film is likely to involve the cooperation of a great many people, some of whom are identified in the credits, although the exact nature of their contribution may not be known. Setting aside all those who indirectly affect the film—like the producers of equipment and raw materials, whose continuous experimentation has made possible technological developments in filmmaking— the number of people concerned will be a formidable one. Even the independent filmmaker—with the exception of those few who prefer to carry out all the operations themselves—depends on others, not only for the developing and printing of his footage, but also for the execution of optical effects like fades, dissolves, and wipes, or the mixing of sound. The production of a motion picture for general exhibition in commercial theaters may involve a small army: costumers, hairdressers, and makeup men, set designers and builders, those who scout locations outside the studio and those in charge of properties, electricians, lighting experts, sound men, and those who create special effects, writers, composers and musicians, the script clerk, who is responsible for keeping a record of the production and for maintaining continuity—which in this context means consistency—from shot to shot, cameramen, editors, actors, directors, producers, and many others who assist in one way or another in bringing the film to completion. All play important roles, but there are some who obviously shape the whole creative endeavor and more than the rest determine the nature of the finished product: the writers, cameramen, actors, editors, directors, producers, and, in a curious way, some persons who are not listed on the credits but sometimes ought to be—the censors.

THE WRITER

Of all those involved in the creation of a film, the writer is the most difficult to identify in the finished product. From time to time writers, critics, and historians lament the attention given to stars and directors and point out that frequently the success of the film is due to the writer, who has worked out a script the production crew simply records in action and image. At times this is very nearly true, as in Robbe-Grillet's script for *Last Year at Marienbad*, which includes details of setting, costume, action, camera angle, movement, editing, photographic quality, and sound. All of these details are so clearly presented that it is relatively simple to determine the nature of the writer's contribution. But this is not always so, as a comparison of Robbe-Grillet's script with the screenplays of James Agee will reveal, for the latter provide little more than dialogue and generalized comments on action and setting. In her study of *Citizen Kane*, Pauline Kael has shown how much this signal film, so closely associated with Orson Welles and his cameraman Gregg Toland, seems to owe to Herman J. Mankiewicz, who collaborated on the script.[1] Yet it is not without significance, perhaps, that Robbe-Grillet, when he directed his own film *L'Immortelle* (1963), did not succeed in achieving the cinematic quality of *Last Year at Marienbad*. Whatever the writer's contribution, there is a great distance between the script and the visual realization.

There is no set pattern for the production of a script, although like any other work of art, the film begins with an idea. Sometimes the idea is simply the director's desire to work with a certain actor or actress, as Bergman once pointed out to Vilgot Sjöman.[2] Or it may be a feeling, a theme, or a visual image. And sometimes there may be an already existing story, theatrical piece, or essay that seems suitable for adaptation to the screen. Once the

thematic material has been chosen, a synopsis is prepared for the producer. When the synopsis has been accepted, an expanded summary or description called a *treatment* is produced. This is not unlike a short story or article, and from it the script, or, as it is sometimes called, the *continuity* or master screenplay is developed. The latter contains dialogue and descriptions of action and such things as settings. Finally, the shooting script is prepared. In this, the play is broken down into numbered shots, and specific instructions are given for camera distances, angles, and effects.

Such a system, which is more or less traditional in American commercial studios, allows for the division of labor among specialists who are experienced in writing synopses, treatments, continuity, or dialogue, encourages the development of writing teams, and permits the introduction of new writing talent at any phase of the production. Hitchcock's *Shadow of a Doubt* (1943) was based on an idea Gordon McDonnell summarized over lunch and typed into a nine-page treatment, which then went to Thornton Wilder, who wrote the screenplay. Once the screenplay had been completed, Hitchcock called in Sally Benson to inject some light moments into it. Ben Hecht, on the other hand, describes how, six weeks after shooting had begun, he was called in to write a new script for Victor Fleming's *Gone with the Wind* (1939). At times the writer works in close conjunction with the director through every stage of the work, at other times he simply creates a script and departs, and sometimes director and writer improvise on the set. The writer's role thus varies depending on the film. And so, curiously enough, does the cameraman's.

THE CAMERAMAN

When methods of filmmaking became increasingly elaborate, the cameraman was designated the director of photography or the cinematographer and placed in charge of a crew of cameramen and assistant cameramen. His principal function is to provide a satisfactory image of a scene, a job that would appear to be relatively mechanical and routine. But in fact, the cameraman's role may be

much more creative, and it often is. Because he does record a scene, he may select the film, supervise the lighting, determine the exposure and depth of focus, select camera positions, control camera movement, and introduce special photographic effects. In short, he can determine the spatial and tonal organization and the visual accent and thereby to a considerable extent the expressive quality of the image. In fact, he can impress his own personal style on a film so that his work is recognizable whoever the director may be. He is capable of contributing whole sequences, like the montage of stone lions in the "Odessa Steps Sequence" (Figs. 393–395), an invention of Eisenstein's cameraman Eduard Tisse. In an interview with Charles Higham, William Daniels sums up the role of the cameraman quite simply: "You see, we try to tell the story with light as the director tries to tell it with his action."[3]

Some cameramen have acquired reputations comparable to those of directors, either for their technical inventions or for the expressive character of their imagery. Billy Bitzer (Fig. 764), who was Griffith's camera-

764. Billy Bitzer and D. W. Griffith.

man on many of his important films, is often credited with introducing backlighting and developing the use of soft focus, reflected light, and dramatic and atmospheric lighting effects. Gregg Toland is famous for having developed the *pan-focus process* that enabled Welles to achieve clarity in focus from 20 inches to infinity.

Unfortunately, the cameraman's role, like the writer's, often remains ambiguous and uncertain, due in large part to the variety of working methods employed by directors. Some directors place their confidence in the cameraman and give him almost complete autonomy. Charles Rosher has mentioned that in the filming of *Sunrise* (1927), Murnau could only occasionally be persuaded to look through the lens. Other directors work out everything in conjunction with the cameraman: sets, camera angles, lighting, movement, and focal length, as Welles did with Toland in the filming of *Citizen Kane*. There are directors who have insisted on more individual control, acting as directors of photography themselves. Josef von Sternberg acquired a reputation for his lighting, camera movement, and pictorial compositions. Documentary and independent filmmakers often personally handle the camera, as Flaherty did at the beginning of his career. The spectator has little way of knowing who has contributed what, and the problem is often compounded by a cameraman's adaptation of style to material: Gregg Toland, who photographed *Kane* in a nearly expressionist style, had previously shot William Wyler's *Dead End* (1937) like a newsreel.

The difficulties of assigning credit become very apparent if we consider the career of Ingmar Bergman, who has used two photographers for most of his films. From 1948 to 1959 Gunnar Fischer shot nearly all Bergman's films, including *Illicit Interlude* (1951), *Secrets of Women* (1952), *Monika, Smiles of a Summer Night* (1955), *The Seventh Seal, Wild Strawberries,* and *The Magician* (1958). These films established Bergman's reputation and, for many people, represent Bergman as they wish to see him. Since 1959 Sven Nykvist has shot most of Bergman's films (Fig. 765), including *Through a Glass Darkly* (1961), *The Virgin Spring* (1960), *Winter Light* (1962), *The Silence* (1963), *All These Women* (1964), *Persona, Hour of the Wolf* (1968), *Shame* (1968), and *The Passion of Anna*. The character of the visual images changes with the cameraman. A baroque flamboyance, sensuality, and expressionistic quality that mark much of Bergman's work in the earlier decade are supplanted by a dry, direct, almost laconic style in the second, even in the melodramatic Surrealism of *Hour of the Wolf.*

Is the change due to the photographer? Perhaps. But at the same time Bergman seems deliberately to have changed his approach to film, trying to rid his work of its self-consciousness, examining with increasing frequency the interior drama rather than the action, depending more and more on the close-up, the medium shot, and on the face and words than he had in the past. *The Passion of Anna* (Fig. 528) appears almost amateurish in its composition and photography until one realizes that the seemingly casual quality of the framing, the graininess of the film, the almost reportorial approach to much of the film intensifies the reality of the work and curiously, too, the sense of intimacy. A certain laconic quality has appeared before, in *A Lesson in Love, Dreams* (1955), or *Three Strange Loves* (1949), for example. And there is a strong

765. Ingmar Bergman (seated) with Sven Nykvist.

documentary quality about *Brink of Life*, but the journey from *The Magician* (1958) to *The Passion of Anna* (1969) is a long one. Has the change been due to Bergman's direction entirely? Has he selected a cameraman who would conform to his new approach? Have the two worked in intimate collaboration? Or is Nykvist responsible for the new style? An article by Nykvist in *American Cinematographer* suggests that the answer to all these questions except the last would be in the affirmative.[4]

THE EDITOR

The editor is even less familiar to the audience than the writer or cinematographer, for while the latter two may be recognized and remembered and their work acknowledged in reviews, criticism, and history, the editor more often than not is ignored. Undoubtedly, one reason for this is simply the manner in which the credits are traditionally presented: writers and cinematographers are listed individually, while the editor's name usually appears in company with others. The difference implies a hierarchy of importance that may or may not be appropriate. If, as this book implies, the structure of the film determines its content, the character and quality of the editing is of primary importance. But a question arises about whether the person to whom credit is given is truly responsible for the work. The editing may be predetermined in a script, it may be determined by the editor, it may be the work of the director, or it may be the result of cooperation between the director and the editor and others as well.

In the early history of the film, scenes were shot in their entirety in one camera from a fixed position and were usually presented as separate units ending with a fade or iris and set off from the next scene by a title. The editing process was one of cutting out dead footage and joining scenes and titles end to end. Later, as the methods of construction became more sophisticated, as scenes were shot from various distances or with more than one camera—Leni Riefenstahl used forty at the Nuremberg Stadium when shooting *Triumph of the Will* (1936)—and as directors shot varying interpretations of one scene, the editor's

766. Leni Riefenstahl editing *Olympia*, 1938.

job became more complex and more crucial (Fig. 766). It required the assembly of long shots, medium shots, and close-ups in a significant order matching the action and pattern of one to another. If handled in a more than routine fashion, it served to punctuate the film, control its impact, and establish its rhythm.

Until the early 1920s, when editing machines became popular, editing was generally done by hand, a matter of holding the film up to the light to find the precise frame at which a cut should be made. In Kevin Brownlow's book *The Parade's Gone By*, Margaret Booth, one of the great film editors, describes how she established rhythm:

> When I cut silent films, I used to count to get the rhythm. If I was cutting a march of soldiers, or anything with a beat to it, and I wanted to change the angle, I would count one-two-three-four-five-six. I made a beat for myself. That's how I did it when I was cutting the film in the hand. When Moviolas came in, you could count that way too. You watched the rhythm through the glass. . . .
>
> As we cut the picture, we would continually screen it. We would make the necessary adjustments, and then screen it again. Cut it and run it, cut it and run it. And gradually we would make our rhythm, our pattern, for the picture.[5]

Naturally, the editor does not work entirely without direction. The director usually selects the shots, provides instructions, makes sugges-

tions, requests changes. According to Margaret Booth, directors are not very good editors. Yet, as directors have become more self-conscious about their role as authors, they have more intimately involved themselves in the editing process, and increasing numbers of them have done their own editing. As with the writer and the cinematographer, the editor makes a contribution that may in the end be known only to the participants.

THE ACTOR

The practical roles of the writer, cinematographer, and editor are clearcut, but their creative roles are ambiguous. Listed in the credits, they remain faceless and, for the spectator, almost anonymous. If their presence is revealed in their style, their identity is not easy to define and their role not easy to delimit. In the case of actors, this is not so, for actors inhabit the space of the screen and often remain in our memory when everything else about a film has been forgotten. However, their creative contribution is not necessarily any more tangible than that of the others.

The art of the film has long been popularly associated with the art of the drama and with acting and theatrical production. In the early history of the film, many people concerned with elevating cultural standards saw in the film an opportunity to give theatrical drama to the masses. A star system developed in America and elsewhere, and film was and sometimes still is sold as much on the basis of public interest in the players as for any other reason. But films that require actors compose only a fraction of the films produced, and in any good film the actor is only one of the aspects that determines the character and quality of the production.

Moreover, there are fundamental differences between an actor's role in film and his role on the stage. The possibility of close-up shots inevitably allows for a greater subtlety in facial expression than is practicable in most theaters and imposes different demands on the performer. But 'he expressive power of spatial and tonal configurations, sound, editing, and montage may make the projection of feeling associated with the theater unneces-

sary, as the now legendary experiment of Pudovkin and Kuleshov demonstrated. They took from a film three close-up shots of a well-known Russian actor in which the face expressed no identifiable feeling. Each shot was placed in conjunction with a different image: a bowl of soup, a coffin, and a little girl playing with a toy bear. Pudovkin explains the results: "When we showed the three combinations to an audience which had not been let into the secret the result was terrific. The public raved about the acting of the artist. They pointed out the heavy pensiveness of his mood over the forgotten soup, were touched and moved by the deep sorrow with which he looked on the dead woman, and admired the light, happy smile with which he surveyed the girl at play. But we knew that in all three cases the face was exactly the same."[6]

Different directors approach the actor in different ways. Robert Bresson attempts to suppress acting—that is, the projection of feeling—entirely, depending on the filmic context for expression; de Sica has employed nonprofessionals to achieve greater credibility and naturalness; John Cassavetes has demanded improvisation in some of his films; Antonioni confesses to using all sorts of subterfuge to prevent his actors from thinking rather than being; Bergman and Vilgot Sjöman work out ideas thoroughly with their casts; and legendary directors like Von Stroheim and Welles, rather than accepting an actor's interpretation, have on occasion goaded him into actual emotion rather than acting.

None of these approaches to acting is foreign to the theater; what is absent from the theater is the absolute control over the spatial order in which the actor participates, whether stationary or in action, the concentration on particular angles of vision, proximity of view, light and dark patterns, and all the other elements we have found making up the filmic image. In the end, actors must be thought of not only as persons but as objects and configurations in space to be manipulated by the director like any other aspect of the film. Antonioni points out in an interview excerpted in Pierre Leprohon's *Michelangelo Antonioni:* "The actor is one of the elements in the image. A modification of his pose or gesture modifies

the image itself. A speech which the actor makes in profile gives a different weight from one spoken in full-face. A speech made with the camera placed overhead has a different value from a speech made with the camera below."[7]

Acting style has changed quite drastically through the course of film history, partly because the styles of theatrical action and public taste have been modified, but also because the demands of the medium have fundamentally altered. During the silent period, actors developed or utilized a rich pantomimic vocabulary of stylized action. Dejected, they walked in shuffling steps with shoulders hunched, head down, and knees bent. Elated, they moved with chest out and brisk steps. Surprised, they recoiled, throwing up their hands as if to ward off shock or slapping their face as if to punish themselves for not having been enlightened earlier. Despair was conveyed by throwing back the head, stretching one arm stiffly down, and throwing the other up with the back of the hand to the forehead. Servile mendacity was associated with bent knees, crouching but tense shoulders, and rubbing hands. An extensive repertoire developed for twirling moustaches and batting eyelashes. Actors used such gestures and attitudes with varying degrees of subtlety and grossness depending on the nature of the film, the demands of the director, and their own limitations (Figs. 767, 768). Whether pantomime was dependent on a custom in ordinary life or emerged in the theater is difficult to establish. Certainly little boys no longer slap their cheeks in wonder as they did in the thirties when Mickey McGuire, Freckles, Spanky, and their associates were doing so every Saturday in the local Odeon.

We have seen some measure of the virtuosity developed by film actors in the range of facial expressions Mae Marsh managed to deploy in a few seconds of D. W. Griffith's *Intolerance* (Figs. 230–238), when the boy proposes to her through the barrier of a door which "The Little Dear One" had vowed "to Our Lady and to my father" that no man should ever pass. If her facial gymnastics no longer exert a strong tug on our heartstrings, if in fact they seem today to approach the grotesque, they do suggest how contained, single-minded,

767

768

767, 768. Metropolis. Fritz Lang. Germany, 1926. Exaggerated gestures express triumphant exaltation or profound spiritual inspiration.

impressionistic, and dependent on context much facial acting has become.

A number of historical developments seem to have affected the evolution of acting style: the emergence of taste for a more intimate and realistic drama; the perception that the motion picture permitted different means of expression; the notion—based on the theories of Kuleshov—that interpretation of expression and attitude could depend on context. Some directors and actors in the silent period perceived the possibility that the film—with its opportunity for close-ups, selection, and isolation—could utilize a more restrained and a

769. *On the Waterfront.*
Elia Kazan. U.S.A., 1954.
Marlon Brando improvises a scene.

more naturalistic technique. But even in the work of Erich von Stroheim, whose finicky precision in naturalistic detail was notorious and whose awareness of the possibilities of subtle overtones in gesture and attitude is famous, the acting may strike us today as somewhat exaggerated; the heroines may still seem to make conventionalized movements of love or despair.

Probably the single most important cause of the transition to more restrained style was the development of the sound track, which afforded a wholly new dimension of cinematic expression. Words could take the place of pantomime, verbal rhythms could supplant or reinforce rhythms of movement, and the rich overtones of the human voice could be substituted for gesture, attitude, and facial expression. Like the movement of the camera, the movement of phrasing could create a rhythm comparable to the rhythm of cutting. Interior monologue could replace a lengthy development of varying facial expressions and bodily attitudes. Music or miscellaneous sounds could supply the accent that had formerly been created by the slap or a recoil.

The immediate impact of sound on the motion picture and on its actors is frequently associated with a number of effects—the disappearance of certain actors from the screen when their voices were discovered not to conform to their public image, the tendency to transplant theatrical drama to the screen in "talkies," the loss of the expressive power of space and time. Somewhat less attention has been given to how the style of acting was affected during the period in which the industry was learning to cope with a new dimension. Frequently the acting style that developed during the silent era was perpetuated with the accompanying dialogue, which created an effect of exaggeration in emotional content that now frequently seems ludicrous.

A much-praised film, John Ford's *The Informer* (1935), provides an instructive example. Although it was regarded as a masterpiece in its day and the aura of its reputation still clings to it, the film seems sadly overplayed today. Yet the coupling of sound with the pantomimic techniques of the silent days can be extraordinarily moving. Abel Gance, who made his monumental masterpiece *Napoléon* as a silent film in 1927, reissued part of it in 1971 as a sound film called *Bonaparte et la révolution.* The addition of dialogue and sound effects only enhanced and intensified its expressive power.

In some films, the period of transition resulted in a melange of styles, with some actors retaining the lessons and habits of earlier

times, while others adapted themselves to the requirements of the newly expanded medium, which demanded a greater subtlety of expression. Sometimes there has been a deliberate revival of a stylization associated with silent films that lends period flavor and helps to establish a historical moment just as effectively as costumes, settings, and speech patterns. But the general tendency has been toward a more naturalistic behavior and speech, the full impact of which became apparent to public and critics alike when Marlon Brando improvised a number of sequences in Elia Kazan's *On the Waterfront* (1954) to suggest an impact and intimacy that made many earlier realistic presentations seem artificial (Fig. 769).

If the general trend since the introduction of sound has stressed naturalism, however, a more aesthetically significant tendency has been to adapt the style of acting to a particular film and sometimes, as Godard does in *Weekend* (1967), to juxtapose a variety of acting styles for expressive purposes.

THE DIRECTOR

In our discussion of writer, cinematographer, editor, and actor and in the text as a whole, the director repeatedly appears. There are directors of dialogue, dance, photography, and music; there is also the man in charge. He may conceivably do nothing more than translate other people's instructions into film, or he may conceive, write, determine the setups, instruct the actors, specify the sound track, and do the final editing. If he is someone like Charlie Chaplin, he may write and direct the music; and he may also produce and market the film. As far as the moviegoing public is concerned, a director's importance has varied, partly as a result of the development of the star system and the drawing power of individual actors; but from the beginning, some directors impressed on the film a characteristic personal style that had attractions equivalent to those of the stars—Méliès, Griffith, Von Stroheim, de Mille, Hitchcock, to mention only a few. More and more in the decades following World War II, directors have utilized the medium for personal expression, and as a means of exploring their own attitudes toward life, art, and the

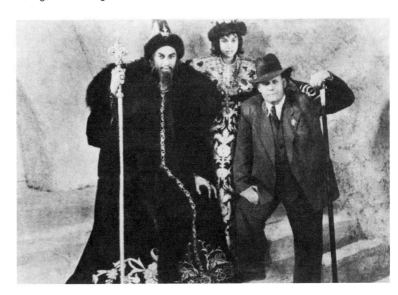

770. Sergei Eisenstein (right) with Nikolai Cherkasov and Erik Pyriev during the shooting of *Ivan the Terrible*.

world, although probably less in the United States—where the commercial substructure has continued to be a powerful determinant of motion picture subject matter and style—than in Europe.

The method of working inevitably varies with the personality of the director; it may be deliberate and tightly organized like Eisenstein's (Fig. 770), spontaneous like that of Fellini (who is often still writing the script when the actors appear for shooting), or consciously casual like Godard's. Directors like Eisenstein may impose style; they may try to eliminate acting, like Bresson; develop ideas in conjunction with actors and crew, like Bergman; allow actors to improvise, like Cassavetes. Whatever his method of working and his relationship with the actors, a director can impose a style that is immediately identifiable to one familiar with his work. Eisenstein's montage rhythms contrast with Von Sternberg's luxurious lighting, his tendency to shoot through impeding material, and his preference for lateral tracking shots and long, long dissolves. In the end, the style imitates an attitude; the baroque, romantic artificiality of Von Sternberg, the urgency of Fellini, the deliberateness of Antonioni, the mystery of Resnais, the speculative, experimental spirit of Godard—all emerge from individual orientation.

It is instructive to compare the directing styles of Antonioni and Fellini (Figs. 771, 772) under rather similar circumstances. Antonioni in *La Notte* and Fellini in *8½* collaborated with the same scenarist, Ennio Flaiano, and the same director of photography, Gianni Di Venanzo. They used the same leading man, Marcello Mastroianni. There are even parallels in situation: both films concern creative artists in personal crisis, involving temptations, infidelities, dissolving marriages, tensions between custom and ambition, feeling and intellect, the rational and the irrational, the ambiguities of conscience. While the characters perhaps become more aware of themselves by the end and the films come to a kind of conclusion, the awareness does not lead to a resolution of the central problems. Some scenes, in fact, seem almost interchangeable.

There are, of course, obvious differences in method. Fellini expresses fantasies by illustrating them, Antonioni by hinting at them through action and setting. Fellini uses flashbacks; Antonioni develops his action chronologically, evoking the past almost covertly through action and dialogue. Fellini searches the past for understanding, Antonioni remains in the present. But setting aside such differences in explicit narrative, content, and method, there is a dissimilarity in the tenor and in the overtones. The movement of the characters and the camera, the angle of vision, the lighting, the cutting rhythms, the action in planes, even the way the central character sits all contain different feelings and allow us to speak of the exuberance, vitality, flamboyance, and optimism of Fellini compared to the reticence, introversion, and cerebral or introspective qualities of Antonioni.

In short, we can distinguish a personal style and a latent content that style implies, and we can see all these qualities operating and developing in the series of works that makes up the total oeuvre of a director. There is nothing unusual in this, for we are accustomed to viewing a single artist's work in other media with such expectations in mind, and, for that matter, we imply as much when we discuss the work of one filmmaker as opposed to another. Since the early 1950s, however, concern for the personal and individual attributes of a director's style as they are manifest in his total oeuvre have attracted increasing attention among critics and historians, in part at least because of the emergence in French film criticism of what came to be called the *politique des auteurs,* and later in the United States was referred to as the *auteur* theory.

The *politique* (policy) *des auteurs* was originally associated with the editorial stand adopted by some journals that assigned films for critical review to writers known to be devotees of the director of the film in question. While the method was subject to abuse and was frequently objected to on the grounds that exponents of the *auteur* theory allowed their enthusiasm for a particular director to stand in the way of valid critical judgments, it did focus on the need to consider the total work of a filmmaker and the individual works as well, in much the same way one might view the work of a painter or writer. The assumption in the past had been that the cooperative method of film production negated the possibility of seeing films as expressions of individual personalities. The *auteur* theory thus had

771. Michelangelo Antonioni.

772. Federico Fellini.

the value of pointing up the need to look more closely and systematically at style; to find the consistencies, choices, and predilections that make up a style; and to reveal the latent content of a particular director's use of the medium—that is, to view him as a creative artist.

Whatever the contributions of those listed in the credits, theoretically at least it is the director who accepts or refuses those contributions, organizes them into a structural whole, determines the final form of the work, signs it, and gives it his imprimatur. By so doing, he imprints on the film his style and through his style his own individuality. There are, however, two other people who, while their role is not nominally a creative one, may affect the final shape of the film in basic ways. These are the producer and the censor.

THE PRODUCER

The producer, whether an individual, an industrial, commercial, educational, or religious institution, or a film company devoted exclusively to the production of entertainment films, is concerned nominally with the financial aspects of the filmmaking process. It is his function to find, provide, control, and ultimately to make money—in the case of training films by increasing efficiency, in institutional advertising by attracting clients, and in entertainment films by attracting moviegoers. The producer may also be the director and in the case of personal films he often is. He might assume other functions as well—finding locations, feeding actors and crew, arranging for costuming and sets, setting schedules, determining distribution. But our principal concern is his potential effect on the construction of the film.

Most basically, the producer can determine whether the film is even seen. The United States government has refused distribution of John Huston's *Let There Be Light;* UNESCO prevented distribution of Shirley Clarke's *A Scarey Time* (1960); and Samuel Goldwyn at-

tempted to prevent and certainly delayed circulation of Orson Welles' *Citizen Kane*. The producer may interfere in the production as well. If some directors—like Griffith, Welles, and Kubrick—have been able because of some quality of prestige, youth, integrity, confidence, or orneriness to demand absolute control over their work, even to the extent of throwing the producer's emmissaries off the set, not all directors, even the most prestigious, have been able to do so.

Erich von Stroheim's career as a director illustrates the grossest kinds of interference. Von Stroheim wanted to break the custom of limiting a film to a preordained length of time, to tell his story as completely as possible even if it meant showing the film in two sections. He wanted, that is, the license of the novelist to tell a tale at any length necessary. Von Stroheim intended *Greed* (1924; Fig. 773) to be shown in two sections with an interval for dinner. When he completed editing the original script, which had been approved by Samuel Goldwyn, he found himself with a film 42 reels long. Cut to 24 reels, it was sent to Rex Ingram, who cut it to 18. Louis B. Mayer insisted on cutting it to commercial length, 10 reels, and gave it to a cutter who made the

reduction. The negative of the parts not used was destroyed, so the film as conceived by Von Stroheim can be neither seen nor reconstructed. When Von Stroheim made *The Merry Widow* (1925), the stars, Mae Murray and John Gilbert, were forced on him by producers Mayer and Irving Thalberg. Similarly, direction of the two-part film *Wedding March* (1928) was turned over to Josef von Sternberg. When production was halted on *Queen Kelly* (1928) because of the introduction of sound, the star, Gloria Swanson, acting in the role of producer and hoping to salvage the film and to make some profit, changed the ending. In addition, she incorporated material Von Stroheim had intended to cut. After Von Stroheim had completed *Walking Down Broadway* (1933), on time and under budget, the producers called in Alfred Werker to prepare a "commercial" version of the film, which was distributed under the title, *Hello, Sister!* The producers operated on Von Stroheim's work from the outside.

The factory system that Hollywood ultimately developed enabled the producer to work inside as well, as Lillian Ross' account of the making of *The Red Badge of Courage* (1951) reveals very clearly.[8] Although John

773. Erich von Stroheim
on the set of *Greed*, 1924.

Huston was the director, producer Gottfried Reinhardt wrote the script, turned the editing over to Margaret Booth, supervised the dubbing, and, after the first unsuccessful sneak preview, altered the order of scenes, introduced voice-over narration, provided a prologue, and—at the insistence of Dore Shary, vice president in charge of productions, a sort of superproducer—deleted material, altered a climactic sequence, and changed the ending, so that the movie as released was not the movie Huston conceived. In fact, according to Lillian Ross' account, Huston's interest in the film seems to have declined once the shooting was completed, and although he was consulted on many of the changes, he seems to have acceded to the suggestions without argument, leaving the defense of his conception entirely to Reinhardt.

Whether Huston regarded *The Red Badge of Courage* simply as a potboiler—he was already making plans for his own production of *The African Queen* (1951)—whether the producers destroyed a great film, or whether they tried to rescue an inferior one, it would be difficult to say. But it is certainly true that the producer, in this instance, did shape the film to a considerable extent. It was at least in part to escape such controlling influences that Huston and other directors took to producing their own films. Even then, their films were subject to review and modification by censors.

THE CENSOR

A text on the aesthetics of the film medium is not the place to examine the social, economic, moral, and legal arguments for and against censorship or to try to resolve the problems that the need for freedom of expression creates. Nor is it the place to answer the questions that inevitably arise: Does film adversely affect behavior? Should adults be force-fed a diet adapted to children? Should there be censorship of any kind, or should there be a system of classification to protect the young from what they are unprepared to understand? Should censorship operate only in the face of nudity and erotic material, or should it be applied to sadism, violence, and political attitudes as well? Should censorship

be permitted before the exhibition of a film or only after a complaint has been filed? Such questions have been raised through much of the history of the motion picture. Many films that today would probably be regarded as acceptable have in one way or another been subject to censorship, like the film of Little Egypt dancing at the World's Fair in 1901.

The demand for censorship manifests itself most overtly in the establishment of state and local censorship boards and the institution of the Motion Picture Production Code, which was so stringent as to be ludicrous; but it manifests itself in other ways as well. As mentioned earlier, the United States government would not release John Huston's *Let There Be Light* for fear its honesty might offend the general population, and *The Battle of San Pietro* had some footage removed from it before it was released. The Bureau of Customs has refused to allow certain foreign films to enter the United States without deletions. Groups like the Legion of Decency have exerted pressure on producers, and fear of economic reprisals has caused producers to engage in censorship at the source. But in the decades following World War II, filmmakers became increasingly militant in their opposition to censorship; and society, as represented by its elected and appointed officials, became more permissive, so that by 1969 there remained only one official state censorship board, that of Maryland. The history of censorship is integrally related to the history of film in a variety of ways, but what is important in the context of this study is the effect that censorship may have on the work of art.

Whatever his conscious intention, the censor, whenever he demands modification of a film, involves himself in the creative act. In the total structure of a film the very interdependence of elements necessitates that a change in one dimension modify the rest, so that when the censor demands that language be modified—in subtitles, for example—or orders the excision of shots he considers offensive, he transforms not only the structure but the meaning of the film. This point will be illustrated if we examine two films that in different ways have been subjected to censorship: *Monika* and *I Am Curious (Yellow)*.

774

775

776

777

774–781. *Monika*. Ingmar Bergman. Sweden, 1953. Spatial configurations parallel the freedom of a vacation idyll and the constraints and tensions of ordinary life.

Ingmar Bergman's *Monika* (Figs. 774–781) was on some occasions exhibited in a version that had obviously been cut. After an initial run, it was relegated to exploitation houses under the title *The Story of a Bad Girl*. The narrative is a relatively simple one. Monika is a child of the slums, unkempt, ignorant, incorrigible, and at the same time sentimental, living in a crowded apartment under the constant surveillance of her parents. Harry is the son of a bourgeois father whose wife has either left him or has died. They work near each other, become acquainted, begin to date, and fall in love. Harry is fired, Monika quits, and together they sail off in Harry's boat to spend the summer on an island. At first their life is a carefree idyll of sunbathing, swimming, boating, dancing, and making love.

The shots are imbued with naturalness and innocent joy in life and in the relationship between man and woman (Figs. 774–777). Then Monika becomes pregnant, the nights become longer, the days grow cooler, their food runs out, and the mood changes as they sadly return to the city. They marry, the child is born, and Harry works by day and studies by night, the tensions between them mounting as their life becomes more circumscribed (Fig. 778). Harry's work takes him away for a few days. When he returns, he discovers that Monika has taken up with another man. After a violent quarrel (Fig. 779) Monika leaves Harry and her child. Harry is last seen holding the baby in his arms gazing into a mirror in which Monika first appeared (Fig. 780). The last shot shows her, apparently in a cocktail lounge with another man, gazing at the spectator (Fig. 781).

The film contains shots of Monika relieving herself, the pair undressing, bathing nude, and the initial, tentative, intimate gestures of love. Two shots, one of Monika running naked toward the sea and one of Monika on the boat, are repeated at the end of the film when Harry is looking in the mirror recalling their life on the island. These were the scenes the censors excised. Superficially they would seem to con-

tribute nothing essential to the film. Yet their presence clarifies the development of the narrative and curiously and ironically places the film on a different plane from the censored version. More than any other scenes, these establish the mood of intimacy, love, and trust and express a simple joy in nature and the senses. More importantly, they express an escape from the conventions of society, the liberation of the spirit, and the reattainment of an innocence comparable to the primeval life of Adam and Eve before the Fall.

Escape from society is expressed in a variety of ways that have become familiar in Bergman's films, but at first it is expressed chiefly through the opening up of space. As the pair leave the city, passing under bridge after bridge, the space expands, the water becomes open, the light becomes brighter, and the city disappears behind them. On another occasion, as they take the boat out, it exuberantly mounts the screen, traveling straight toward the open water, the sky, and the sun. But the complete escape does not occur until Harry and Monika divest themselves of the last shred of contact with civilization—their clothes—to become children of nature.

Bergman's films have been marked by a consistent concern for moral and religious problems, and, considering his tendency to use religious symbolism, it is not difficult to see Harry and Monika as images of a return to a paradisiacal state of grace or, for that matter, to see them chased from the island not by the police but by an avenging angel. The elimination of these scenes not only removes a probable Biblical reference, but also one level of interpretation of the characters. In these scenes Harry and Monika become something more than adolescents out for a lark; they grow into fully developed personalities.

Harry's particular recollection of Monika is of more than ordinary significance. As far as the structure of the film is concerned, it brings the ending into direct relationship with the middle—the beginning of the film is in the mirror itself. It sets into direct conflict the joy, innocence, and grace of man in a state of nature as opposed to the pathos, tension, and degradation of man in metropolitan life; and it contrasts as well with the last shot of Mon-

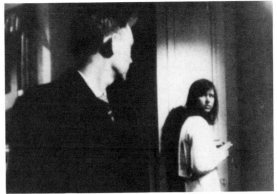

778

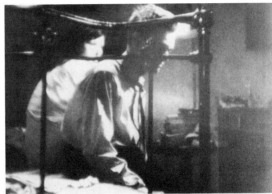

779

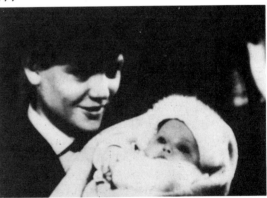

780

781

ika, whose inability to cope with society has smothered her innocence and transformed her personality. Ironically, in their zeal to suppress the prurient, the censors have removed those scenes that most clearly express innocence and in which the Biblical reference seems most necessary to our full comprehension of the film.

Vilgot Sjöman's *I Am Curious (Yellow)* (1966; Figs. 782–787) investigates contemporary Sweden, its economics, politics, and mores. It examines the behavior and attitudes of a wide spectrum of Swedish society: politicians, professionals, workers—both blue and white collar—students, housewives, soldiers, religious leaders. At one time or another it touches directly or indirectly on international relations, socialism, Communism, Fascism, monarchy, democracy, the class system, unionism, pay sacles, living conditions, alcoholism, the extraordinary suicide rate, women's rights, marital relations, religion, education, the draft, the atomic bomb, passive resistence as a way of life, fads in philosophy, tourism, complacency, hypocrisy, conservatism, liberalism, filmmaking, censorship, and sex. It includes a poetry reading by the Russian poet Yevgeny Yevtushenko and an interview with him, a speech by Martin Luther King, and interviews with Olof Palme, then transport minister and later prime minister of Sweden.

Much of *I Am Curious (Yellow)* is documentary and presented in *cinéma vérité* interviews (Fig. 782). The main concern is the confusion facing youth as it attempts to formulate values, the conflict between ideals and human frailty, the tensions between the needs of the individual and the needs of society. The film is held together by the central figure, Lena, a drama student intent on trying to discover what Sweden and life are all about.

The structure is extraordinarily complex, since the film at once follows a number of threads: the documentation of life in Sweden, the narration of the making of a film, the narrative of the film being made, and the exploration of the relationship between the director and the leading lady. In addition, the filmmaker from time to time interjects comments. So, while the film is part informational, part fictional, it fits no genre, nor, moving freely from realism to fantasy, does it adhere to one mode. Just as time past, present, and future elide and coalesce in *Last Year at Marienbad*, so the various threads of *I Am Curious* intertwine, appear, and disappear. Fiction and reality are now identical and now separate, with only Lena holding everything together.

As far as a discussion of censorship is concerned, the most important aspect of the film is the film-within-the-film. Given the working title "Lena on the Road," it concerns Lena's journey into self-discovery. Lena lives with her father in a rather squalid two-room apartment, unable to forget that her mother has deserted her and that her father, who once idealistically went off to fight in Spain, ultimately renounced his ideals. Like many young people of the time, she abhors the values she sees operating in contemporary society, denounces its hypocrisy, follows ideals of a classless, nonviolent, democratic system, investigates Buddhist thought, demonstrates against Vietnam, insists on sexual freedom.

In her crowded room she keeps a file of ideas and opinions and a record of the characteristics and attitudes of the boys she has slept with. She becomes involved with a young automobile salesman, Börje. Then, annoyed at learning that Börje has another girl friend and a child as well, confused by the diversity of attitudes she has confronted—and especially by her interview with Yevtushenko—she bicycles to a retreat in northern Sweden, where she spends her days fasting, meditating, studying oriental philosophy, local dialects, and sex manuals. Börje arrives. They make love, tour the countryside, and debate. It soon becomes apparent that Börje has adopted the very values Lena finds abhorrent. They argue over his ideas and his other girl friend and finally, after raping Lena in a fit of rage, Börje leaves. By this time Lena has come to recognize the violence she harbors within herself. As she stuffs herself with cakes in frustration and despair, a voice on the television set speaks of nonviolence. The idea is alive at least, even if she cannot regulate her life to follow it. She destroys her files. Then she discovers she has scabies. She and Börje go to a clinic to have the disease treated. Finally they part, as a voice sings, "It's hard to be free."

782

782–787. *I Am Curious (Yellow).*
Vilgot Sjöman. Sweden, 1966.
Contemporary Sweden's politics, eco-
nomics, and mores are investigated
through an intimate study of Lena,
the central character.

Lena, of course, in a sense is free, at least to the extent that she has a deeper understanding of herself, is able to end a pointless affair, can stop her torture of her father and her psychic dependence on him, and presumably her relationship with him. So, too, the Lena who plays the part of the Lena in the film-within-the-film can end her relationship with the director and pick up with an actor.

Censorious minds have objected to a number of episodes involving either nudity or sexual activity or both, all of which have been interpreted as more explicit than customary. Some of them are viewed at such a distance or are so ambiguous that it is difficult to be sure what is going on, some of them misidentified, all of them together making up a rela-

tively small portion of the film, according to one analysis 12 minutes of the total 128. They include: Lena and Börje disrobing and embracing in the half light of Lena's room (Figs. 783, 784); Lena and Börje fully clothed, apparently making love on a balcony in front of the royal palace, in a tree, and, perhaps, in a pond; Börje throwing Lena to the ground and burying his head in her lap; Lena briefly and tenderly kissing Börje's penis while they talk afterwards; Börje and Lena making love on the floor of the retreat; the initial moments of the rape; views of the two nude bodies as they are treated for scabies (Figs. 785–787).

The method of handling the scenes is consistently calculated to suppress erotic intensity. There is no baroque lighting, no romantic

783

784

782–787. *I Am Curious (Yellow).*
Vilgot Sjöman. Sweden, 1966.

785

786

at the clinic in the morning

787

music rising to a crescendo, no attempt to imitate the rhythms of love in the editing, and for the most part no possibility of the spectator turning on his own erotic fantasies, which might be possible if there were ambiguous close-ups or if the camera discretely moved away from the coupling pair. What action there is remains clearly visible—except in the first scene in Lena's room and in the scene in the water, in the latter of which the pair, according to Lena Nyman's diary, were engaged in trying to hold their breaths, as anybody would in the circumstances. The photography is realistic, objective, almost clinical, but the word promises more than is in the film.

More important, however, in each scene Sjöman diverts attention from the erotic content of the action in one way or another. In the first encounter in Lena's bedroom, he turns the incident into a comedy of fumbling, disheveled clothes and inane conversation. The incident on the balustrade stresses the patent absurdity of the situation and its obvious symbolic function, for it is a way of flaunting the government. In the sequence in which the pair make love in the tree, the emphasis again is on the comic and symbolic. The awkwardness of the position is amusing enough, but it is also a travesty of the current search for variety in sexual positions and a symbolic contrast of the new and the old, for the tree is the oldest tree in Europe.

The sequence in which the two seem to be making love in the pool is viewed at such a distance from the figures that they might just as well be splashing ducks. In the sequence containing the presumed cunnilingus, the director first creates a parody of the Western film, with Lena holding a loaded rifle stalking Börje. There is a constant threat of violence until Börje buries his face between Lena's legs, at which point there is a quick cut so that the spectator, caught up in one set of interpretations, finds the action changing almost before he is aware of what has happened. In the so-called fellatio episode, the diversion is a discussion of cars and Börje's job. In the scene on the floor of the retreat, the diversion is a dialogue that is like Lena's interviews, question and answer. In the scene of the rape, diversion is created by the intensity of their ar-

gument, the vituperative shouts, the sobs, the speed of the action, and the rapidity of the cutaway. And in the scene in the clinic, it is the clinical quality itself and the moralistic note that seems implied as the pair stand naked, embarrassed, humiliated, translated into objects, demeaned by the medical treatment. In short, the erotic content is always diluted, and the scenes less sexual in tone than the action of Rita Hayworth taking off her gloves as she sings in *Gilda*.

Nevertheless, the question remains how the film would be affected by deleting those parts the censorious find objectionable. First of all, the analysis of Lena as a representative of contemporary youth would be incomplete. The film presents an extraordinarily comprehensive picture of Lena as a personality. It reveals her background, which has much to do with her thinking, involving as it does the mother who deserted her and father who, once an active socialist and idealist, is now a failure, unable to provide enough money for his own subsistence, living in squalor but still touched with sentiment. It examines her faith, her confusion, her fantasies, her association with the king and crown prince at one extreme and her emasculation of Börje at the other. It shows her intelligence, her wit, her temperament, her generosity, her jealousy, her philosophical and religious speculations, even her eating habits—now fasting and dieting, now stuffing herself. It follows her attempts to find herself in a confusing world.

The study would hardly be complete without some concern for Lena's sexual behavior, surely as basic to her life as her eating habits, and especially important in completing the picture of contemporary Swedish youth, whose sexual mores have interested both the country itself and the western world at large. Equally important, however, the sexual scenes, like the eating scenes, convey the interrelatedness of all aspects of the human personality. Lena's political, social, and family life—that is, her public and semipublic life—is compared with her most personal and intimate life and found to be composed of the same ingredients. Moreover, it is in her relationship with Börje and especially in the sexual encounters that she comes to discover and accept herself. The chronological arrangement of the episodes is in itself significant, for it clearly illustrates Lena's psychological development, and in so doing constructs a rational thesis, as an examination of the offending episodes will reveal.

The scene in Lena's room provides a great deal of information about Lena and establishes a baseline from which her psychological development can be measured. It demonstrates that her curiosity and her obsessive record keeping, her analytical, almost scientific attitude extends to her personal life. It affirms her honesty and her naturalness, her desire to confront reality, her search for deeper understanding. The cut is made before the couple lie down. Conceivably, it could have occurred earlier, as the two begin to disrobe, before they kneel on the mattress and exchange intimate caresses and kisses and before Lena removes Börje's watch. But an earlier cut would only have allowed the spectator to imagine the nature of the activity, which is full of comic urgency and clumsiness, naturalness, and awe and makes clear Lena's point of view. Even the removal of the watch, which seems a trivial detail, stresses Lena's need for complete openness and her desire to set aside time and all it implies as a container of the past.

The episode on the balustrade in front of the palace contrasts sharply with the earlier one. If its public character reinforces our awareness of Lena's insistence on individual freedom, its location suggests the direct interrelationship between social, political, public life and personal, intimate, private life. But in addition it suggests that sexual behavior is not necessarily limited in its expressive implications to one dimension of the personality. In the earlier scene the erotic activity emerged from personal desire; in this scene it becomes a way of commenting on the government.

The Wild West episode, which has evoked some of the most wrathful criticism, examines the relationship between violence and love and reveals the violence inherent in Lena, who up to this point has been an almost religious devotee of nonviolence. The difficulties in maintaining a pacifist point of view, the conflict between personal drives and theoretical concerns are revealed as Lena stalks Börje

with a rifle ironically snatched from her altar to Martin Luther King. Börje's action, too, is an act of love expressed in violent terms—and is also, clearly, an expression of male authority. But something else is conveyed in the "objectionable" shots—new aspects of Lena's personality and an additional interpretation of the nature of love. In the bedroom scene Lena was eager, impatient, mildly aggressive; in the balustrade scene she was humorously compliant and conspiratorial; now, as she lightly kisses Börje, there is a childlike gratitude and tenderness that suggest the transforming power of love, one might almost say the ability of love to conquer violence.

The scene in the tree, too, operates in a variety of ways. It reinforces our awareness of the pervasiveness of Lena's curiosity; it burlesques the search for new sexual positions—not only through the gymnastics of the pair, but through the shot of a cow that seems to be looking on and over whose head a question mark suddenly appears. It also symbolizes Lena's rejection of traditional attitudes by staging the event in the oldest tree in Europe and in view of a hymn-singing revival meeting.

The scene on the floor of the retreat and the subsequent rape and dream of revenge bring to a climax Lena's affair with Borje and the investigation of the relationship between violence and love, personal drives and theoretical ideals. It is here that Lena's desire for honesty and her jealousy become confused, and she yields completely to her violent impulses, verbally at first, then physically, destroying the relationship by questions, then by accusations. Associated with the scene is her past in the form of her teddy bear, the ironic symbol of her former innocence. She destroys her ideals as she will later attack her files; and she destroys her past innocence as she will later attack with a knife the portrait of Franco she has kept to torment her father.

In the clinic the couple are touched by hands without love, dealt with as objects. The end result of the affair has been humiliation, an objectification of the humiliation Lena felt when earlier, in an imaginary conversation with Martin Luther King, she admits she cannot fulfill the demands of pacifism. The medicinal treatment becomes a kind of ritual cleansing as well, implying a renunciation of the past and a course for the future quite different from the one the past implied.

These scenes complete our understanding of Lena's personality and character, and they precipitate a crisis in her intellectual development that is fundamental to the film. So intricately interwoven are the threads of the film, both ideological and dramatic, that to remove the scenes deemed offensive would make the production almost totally incomprehensible. It is possible that the ideas could have been presented in a multitude of other ways, although one doubts they could have been presented quite as effectively and honestly without explicit reference to sex. And honesty is the fundamental concern of the film as it is for Lena. The work obviously searches for the truth on every level; to shy away from the truth in matters of sex would be to violate the very morality of the production. The honesty of the sexual scenes has another function; like the Surrealist shock, it demands that the spectator confront not illusion but reality, whether it be the reality of the perpetuation of classes in a so-called classless society, the reality of the army of a seemingly pacifist state, or the honest statement of sexual relationships. Considered from another point of view, the removal of the scenes would destroy the counterpoint that is established between the views of the society and the views of the individual and would break the rhythmic development of the structure to climax and resolution.

The censor, it would seem, has the power not only to alter the structure and content of the film, but to destroy them completely.

When the film has been conceived, written, shot, and edited, when it is finally issued to the public, it would seem to be complete, an integral whole bearing in effect the imprimatur of the producer. But the creative process has not ended, for the work of art is finally not the object but the experience of the viewer. Viewing, too, is an act of creation, in which the spectator's perception, experience, and sensibilities give particular meaning to the work. Nevers says in *Hiroshima, mon amour,* the "art of viewing has to be learned." And learning—and therefore creation—never ends.

Filmography

The filmography is arranged in two parts:
Part 1 provides credits for feature-length films (which have a running time of 60 minutes or longer);
Part 2 lists credits for short films (with less than 60 minutes' running time).
The phrase "conceived and produced by" is used to describe films created by a single person.
The following abbreviations have been used:

ani.	animator	**p.c.**	production company
cho.	choreographer, director of choreography	**pho.**	still photographer (films incorporating stills)
cin.	cinematographer, director of cinematography	**pla.**	player or narrator, the latter so designated
com.	composer or compiler, the latter so designated	**pro.**	producer
des.	production designer, art director	**rec.**	sound recordist
dir.	director	**rel.**	releasing company
edi.	editor	**scr.**	scriptwriter, scenarist
mus.	musical director	**spe.**	special effects by . . .

FEATURE-LENGTH FILMS

The African Queen
1951
dir. John Huston **cin.** Jack Cardiff **edi.** Ralph Kemplen **scr.** James Agee and John Huston, based on the novel by C. S. Forester **com.** Allan Gray **des.** Wilfred Singleton **pla.** Katharine Hepburn, Humphrey Bogart, Robert Morley, Theodore Bickel, Peter Bull **pro.** S. P. Eagle (Sam Spiegel) **p.c.** Horizon-Romulus **rel.** United Artists

Alexander Nevsky (Alexandr Nevskii)
1938
dir. Sergei Eisenstein, D. I. Vasiliev **cin.** Eduard Tisse, with A. Astafiev and N. Bolchakov **edi.** Sergei Eisenstein (film), B. Volsky and V. Popov (sound) **scr.** Sergei Eisenstein, Piotr Pavlenko **com.** Sergei Prokofiev **des.** Isaac Shpinel, Nikolai Soloviov, K. Eliseyev, based on drawings by Sergei Eisenstein **pla.** Nikolai Cherkassov, Nikolai P. Okhlopkov, Andrei Abrikosov, Varvasa Massallitinova, Valentina Ivashova, Dmitri Orlov, Vassili Novikov, Nikolai Arsky, Anna Danilova, V. Erchov, S. Blinnkov, I. Lagutin, N. Rogozhin **pro.** E. Solviokov, M. Kavkin, V. Gordov **p.c.** Mosfilm, Moscow

All These Women
(För att Inte Tala om alla Dessa Kvinnor)
1964
dir. Ingmar Bergman **cin.** Sven Nykvist **edi.** Ulla Ryghe (film), P. O. Pettersson, Tage Sjöberg (sound) **scr.** Ingmar Bergman, Erland Josephson **des.** P. A. Lundgren **spe.** Evald Andersson **com.** Erik Nordgren **rec.** P. O. Pettersson, Tage Sjöberg **pla.** Carl Billquist, Jarl Kulle, Georg Funkquist, Allan Edwall, Eva Dahlbeck, Karin Kavli, Harriet Andersson, Bibi Andersson, Gertrud Fridh, Barbro Hiort af Ornäs, Mona Malm **pro.** Lars-Owe Carlberg **p.c.** Svensk Filmindustri

The Armoured Cruiser Potemkin (see Potemkin)

L'Atalante
1934
dir. Jean Vigo **cin.** Boris Kaufman, Louis Berger, Jean-Paul Alphen **edi.** Louis Chavance **scr.** Jean Vigo, Albert Riéra after Jean Guinée **com.** Maurice Jaubert, songs by Charles Goldblatt and Cesare Andrea Bixio ("Le Chaland qui passe") **des.** Francis Jourdain **pla.** Michel Simon, Dita Parlo, Jean Dasté, Gilles Margaritis, Louis Lefèvre **pro.** J.-L. Nounez **p.c.** Gaumont-Franco-Film-Aubert

À Bout de souffle (see Breathless)

l'Avventura
1960
dir. Michelangelo Antonioni **cin.** Aldo Scavarda **edi.** Eraldo da Roma (film), Claudio Maielli (sound) **scr.** Michelangelo Antonioni, Elio Bartolini, Tonino Guerra **com.** Giovanni Fusco **des.** Piero Poletto **pla.** Monica Vitti, Gabriele Ferzetti, Lea Massari, Renzo Ricci, Dominique Blanchar, James Addams, Dorothy De Poliolo, Lelio Luttazi, Giovanni Petrucci, Esmeralda Ruspoli **pro.** Amato Penn **p.c.** Cino del Duca (Rome), Cinématographique Lyre (Paris)

Barberousse
1916
dir. Abel Gance **cin.** Léonce-Henry Burel and Duboise **scr.** Abel Gance **pla.** Léon Mathot, Maude Richard, Jeanne Briey, Maillard, Keppen, Doriani **pro.** Abel Gance **p.c.** Film d'art

The Battle of Algiers (La Battaglia di Algeri)
1966
dir. Gillo Pontecorvo **cin.** Marcello Gatti **scr.** Franco Solinas, based on a story by Gillo Pontecorvo and Franco Solinas **com.** Ennio Morricone, Gillo Pontecorvo **pla.** Jean Martin, Yacef Saadi, Brahim Haggiag, Tommaso Neri **pro.** Antonio Musu, Yacef Saadi

The Battleship Potemkin (see Potemkin)

Berlin: The Symphony of a Great City (Berlin, Die Sinfonie der Grosstadt)
1927
dir. Walter Ruttman **cin.** Karl Freund, with Reimar Kuntze, Robert Baberske, Läszlo Schaeffer **edi.** W. Ruttman, Edmund Meisel **scr.** Carl Mayer **com.** Edmund Meisel **pro.** Fox-Europa

The Bicycle Thief (Ladri di Biciclette)
1949
dir. Vittorio de Sica **cin.** Carlo Montuori **edi.** Eraldo Da Roma **scr.** Cesare Zavattini, based on a novel by Luigi Bartolini **com.** Alessandro Cigognini **des.** Antonio Traverso **pla.** Lamberto Maggiorani, Enzo Staiola, Lianella Carell **pro.** Umberto Scarpelli **p.c.** Produzioni De Sica

The Birth of a Nation
1915
dir. D. W. Griffith **cin.** G. W. Bitzer **scr.** D. W. Griffith and Frank E. Woods, from the novels *The Clansman* and *The Leopard's Spots* by Thomas Dixon **com.** Joseph C. Breil and D. W. Griffith (compilation) **pla.** Mae Marsh, Lillian Gish, Henry Walthall, Robert Harron, Wallace Reid, Miriam Cooper, Mary Alden, Ralph Lewis, George Seigman, Walter Long, Joseph Henaberry, Elmer Clifton, Josephine Crowell, Spottiswoode Aiken, André Beringer, Maxfield Stanley, Jennie Lee, Donald Crisp, Howard Gaye, Sam de Grasse, Raoul Walsh, Elmo Lincoln, Olga Grey, Eugene Pallette, Bessie Love, William de Vaull, Tom Wilson **pro.** Harry Aitken **p.c.** Epoch Producing Corporation

Blood of a Poet (Le Sang d'un poète)
1930
dir. Jean Cocteau (technical director Michel J. Arnaud) **cin.** Georges Périnal **edi.** Jean Cocteau **scr.** Jean Cocteau **com.** Georges Auric **des.** Jean Cocteau **pla.** Lee Miller, Enrique Rivero, Jean Desbordes, Pauline Carton, Odette Talazac, Fernand Dichamps, Lucien Jager, Féral Benga, Barbette **pro.** Jean Cocteau

The Blue Angel (Der Blaue Engel)
1930
dir. Josef von Sternberg **cin.** Günther Rittau, Hans Schneeberger **edi.** Josef von Sternberg **scr.** Carl Zuckmayer, Karl Vollmöller, Robert Liebmann, from the novel *Professor Unrath* by Heinrich Mann **com.** Friedrich Holländer (lyrics and dialogue by Robert Liebmann) **des.** Otto Hunte, Emil Hasler **spe.** Fritz Thiery (sound) **pla.** Emil Jannings, Marlene Dietrich, Kurt Gerron, Rosa Valetti, Hans Albers, Ilse Fürstenberg **pro.** Erich Pommer

Bonaparte and the Revolution (Bonaparte et la revolution)
1971
Sound version of part of *Napoléon vu par Abel Gance* with some new footage, put together by Abel Gance and Claude Lelouch

Le Bonheur
1964
dir. Agnès Varda **cin.** Jean Rabier, Claude Beausoleil **edi.** Janine Verneau **scr.** Agnès Varda **des.** Hubert Montloup **pla.** Jean-Claude Drouot, Claire Drouot, Sandrine Drouot, Olivier Drouot, Marie-France Boyer, Paul Vecchiali **pro.** Mag Bodard **p.c.** Parc Film

Breathless (A bout de souffle)
1959
dir. Jean-Luc Godard (under supervision of Claude Chabrol) **cin.** Raoul Coutard **edi.** Cécile Decugis, Lila Herman **scr.** Jean-Luc Godard, based on a story by François Truffaut **com.** Martial Solal **rec.** Jacques Maumont **des.** Claude Chabrol **pla.** Jean Seberg, Jean-Paul Belmondo, Liliane David, Daniel Boulanger, J. P. Melville, Henri-Jacques Huet, Claude Mansart, Jean-Pierre van Doude, Jean-Luc Godard **pro.** Georges de Beauregarde **p.c.** Société Nouvelle de Cinéma

Brink of Life (Nära Livet)
1957
dir. Ingmar Bergman **cin.** Max Wilén **edi.** Carl-Olov Skeppstedt **scr.** Ingmar Bergman and Ulla Isaksson, based on *The Friendly, the Dignified* by U. Isaksson **des.** Bibi Lindstrom **pla.** Ingrid Thulin, Eva Dahlbeck, Bibi Andersson, Barbro Hiort af Ornäs, Max von Sydow, Erland Josephson, Inga Landgré

The Cabinet of Dr. Caligari (Das Cabinett des Dr. Caligari)
1919
dir. Robert Wiene **cin.** Willy Hameister **scr.** Hans Janowitz, Carl Mayer **des.** Hermann Warm, Walter Röhrig, Walter Reimann **pla.** Werner Krauss, Conrad Veidt, Lil

Dagover, Friedrich Feher, Hans von Twardowski, Rudolf Lettinger, Rudolf Klein-Rogge **pro.** Erich Pommer **p.c.** Deutsche Eclair-Bioscop (Decla-Bioscop)

Citizen Kane
1941
dir. Orson Welles **cin.** Gregg Toland **edi.** Robert Wise, Mark Robson **scr.** Orson Welles, Herman J. Mankiewicz, Joseph Cotton, John Houseman **com.** Bernard Herrmann **rec.** Bailey Fesler, James G. Stewart **des.** Van Nest Polglase, Perry Ferguson **spe.** Vernon L. Walker **pla.** Orson Welles, Joseph Cotton, Everett Sloane, Agnes Moorehead, Dorothy Comingore, Ruth Warrick, Ray Collins, George Coulouris **pro.** Orson Welles **p.c.** A Mercury Production, RKO Radio Pictures

City Streets
1931
dir. Rouben Mamoulian **cin.** Lee Garmes **scr.** Max Marcin and Oliver Garrett, from a story by Dashiell Hammett **com.** Sidney Cutner (orchestration) **rec.** J. A. Goodrich, M. M. Paggi **pla.** Gary Cooper, Sylvia Sidney, Paul Lukas, Guy Kibbee, William Boyd, Betty Sinclair, Stanley Fields **p.c.** Paramount

The Connection
1960
dir. Shirley Clarke **cin.** Arthur J. Ornitz **scr.** Jack Gelber, based on his play **com.** Freddie Redd **des.** Dick Sylbert **pla.** Warren Finnerty, William Redfield, Carl Lee, Roscoe Browne, Jim Anderson, Larry Ritchie, Jackie McLean, Michael Mattos, Barbara Winchester, Henry Proach **pro.** Lewis Allen **p.c.** Allen-Hodgdon Productions

Dead End
1937
dir. William Wyler **cin.** Gregg Toland **edi.** Daniel Mandell **scr.** Lillian Hellman, from the play by Sidney Kingsley **com.** Alfred Newman **rec.** Frank Maher **des.** Richard Day **pla.** Humphrey Bogart, Claire Trevor, Joel McCrae, Wendy Barrie, Allen Jenkins, Sylvia Sidney, Marjorie Main **pro.** Samuel Goldwyn **p.c.** United Artists

Les Demoiselles de Rochefort
1967
dir. Jacques Demy **cin.** Ghislain Cloquet **edi.** Jean Hamon **scr.** Jacques Demy **des.** Bernard Evein **mus.** Michel Legrand **pla.** Catherine Deneuve, Françoise Dorléac, George Chakiris, Grover Dale, Danielle Darrieux, Michel Piccoli, Gene Kelly **pro.** Mag Bodard **p.c.** Parc Film/Madeleine Films

The Devil is a Woman
1935
dir. Josef von Sternberg **cin.** Josef von Sternberg, Lucien Ballard **scr.** Josef von Sternberg, John Dos Passos, and

Sam Winston, from the novel *Woman and the Puppet* by Pierre Louys **com.** Music arranged by Ralph Rainger and Andrea Setaro from Rimski-Korsakov's "Capriccio Espagnol" and Spanish folk songs. Lyrics by Leo Robin **des.** Hans Dreier and Josef von Sternberg **pla.** Marlene Dietrich, Lionel Atwill, Cesar Romero, Edward Everett Horton, Alison Skipworth, Don Alvarado, Morgan Wallace **p.c.** Paramount

La Dolce Vita
1959
dir. Federico Fellini **cin.** Otello Martelli **edi.** Leo Cattozzo (film), Agostino Moretti (sound) **scr.** Federico Fellini, Ennio Flaiano, Tullio Pinelli, Brunello Rondi **com.** Nino Rota **des.** Piero Gherardi **pla.** Marcello Mastroianni, Yvonne Furneaux, Anouk Aimée, Anita Ekberg, Alain Cuny, Nadia Gray, Annibale Nichi, Lex Barker, Magali Noël, Jacques Sernas, Alan Dijon, Walter Santesso, Adriana Moneta, Valeria Ciangottini **pro.** Giuseppe Amato, Angelo Rizzoli **p.c.** Riama Film/Pathé Consortium Cinéma, Paris

Easy Rider
1969
dir. Dennis Hopper **cin.** Laszlo Kovacs **edi.** Don Cambern **scr.** Peter Fonda, Dennis Hopper, Terry Southern **des.** Jerry Kay **spe.** Steve Karkus **pla.** Peter Fonda, Dennis Hopper, Jack Nicholson, Karen Black, Luke Askew, Toni Basil, Kuana Anders, Warren Finnerty, Sabrina Scharf, Robert Walker **pro.** Peter Fonda **p.c.** Pando Company and Raybert Productions

Eclipse (L'Éclisse)
1962
dir. Michelangelo Antonioni **cin.** Gianni Di Venanzo **edi.** Eraldo da Roma **scr.** Michelangelo Antonioni and Tonino Guerra, with Elio Bartolini and Ottiero Ottieri **com.** Giovanni Fusco **des.** Piero Poletto **pla.** Alain Delon, Monica Vitti, Francisco Rabal **pro.** Robert and Raymond Hakim **p.c.** Interopa Film-Cineriz (Rome), Paris Film Production (Paris)

Ecstasy (Extase)
1933
dir. Gustav Machaty **cin.** Jan Stallich **scr.** Gustav Machaty, Robert Horky **com.** G. Becci **pla.** Hedy Lamarr, Aribert Mog, Frederick A. Rogoz, Leopold Kramer **pro.** Gustav Machaty **p.c.** Elektra Film Slavia

8½ (Otto e Mezzo)
1963
dir. Federico Fellini **cin.** Gianni Di Venanzo **edi.** Cattozzo **scr.** Federico Fellini, Ennio Flaiano, Tullio Pinelli, Brunello Rondi **com.** Nino Rota **des.** Piero Gherardi **pla.** Marcello Mastroianni, Anouk Aimée, Claudia Cardinale, Sandra Milo, Rossella Falk, Barbara Steele, Mario Pisu,

Edra Gale, Guido Alberti, Madeleine Lebeau, Jean Rougeul, Caterina Boratto, Annibale Nichi, Giuditta Risson **pro.** Angelo Rizzoli **p.c.** Federiz/Cineriz

Elvira Madigan
1967
dir. Bo Widerberg **cin.** Jörgen Perssen **edi.** Bo Widerberg **scr.** Bo Widerberg **pla.** Pia Degermark, Thommy Berggren, Lennart Malmen, Cleo Jensen **p.c.** Europa Films

Empire
1964
Produced by Andy Warhol

The Exiles
1959–61
dir. Kent Mackenzie **cin.** Erik Daarstad, Robert Kaufman, John Morrill **edi.** Kent Mackenzie **scr.** Kent Mackenzie **com.** Tony Hilder, Bob Hafner, The Revels; authentic Indian songs led by Eddie Sunrise and Jacinte Valenzuela **pro.** Kent Mackenzie

Five Easy Pieces
1970
dir. Bob Rafelson **cin.** Laszlo Kovacs **edi.** Christopher Holmes, Gerald Shepard **scr.** Adrien Joyce, Bob Rafelson **des.** Toby Rafelson **pla.** Jack Nicholson, Karen Black, Lois Smith, Susan Anspach, Ralph Waite **p.c.** B.B.S./Columbia

A Fool There Was
1914
dir. Frank Powell **scr.** Frank Powell, from a play of the same name based on Rudyard Kipling's poem "The Vampire" **pla.** Theda Bara, Edward José **p.c.** Fox Film Corporation

Foolish Wives
1921
dir. Erich von Stroheim **cin.** Ben Reynolds, William Daniels **scr.** Erich von Stroheim **des.** Erich von Stroheim, Captain Richard Day **pla.** Erich von Stroheim, Mae Busch, Maud George, George Christians, Miss Dupont, Cesare Gravina, Malvine Polo, Dale Fuller **p.c.** Universal Studios

The 400 Blows (Les Quatre cents coups)
1959
dir. Francois Truffaut **cin.** Henri Decae **edi.** Marie-Josephe Yoyotte **scr.** François Truffaut, dialogue by Marcel Moussy **des.** Bernard Evein **com.** Jean Constantin **rec.** Jean-Claude Marchetti **pla.** Jean-Pierre Léaud, Patrick Auffay, Claire Maurier, Albert Rémy, Guy Decomble **pro.** Georges Charlot **p.c.** Les Films du Carrosse/S.E.D.I.F.

French Cancan
1954
dir. Jean Renoir **cin.** Michel Kelber **edi.** Boris Lewin **scr.** Jean Renoir, based on an idea by André-Paul Antoine **com.** Georges Van Parys **rec.** Antoine Petit-Jean **cho.** Claude Grandjean **des.** Max Bouy (sets), Rosine Delamare (costumes) **pla.** Jean Gabin, Françoise Arnoul, Maria Félix, Anna Amendola, Jean-Roger Caussimon, Dora Doll, Giani Esposito, Gaston Gabaroche, Jacques Jouannea, Jean Parédés, Michèle Philippe, Michel Piccoli, Albert Rémy, France Roche, Jean-Marc Tennberg, Valentine Tessier, Philippe Clay, Edith Piaf, Patachou **pro.** Louis Wipf **p.c.** Franco-London Films, S.A.

Frustration (see Ship to the Indies)

Gold Diggers of 1933
1933
dir. Mervyn LeRoy **cin.** Sol Polito **edi.** George Amy **scr.** David Boehm and Ben Markson, based on the play by Avery Hopwood **com.** Harry Warren and Al Dubin **cho.** Busby Berkeley **des.** Busby Berkeley **pla.** Dick Powell, Ruby Keeler, Joan Blondell, Aline MacMahon, Guy Kibbee, Ned Sparks, Ginger Rogers, Warren William **pro.** Samuel Goldwyn, Florenz Ziegfeld **p.c.** Warner Brothers

Gone with the Wind
1939 (reissued in 1967 in 70mm and stereophonic sound)
dir. George Cukor, Victor Fleming, Sam Wood, Lee Garmes **cin.** Ernest Haller **edi.** Hal C. Kern, James E. Newcom **scr.** Sidney Howard, D. O. Selznick, and others, from the novel by Margaret Mitchell **com.** Max Steiner **des.** Lyle Wheeler (art director), William Cameron Menzies (production designer) **spe.** Jack Cosgrove, Lee Zavitz **pla.** Vivien Leigh, Leslie Howard, Clark Gable, Hattie McDaniel, Thomas Mitchell, Barbara O'Neil, Victor Jory, Olivia de Havilland, Laura Hope Crews, Harry Davenport, Jane Darwell, Cliff Edwards, Ona Munson, J. M. Kerrigan **pro.** David O. Selznick **p.c.** MGM/Selznick-International

Grand Prix
1966
dir. John Frankenheimer **cin.** Lionel Lindon **edi.** Frederic Steinkamp **scr.** Robert Alan Arthur **com.** Maurice Jarre **des.** Richard Sylbert **spe.** Milton Rice (visual consultant, Saul Bass) **pla.** James Garner, Eva Marie Saint, Genevieve Page, Françoise Hardy, Yves Montand **pro.** Edward Lewis **p.c.** Joel-JFP-Cherokee Film **rel.** MGM

Greed
1924
dir. Erich von Stroheim **cin.** Ben Reynolds, William Daniels, Ernest Schoedsack **edi.** Joseph Farnham, Erich von Stroheim, Rex Ingram, June Mathis **scr.** Erich von

Stroheim, from the novel *McTeague* by Frank Norris **des.** Cedric Gibbons, Captain Richard Day **pla.** Gibson Gowland, Jean Hersholt, Zasu Pitts, Chester Conklin, Dale Fuller, Sylvia Ashton, Austin Jewell, Max Tyron, Cesare Gravina **p.c.** Metro-Goldwyn Pictures

La Guerre est finie
1966
dir. Alain Resnais **cin.** Sacha Vierny **edi.** Eric Pluet **scr.** Jorge Semprun **com.** Giovanni Fusco **des.** Jacques Saulnier **pla.** Yves Montand, Ingrid Thulin, Geneviève Bujold, Michel Piccoli, Dominque Rozan, Françoise Bertin, Paul Crauchet, Gérard Séty **pro.** Catherine Winter, Gisèle Rebillon **p.c.** Sofracima/Argos (Paris), Europa Film (Stockholm)

Hamlet
1948
dir. Laurence Olivier **cin.** Desmond Dickinson **edi.** Helga Cranston **scr.** Laurence Olivier, Alan Dent **mus.** William Walton **des.** Carmen Dillon, Roger Furse **rec.** John Mitchell, L. E. Overton **pla.** Laurence Olivier, Jean Simmons, Basil Sydney, Eileen Herlie, Felix Aylmer, Norman Wooland, Terence Morgan, Peter Cushing, Anthony Quayle, Esmond Knight, Stanley Holloway, John Laurie, Russell Thorndyke, Harcourt Williams **p.c.** Two Cities Films, Ltd.

Hello, Sister! (see Walking Down Broadway)

Hemo the Magnificent
1957
dir. Frank Capra **cin.** Harold Wellman **ani.** Shamus Culhane Productions, Inc. **edi.** Frank P. Keller **scr.** Frank Capra (research by Nancy Pitt) **mus.** Raoul Kraushaar **spe.** Archie Dattlebaum (sound effects) **pla.** Richard Carlson, Frank Baxter **pro.** Joseph Sistrom (associate producer) **p.c.** Frank Capra Productions, Inc., for the Bell Telephone Co.

Hiroshima, mon amour
1959
dir. Alain Resnais **cin.** Sacha Vierny, Michio Takahashi **edi.** Henri Colpi, Jasmine Chasney, Anne Sarraute **scr.** Marguerite Duras **com.** Giovanni Fusco, Georges Delerue **des.** Esaka, Mayo, Petri **pla.** Emmanuèle Riva, Eiji Okada, Bernard Fresson, Stella Dassas, Pierre Barbaud **p.c.** Argos Film, Como Film, Pathé Overseas, Daiei Motion Pictures

Hour of the Wolf (Vargtimmen)
1968
dir. Ingmar Bergman **cin.** Sven Nykvist **edi.** Ulla Ryghe **scr.** Ingmar Bergman **com.** Lars-Johan Werle **des.** Marik Vos-Lundh **pla.** Liv Ullmann, Max von Sydow, Erland Josephson, Gertrud Fridh, Bertil Anderberg, Ingrid Thu-

lin, Georg Ryderberg, Naima Wifstrand, Lenn Hjortzberg, Mona Seilitz, Mikael Rundqvist, Agada Helin **pro.** Lars-Owe Carlberg **p.c.** Svensk Filmindustri

I Am Curious (Yellow) (Jag Är Nyfiken–Gul)
1966
dir. Vilgot Sjöman **cin.** Peter Wester **edi.** Wic Kjellin (film) **rec.** Tage Sjöborg **pla.** Lena Nyman, Peter Lindgren, Börje Ahlstedt, Magnus Nilsson, Chris Wahlström, Marie Göranzon, Ulla Lyttkens, Holger Löwenadler, with appearances by Yevgeny Yevtushenko, Olof Palme, Martin Luther King **pro.** Göran Lindgren **p.c.** Sandrew Film and Theater Co.

Illicit Interlude (Sommarlek)
1951
dir. Ingmar Bergman **cin.** Gunnar Fischer, Bengt Jarnmark **edi.** Oscar Rosander **scr.** Ingmar Bergman, Herbert Crevenius **com.** Erik Nordgren **des.** Nils Svenwall **pla.** Maj-Britt Nilson, Birger Malmsten, Alf Kjellin, Georg Funkquist, Mimi Pollack, Annalisa Ericson, Stig Olin, Royal Stockholm Opera Ballet **pro.** Allan Ekelund **p.c.** Svensk Filmindustri

L'Immortelle
1963
dir. Alain Robbe-Grillet **cin.** Maurice Barry **edi.** Bob Wade, Annie Kespus **com.** Georges Delerue, Tashin Karaleioglu **scr.** Alain Robbe-Grillet **pla.** Françoise Brion, Jacques Doniol-Valcroze, Guido Celano, Catherine Robbe-Grillet, Belkio Mutlu, Sezer Sezin, Ulvi Uraz **pro.** Sammy Halfron, Michael Fano **p.c.** Les Films Tamara/Como Films/Cocinor/Dino de Laurentis

The Informer
1935
dir. John Ford **cin.** Joseph August **edi.** George Hively **scr.** Dudley Nichols, based on a novel by Liam O'Flaherty **com.** Max Steiner **rec.** Hugh McDowell, Jr. **pla.** Victor McLaglen, Heather Angel, Preston Foster, Wallace Ford, Margot Grahame, Una O'Conner, J. M. Kerrigan, Donald Meek, May Boley **pro.** Cliff Reid **p.c.** RKO Radio Pictures, Inc.

Intolerance
1916
dir. D. W. Griffith, assisted by George Siegmann, W. S. van Dyke, and Joseph Henabery **cin.** G. W. Bitzer, Karl Brown **scr.** D. W. Griffith **des.** R. Ellis Wales **com.** Joseph C. Breil, D. W. Griffith (arrangers) **pla.** Lillian Gish, Mae Marsh, Robert Harron, Miriam Cooper, Monte Blue, Tod Browning, Olga Grey, Bessie Love, Erich von Stroheim, Constance Talmadge, Eugene Pallette, Sam de Grasse, Pauline Starke, Mildred Harris, Fred Turner, Vera Lewis, Walter Long, Tom Wilson, Ralph Lewis, Margery Wilson, Maxfield Stanley, Josephine Crowell, Elmer

Clifton, Alfred Paget, Seena Owen, Tully Marshall, Ruth St. Denis, Ted Shawn **pro.** D. W. Griffith **p.c.** Wark Producing Corporation

Ivan the Terrible, Part I (Ivan Grozny)
1944
dir. Sergei Eisenstein **cin.** Eduard Tisse (exteriors), Andrei Moskvin (interiors) **edi.** Sergei Eisenstein, E. Tobak **scr.** Sergei Eisenstein **com.** lyrics by Vladimir Lugovsky to music by Prokofiev **rec.** V. Bogdankevich, B. Volsky **des.** Isaac Shpinel (sets), L. Naumov (costumes), V. Goryunov (makeup), based on drawings by Sergei Eisenstein **pla.** Nikolai Cherkassov, Ludmila Tselikovskaya, N. Nabanov, V. I. Pudovkin, Serafima Birman, Mikhail Zharov, Amvrozy Buchmina, Mikhail Nazvasarov, Pyotr Kadochnikov, Alexander Abrikosov, A. Mgebrov, M. Kuznetsov **pro.** E. Eidous **p.c.** Central Cinema Studio, Alma-Ata Film Studios

Ivan the Terrible, Part II
1945 (condemned by a resolution of the Central Committee on Cinema and Theater in 1946; Moscow Premiere, 1958) Credits the same as for Part I, except for additional players Erik Pyriev, P. Massalsky, V. Balachov

Le Joli mai
1963
dir. Chris Marker **cin.** Pierre Lhomme **edi.** Eva Zora **scr.** Cathérine Varlin, with commentary by Chris Marker **pla.** Simone Signoret, Yves Montand (narrators) **pro.** André Heinrich **p.c.** Sofracima

Juliet of the Spirits (Giulietta degli Spiriti)
1965
dir. Federico Fellini **cin.** Gianni Di Venanzo **edi.** Ruggiero Mastroianni **scr.** Federico Fellini, Ennio Flaiano, Tullio Pinelli, Brunello Rondi **com.** Nino Rota **des.** Piero Gherardi **pla.** Giulietta Masina, Mario Pisu, Sandra Milo, Valentina Cortese, Lou Gilbert, Silva Koscina, Valeska Gert, José Luis de Villalonga, Friedrich Ledebur, Caterina Boratto **pro.** Angelo Rizzoli **p.c.** Federiz Film

The Koumiko Mystery (Le Mystère Koumiko)
1965
dir. Chris Marker (assisted by Koichi Yamada) **cin.** Chris Marker **edi.** Chris Marker **scr.** Chris Marker **com.** Toru Takemitsu **pla.** Kumiko Muraoka **p.c.** Sofracima/APEC-Joudioux

The Last Command
1928
dir. Josef von Sternberg **cin.** Bert Glennon **edi.** William Shea **scr.** John F. Goodrich, from a story by Josef von Sternberg based on an anecdote told to Ernst Lubitsch by Lajos Biro; titles by Herman J. Mankiewicz **des.** Hans

Dreier **pla.** Emil Jannings, Evelyn Brent, William Powell **pro.** J. B. Bachmann **p.c.** Famous Lasky Corporation

The Last Laugh (Der Letzte Mann)
1924
dir. F. W. Murnau **cin.** Karl Freund **scr.** Carl Mayer **des.** Walther Roehrig, Robert Herlth **pla.** Emil Jannings, Georg John, Maly Delschaft, Emilie Kurz, Max Hiller **pro.** Erich Pommer **p.c.** UFA

Last Year at Marienbad (L'Année dernière à Marienbad)
1961
dir. Alain Resnais **cin.** Sacha Vierny **edi.** Henri Colpi, Jasmine Chasney **scr.** Alain Robbe-Grillet **com.** Francis Seyrig **des.** Jacques Saulnier **pla.** Delphine Seyrig, Giorgio Albertazzi, Sacha Pitoeff **pro.** Pierre Courau, Raymond Froment **p.c.** Précitel/Terrafilm

A Lesson in Love (En Lektion i Kärlek)
1954
dir. Ingmar Bergman **cin.** Martin Bodin **edi.** Oscar Rosander **scr.** Ingmar Bergman **com.** Dag Wirén **des.** P. A. Lundgren **pla.** Eva Dahlbeck, Gunnar Björnstrand, Yvonne Lombard, Harriet Andersson, Åke Grönberg, Olof Winnerstrand, Birgitte Reimer, John Elfström, Renée Björling, Dagmar Ebbesen, Helge Hagerman, Gösta Prüzelius, Sigge Fürst, Carl Ström, Arne Lindblad, Torsten Lilliecrona, Yvonne Brosset **p.c.** Svensk Filmindustri

Lola
1960
dir. Jacques Demy **cin.** Raoul Coutard **edi.** Anne-Marie Cotret **scr.** Jacques Demy **mus.** Michel Legrand **des.** Bernard Evein **pla.** Anouk Aimée, Marc Michel, Jacques Hardin, Ellen Scott, Elina Labourdette **pro.** Carlo Ponti, Georges Beauregard **p.c.** Rome-Paris Films

Louisiana Story
1948
dir. Robert Flaherty **cin.** Richard Leacock **edi.** Helen van Dongen **scr.** Robert and Frances Flaherty **com.** Virgil Thomson (music performed by Philadelphia Orchestra conducted by Eugene Ormandy and recorded by Bob Fine) **rec.** Benjamin Doniger **pro.** Robert Flaherty **p.c.** Standard Oil Company of New Jersey

Lovers and Thieves (Assassins et voleurs)
1957
dir. Sacha Guitry **scr.** Sacha Guitry **com.** Jean Français **pla.** Jean Poiret, Michel Serrault, Magali Noël, Clément Duhour, Zita Perzel, Darry Cowl **p.c.** C. L. M. Gaumont

The Magician (Ansiktet)
1958
dir. Ingmar Bergman **cin.** Gunnar Fischer **edi.** Oscar Rosander **scr.** Ingmar Bergman **com.** Erik Nordgren **des.** P. A. Lundgren **pla.** Max von Sydow, Ingrid Thulin, Åke Fridell, Naima Wifstrand, Lars Ekborg, Gunnar Björnstrand, Erland Josephson, Gertrud Fridh, Toivo Pawlo, Ulla Sjöblom, Bengt Ekerot, Sif Ruud, Bibi Andersson, Oscar Ljung, Axel Düberg, Birgitta Pettersson **p.c.** Svensk Filmindustri

Man of Aran
1934
dir. Robert Flaherty **cin.** Robert Flaherty, David Flaherty, John Taylor **edi.** John Goldman **scr.** Robert and Frances Flaherty **com.** John Greenwood **pro.** Robert Flaherty **p.c.** Gainesborough Pictures, Ltd. for Gaumont-British Corporation, Ltd.

Masculine Feminine
1966
dir. Jean-Luc Godard **cin.** Willy Kurant **edi.** Agnès Guillemot **scr.** Jean-Luc Godard, based on two stories by Guy de Maupassant: *La Femme de Paul* and *Le Signe* **mus.** Francis Lai **rec.** René Levert **pla.** Jean-Pierre Léaud, Chantal Goya, Chaterine-Isabelle Duport, Marlène Jobert, Michel Debord, Birger Malmsten, Brigitte Bardot **pro.** Philippe Dussart **p.c.** Anouchka Films/Argos-Films (Paris)/Svensk Filmindustri/Sandrews (Stockholm)

The Merry Widow
1925
dir. Erich von Stroheim **cin.** Ben Reynolds, William Daniels, Oliver Marsh **edi.** Frank E. Hull **scr.** Erich von Stroheim, based on the operetta *Die lustige Witwe* (1906) by Leo Stein and Victor Léon, with dialogue by Benjamin Glazer and titles by Marian Ainslee **com.** William Axt and David Mendoza, based on the music by Franz Lehar **des.** Cedric Gibbons, Captain Richard Day, Erich von Stroheim **pla.** Mae Murray, John Gilbert, Roy D'Arcy, Tully Marshall, Josephine Crowell, George Fawcett **p.c.** MGM

Metropolis
1926
dir. Fritz Lang **cin.** Karl Freund, Günther Rittau **scr.** Fritz Lang and Thea von Harbou, based on the novel by the latter **des.** Otto Hunte, Erich Kettlehut, Karl Vollbrecht **pla.** Brigitte Helm, Alfred Abel, Gustav Froehlich, Rudolf Klein-Rogge, Fritz Rasp, Theodor Loos, Heinrich George **p.c.** UFA

Le Million
1931
dir. René Clair **cin.** Georges Périnal, Georges Raulet **edi.** René Le Henaff **scr.** René Clair, based on the play by Georges Berr and M. Guillemaud **com.** Georges Van Parys, Armand Bernard, Phillipe Parès **des** Lazare Meerson **pla.** René Lefèvre, Annabella, Louis Allibert, Wanda Gréville, Paul Olivier, Odette Talazac, Constantin Stroesco **p.c.** Films Tobis

Mississippi Mermaid
(La Sirène du Mississippi)
1969
dir. François Truffaut **cin.** Denys Clerval **edi.** Agnès Guillemot **scr.** François Truffaut, after the novel *Waltz into Darkness* by William Irish **com.** Antoine Duhamel **rec.** René Levert **des.** Claude Pignot **pla.** Jean-Paul Belmondo, Catherine Deneuve, Michel Bouquet, Nelly Borgeaud, Marcel Berbert, Martine Ferrière, Roland Thenot **pro.** Marcel Berbert **p.c** Les Films du Carrosse (Paris)/ Artistes Associés, Produzioni Associate Delphos (Rome)

Moana
1926
dir. Robert Flaherty and Frances Flaherty **cin.** Robert Flaherty with Bob Roberts **edi.** Julian Johnson **scr.** Robert Flaherty **pro.** David Flaherty **p.c.** Famous Players-Lasky

Modern Times
1936
dir. Charles Chaplin **cin.** Rollie Totheroh, Ira Morgan **edi.** Charles Chaplin **com.** Charles Chaplin **pla.** Charles Chaplin, Paulette Goddard, Chester Conklin, Stanley Sandford, Allan Garcia, Hank Mann, Lloyd Ingraham, Henry Bergman, Wilfred Lucas, Louis Natheax **pro.** Charles Chaplin **p.c.** United Artists

Monika (Sommaren med Monika)
1952
dir. Ingmar Bergman **cin.** Gunnar Fischer **edi.** Tage Homberg, Gösta Lewin **scr.** Ingmar Bergman, Per-Anders Fogelström from the latter's novel **com.** Erik Nordgren **des.** P. A. Lundgren and Nils Svenwall **pla.** Harriet Andersson, Lars Ekborg, John Harryson, Georg Skarstedt, Dagmar Ebbeson, Åke Fridell, Naemi Briese, Åke Grönberg **pro.** Allan Ekelund **p.c.** Svensk Filmindustri

My Life to Live (Vivre sa vie)
1962
dir. Jean-Luc Godard **cin.** Raoul Coutard **edi.** Agnès Guillemot, Lila Lakshmanan **scr.** Jean-Luc Godard, with documentation from *Où en est la prostitution?* by Marcel Sacotte **com.** Michel Legrand **rec.** Guy Villette, Jacques Maumont **pla.** Anna Karina, Sady Rebbot, André Labarthe, Guylaine Schlumberger, Gérard Hoffman, Monique Messine, Brice Parain **pro.** Pierre Braunberger **p.c.** Films de la Pléiade

The Naked Night (Gycklarnas Afton)
1953
dir. Ingmar Bergman **cin.** Sven Nykvist, Hilding Bladh **edi.** Carl-Olov Skeppstedt **scr.** Ingmar Bergman **com.** Karl-Birger Blomdahl **des.** Bibi Lindström **pla.** Harriet Andersson, Åke Grönberg, Anders Ek, Gudrun Brost, Hasse Ekman, Gunnar Björnstrand, Annika Tritow, Erik Strandmark, Kiki, Åke Fridell **pro.** Rune Waldekranz **p.c.** Sandrew Film and Theater Company

Nanook
1920
dir. Robert Flaherty **cin.** Robert Flaherty **edi.** Robert Flaherty **scr.** Robert Flaherty **pro.** Robert Flaherty **p.c.** Revillon Frères

Napoléon vu par Abel Gance
1927
dir. Abel Gance **cin.** Jules Kruger, L.-H. Burel, J.-P. Mundviller, Roger Hubert, Emile Pierre, Lucas Briquet **edi.** Abel Gance **scr.** Abel Gance **com.** Arthur Honegger **pla.** Albert Dieudonné, Antonin Artaud, Pierre Batcheff, Alexandre Kontritzky **p.c.** Société Générale de Films/Wengeroff-Stinnes

New Earth (Nieuwe Gronden)
1934
dir. Joris Ivens **cin.** Joris Ivens, Éli Latar, John Fernhout, Piet Huisken **edi.** Joris Ivens (film) and Helen van Dongen (sound) **scr.** Joris Ivens **com.** Hanns Eisler **pla.** Joris Ivens (narrator) **p.c.** CAPI

The Night They Raided Minsky's
1968
dir. William Friedkin **cin.** Andrew Laszlo **scr.** Arnold Schulman, Sidney Michaels, Norman Lear, based on the book by Rowland Barber **com.** Charles Strouse **des.** John Robert Lloyd **pla.** Jason Robards, Britt Ekland, Norman Wisdom, Forrest Tucker, Harry Andrews, Elliot Gould, Jack Burns, Bert Lahr **pro.** Norman Lear **p.c.** Tandem Productions, Inc. **rel.** United Artists

Nobody Waved Goodbye
1964
dir. Don Owen **cin.** John Spotton **edi.** Donald Ginsberg and John Spotton (film), Jean-Pierre Joutel (sound) **scr.** Don Owen **com.** Eldon Rathburn **rec.** Roger Hart, Ron Alexander **pla.** Peter Kastner, Julie Biggs, Claude Rae, Charmion King **pro.** Don Owen and Roman Kroitor **p.c.** National Film Board of Canada

La Notte
1961
dir. Michelangelo Antonioni **cin.** Gianni Di Venanzo **edi.** Eraldo da Roma (film), Claudio Maielli (sound) **scr.** Ennio Flaiano and Tonino Guerra, from a story by Michelangelo Antonioni **com.** Giorgio Gaslini **des.** Piero Zuffi **pla.** Jeanne Moreau, Marcello Mastroianni, Monica Vitti, Bernhard Wicki, Maria Pia Luzi, Rosy Mazzacurati, Guido Marsan **pro.** Emmanuel Cassuto **p.c.** Nepi Film (Rome), Sofitedip (Paris), Silver Film (Paris)

October (see Ten Days That Shook the World)

Olympia: Part I. Fest der Völker (Festival of the People)
Part II. Fest der Schonheit (Festival of Beauty)
1936–38
dir. Leni Riefenstahl, assisted by Walther Ruttmann **cin.** Hans Ertl, Walter Frentz, Guzzi Lantschner, Willy Zielke, Hans Scheib, Kurt Neubert, with the newsreel crews of Fox, Paramount, Tobis-Melo, and UFA **edi.** Leni Riefenstahl **com.** Herbert Windt **pro.** Leni Riefenstahl **p.c.** Leni Riefenstahl/Tobis-Filmkunst

On the Waterfront
1954
dir. Elia Kazan **cin.** Boris Kaufman **edi.** Gene Milford **scr.** Budd Schulberg, from his story based on articles by Malcolm Johnson **com.** Leonard Bernstein **pla.** Marlon Brando, Karl Malden, Lee J. Cobb, Eva Marie Saint, Rod Steiger, Pat Henning **pro.** Sam Spiegel **p.c.** Columbia

The Passion of Anna (En Passion)
1969
dir. Ingmar Bergman **cin.** Sven Nykvist **edi.** Siv Kanälv **scr.** Ingmar Bergman **des.** P. A. Lundgren **pla.** Max von Sydow, Liv Ullmann, Bibi Andersson, Erland Josephson, Erik Hell, Sigge Fürst, Svea Holst, Annika Kronberg, Hjördis Pettersson **pro.** Lars-Owe Carlberg **p.c.** Svensk Filmindustri

Persona
1966
dir. Ingmar Bergman **cin.** Sven Nykvist **edi.** Ulla Ryghe **scr.** Ingmar Bergman **com.** Lars-Johan Werle **des.** Bibi Lindström **pla.** Bibi Andersson, Liv Ullmann, Gunnar Björnstrand, Margaretha Krook **p.c.** Svensk Filmindustri

Picnic on the Grass (Le Déjeuner sur l'herbe)
1959
dir. Jean Renoir **cin.** Georges Leclerc **edi.** Renée Lichtig **scr.** Jean Renoir **com.** Joseph Kosma **des.** Marcel-Louis Dieulot **pla.** Paul Meurisse, Catherine Rouvel, Jacqueline Morane, Fernand Sardou, Jean-Pierre Granval, Charles Blavette **p.c.** Cie Jean Renoir

Potemkin (Bronenosets Potyomkin)
1925
dir. Sergei Eisenstein (assisted by Grigori Alexandrov) **cin.** Eduard Tisse **edi.** Sergei Eisenstein **scr.** Sergei Ei-

senstein, from a story by Nina Agadjhanova-Shutko com. Background music by Nikolai Kryukov, scored by Edmund Meisel des. Vassili Rakhals pla. A. Antonov, Vladimir Barsky, G. Alexandrov, M. Gomorov, Levchenko, Repnikova, Marusov, sailors, citizens of Odessa, members of the Proletkult Theater pro. Jacob Bliokh p.c. First Goskino Production, Moscow

Queen Kelly
1928
dir. Erich von Stroheim cin. Gordon Pollock, Paul Ivano scr. Erich von Stroheim, based on his story *The Swamp* com. Adolf Tandler des. Harold Miles pla. Gloria Swanson, Walter Byron, Seena Owen, Sidney Bracey, William von Brincken, Sylvia Ashton, Tully Marshall pro. Joseph Kennedy/Gloria Swanson p.c. United Artists (unfinished; 10 reels of the planned 25 produced; edited to 8-reel version for Gloria Swanson with an ending filmed by Irving Thalberg)

The Red Badge of Courage
1951
dir. John Huston cin. Harold Rosson edi. Ben Lewis scr. John Huston, based on an adaptation by Albert Band of Stephen Crane's novel *The Red Badge of Courage* des. Cedric Gibbons, Hans Peter pla. Audie Murphy, Bill Mauldin, Douglas Dick, Royal Dano pro. Gottfried Reinhardt p.c. MGM

Red Desert (Deserto Rosso)
1964
dir. Michelangelo Antonioni cin. Carlo Di Palma edi. Eraldo Da Roma (film), Claudio Maielli and Renato Cadveri (sound) scr. Michelangelo Antonioni, Tonino Guerra com. Giovanni Fusco, Vittorio Gelmetti des. Piero Poletto pla. Monica Vitti, Richard Harris, Carlo Chionetti, Xenia Valderi, Valerio Bartoleschi, Rita Renoir, Aldo Grotti, Giuliano Missirini, Lili Rheims, Valerio Bartoleschi, Emanuela Paolo Carboni pro. Antonio Cervi p.c. Film Duemila-Cinematografica Federiz (Rome), Francoriz (Paris)

Red Psalm (Meg Ker a Nep)
1972
dir. Miklos Jancsō cin. János Kende edi. Zoltan Farikas scr. Gyula Hernádi com. "History" and "Always Along," Tamas Cseh, with lyrics by Céza Bereményi; additional music compiled by Ferenc Sebo cho. Ferenc Pesovar; children's dances by Sandor Pécsi des. Tamás Banovich rec. Gyorgy Pinter pla. Ersi Cserhalmi, Ilona Gurnik, Zsuzsa Ferdinándy, Lajos Balázsovits, Bertalan Solti, János Koltai, István Bujor, Péter Haumann, Mark Zala, Gyula Piróth, András Szigeti; singers: Tamás Cseh, Ages Lipták, Ferenc Sebo pro. Ottó Föld p.c. Studio #1, Hungarian Film Production Company

Red Shoes
1948
dir. Michael Powell cin. Jack Cardiff scr. Emeric Pressburger and Keith Winter, from a story by Hans Christian Andersen mus. Brian Easdale cho. Robert Helpmann des. Hein Heckroth pla. Anton Walbrook, Marius Goring, Moira Shearer, Robert Helpmann, Leonide Massine, Albert Basserman, Ludmilla Tcherina, Esmond Knight, Irene Browne, Austin Trevor, Marcel Poncin, Jerry Verno pro. Emeric Pressburger p.c. Archers

Romeo and Juliet
1954
dir. Renato Castellani scr. Renato Castellani, based on the play by Shakespeare com. Roman Vlad pla. Lawrence Harvey, Susan Shentall, Sebastian Cabot, Mervyn Johns, Flora Robson pro. Sandro Ghenzi in association with Joseph Janni p.c. Universalcina, S. P. A., Rome/Verona Productions, Ltd., London

Rope
1948
dir. Alfred Hitchcock cin. Joseph Valentine, William V. Skall edi. William H. Ziegler scr. Arthur Laurents, based on the play by Patrick Hamilton as adapted by Hume Cronyn com. Leo F. Forbstein, based on a theme by Poulenc pla. James Stewart, Farley Granger, John Dall, Joan Chandler, Cedric Hardwicke, Constance Collier, Edith Evanson, Douglas Dick, Dick Hogan pro. Sidney Bernstein p.c. Transatlantic Pictures

Le Sang d'un poète (see Blood of a Poet)

The Savage Eye
1959
dir. Ben Maddow, Sidney Meyers, Joseph Strick cin. Jack Couffer, Helen Levitt, Haskell Wexler, Sy Wexler, Joel Coleman scr. Ben Maddow, Sidney Meyers, Joseph Strick com. Leonard Rosenman rec. LeRoy Robbins, Verne Fields pla. Barbara Baxley, Gary Merrill, Herschel Bernardi, Jean Hidey, Elizabeth Zemach pro. Ben Maddow, Sidney Meyers, Joseph Strick

The Seventh Seal (Det Sjunde Inseglet)
1957
dir. Ingmar Bergman cin. Gunnar Fischer edi. Lennart Wallén scr. Ingmar Bergman com. Erik Nordgren cho. Else Fischer des. P. A. Lundgren rec. Aaby Wedin, Lennart Wallén, Evald Andersson pla. Gunnar Björnstrand, Max von Sydow, Bibi Andersson, Bengt Ekerot, Nils Poppe, Inga Gill, Maud Hansson, Bertil Anderberg, Anders Ek, Gunnar Olsson, Erik Strandmark, Lars Lind, Inga Landgré, Gunnel Lindblom, Ake Fridell, Gudrun Brost, Ulf Johansson pro. Allan Ekelund p.c. Svensk Filmindustri

The Shame (Skammen)
1968
dir. Ingmar Bergman **cin.** Sven Nykvist **edi.** Ulla Ryghe **scr.** Ingmar Bergman **pla.** Liv Ullmann, Max von Sydow, Gunnar Björnstrand, Sigge Fürst, Barbro Hiort af Ornäs, Håkan Jahnberg, Ingvar Kjellson, Willy Peters, Ulf Johansson, Axel Dahlberg **pro.** Lars-Owe Carlberg **p.c.** Svensk Filmindustri

Ship to the Indies (Skepp till Indialand)
1947
dir. Ingmar Bergman **cin.** Göran Strindberg **edi.** Tage Holmberg **scr.** Ingmar Bergman, from a play by Martin Söderhjelm **com.** Erland von Koch **des.** P. A. Lundgren **pla.** Holger Löwenadler, Birger Malmsten, Gertrud Fridh, Naemi Briese, Anna Lindahl, Hjördis Pettersson, **pro.** Lorens Marstedt **p.c.** Sveriges Folkbiografer

The Silence (Tystnaden)
1963
dir. Ingmar Bergman **cin.** Sven Nykvist **edi.** Ulla Ryghe **scr.** Ingmar Bergman **com.** Bo Nilsson **des.** P. A. Lundgren **pla.** Ingrid Thulin, Gunnel Lindblom, Jörgen Lindström, Hakan Jahnberg, Birger Malmsten **pro.** Lars-Owe Carlberg **p.c.** Svensk Filmindustri

Sleep 1963
dir. Andy Warhol

Smiles of a Summer Night (Sommarnattens Leende)
1955
dir. Ingmar Bergman **cin.** Gunnar Fischer **edi.** Oscar Rosander **scr.** Ingmar Bergman **com.** Erik Nordgren **rec.** P. O. Pettersson **des.** P. A. Lundgren **pla.** Ulla Jacobsson, Eva Dahlbeck, Margit Carlquist, Harriet Andersson, Gunnar Björnstrand, Naima Wifstrand, Jarl Kulle, Åke Fridell, Björn Bjelvenstam, Jullan Kindahl, Gull Natorp **pro.** Allan Ekelund **p.c.** Svensk Filmindustri

The Spanish Earth
1937
dir. Joris Ivens **cin.** John Fernhout and Joris Ivens **edi.** Helen van Dongen **scr.** Lillian Hellman, John Dos Passos, Archibald MacLeish, narration by Ernest Hemingway **com.** Virgil Thomson, Mark Blitzstein **rec.** Irving Reis **pla.** Ernest Hemingway (narrator) **p.c.** Contemporary Historians, U.S.A.

Strike (Stachka)
1925
dir. Sergei Eisenstein **cin.** Eduard Tisse, Vassili Khvatov **scr.** Proletkult Collective **des.** Vassili Rakhals **pla.** I. Kuvki, Alexander Antonov, Grigori Alexandrov, Mikhail Gomorov, Jay Leyda, Judith Glizer, I. Ivanov, Boris Yurtsev, V. Yankova **p.c.** Goskino and Proletkult, Moscow

Summer Interlude (see Illicit Interlude)

Summer with Monika (see Monika)

Sunrise: A Song of Two Humans
1927
dir. F. W. Murnau **cin.** Charles Rosher, Karl Struss **edi.** Katherine Hilliker, H. H. Caldwell **scr.** Carl Mayer, from Hermann Sudermann's novelette *A Trip to Tilsit* **com.** Hugo Riesenfeld **des.** Rochus Gliese **pla.** Janet Gaynor, George O'Brien, Margaret Livingston **p.c.** Fox Film Corporation

Ten Days That Shook the World (Oktiabr)
1928
dir. Sergei Eisenstein, Grigori Alexandrov **cin.** Eduard Tisse, V. Popov **edi.** Sergei Eisenstein with V. Popov **scr.** Sergei Eisenstein, Grigori Alexandrov **des.** Kovriguin **pla.** Nikandrov, N. Popov, Boris Livanov, Eduard Tisse **p.c.** Sovkino, Moscow

The Thomas Crown Affair
1968
dir. Norman Jewison **cin.** Haskell Wexler **scr.** Alan Trustman **com.** Michel Legrand **pla.** Steve McQueen, Faye Dunaway, Paul Burke **p.c.** United Artists

Three Strange Loves
(Thirst; Törst)
1949
dir. Ingmar Bergman **cin.** Gunnar Fischer **edi.** Oscar Rosander **scr.** Herbert Grevenius, based on the novel by Birgit Tengroth **com.** Erik Nordgren **des.** Nils Svenwall **pla.** Eva Henning, Birger Malmsten, Birgit Tengroth, Hasse Ekman, Mimi Nelson, Bengt Eklund, Naima Wifstrand **pro.** Helge Hagerman **p.c.** Svensk Filmindustri

Through a Glass Darkly
(Såsom i en Spegel)
1961
dir. Ingmar Bergman **cin.** Sven Nykvist **edi.** Ulla Ryghe **scr.** Ingmar Bergman **des.** P. A. Lundgren **pla.** Harriet Andersson, Gunnar Björnstrand, Max von Sydow, Lars Passgard **pro.** Allan Ekelund **p.c.** Svensk Filmindustri

The Train
1964
dir. John Frankenheimer **cin.** Jean Tournier, Walter Wottitz **edi.** David Bretherton and Gabriel Rongier (film), Joseph de Bretagne (sound) **scr.** Franklin Coen, Frank Davis, Walter Bernstein, based on Rose Valland's novel *Le Front de l'Art* **com.** Maurice Jarre **des.** Willy Holt **spe.** Lee Zavitz **pla.** Burt Lancaster, Paul Scofield, Jeanne Moreau **pro.** Jules Bricken **p.c.** United Artists-Ariane-Dear Films

Triumph of the Will (Triumph des Willens)
1936
dir. Leni Riefenstahl **cin.** Sepp Allgeier, Karl Attenberger, Werner Buhne **edi.** Leni Riefenstahl **com.** Herbert Windt **pro.** Leni Riefenstahl **p.c.** Leni Riefenstahl/N.S.D.A.P.

Twilight of a Clown (see The Naked Night)

2001: A Space Odyssey
1970
dir. Stanley Kubrick **cin.** Geoffrey Unsworth, John Alcott **edi.** Ray Lovejoy (film), Winston Ryder (sound) **scr.** Stanley Kubrick and Arthur C. Clarke, based on the latter's story *The Sentinel*; scientific consultant, Frederick I. Ordway III **rec.** A. W. Watkins **des.** Tony Masters, Harry Lange, Ernest Archer; John Hoesli, art director **spe.** Stanley Kubrick, Wally Veevers, Douglas Trumbull, Con Pederson, Tom Howard **pla.** Keir Dullea, Gary Lockwood, William Sylvester, Daniel Richter, Leonard Rossiter, Margaret Tyzack, Robert Beatty, Sean Sullivan, Douglas Rain **pro.** Stanley Kubrick **p.c.** MGM

Under the Roofs of Paris (Sous les toits de Paris)
1930
dir. René Clair **cin.** Georges Périnal, Georges Raulet **edi.** René Le Henoff (sound) **scr.** René Clair **mus.** Armand Bernard **com.** Raoul Moretti, R. Nazelles (theme song) **des.** Lazare Meerson **rec.** Hermann Storr, W. Morhenn **pla.** Albert Préjean, Pola Illery, Gaston Modot, Edmond Gréville, Bill Blockett, Paul Olivier, Aimos, Jane Pierson **pro.** Frank Clifford **p.c.** Films-Sonores-Tobis

The Virgin Spring (Jungfrukällan)
1960
dir. Ingmar Bergman **cin.** Sven Nykvist **edi.** Oscar Rosander **scr.** Ulla Isaksson **com.** Erik Nordgren **des.** P. A. Lundgren **pla.** Max von Sydow, Birgitta Valberg, Gunnel Lindblom, Birgitta Pettersson, Axel Düberg, Tor Isedal, Allan Edwall, Ove Porath, Axel Slangus, Gudrun Brost, Oscar Ljung, Tor Borong, Leif Forstenberg **p.c.** Svensk Filmindustri

Viridiana
1961
dir. Luis Buñuel **cin.** José Agayo **edi.** Pedro del Rey **scr.** Luis Buñuel, Julio Alejandro **des.** Francisco Canet **pla.** Silvia Pinal, Francisco Rabal, Fernando Rey, Victoria Zinny, Margarita Lozano, Teresa Rabal **pro.** Gustavo Alatriste, R. Muñoz Suay **p.c.** Mexico and Uninci Films 59, Madrid

Visions of Eight
1973
dir. Milos Forman (The Hardest), Kon Ichikawa (The Fastest), Claude Lelouch (The Losers), Yurii Ozerov (The Beginning), Arthur Penn (The Highest), Michel Pfleghar (The Women), Arthur Schlesinger (The Longest), Mai Zetterling (The Strongest) **pro.** David Wolper

Vivre sa vie (see My Life to Live)

Walking Down Broadway
1933
dir. Erich von Stroheim **cin.** James Wong Howe **edi.** Unfinished and unedited by Erich von Stroheim; new scenes directed by Alfred Werker and Edwin Burke, edited by Frank E. Hull, and called *Hello, Sister!* **scr.** Erich von Stroheim and Leonard Spiegelgass, after the novel by Dawn Powell **pla.** Boots Mallory, Zasu Pitts, James Dunn, Terrance Ray, Minna Gombell **pro.** Winfield Sheehan **p.c.** Fox Film Corporation

Wedding March
1928
dir. Erich von Stroheim **cin.** Ben Reynolds, Hal Mohr **edi.** Erich von Stroheim, Denise Vernac, and Renée Lichtig in 1954 for the Cinémathèque Française **scr.** Erich von Stroheim **com.** L. Zamecnik **des.** Captain Richard Day **pla.** Erich von Stroheim, George Fawcett, Maud George, Fay Wray, Cesare Gravina, Dale Fuller, Hughie Mack, Matthew Betz, George Nichols, Zasu Pitts, Anton Wawerka, Sidney Bracey, Danny Hoy, Lulee Wilse **p.c.** Paramount Famous Lasky Corporation

Weekend
1967
dir. Jean-Luc Godard **cin.** Raoul Coutard **edi.** Agnès Guillemot **scr.** Jean-Luc Godard **mus.** Antoine Duhamel **pla.** Jean-Pierre Léaud, Mireille Darc, Jean Yanne, Jean-Pierre Kalfon **pro.** Ralph Baum, Philippe Senné **p.c.** Comacico/Les Films Copernic/Lira Films (Paris), Ascot Cineraid (Rome)

The Wild Child (L'Enfant sauvage)
1970
dir. François Truffaut **cin.** Nestor Almendros **edi.** Agnès Guillemot **scr.** François Truffaut and Jean Gruault, based on the book *Mémoire et rapport sur Victor de l'Aveyron* by Jean Itard **des.** Jean Mandaroux **rec.** René Levert **pla.** Jean-Pierre Cargol, Paul Ville, François Truffaut, Françoise Seigner, Claude Miler, Annie Miler **pro.** Marcel Berbert **p.c.** Les Films du Carrosse/Artistes Associés

The Wild One
1954
dir. Laslo Benedek **cin.** Hal Mohr **edi.** Al Clark **scr.** John Paxton, based on Frank Rooney's *The Cyclists' Raid* **com.** Leith Stevens **des.** Walter Holscher **pla.** Marlon Brando, Mary Murphy, Robert Keith, Lee Marvin, J. C. Flippen **pro.** Stanley Kramer **p.c.** Columbia

Wild Strawberries (Smultronstället)
1957
dir. Ingmar Bergman cin. Gunnar Fischer edi. Oscar Rosander scr. Ingmar Bergman com. Erik Nordgren mus. E. Eckert-Lundin rec. Aaby Wedin, Lennart Wallén des. Gittan Gustafsson pla. Victor Sjöström, Bibi Andersson, Ingrid Thulin, Gunnar Björnstrand, Jullan Kindahl, Folke Sundquist, Björn Bjelvenstam, Naima Wifstrand, Gunnel Broström, Gertrud Fridh, Åke Fridell, Sif Ruud, Gunnar Sjöberg, Max von Sydow, Yngve Nordwall, Per Sjöstrand, Gio Petré, Gunnel Lindblom, Maud Hansson, Anne-Mari Wiman, Eva Norée, Lena Bergman, Monica Ehrling, Per Skogsberg, Göran Lundquist, Prof. Sigge Wulff pro. Allan Ekelund p.c. Svensk Filmindustri

Winter Light (Nattvardsgästerna)
1962
dir. Ingmar Bergman cin. Sven Nykvist, Rolf Holmqvist, Peter Wester edi. Ulla Ryghe scr. Ingmar Bergman des. P. A. Lundgren rec. Stig Flodin, Brian Wikstrom, Evald Andersson pla. Ingrid Thulin, Gunnar Björnstrand, Max von Sydow, Gunnel Lindblom, Allan Edwall, Olof Thunberg, Elsa Ebbesen, Tor Borong, Bertha Sannell, Helena Palmgren, Kolbjörn Knudsen pro. Lars-Owe Carlberg p.c. Svensk Filmindustri

**A Woman Is a Woman
(Une Femme est une femme)**
1961
dir. Jean-Luc Godard cin. Raoul Coutard edi. Agnès Guillemot, Lila Herman scr. Jean-Luc Godard, based on an idea by Geneviève Cluny com. Michel Legrand rec. Guy Villette des. Bernard Evein pla. Anna Karina, Jean-Paul Belmondo, Jean-Claude Brialy pro. Georges de Beauregard, Carlo Ponti p.c. Rome-Paris Films

SHORT FILMS

Abstract in Concrete
1954
Conceived and produced by John Arvonio

An Andalusian Dog (Un Chien andalou)
1928
dir. Luis Buñuel, Salvador Dali cin. Albert Dubergen edi. Luis Buñuel scr. Luis Buñuel, Salvador Dali des. Schilzneck pla. Pierre Batcheff, Simone Mareuil, Jaime Miravilles, Salvador Dali, Luis Buñuel pro. Luis Buñuel, Salvador Dali

Anemic Cinema
1926
dir. Marcel Duchamp cin. Man Ray scr. Marcel Duchamp, Marc Allegret

Arnulf Rainer
1960
Conceived and produced by Peter Kubelka

The Arrival of a Train (L'Arrivée d'un train)
1895
Filmed by Louis Lumière

L'Arroseur arrosé
1895
Filmed by Louis Lumière

**The Automatic Moving Company
(Mobilier fidèle)**
1910
dir. Emile Cohl p.c. Gaumont

Ballet mécanique
1924
dir. Fernand Léger cin. Dudley Murphy, Man Ray scr. Fernand Léger com. George Antheil des. Fernand Léger pla. Kiki p.c. Synchro-Ciné

The Battle of San Pietro (see San Pietro)

Begone Dull Care
1949
dir. Norman McLaren ani. Norman McLaren and Evelyn Lambart com. Oscar Peterson Trio p.c. National Film Board of Canada

The Blood of the Beasts (Le Sang des bêtes)
1949
dir. Georges Franju cin. Marcel Fradetal scr. Georges Franju; commentary by Jean Painlevé pla. Narration by Nicole Ladmiral and Georges Hubert mus. Joseph Kosma ("La Mer" sung by Charles Trenet) p.c. Forces et Voix de la France

Blow Job
1964
Produced by Andy Warhol

Le Catch (see Wrestling)

Un Chien andalou (see An Andalusian Dog)

Christmas on Earth
1963
Conceived and produced by Barbara Rubin

Colour Box
1935
Conceived, produced, and animated by Len Lye **p.c.** The British General Post Office

Corn and the Origins of Settled Life in Meso America
1961
dir. Jack Churchill **cin.** Abraham Merechnik, Adam Gifford **pla.** Dr. Paul Mengelsdorf, Dr. Richard MacNeish, Dr. Michael Cox **rel.** Educational Services, Inc.

Cosmic Ray
1961
Conceived and produced by Bruce Conner, with music ("What'd I Say?") by Ray Charles.

The Critic
1963
dir. Ernest Pintoff **ani.** Bob Heath **des.** Bob Heath **pla.** Mel Brooks (narrator) **pro.** Ernest Pintoff **p.c.** Pintoff-Crossbows

The Day Manolete Was Killed
1957
dir. Barnaby Conrad and Dave Butler **pho.** Joseph Dieves **edi.** Richard Fowler (film), Forrest Boothe (sound) **scr.** Barnaby Conrad **com.** Barnaby Conrad (performed by Juan Buckingham) **des.** Early Henry **spe.** Lela Smith **pla.** Barnaby Conrad (narrator) **p.c.** W. A. Palmer Films, Inc., San Francisco

Daybreak
1957
Conceived and produced by Stan Brakhage

The Demolition of a Wall (La Démolition d'un mur)
1895
Filmed by Louis Lumière

Desistfilm
1954
Conceived and produced by Stan Brakhage

La Divina
1969
Conceived and directed by John A. O'Conner **p.c.** University of Southern California Cinema

The Dream of a Rarebit Fiend
1906
dir. Edwin S. Porter **p.c.** The Edison Company

The Dream of the Wild Horses
(Le Rêve des chevaux sauvages)
1960
dir. Denys Colomb de Daunant **cin.** Denys Colomb de

Daunant **edi.** Claude Guillemot **com.** Jacques Laspy **p.c.** Simpri-Guy Perol

Edvard Munch: I Graphics, Watercolors, Drawings,
and Sculpture
II Paintings, Prints
1967
dir. Clifford B. West **cin.** Clifford B. West **scr.** Clifford B. West; narration by Berate E. Tor Jusen and Gilian Ford Shallcross **com.** Robert Jager **mus.** Robert Jager **pla.** E. G. Burroughs, narrator **pro.** Clifford B. West **p.c.** O.I.P. Films

Emak Bakia
1927
Conceived and produced by Man Ray

Entr'acte
1923–24
dir. René Clair **cin.** Jimmy Berliet **scr.** Francis Picabia and René Clair **com.** Erik Satie (music to accompany the silent film) **pla.** Man Ray, Jean Borlin, Erik Satie, Inge Fries, Francis Picabia, Marcel Duchamp **p.c.** Ballets Suédois de Rolf de Maré

Feeding Baby
(Le Dejeuner de bébé)
1895
Filmed by Louis Lumière

Fiddle-De-Dee
1947
Conceived and animated by Norman McLaren **p.c.** The National Film Board of Canada

Film Studies: Study 5 (1928)
Study 6 (1929)
Study 7 (1929)
Study 8 (1930)
Conceived and animated by Oskar Fischinger

The Flicker
1966
Conceived and produced by Tony Conrad

Football as It Is Played Today
1962
dir. Joseph Anderson **cin.** Staff **edi.** Richard B. Long **scr.** Joseph Anderson **rec.** Bill Chance **p.c.** Ohio State University Department of Photography and Cinema

Glimpses of the U.S.A.
1959
Conceived and produced by Charles and Ray Eames for exhibition at the Moscow World's Fair

Good Night, Socrates (Kali Nihta, Socrates)
1962
dir. Stuart Hagman and Maria Moraites scr. Mary Strachen, written by Maria Moraites com. Moyneen Brown rec. James F. Bourgois, John Burckhardt, Barnett Weiss, with Joel Katz and Arnold Rosenthal des. Maria Moraites pla. Charles Mitchell, Richard Sterne, John Coleris, Maria Moraites pro. Maria Moraites p.c. A Maria-Stuart Production, produced at Northwestern University with assistance from the North Shore Film Society, Nicholas Philippides, and Nicholas Elias

Granton Trawler
1934
dir. Edgar Anstey cin. John Grierson rec. E. A. Pawley pro. John Grierson p.c. Empire Marketing Board, London

The Great Train Robbery
1903
dir. Edwin S. Porter pla. G. M. (Bronco Billy) Anderson, George Barnes, Marie Murray, Frank Hanaway p.c. The Edison Company

Haircut
1964
Produced by Andy Warhol

Happy Birthday, Felicia
1968
dir. Jeff Dell cin. Susan Pot, John Steinburg edi. Jeff Dell p.c. Anifilm Studios

The House of Science
1962
Conceived and produced by Charles and Ray Eames for the Science Pavilion of the Seattle World's Fair, with music by Elmer Bernstein.

H_2O
1929
Conceived and produced by Ralph Steiner

Let There Be Light
1946
dir. John Huston cin. Stanley Cortez pla. John Huston (narrator) p.c. U.S. War Department

Lichtspiele
1925–30
Conceived and produced by László Moholy-Nagy

The Life of an American Fireman
1903
dir. Edwin S. Porter pla. Arthur White, Vivian Vaughan p.c. The Edison Company

Listen to Britain
1942
dir. Humphrey Jennings, Stewart McAllister cin. H. E. Fowle rec. Ken Cameron pla. Leonard Brockington, narrator of foreword; Myra Hess in concert pro. Ian Dalrymple p.c. The Crown Film Unit

The Lonedale Operator
1911
dir. D. W. Griffith cin. G. W. Bitzer edi. D. W. Griffith pla. Blanche Sweet, Frank Grandin, Wilfred Lucas p.c. Biograph

Lonely Boy
1962
dir. Wolf Koenig and Roman Kroiter edi. John Spotton, Guy L. Coté (film); Kathleen Shannon (sound) rec. Marcel Carrière, Ron Alexander pro. Roman Kroiter pla. Paul Anka p.c. National Film Board of Canada

La Lotta (see Wrestling)

Loving
1956
Conceived and produced by Stan Brakhage

Manhatta
1921
Conceived and produced by Charles Sheeler and Paul Strand

March of Time
Newsreel, documentary, reportage, and commentary produced by Louis de Rochemont for *Time* and *Fortune* Magazines once a month from the spring of 1935 to the fall of 1951

Mechanics of Love
1955
Conceived and directed by Willard Maas and Ben Moore, with a zither score by John Gruen

Meshes of the Afternoon
1943
dir. Maya Deren cin. Alexander Hammid com. Teiji Ito pla. Maya Deren and Alexander Hammid

The Mischief Makers (Les Mistons)
1958
dir. François Truffaut cin. Jean Maligo edi. Cécile Decugis scr. François Truffaut, based on a short story *Virginales* by Maurice Pons com. Maurice Le Roux pla. Bernadette Lafont, Gérard Blain; narration by Michele François p.c. Les Films du Carrosse

A Movie
1958
Conceived and produced by Bruce Conner

My Own Yard to Play In
1959
dir. Phil Lerner p.c. and edi. Patricia Jaffe, Larry Silk, John Schutz, Peggy Lawson rec. Tony Schwartz

A New Way of Gravure:
Stanley William Hayter at Work in Atelier 17
1950
cin. Jess Paley, aided by Edward Countey scr. commentary by Stanley William Hayter p.c. A. F. Films

Night and Fog
(Nuit et brouillard)
1955
dir. Alain Resnais cin. Ghislain Cloquet, Sacha Vierny edi. Henri Colpi (sound), Jasmine Chasney scr. Jean Cayrol; Olga Wormser (historical consultant) com. Henri Michel, Hanns Eisler mus. Georges Delerue spe. Henry Ferrand pla. Michel Bouquet (narrator) pro. S. Halfron, A. Dauman, Ph. Lifchiz p.c. Como-Films, Argos-Films, Cocinor

O
1968
Conceived and produced by Tom Palazzolo with music, "Visage," composed by Luciano Berio and sung by Cathy Bergerian

Oh Dem Watermelons
(An Interlude for
the San Francisco Mime Group's "Minstrel Show")
1965
dir. Robert Nelson cin. Robert Nelson com. Steve Reich pla. Fifteen watermelons p.c. San Francisco Mime Group

Orange and Blue
1962
Conceived and produced by Peter and Clare Chermayeff, with music by Joseph Raposo

Ouverture
(Overture; Nyitany)
1965
dir. János Vádasz cin. János Vádasz spe. Dr. Márta Erdélyi; Dr. Sándor Braun (technical advisor) p.c. Studios Documentaires et de Vulgarisation Scientifique/Mafilm

Penpoint Percussion
1951
Conceived and animated by Norman McLaren p.c. National Film Board of Canada

Poem 8
1932
Conceived and produced by Emlen Etting

Praise the Sea: A Portrait of the Netherlands
1961
dir. Herman van der Horst

Prelude: Dog Star Man
1961
Conceived and produced by Stan Brakhage

Rain (Regen)
1929
dir. Joris Ivens, Mannus Franken cin. Joris Ivens edi. Joris Ivens mus. 1931 music by Lou Lichtveld added by Helen van Dongen for Tobis-Film-Sonores (Paris); in 1931 music by Hanns Eisler added in U.S. scr. Mannus Franken p.c. Liga Films/CAPI

Ray Gun Virus
1966
Conceived and produced by Paul Sharits

The Red Balloon (Le Ballon rouge)
1956
dir. Albert Lamorisse cin. Edmond Séchan edi. Pierre Gillette scr. Albert Lamorisse rec. Pierre Vuillemin pla. Pascal and Sabine Lamorisse pro. Michel Pezin p.c. Films Montsouris

Relativity
1966
Conceived and produced by Ed Emshwiller

Rhythmus 21
1921
Conceived and produced by Hans Richter

The River
1937
dir. Pare Lorentz cin. Willard van Dyke, Stacey Woodward, Floyd Crosby scr. Pare Lorentz com. Virgil Thompson p.c. Farm Security Administration, U.S. Department of Agriculture

The Rose and the Mignonette
(La Rose et le réséda)
French version 1945; English version 1949
dir. André Michel cin. Maurice Barry le Chevalier scr. based on a poem by Louis Aragon translated by Stephen Spender com. Georges Auric, from a Bach Chorale pla. Emlyn Williams (English narrator); Jean-Louis Barrault (French narrator) p.c. Coopérative Générale du Cinéma Français

San Pietro
1944
dir. John Huston cin. Captain Jules Buck and Signal Corps cameramen pla. General Mark Clark (narrator of prologue); John Huston (narrator) mus. traditional, performed by the Army Air Force Orchestra, St. Brendan's Boys Choir, and the Mormon Tabernacle Choir p.c. The Army Pictorial Service

A Scarey Time
1960
Conceived and produced by Shirley Clarke p.c. UNICEF

Scorpio Rising
1963
dir. Kenneth Anger cin. Kenneth Anger edi. Kenneth Anger scr. Kenneth Anger com. various pop song writers pla. Bruce Byron, Johnny Sapienza, Frank Carifi, John Palone, Ernie Allo, Barry Rubin, Steve Crandell

7362
1967
dir. Patrick O'Neill cin. Patrick O'Neill edi. Patrick O'Neill com. Joseph Byrd, Michael Moore rec. Gary Margoulis

The Song of Ceylon
1934
dir. Basil Wright cin. Basil Wright scr. Basil Wright; spoken commentary written by Robert Knox in 1680 com. Walter Leigh rec. E. A. Pawley pla. Lionel Wendt, narrator pro. John Grierson p.c. The Ceylon Tea Propaganda Board

Sunday
1961
dir. Dan Drasin cin. Dan Drasin, Frances Stillman, Gerald McDermott, Frank Simon rec. Howard Milkin mus. Dave Cohen, Jan Dorfman pro. Dan Drasin

Think
1964
Conceived and produced by Charles and Ray Eames for the IBM Pavilion at the New York World's Fair. Also produced in a single film version as *View from the People Wall*, with music by Elmer Bernstein.

Third Eye Butterfly
1968
Conceived and produced by Storm de Hirsch

The Thunderbolts of Jupiter (Le Tonnerre de Jupitre)
1901
dir. Georges Méliès

Überfall
1929
dir. Ernö Metzner cin. Eduard von Borsody scr. Ernö Metzner and Grace Chiang des. Ernö Metzner pla. Heinrich Gotho, Sybille Schmitz, Eva Schmidt-Kayser, Alfred Loretto, Hans Ruys, Tibot Halmy, Imre Raday, Hans Casparius, Rudolf Hiberg, Neinrich Falconi, Ernö Metzner

Uncle Tom's Cabin
1903
dir. Edwin S. Porter scr. Edwin S. Porter, based on Harriet Beecher Stowe's novel p.c. The Edison Company

Wavelength
1967
Conceived and produced by Michael Snow

We Are Young
1967
Conceived and directed by Francis Thompson (for Pacific-Cominco, Expo '67)

The Wonder Ring
1955
Filmed and produced by Stan Brakhage, on a theme by Joseph Cornell

Works of Calder
1950
dir. Herbert Matter cin. Herbert Matter scr. narrative by John Latouche com. John Cage pla. Burgess Meredith (narrator) pro. Burgess Meredith

Wrestling
1961
Conceived and produced by Michel Brault, Marcel Carrière, Claude Fournier, and Claude Jutra pro. Jacques Bobet p.c. National Film Board of Canada

Yantra
1950–60
Conceived and produced by James Whitney

Zero for Conduct
(Zéro de conduite)
1933
dir. Jean Vigo cin. Boris Kaufman, Louis Berger edi. Jean Vigo scr. Jean Vigo com. Maurice Jaubert, songs by Charles Goldblatt des. Jean Vigo, Henri Storck, Boris Kaufman pla. Louis Lefèvre, Gilbert Pruchon, Constantin Kelber, Gérard de Bédarieux, Jean Dasté, Robert le Flon, Delphin, Blanchar, Léon Larive, Du Verron pro. J.-L. Nounez p.c. Arqui-Films

Bibliography

This bibliography is not intended to be comprehensive or exhaustive,
but rather to provide the student with suggestions for further exploration
of material discussed or mentioned in the text.
Periodical literature, except when it appears in collections,
compilations, and bibliographies, has not been included.
Readers interested in contemporary reviews should consult
items listed here and in The Reader's Guide.
With a few quite obvious exceptions, all books are written in English
or have been published in English translation.
Since some books inevitably do not fit nicely into a single category,
they have been introduced under the heading that seems most useful.

GENERAL INTRODUCTIONS

Arnheim, Rudolf. *Film as Art.* Berkeley and Los Angeles: U. of California, 1957.

Balázs, Béla. *Theory of the Film: Character and Growth of a New Art.* New York: Dover, 1971.

Bazin, André. *What Is Cinema?* Berkeley and Los Angeles: U. of California, 1967.

Benoit-Lévy, Jean. *The Art of the Motion Picture.* New York: Coward-McCann, 1946.

Bobker, Lee. *Elements of Film.* New York: Harcourt, Brace, 1969.

Casty, Alan. *The Dramatic Art of the Film.* New York: Harper and Row, 1971.

Gessner, Robert. *The Moving Image.* New York: Dutton, 1968.

Jacobs, Lewis, ed. *Introduction to the Art of the Movies.* New York: Noonday, 1960.

———. *The Movies as Medium.* New York: Farrar, Stauss, 1970.

Lawson, John Howard. *Film: The Creative Process.* New York: Hill and Wang, 1967.

Lindgren, Ernest. *The Art of the Film.* London: Allen and Unwin, 1948.

Lindsay, Vachel. *The Art of the Moving Picture.* 1915. Reprint, New York: Liveright, 1970.

Manvell, Roger. *Film.* Harmondsworth, Eng.: Penguin, 1950.

Montagu, Ivor. *Film World: A Guide to Cinema.* Baltimore: Penguin, 1964.

Pudovkin, V. I. *Film Technique and Film Acting.* New York: Crown, 1949.

Spottiswoode, Raymond. *A Grammar of the Film.* Berkeley and Los Angeles: U. of California, 1950.

Stephenson, Ralph, and Jean R. Debrix. *The Cinema as Art.* Baltimore: Penguin, 1965.

SOME THEORETICAL APPROACHES

Deren, Maya. *An Anagram of Ideas on Art, Form and Film.* Yonkers, N.Y.: Alicat Book Shop, 1946.

Eisenstein, Sergei M. *Film Form.* New York: Harcourt, Brace, 1949.

———. *The Film Sense.* New York: Harcourt, Brace, 1942.

Kinder, Marsha, and Bervele Houston. *Close-Up.* New York: Harcourt, Brace, 1972.

Kracauer, Siegfried. *Theory of Film: The Redemption of Physical Reality.* New York: Oxford U., 1960.

MacCann, Richard Dyer, ed. *Film: A Montage of Theories.* New York: Dutton, 1966.

Nilsen, Vladimir S. *The Cinema as a Graphic Art.* New York: Hill and Wang, 1959.

Solomon, Stanley. *The Film Idea.* New York: Harcourt, Brace, 1972.

Youngblood, Gene. *Expanded Cinema.* New York: Dutton, 1970.

TECHNICAL ASPECTS
General

Happe, L. Bernard. *Basic Motion Picture Technology.* New York: Hastings, 1971.

Herman, Lewis. *A Practical Manual of Screen Playwriting for Theater and Television Films.* 1963. Reprint, Cleveland and New York: World, 1970.

Malkiewicz, J. Kris, and Robert E. Rogers. *Cinematography.* New York: Van Nostrand, 1973.

Pincus, Edward. *Guide to Film Making.* New York: New American Library, 1969.

Roberts, Kenneth H., and Win Sharples, Jr. *A Primer for Film-Making.* New York: Pegasus, 1971.

Smallman, Kirk. *Creative Film-Making.* New York: Macmillan, 1969.

Spottiswoode, Raymond. *Film and Its Techniques.* Berkeley and Los Angeles: U. of California, 1959.

Wheeler, Leslie. *Principles of Cinematography: A Handbook of Motion Picture Technology.* 1954. Rev. ed. Hastings-on-Hudson, N.Y.: Morgan, 1969.

Direction

Marner, Terence St. John. *Directing Motion Pictures.* Cranbury, N.J.: A. S. Barnes, 1972.

See also Directors and Directing.

Use of the Camera

Campbell, Russell, ed. *Photographic Theory for the Motion Picture Cameraman.* Cranbury, N.J.: A. S. Barnes, 1970.

———. *Practical Motion Picture Photography.* Cranbury, N.J.: A. S. Barnes, 1970.

Douto, H. Mario Raimondo. *The Technique of the Motion Picture Camera.* London and New York: Focal, Hastings, 1967.

Color

Society of Motion Picture and Television Engineers. *Elements of Color in Professional Motion Pictures.* New York: S.M.P. & T.V.E., 1957.

Sound

Eisler, Hanns. *Composing for the Films.* London and New York: Oxford U., 1947.

Huntley, John, and Roger Manvell. *The Technique of Film Music.* London and New York: Focal, Hastings, 1957.

Nisbett, Alec. *The Technique of the Sound Studio.* London and New York: Focal, Hastings, 1972.

Rapée, Erno. *Encyclopedia of Music for Pictures.* 1925. Reprint, New York: Arno, 1970.

———. *Motion Picture Moods for Pianists and Organists.* 1928. Reprint, New York: Arno, 1970.

Special Effects

Bulleid, H. A. V. *Special Effects in Cinematography.* 1954. Reprint, London: Fountain, 1960.

Fielding, Raymond. *The Technique of Special Effects Cinematography.* London and New York: Focal, Hastings, 1968.

Animation

Halas, John, and Roger Manvell. *Design in Motion.* New York: Hastings, 1962.

———. *The Technique of Film Animation.* London and New York: Focal, Hastings, 1959.

Madsen, Roy. *Animated Film: Concepts, Methods and Uses.* New York: International, 1969.

Editing

Burder, John. *The Technique of Editing 16mm Films.* London and New York: Focal, Hastings, 1968.

Reisz, Karel. *The Technique of Film Editing.* 2nd rev. ed. New York: Amphoto, 1968.

Walter, Ernest. *The Technique of the Film Cutting Room.* New York: Hastings, 1969.

HISTORY

General

Bardèche, Maurice, and Robert Brasillach. *The History of Motion Pictures.* New York: Norton, Museum of Modern Art, 1938.

Knight, Arthur. *The Liveliest Art.* New York: Macmillan, 1957.

Macgowan, Kenneth. *Behind the Screen: The History and Techniques of the Motion Picture.* New York: Delacorte, 1965.

Mast, Gerald. *A Short History of the Movies.* Indianapolis: Bobbs-Merrill, 1971.

Rotha, Paul, and Richard Griffith. *The Film Till Now.* London: Spring, 1967.

Sadoul, Georges. *Histoire du cinéma mondial, des origines à nous jours.* Paris: Flammarion, 1961.

———. *Histoire générale du cinéma.* 3 vols. Paris: Denoël, 1947–54.

National and Regional

Anderson, Joseph L., and Donald Richie. *The Japanese Film.* Tokyo and Rutland, Vt.: Tuttle, 1959.

———. *The Japanese Film: Art and Industry.* New York: Grove, 1960.

Armes, Roy. *French Cinema Since 1946.* 2 vols. London and New York: Zwemmer and Barnes, 1966.

Barnouw, Erik, and S. Krishnaswamy. *Indian Film.* New York: Columbia U., 1963.

Bucher, Felix. *Germany.* New York: A. S. Barnes, 1970.

Cowie, Peter. *Sweden, 1 & 2.* London and New York: Zwemmer & Barnes, 1970.

———. *Swedish Cinema.* London and New York: Zwemmer & Barnes, 1966.

Hardy, Forsyth. *Scandinavian Film.* London: Falcon, 1952.

Jacobs, Lewis. *The Rise of the American Film.* 1939. Reprint, New York: Teachers College, 1968.

Landau, Jacob. *Studies in the Arab Theater and Cinema.* Philadelphia: U. of Pennsylvania, 1958.

Leprohon, Pierre. *Italian Cinema.* New York: Praeger, 1972.

Leyda, Jay. *Kino: A History of the Russian and Soviet Film.* London: Allen and Unwin, 1960.

Low, Rachel, and Roger Manvell. *The History of the British Film.* 3 vols. (1896–1906, 1906–14, 1914–18). London: Allen and Unwin, 1948–50.

Malerba, Luigi, and Carmine Siniscalco, eds. *Fifty Years of Italian Cinema.* Rome: Besletti, c. 1955.

Martin, Marcel. *France.* Cranbury, N.J.: A. S. Barnes, 1971.

Mendez-Leite, Fernando. *Historia del cine Español.* Madrid: Ediciones Rialp, 1965.

Rondi, Gian Luigi. *Italian Cinema Today: 1952–1965.* New York: Hill and Wang, 1966.

Sadoul, Georges. *French Film.* London: Falcon, 1953.

Wollenberg, Hans H. *Fifty Years of German Film.* London: Falcon, 1948.

See also Studies of Particular Phases and Studies of Particular Genre.

Studies of Particular Phases

Brownlow, Kevin. *The Parade's Gone By.* New York: Ballantine, 1969.

Cameron, Ian, ed. *Second Wave.* New York: Praeger, 1970.

Ceram, C. W. *Archeology of the Cinema.* New York: Harcourt, Brace, 1965.

Durgnat, Raymond. *Nouvelle Vague: The First Decade.* Loughton, Eng.: Motion, 1963.

Eisner, Lotte. *The Haunted Screen.* Berkeley and Los Angeles: U. of California, 1969.

Graham, Peter, ed. *The New Wave.* Garden City, N.Y.: Doubleday, 1968.

Houston, Penelope. *The Contemporary Cinema*. Baltimore: Penguin, 1963.

Hull, David Stewart. *Film in the Third Reich*. Berkeley and Los Angeles: U. of California, 1969.

Ramsaye, Terry. *A Million and One Nights*. 1926. Reprint, New York: Simon and Schuster, 1964.

Slide, Anthony. *Early American Cinema*. Cranbury, N.J.: A. S. Barnes, 1970.

Studies of Particular Genre

Factual Film

Baddeley, W. Hugh. *The Technique of Documentary Film Production*. New York: Hastings, 1968.

Barsam, Richard M. *Nonfiction Film: A Critical History*. New York: Dutton, 1973.

Issari, M. Ali. *Cinéma Vérité*. East Lansing: Michigan State U., 1971.

Jacobs, Lewis, ed. *The Documentary Tradition from Nanook to Woodstock*. New York: Hopkinson and Blake, 1971.

Leyda, Jay. *Films Beget Films*. New York: Hill and Wang, 1971.

Rotha, Paul. *Documentary Film*. London: Faber, 1952.

———, Sinclair Road, and Richard Griffith. *Documentary Film*. London: Faber, 1966.

Waldron, Gloria. *The Information Film*. New York: Columbia U., 1949.

Fictional Film (Comedy, Musical, Science Fiction, Western)

Baxter, John. *Science Fiction in the Cinema*. Cranbury, N.J.: A. S. Barnes, 1970.

Bluestone, George. *Novels into Film*. Berkeley and Los Angeles: U. of California, 1961.

Fenin, George, and William K. Everson. *The Western from Silents to Cinerama*. New York: Bonanza, 1962.

Gifford, Denis. *The Science Fiction Film*. New York: Dutton, 1971.

Kitses, James. *Horizons West: Studies in Authorship in the Western*. Bloomington: Indiana U., 1970.

Lahue, Kalton C. *Continued Next Week: A History of the Motion Picture Serial*. Norman: U. of Oklahoma, 1964.

———. *The World of Laughter: The Motion Picture Comedy Short, 1910–30*. Norman: U. of Oklahoma, 1966.

McCaffrey, Donald. *Four Great Comedians: Keaton, Chaplin, Lloyd, Langdon*. Cranbury, N.J.: A. S. Barnes, 1968.

McVay, Douglas. *The Musical Film*. Cranbury, N.J.: A. S. Barnes, 1967.

Robinson, David. *The Great Funnies: A History of Film Comedy*. New York: Dutton, 1969.

Solomon, Stanley J. *The Film Idea*. New York: Harcourt, Brace, 1972.

Animation

Stephenson, Ralph. *The Animated Film*. Cranbury, N.J.: A. S. Barnes, 1972.

Avant-Garde, Experimental, Underground, and Independent Film

Manvell, Roger, ed. *Experiment in the Film*. London: Grey Walls, 1949.

Renan, Sheldon. *An Introduction to the American Underground Film*. New York: Dutton, 1967.

Tyler, Parker. *Underground Film: A Critical History*. New York: Grove, 1969.

See also Some Theoretical Approaches.

FILM AND SOCIETY

General

Kracauer, Siegfried. *From Caligari to Hitler: A Psychological Study of the German Film*. Princeton, N.J.: Princeton U., 1947.

MacCann, Richard D. *Film and Society*. New York: Scribner's, 1964.

Manvell, Roger. *The Film and the Public*. Baltimore: Penguin, 1955.

Powdermaker, Hortense. *Hollywood, the Dream Factory*. Boston: Little, Brown, 1950.

Censorship

Carmen, Ira H. *Movies, Censorship and the Law*. Ann Arbor: U. of Michigan, 1966.

Commission on Freedom of the Press. *Freedom of the Movies*. Chicago: U. of Chicago, 1947.

Commission on Obscenity and Pornography. *The Report of the Commission on Obscenity and Pornography*. New York: Bantam, 1970.

Kahn, Gordon. *Hollywood on Trial: The Story of the Ten Who Were Indicted*. New York: Boni & Gaer, 1948.

Koenigil, Mark. *Movies in Society (Sex, Crime and Censorship)*. New York: Speller, 1962.

Randall, Richard S. *Censorship of the Movies*. Madison: U. of Wisconsin, 1968.

Schumach, Murray. *The Face on the Cutting-Room Floor*. New York: Morrow, 1964.

Vizzard, Jack. *See No Evil: Life Inside a Hollywood Censor*. New York: Simon and Schuster, 1970.

FILMMAKERS

General Studies, Collected Essays, and Interviews

American Film Institute. *Dialogue on Film*. Washington, D.C.: The American Film Institute for the Center for Advanced Film Studies (published periodically).

Butler, Ivan. *The Making of Feature Films—A Guide*. Baltimore: Penguin, 1971.

Sherman, Eric, and Martin Rubin. *The Director's Event: Interviews with Five American Film-makers, Budd Boetticher, Peter Bogdanovich, Samuel Fuller, Arthur Penn, Abraham Polonsky*. New York: New American Library, 1969.

Directors and Directing

General Studies

Livingston, Don. *Film and the Director*. Reprint, New York: Capricorn, 1969.

Reynertson, Audrey Joan. *The Work of the Film Director*. New York: Communication Arts, 1970.

Works on Individual Directors

Antonioni

Cameron, Ian, and Robin Wood. *Antonioni*. New York: Praeger, 1969.

Leprohon, Pierre. *Michelangelo Antonioni*. New York: Simon and Schuster, 1963.

Bergman

Donner, Jörn. *The Personal Vision of Ingmar Bergman.* Bloomington: Indiana U., 1964.

Gibson, Arthur. *The Silence of God: A Creative Response to the Films of Ingmar Bergman.* New York: Harper, 1969.

Simon, John. *Ingmar Bergman Directs.* New York: Harcourt, Brace, 1972.

Steene, Birgitta, ed. *Focus on "The Seventh Seal."* Englewood Cliffs, N.J.: Prentice-Hall, 1972.

————. *Ingmar Bergman.* New York: Twayne, 1968.

Wood, Robin. *Ingmar Bergman.* New York: Praeger, 1969.

Bresson

Cameron, Ian, ed. *The Films of Robert Bresson.* New York: Praeger, 1970.

Buñuel

Durgnat, Raymond. *Luis Buñuel.* Berkeley and Los Angeles: U. of California, 1968.

Kyrou, Ado. *Luis Buñuel.* New York: Simon and Schuster, 1963.

Chabrol

Wood, Robin, and Michael Walker. *Claude Chabrol.* New York: Praeger, 1970.

Chaplin

Chaplin, Charles. *My Autobiography.* New York: Simon and Schuster, 1964.

Huff, Theodore. *Charlie Chaplin.* New York: Schuman, 1951.

Quigly, Isabel. *Charles Chaplin: Early Comedies.* Cranbury, N.J.: A. S. Barnes, 1968.

Cocteau

Cocteau, Jean. *Cocteau on the Film.* 1954. Reprint, New York: Dover, 1972.

Disney

Schickel, Richard. *The Disney Version.* New York: Simon and Schuster, 1968.

Dreyer

Milne, Tom. *The Cinema of Carl Dreyer.* Cranbury, N.J.: A. S. Barnes, 1971.

Eisenstein

Montagu, Ivor. *With Eisenstein in Hollywood.* New York: International, 1969.

Moussinac, Léon. *Sergei Eisenstein.* New York: Crown, 1970.

Seton, Marie. *Sergei M. Eisenstein.* New York: Grove, 1960.

See also Some Theoretical Approaches.

Fellini

Boyer, Deena. *The Two Hundred Days of 8½.* New York: Macmillan, 1964.

Salachas, Gilbert. *Federico Fellini.* New York: Crown, 1969.

Flaherty

Calder-Marshall, Arthur. *The Innocent Eye: The Life of Robert J. Flaherty.* 1963. Reprint, Baltimore: Penguin, 1970.

Griffith, Richard. *The World of Robert Flaherty.* New York and Boston: Duell, Sloan; Little, Brown, 1953.

Ford

Baxter, John. *The Cinema of John Ford.* London and New York: Zwemmer and Barnes, 1971.

Franju

Durgnat, Raymond. *Franju.* Berkeley and Los Angeles: U. of California, 1968.

Frankenheimer

Pratley, Gerald. *The Cinema of John Frankenheimer.* Cranbury, N.J.: A. S. Barnes, 1969.

Godard

Cameron, Ian, ed. *The Films of Jean-Luc Godard.* New York: Praeger, 1969.

Mussman, Toby, ed. *Jean-Luc Godard: A Critical Anthology.* New York: Dutton, 1968.

Roud, Richard. *Godard.* 2nd rev. ed. Garden City, N.Y.: Doubleday, 1970.

Grierson

Hardy, Forsyth, ed. *Grierson on Documentary.* 1945. Reprint, New York: Praeger, 1972.

Griffith

Barry, Iris. *D. W. Griffith: American Film Master.* New York: Museum of Modern Art, 1965.

Brownlow, Kevin. *The Parade's Gone By.* New York: Ballantine, 1969.

O'Dell, Paul. *Griffith and the Rise of Hollywood.* Cranbury, N.J.: Barnes, 1970.

Ramsaye, Terry. *A Million and One Nights.* 1926. Reprint, New York: Simon and Schuster, 1964.

Silva, Fred, ed. *Focus on "The Birth of a Nation."* Englewood Cliffs, N.J.: Prentice-Hall, 1971.

Hitchcock

Perry, George. *The Films of Alfred Hitchcock.* New York: Dutton, 1965.

Truffaut, François. *Hitchcock.* New York: Simon and Schuster, 1967.

Wood, Robin. *Hitchcock's Films.* London and New York: Zwemmer and Barnes, 1965.

Ivens

Grelier, Robert. *Joris Ivens.* Paris: Editeurs Français Réunis, 1965.

Ivens, Joris. *The Camera and I.* New York: International, 1969.

Kubrick

Agel, Jerome, ed. *The Making of Kubrick's 2001.* New York: New American Library, 1968.

Walker, Alexander. *Stanley Kubrick Directs.* New York: Harcourt, 1971.

Kurosawa

Richie, Donald. *The Films of Akira Kurosawa.* Berkeley and Los Angeles: U. of California, 1965.

Lang

Bogdanovich, Peter. *Fritz Lang in America.* New York: Praeger, 1969.

Jensen, Paul M. *The Cinema of Fritz Lang.* Cranbury, N.J.: Barnes, 1969.

Lorentz

Snyder, Robert L. *Pare Lorentz and the Documentary Film.* Norman: U. of Oklahoma, 1968.

Lubitsch

Weinberg, Herman G. *The Lubitsch Touch: A Critical Study.* New York: Dutton, 1968.

Mamoulian

Milne, Tom. *Rouben Mamoulian.* Bloomington: Indiana U., 1969.

Marx Brothers

Eyles, Allen. *The Marx Brothers: Their World of Comedy.* Cranbury, N.J.: A. S. Barnes, 1966.

Murnau

Eisner, Lotte H. *Murnau.* Berkeley and Los Angeles: U. of California, 1973.

Pasolini

Pasolini on Pasolini. Interviews with Oswald Stack. Bloomington: Indiana U., 1969.

Penn

Wood, Robin. *Arthur Penn.* New York: Praeger, 1970.

Renoir

Bazin, André. *Jean Renoir.* New York: Simon and Schuster, 1973.

Braudy, Leo. *Jean Renoir, the World of His Films.* Garden City, N.Y.: Doubleday, 1972.

Resnais

Armes, Roy. *The Cinema of Alain Resnais.* Cranbury, N.J.: A. S. Barnes, 1968.

Ward, John. *Alain Resnais or the Theme of Time.* Garden City, N.Y.: Doubleday, 1968.

Rossellini

Guarner, José Luis. *Roberto Rossellini.* New York: Praeger, 1970.

Sennett

Sennett, Mack, and Cameron Shipp. *King of Comedy.* Garden City, N.Y.: Doubleday, 1965.

Truffaut

Petrie, Graham. *The Cinema of François Truffaut.* Cranbury, N.J.: Barnes, 1970.

Vigo

Feldman, Joseph and Harry, eds. *Jean Vigo.* London: British Film Inst., 1950.

Smith, John M. *Jean Vigo.* New York: Praeger, 1972.

Visconti

Nowell-Smith, Geoffrey. *Luchino Visconti.* Garden City, N.Y.: Doubleday, 1968.

Von Sternberg

Baxter, John. *The Cinema of Joseph von Sternberg.* Cranbury, N.J.: A. S. Barnes, 1971.

Sarris, Andrew. *The Films of Josef von Sternberg.* New York and Garden City, N.Y.: Museum of Modern Art, Doubleday, 1966.

Weinberg, Herman G. *Josef von Sternberg: A Critical Study.* New York: Dutton, 1967.

Von Stroheim

Finler, Joel. *Stroheim.* Berkeley and Los Angeles: U. of California, 1968.

Noble, Peter. *Hollywood Scapegoat: The Biography of Erich von Stroheim.* London: Fortune, 1950.

Welles

Cowie, Peter. *The Cinema of Orson Welles.* London and New York: Zwemmer and Barnes, 1965.

Gottesman, Ronald, ed. *Focus on "Citizen Kane."* Englewood Cliffs, N.J.: Prentice-Hall, 1971.

Higham, Charles. *The Films of Orson Welles.* Berkeley and Los Angeles: U. of California, 1970.

Collected Essays and Interviews with Directors

Geduld, Harry M., ed. *Film Makers on Film Making.* Bloomington: Indiana U., 1967.

Gelmis, Joseph. *The Film Director as Superstar.* Garden City, N.Y.: Doubleday, 1970.

Hughes, Robert, ed. *Film: Book I. The Audience and the Filmmaker.* New York: Grove, 1959.

———. *Film: Book II. Films of Peace and War.* New York: Grove, 1962.

Sarris, Andrew, ed. *Interviews with Film Directors.* New York: Bobbs-Merrill, 1967.

Sherman, Eric, and Martin Rubin. *The Director's Event.* New York: New American Library, 1972.

Cinematographers

Brownlow, Kevin. *The Parade's Gone By.* New York: Ballantine, 1969.

Higham, Charles. *Hollywood Cameramen.* Bloomington: Indiana U., 1970.

Maltin, Leonard. *Behind the Camera.* New York: Signet, 1971.

SCREENPLAYS

Antonioni

Screenplays of Michelangelo Antonioni. (L'Avventura, Il Grido, La Notte, L'Eclisse.) New York: Orion, 1963.

L'Avventura. New York: Grove, 1969.

Di Carlo, Carlo, ed. *Il deserto rosso di Michelangelo Antonioni.* Bologna: Capelli, 1964.

Red Desert. Zabriskie Point. New York: Simon and Schuster, 1972.

Bergman

Four Screenplays of Ingmar Bergman. (Smiles of a Summer Night, Wild Strawberries, The Seventh Seal, The Magician.) New York: Simon and Schuster, 1960.

Seventh Seal. New York: Simon and Schuster, 1969.

Bergman's Trilogy: Through a Glass Darkly, The Communicants—Winter Light, The Silence. New York: Grossman, 1967.

Persona. New York: Grossman, 1972.

Steene, Birgitta, ed. *Focus on "The Seventh Seal."* Englewood Cliffs, N.J.: Prentice-Hall, 1972.

Buñuel

L'Age d'Or, Chien Andalou. New York: Simon and Schuster, 1968.

Three Screenplays: Viridiana, The Exterminating Angel, Simon of the Desert. New York: Grossman, 1969.

Clair

À Nous la liberté and Entr'acte. New York: Simon and Schuster, 1970.

Viazzi, Glauco, ed. *Entr'acte.* Milan: Poligno Societa, 1945.

Cocteau

Two Screenplays: Blood of a Poet, Testament of Orpheus. Baltimore: Penguin, 1969.

The Blood of a Poet. New York: Bodley Head, 1949.

Eisenstein

Lanza, Pier Luigi, ed. *La Corazzata Po-*

Eisenstein (cont'd.)

tiomkin (1925). Milan and Rome: Fratelli Bocca, 1954.

Potemkin. New York: Simon and Schuster, 1968.

Ivan the Terrible, I and II. New York: Simon and Schuster, 1962.

Fellini

La Dolce Vita. New York: Ballantine, 1961.

8½. New York: Ballantine, 1970.

Boyer, Deena. *The Two Hundred Days of 8½*. New York: Macmillan, 1964.

Juliet of the Spirits. New York: Ballantine, 1965.

Ford

Nichols, Dudley, and John Gassner, eds. *The Informer*, in *Theater Arts*, New York, vol. 35, August 1951.

Godard

Masculine-Feminine. New York: Grove, 1969.

Weekend. (With Wind from the East.) New York: Simon and Schuster, 1972.

Griffith

Huff, Theodore, ed. *Birth of a Nation*. New York: Museum of Modern Art, 1961.

Intolerance. New York: Simon and Schuster, 1971.

Hopper

Fonda, Peter, Dennis Hopper, and Terry Southern. *Easy Rider*. New York: New American Library, 1969.

Huston

Let There Be Light, in *Film: Book II*, by Robert Hughes. New York: Grove, 1962.

Kurosawa

Ikiru. New York: Simon and Schuster, 1969.

Rashomon. New York: Grove Press, 1969.

Lorentz

The River. New York: Stackpole, 1938.

Penn

Herndon, Venable, and Arthur Penn. *Alice's Restaurant*. Garden City, N.Y.: Doubleday, 1970.

Resnais

Cayrol, Jean, and Alain Resnais. *Night and Fog*, in *Film: Book II*, by Robert Hughes. New York: Grove, 1961.

Duras, Marguerite, and Alain Resnais. *Hiroshima, mon amour*. New York: Grove, 1961.

Robbe-Grillet, Alain. *Last Year at Marienbad*. New York: Grove, 1962.

Semprun, J., and Alain Resnais. *La Guerre est finie*. New York: Grove, 1967.

Robbe-Grillet

L'Immortelle. New York: French and European, 1963.

Sjöman

I Am Curious (Yellow). New York: Grove, 1968.

Truffaut

The 400 Blows. New York: Grove, 1969.

Jules and Jim. New York: Simon and Schuster, 1968.

Von Sternberg

The Blue Angel. New York: Simon and Schuster, 1968.

Von Stroheim

Greed. New York: Simon and Schuster, 1970.

Weine

The Cabinet of Dr. Caligari. New York: Simon and Schuster, 1970.

Welles

Welles, Orson, H. J. Mankiewicz, and Pauline Kael. *The Citizen Kane Book*. Boston: Atlantic-Little, Brown, 1971.

STUDIES OF PARTICULAR FILMS

Agel, Jerome, ed. *The Making of Kubrick's 2001*. New York: New American Library, 1968.

Boyer, Deena. *The Two Hundred Days of 8½*. New York: Macmillan, 1964.

Gottesman, Ronald, ed. *Focus on "Citizen Kane."* Englewood Cliffs, N.J.: Prentice-Hall, 1971.

Ross, Lillian. *Picture*. London: Victor Gollancz, 1953.

Silva, Fred, ed. *Focus on "The Birth of a Nation."* Englewood Cliffs, N.J.: Prentice-Hall, 1971.

Sjöman, Vilgot. *I Was Curious: Diary of the Making of a Film*. New York: Grove, 1968.

Steene, Birgitta, ed. *Focus on "The Seventh Seal."* Englewood Cliffs, N.J.: Prentice-Hall, 1972.

COLLECTIONS OF CRITICISM

Agee, James. *Agee on Film: Reviews and Comments*. Boston: Beacon, 1964.

Alpert, Hollis, and Andrew Sarris, eds. *Film 68/69: An Anthology by the National Society of Film Critics*. New York: Simon and Schuster, 1969.

Battcock, Gregory, ed. *The New American Cinema: A Critical Anthology*. New York: Dutton, 1967.

Crist, Judith. *The Private Eye, The Cowboy and the Very Naked Lady*. New York: Holt, Rinehart, 1968.

Denby, David, ed. *Film 70/71: An Anthology by the National Society of Film Critics*. New York: Simon and Schuster, 1971.

Farber, Manny. *Negative Space*. New York: Praeger, 1971.

Ferguson, Otis. *The Film Criticism of Otis Ferguson*. Philadelphia: Temple U., 1971.

Jacobs, Lewis, ed. *The Emergence of Film Art*. New York: Hopkinson and Blake, 1969.

Kael, Pauline. *Going Steady*. Boston: Little, Brown, 1970.

———. *I Lost It at the Movies*. Boston: Little, Brown, 1965.

———. *Kiss Kiss Bang Bang*. Boston: Little, Brown, 1968.

Kauffmann, Stanley. *Figures of Light: Film Criticism and Comment*. New York: Harper and Row, 1971.

———. *A World on Film: Criticism and Comment*. New York: Harper and Row, 1966.

Reed, Rex. *Conversations in the Raw*. Cleveland and New York: World, 1969.

Robinson, W. R., ed. *Man and the Movies*. Baltimore: Penguin, 1967.

Rotha, Paul. *Rotha on the Film*. Fair Lawn, N.J.: Essential, 1958.

Sarris, Andrew. *The American Cinema*. New York: Dutton, 1968.

_____. *Confessions of a Cultist: On the Cinema, 1955–69.* New York: Simon and Schuster, 1970.

Schickel, Richard, and John Simon, eds. *Film 67/68: An Anthology by the National Society of Film Critics.* New York: Simon and Schuster, 1968.

Simon, John. *Movies into Film.* New York: Dial, 1971.

Sitney, P. Adams, ed. *The Film Culture Reader.* New York: Praeger, 1970.

Talbot, Daniel, ed. *Film: An Anthology.* Berkeley and Los Angeles: U. of California, 1966.

Taylor, John Russell. *Cinema Eye, Cinema Ear: Some Key Film Makers of the Sixties.* New York: Hill and Wang, 1964.

Tyler, Parker. *The Hollywood Hallucination.* New York: Creative Age, 1944.

_____. *Magic and Myth of the Movies.* New York: Holt, Rinehart, 1947.

_____. *The Three Faces of the Film.* New York: Thomas Yoseloff, 1960.

REFERENCE BOOKS

General

Gottesman, Ronald, and Harry M. Geduld. *Guidebook to Film:* New York: Holt, Rinehart, 1972. (Books and periodicals, theses and dissertations, museums and archives, film schools, equipment and supplies, distributors, bookstores, publishers, and sources for stills, film organizations and services, festivals and contests, awards, terminology in general use.)

Spottiswoode, Raymond, ed. *The Focal Encyclopedia of Film and Television Techniques.* New York: Hastings, 1969.

Glossaries

Miller, Tony and Patricia. *"Cut! Print!": The Language and Structure of Filmmaking.* Los Angeles: Ohara, 1972.

Skilbeck, Oswald. *ABC of Film and TV Working Terms.* London and New York: Focal, 1960.

Townshend, Derek. *Photography and Cinematography: A Four Language Illustrated Dictionary and Glossary of Terms.* London: Alvin Redman, 1964.

Filmographies

American Film Institute. *The American Film Institute Catalogue: Feature Films 1921–30.* Kenneth W. Munden, ed. New York: Bowker, 1970.

American Film Institute Catalogue: Motion Pictures Produced in the United States. New York: Bowker, 1971.

Library of Congress. *Motion Pictures 1912–39.* Washington, D.C.: Library of Congress, Copyright Office, 1951.

_____. *Motion Pictures 1940–49.* Washington, D.C.: Library of Congress, Copyright Office, 1953.

_____. *Motion Pictures 1950–59.* Washington, D.C.: Library of Congress, Copyright Office, 1963.

Niver, Kemp R. *Motion Pictures from the Library of Congress Paper Print Collection, 1894–1912.* Berkeley and Los Angeles: U. of California, 1967.

Smolian, Steven. *A Handbook of Film, Theater, and Television Music on Record, 1948–69.* New York: Record Undertaker, 1970.

Weaver, John T. *Forty Years of Screen Credits, 1929–69.* Metuchen, N.J.: Scarecrow, 1970. (Actors credits.)

_____. *Twenty Years of Silents, 1908–28.* Metuchen, N.J.: Scarecrow, 1971.

Bibliographies

Federal Writers' Program. *The Film Index: A Bibliography,* Vol. I, *The Film as Art.* Harold Leonard, ed. 1941. Reprint, New York: Arno, 1966.

Larry Edmunds' Bookshop Catalogues. Los Angeles, n.d.

The New York Times. *The New York Times Film Reviews. 1913–68.* 6 vols. New York: New York Times, Arno, 1970.

Salem, James M., ed. *A Guide to Critical Reviews: Part IV: The Screenplay from "The Jazz Singer" to "Dr. Strangelove."* 2 vols. Metuchen, N.J.: Scarecrow, 1971. (Covers the period 1927–63.)

Annuals

Aaronson, Charles S., ed. *International Motion Picture and Television Almanac.* New York: Quigley. (1935, *Motion Picture Almanac;* 1937–50, *International Motion Picture Almanac.*)

Blum, Daniel, ed. *Screen World.* New York: Greenberg, 1949–.

Cowie, Peter, ed. *International Film Guide.* Cranbury, N.J.: A. S. Barnes, 1964–.

Film Daily Year Book of Motion Pictures. New York: WID's Films and Film Folk, 1917–.

Rental, Lease, and Purchase Directories

Directory of Film Libraries in North America. New York: Film Library Information Council.

A Directory of 16mm Sound Feature Films Available for Rental in the United States. James Limbacher, ed. New York: Bowker.

Educational Film Guide. New York: Wilson.

Educational Motion Pictures. Bloomington: Audio-Visual Center of Indiana U.

8mm Film Directory. Grace Ann Kone, ed. New York: Educational Film Library Assoc.

Feature Films on 8mm and 16mm. James L. Limbacher, ed. New York: Bowker, 1971.

Catalogues Published by Distributors Specializing in Avant-Garde, Experimental, Independent, and Underground Films.

Cinema 16/Grove Press
80 University Place
New York, N.Y. 10003

Creative Film Society
14558 Valerio Street
Van Nuys, California 91405

Film-Makers Cooperative
175 Lexington Avenue
New York, N.Y. 10016

Paradigm Film Distribution
6305 Yucca Street
Hollywood, California 90028

Rogosin Films
144 Bleeker Street
New York, N.Y. 10012

See also Renan, Sheldon. *An Introduction to the American Underground Film.* New York: Dutton, 1967.

Notes

Chapter 1

1. Quoted in John Simon, *Ingmar Bergman Directs* (New York: Harcourt, 1972).

Chapter 5

1. Pier Luigi Lanza, ed., *La Corazzata Potiomkin (1925)* (Milan-Rome: Fratelli Bocca Editori, 1954).
2. David Mayer, *Sergei Eisenstein's Potemkin* (New York: Grossman, 1972).

Chapter 7

1. Nox-Turnabout, *Electronic Music*, TV 4046.
2. RCA Victor International, *La Dolce Vita*, FOC-1.

Chapter 8

1. Robert Hughes, ed., *Film: Book II. Films of Peace and War* (New York: Grove, 1962), p. 240.
2. Alain Robbe-Grillet, *Last Year at Marienbad* (New York: Grove, 1962), p. 10.
3. *Ibid.*, p. 37.
4. *Ibid.*, pp. 22–26.
5. *Ibid.*, p. 151.
6. *Ibid.*, p. 165.
7. *Ibid.*, p. 12.

Chapter 9

1. Glauco Viazzi, ed., *Entr'acte* (Milan: Poligno Societa Editrice, 1945).

Chapter 11

1. Orson Welles and Herman J. Mankiewicz, *The Citizan Kane Book*, with an introduction by Pauline Kael (Boston: Atlantic-Little Brown, 1971).
2. Vilgot Sjoman, *I was Curious: Diary of the Making of a Film* (New York: Grove, 1968).
3. Charles Higham, *Hollywood Cameramen* (Bloomington: Indiana U., 1970).
4. Sven Nykvist in *American Cinematographer*, October 1962.
5. Kevin Brownlow, *The Parade's Gone By* (New York: Ballantine, 1969), p. 344.
6. V. I. Pudovkin, *Film Technique and Film Acting* (New York: Grove, 1958), p. 168.
7. Pierre Leprohon, *Michelangelo Antonioni* (New York: Simon and Schuster, 1963).
8. Lillian Ross, *Picture* (London: Victor Gollancz, 1953).

Glossary

*This glossary includes many terms and descriptions of processes
not found in the body of the text,
partly in the hope that readers pursuing the subject in other literature
and teachers desiring to give more attention to technical aspects
of filmmaking will find such information useful.
In addition, the glossary summarizes much of the material
that is treated in greater depth in the text.*

A and B rolls In *printing*, an arrangement of *shots* used to eliminate visible *splices* and to facilitate the printing of *optical effects*.

abstract film A film composed of mobile lines, shapes, and colors that do not explicitly describe the appearance of the physical world.

accelerated time Time compressed into a shorter than normal period, usually by means of *editing*: phases of an action can be excised by means of *jump cuts* or, when the action is described completely, by a series of *dissolves*; accelerated time may be produced mechanically by *fast motion* and *time-lapse photography*.

action In film context, whatever occurs in a *shot* or *scene*.

action film A *film* that includes much physical movement—sporting events, fights, chases, natural and man-made catastrophes, acrobatics, and derring-do.

actor Person playing a role in a *film;* also, a player.

aerial-image process A method of combining animated drawings with live *action* or actual settings, which is carried out on an *animation stand*. The *cells* on which the drawings are made are placed on the transparent plane of the animation stand. Through a system of mirrors the image of live action or actual setting is projected from below, and the *camera* records both the images drawn on the cell and the projected images simultaneously.

anamorphic lens A *lens* in which the vertical and horizontal dimensions of an image are subject to different magnification, the vertical usually being magnified twice as much as the horizontal. The effect is a distortion of the normal proportions such that circles become ovals, squares are recorded as rectangles, and human figures are elongated.

animation Filming inanimate objects, drawings, paintings, sculptures, and the like in such a way that they seem to move. Various methods are employed, most of them involving *stop-motion* photography.

Cameraless animation: Drawing, painting, scratching, or in other ways creating images and patterns directly on the *film*. One method involves drawing each *frame* separately; another involves disregarding the frames, creating a continuous pattern on the film, and allowing the *intermittent movement* of the *projector* to separate the movement of the forms into individual phases.

Cell animation: Drawing and painting each stage of a movement on a separate *cell* or sheet, usually of transparent acetate. The cells are perforated to fit over *registration pins* to keep them in proper alignment and are usually photographed against an opaque

animation (cont'd.)
background one frame at a time, but sometimes in series of two or three.

Pixillation: Application of *single-frame* photography to human *action* and the movement of objects. A person takes a position; a single frame is *exposed;* the person moves slightly; another frame is exposed.

Puppet animation: Creating a sense of movement in three-dimensional objects by changing their positions or their expressions slightly and photographing each change frame by frame.

Tabletop animation: Making small objects like dolls seem to move by changing their positions slightly and photographing each change frame by frame in the same method as pixillation.

animation board The plane on which *animation cells* are placed during filming.

animation camera A *camera* specially designed for use in *animation*, with a drive that advances the *film* a *frame* at a time.

animation stand The apparatus on which the *animation board* and *animation camera* are mounted. It is frequently equipped with accessories for the *aerial-image process*.

answer print The first *print* of the completed *film*, in which *visual track* and *sound track* are combined, *optical effects*, if any, are printed, and sounds are *mixed* in proper balance. In effect, it becomes a model for all other prints.

aperture The *opening* through which light enters the *camera*. Its size is usually variable, controlled by the expansion and contraction of a diaphragm, that is, a set of overlapping metal plates sometimes called an iris because of its similarity to that of the human eye. Variations in size are indicated by f/numbers or f/stops, a number arrived at by dividing the *focal length* of the *lens* by the diameter of the aperture.

art director Person responsible for *sets, properties*, color relationships, *special effects*. Also called production designer.

ASA American Standards Association. Usually employed in association with numbers designating *film speeds*, the higher the number, the faster the film, that is, the more sensitive to light.

aspect ratio The ratio between the width and the height of the motion picture *frame*. So-called normal ratio is 1.35:1; for *cinemascope* the ratio is 2.5:1.

assembly The arrangement of the *shots* in a film approximately in the proper order prior to making the *rough cut*. See *editing*.

assistant director An assistant to the *director* of the *film*, who acts as a liaison with the *producer*, takes care of details for the direc-

tor, and generally follows the director's instructions.

asynchronous A relationship between the sound and the *visuals* such that the sound is not thought of as present in the *filmic space* of the *scene*.

auteur theory A theory, developed in the editorial policy of the French magazine *Cahiers du cinéma*, which regards the *director* of a *film* as comparable to the author of a literary work, and, it is assumed, one who will reveal more or less personal qualities in all his films whether he has written the *script* or not.

available-light photography Filming that uses, without any reinforcement, only whatever light happens to be present.

avant-garde As applied to *filmmakers*, those who experiment with unconventional subject matter and methods of exposition, *narration*, and expression. While any filmmaker may in fact be avant-garde—Griffith at the height of his career, for example—the term is usually reserved for filmmakers who worked outside the commercial studios beginning in the late teens and continuing through the 1950s.

back lighting Illumination from behind the subject.

back or rear projection A method of filming *actors* in the studio along with a background filmed elsewhere. The actors stand in front of a translucent *screen*; the setting is projected from behind the screen; a *camera* films both simultaneously.

background music Music used to accompany a *film*, sometimes simply to fill the silence, sometimes to reinforce or provide continuity, to perform a more active role by reinforcing or punctuating mood and *action*, by commenting on the *visuals*, or by evoking an idea external to the actual *scene*.

beamsplitter An optical device that causes light to go in two directions; for example, a lightly mirrored glass that reflects a certain percentage of the light striking it and allows the rest to pass through.

best boy A *gaffer*'s or *key grip*'s assistant.

bipack Descriptive of a method of running two films simultaneously through a *camera* or *printer*, one film often being a *mask* or a *traveling matte* for the other.

bit player An *actor* who plays a small part in a *film*.

blimp A soundproof housing for the *camera*, which prevents the sound of the mechanism from being heard or recorded.

blocking The organization of the position and movement of *actors* and *camera* in a *scene*.

bloop 1. A noise caused by a *splice* or other interruption in the *sound track*. 2. A patch

attached or painted on the *film* to eliminate an unwanted sound. 3. To eliminate an unwanted sound.

blowup An enlargement, as from 8mm *gauge film* to 16mm or from 16mm to 35mm.

boom A movable arm that serves as a mount for a microphone or *camera*. A camera boom allows the camera to move over and above the setting.

cameo The appearance of a prominent *actor* in a single *scene*.

camera A light-tight box fitted with a *lens* and constructed in such a way as to admit light and cause selected light rays to form an image on a light-sensitive ground. The basic components of a *film* camera are a body, *aperture*, *shutter*, lens, *viewfinder*, and a driving mechanism with *intermittent movement*. *Raw film* passes from a feed *reel* through a *gate* to a take-up reel. As it passes through the gate in intermittent motion, it stops momentarily while the shutter opens and an *exposure* is made.

camera angle Comparable to the angle of vision or alignment of viewer and subject. *Shots* are often designated by the camera angle employed, the norm being roughly the position of a 35mm camera with a 50mm lens horizontally aligned at shoulder height.

camera movement Movement of the *camera* takes three forms: 1. Movement of the camera lens including change of *focus* (switching sharp focus from one object to another at a different distance from the camera) and *zoom*. 2. Movement of the camera upon its support, the *pan*, *swish pan*, and *tilt*. 3. Movement of the camera with its support, *following, tracking, traveling*, and *trucking*. Various camera supports are the *boom, crane, dolly* and *crab dolly*, and *velocillator*.

camera speed The speed at which the *film* runs through the *camera*. *Normal speed* for films with an optical *sound track* is 24 f.p.s., for silent films 16 to 18 f.p.s. A speed of more than the normal number of frames per second results in the effect of slow motion when the film is *projected* at normal speed. A speed of fewer than the normal number of frames per second results in the effect of *fast motion* when the film is projected at normal speed. An extreme example of fast motion is lapsed-time or *time-lapse photography*, in which the film advances through the camera only after long intervals have passed—minutes, hours, days. Slowing the progress of the film through the camera is called under*cranking;* speeding it is called overcranking, terms derived from the time when cameras were cranked by hand.

camera tracks Tracks of wood or metal used to provide smooth passage for a *dolly* or *boom*.

cameraman or **cinematographer** The person who operates, directs, or contributes to the operation of the *camera*.

cartoon An animated drawing or painting. See *animation*.

casting director Person in charge of finding and contracting *actors* to take part in the *film*.

cell A sheet of cellulose acetate, paper, or other material on which drawings or paintings are made in the process of *animation*.

chase Broadly interpreted, any pursuit of a person, animal, thing, or idea, but usually a pursuit involving physical action, *crosscutting* from pursued to pursuer, and often a race against time.

cheat shot A *shot* calculated to convincingly portray faked *action*; for example, a man seen in a full shot hanging from a cornice 20 stories above the street when actually he hangs 2 feet above the studio floor, or a man climbing the side of a building when in fact he is crawling along a horizontal plane.

cinéma vérité An approach to filmmaking that is devoted to actuality; uses non*actors*, interviews, actual situations or events as subject matter; and recognizes the presence of the *camera*, its equipment, the crew, the filmmaking process, and in some cases the actuality of the *film* itself.

cinemascope A wide-*screen* system using *anamorphic lenses*. The image on the *film* is distorted by laterally cramping it together so that figures, for example, are elongated in appearance. When the distorted image is projected through an anamorphic lens, it regains its proper *aspect ratio*, which, after a number of changes, has been standardized at 2:1.

cinematographer See *cameraman*.

Cinerama A system for wide-screen *projection* involving three *projectors* and a complex *screen* composed of 1,110 vertical slats arranged in an arc embracing an area six times the width spanned by standard 35mm film and having an *aspect ratio* of 2.1:1.

clapper boards A pair of boards hinged to clap together at the beginning of a take. When the *film* is *edited* the first *frame* showing the meeting of the boards is synchronized with the first sound of the clap so as to establish subsequent *synchronization* between visual and optical tracks.

closure The tendency of the human eye to see groups of discrete but related objects as forming a unit or figure, for example, to see a series of dots as composing a line.

color film *Film* sensitive not only to values of light and dark, but to *hue* and *intensity*.

color mixture The mixture of two or more *hues* to produce another that is different from any of the components.

color temperature Color temperature is the temperature to which a black body—which absorbs all light—must be heated in order to give off a color matching a particular light source. It is measured in degrees Kelvin. Because light sources vary in color temperature—even the light of the sun varies during the day—and because the chemical components of an emulsion (see *film*) are balanced to record accurately at specific color temperatures, it is important to expose film under light of the appropriate color temperature or to compensate for differences by using *filters*.

color temperature meter An instrument that measures the *color temperature* of a subject or light source and indicates which *filter*, if any, must be used to obtain a relatively true rendering of color.

complementary colors In light, any two *hues* that, when mixed, will produce white.

composite A film that contains both the *sound* and visual *tracks* in *synchronization*.

concrete music Music made up of sounds not from traditional instruments but from almost anything in the environment that will produce noise.

console A control panel used to mix and balance sound from different sources.

continuity A smooth, harmonious flow from one *shot* to another. Also, a master *screenplay*.

continuity clerk A person responsible for keeping a record of all *scenes* and takes, making technical notes, and putting the information in a form useful to the *cutter*.

continuity cutting *Cutting* for the purpose of maintaining a smooth, uninterrupted flow from one *shot* to another.

contrapuntal structure A type of vertical *montage* in which color, sound, or some other element of the *film* contrasts with the *action* or comments on it.

copy film *Film* that produces a high degree of contrast between dark and light.

core A plastic, wood, or metal center on which *film* is wound.

costume designer (costumer) Person in charge of selecting, designing, and making costumes for a *film*.

countermatte A *negative* image of a *matte*.

crab dolly A *dolly* that can more or less instantaneously change its direction.

crane A large *boom*.

crank To cause the *film* to go through a *camera*; a term associated with early cameras which carried a crank turned by hand. See also *camera speed*.

credits The list of individuals involved in making a *film*, usually with an indication of the role of each.

cross lighting Illumination from the side at a raking angle.

crosscutting *Cutting* from one time or place to another within a *scene* or *sequence*.

cut 1. An instantaneous transition from one *shot* to another. 2. To physically cut *film*, to *edit*. 3. In the imperative, the order given by the director to indicate that a take has been completed and that *action*, filming, and *sound recording* should cease.

cut away To cut from the main *action* to a reaction, subordinate action, or parallel action, or from one image to another image.

cutaway 1. A *shot* that cuts away. 2. Descriptive of a shot that cuts away.

cutter The person who assembles the *film*; very often used as a synonym for *editor*.

cutting rate The relative speed with which one *shot* follows on another, the *tempo* established by the *sequence* of shots.

dailies *Prints* made immediately following a day's *shooting* for inspection by the *filmmakers*; also called rushes.

decelerated motion Motion proceeding at a slower than *normal speed*; *slow motion*, achieved by *cranking* the *camera* at a faster than *normal speed* and *projecting* the *film* at *normal speed*.

decelerated time Time extended to occupy a greater than normal span, usually achieved by *editing*.

depth of field The range of distances within which objects will be in relatively sharp *focus*. Depth of field is affected by the size of the *aperture*: the smaller the opening the greater the depth of field.

depth of focus A colloquial substitute for *depth of field*, but technically the range of distances through which the lens can be moved with respect to the surface of the *film* and still provide an image in relatively sharp *focus*.

diaphragm See *aperture*.

diffuser Any material placed in front of a lamp to diffuse and soften the light; more particularly, pieces of cellular diffusing composition. Also called jelly.

director 1. Person who is in charge of the aesthetic aspects of the *film*, who determines the manner in which the *script* will be interpreted. 2. A director of any specialized aspect of the film, for example, art, dialogue, choreography, music.

dissolve A transitional device whereby one image *fades* out as another fades in. Also known as a lap dissolve.

distance The apparent rather than actual distance of the subject from the *camera*, since long *lenses* may seem to bring a subject closer to the camera than it actually is.

documentary A factual or nonfictional *film* made up of *shots* of actual places, people, and events and having as its primary function the examination of the relationships among people or between the people and their environments or institutions.

dolly A wheeled support for the *camera* which may consist of a tripod on wheels, a bicycle, or a complex engine.

double system See *sound recording*.

dub 1. To transfer sound from one tape, *film*, or disc to another tape, film, or disc. To achieve accurate *synchronization* by the double system of *sound recording*, it may be necessary to transfer sound from discs to 16mm *sprocketed* tape. 2. To record speech or sound after the *visuals* have been shot.

Dunning process An early method of combining foreground *action* in the studio with a background *shot* elsewhere on black-and-white *panchromatic film*.

dupe A duplicate of a *film* or piece of film. A dupe *negative* is a negative made from a *positive print* of an original negative and is used for producing a *work print* and preserving the original intact and undamaged. A color positive dupe is a duplicate of a color *reversal* original. Dupes are usually designated in terms of generations. Those described would be first-generation dupes.

edge number One of a series of numbers printed along the edge of a *film* to aid in the *editing* process, allowing the *cutter* to find relatively easily a particular frame in a *shot*. Also called the footage number.

edit To assemble the *film*. The process involves a number of steps: *assembly* of selected takes; *rough cut*, in which the shots are put in order more or less as they will be in the final film, but lacking refinements in the actual length of shot and the use of *special* and *optical effects*; *fine cut*, the refinement of the rough cut with marking for special effects.

editor 1. Person who assembles the *film*. See also *cutter*. 2. A machine used to facilitate *editing*. Basically, it consists of a viewer that allows the cutter to see an enlarged image, and *rewinds*, geared devices driven either manually or by a motor. Associated with it may be a scale for measuring lengths of *film* and a *splicer*. A *sound reader* may also be coupled with it.

effect Any image or sound that does not result from direct shooting and *sound recording*. See *optical effects, sound effects, special effects*.

establishing shot A *shot* which establishes the time, place, and mood of a *film* or *sequence*.

experimental film A *film* that employs unfamiliar subject matter, new technical methods, or new methods of *narration* and exposition.

exploitation film A film produced for the purpose of commercially exploiting current interests or fads like motorcycling.

exposure The process of exposing *film* to light so that a *latent image* is recorded in the emulsion. The character or quality of the image is determined largely by the relationship between the *film speed*, the size of the *aperture*, and the length of time the *shutter* is open.

Overexposure: In the negative-positive process, overexposure will produce a dense *negative* and light *positive* image.

Underexposure: In the negative-positive process, underexposure will produce a relatively thin negative and a dark positive image.

exposure meter An instrument for measuring the amount of light and calculating the proper *exposure*.

extended flashback A *flashback* extended in time so that it forms a large part or even the bulk of the *film*.

extra A person who plays no role in a *film* but helps to establish the background, as in a street scene.

fade-in A transitional device, or *optical effect*, in which an image gradually appears on the *screen* as a result of increasing definition and contrast. It is achieved in *printing* by gradually increasing the *exposure*.

fade-out A transitional device, or *optical effect*, in which an image gradually disappears as a result of a reduction of definition and contrast. It is achieved in the *printer* by gradually reducing the *exposure*.

fast motion Motion at a speed faster than *normal speed*, achieved by running the *film* through the *camera* at a rate slower than the normal rate and projecting it at the normal rate.

feature film Originally, the main *film* on a program. Since the main film usually lasted an hour or longer, the word has come to mean any film of feature length.

fictional film A film involving characters, things, and events more or less invented by the author.

fill light Illumination that fills or brightens shadows. See also *lighting*.

film 1. The physical material of the motion picture, composed of a transparent base or support of cellulose nitrate or cellulose acetate (the former highly combustible, the latter safety or fire-resistant film). The base

supports an emulsion, which in photographic terminology is a layer of light-sensitive solids suspended in a colloid. 2. A series of static images recorded on celluloid and projected in such a way that through *persistence of vision* they merge into a continuous flow or give the illusion of movement. 3. A work of art in the film medium. 4. The collected work of a *filmmaker*, region, nation, and so forth.

film clip A small fragment of a *film*, which may be exhibited for its intrinsic interest or interpolated into another film, as in the case of a stock shot or *library shot*.

film poem A *film* that has as its chief function the development of a metaphor.

film speed The degree of sensitivity to light characterizing a particular emulsion under controlled conditions of *exposure* and development. See *ASA*.

filmmaker In the context of this book, any person involved in the major aspects of *film* production.

filter A thin sheet of gelatin or optical glass containing a dye, which is placed in front of the *lens, shutter*, or light source to modify the light in a variety of ways.

Color filters absorb some wavelengths and transmit others. They are used to modify the *color temperature* of a light source and to change the general tonality of an image. Neutral-density filters uniformly reduce the *values*, permitting a general reduction of contrast or the use of a larger *aperture* than the unfiltered light would allow.

Polarizing filters eliminate unwanted reflections.

filter factor A number indicating how much the *exposure* must be increased to compensate for a reduction in the *intensity* of light reaching the emulsion caused by *filters*.

fine cut That stage in the *editing* process that follows the *rough cut* and in which *shots* are in the proper order and of proper length but *optical effects* have not been *printed*.

fix To bathe *film* in a solution that makes the developed image permanent.

flange A disk against which *film* is wound on a *core*.

flare An irregularly shaped flash on the *film* caused by reflections inside or outside the *camera* or by static electricity.

flash forward A *shot* or *sequence* that transports the viewer into the future with respect to the time of the *film* as a whole.

flashback A *shot* or *sequence* that transports the viewer to the past in relation to the time of the *film* as a whole.

flat lighting Generally uniform *lighting*, which tends to reduce the sense of volume and the separation of planes in space.

flicker A fluctuation in the *intensity* and sometimes the color of light projected on the *screen*. It is caused by *projection* at a speed less than that required for the *persistence of vision* to fuse the separate images into continuous image. In the flicker film the *film* is projected at *normal speed*, but the effect is induced by the rapid alternation of *hues* or *values*.

flipover wipe A *wipe* that operates as if the two images were *printed* on opposite sides of a card, which is flipped over in either a vertical or horizontal direction.

floodlights Artificial *lighting* sources capable of illuminating large areas and often distinguished by a fixed *focus*.

flutter (wow) In *sound recordings*, a deviation in frequency resulting from an irregular motion in the recording or reproducing of *tone*. Wow is a deviation in frequency that occurs at a relatively slow rate.

f/number See *aperture*.

focal length The distance from the optical center of a *lens* to the point at which the lens brings into sharp *focus* the image of an object at a hypothetically infinite distance.

focus Maximum clarity in the definition of an image.

fogging An unwanted increase in emulsion density, resulting in a lightening of the image, sometimes caused by chemicals or by accidental *exposure* to light.

follow focus A continuous change in the focusing of the *lens* necessitated by changes in the *distance* between the *camera* and the subject that cannot be accommodated by the *depth of field*.

follow shot A *shot* during which the *camera* follows movement of the subject and/or *actor*.

footage The length of a *film* or piece of film.

footage number See *edge number*.

format In visual composition, the shape of a picture. In *film* the actual format is invariably rectangular; the effective format, the area in which *action* takes place and information is presented, may be of any shape determined by a *mask* or *matte* or an interior *framing* device like an area of black shadow.

f.p.s. Abbreviation for frames per second, designating the speed at which the *film* is passing through a *camera* or *projector*.

frame 1. A single *still* photograph on a piece of film. 2. To adjust the position of the frame in *projectors* and *printers* so that the edges of the frame coincide with the edges of the *aperture*. If the two do not coincide, a *frame line* will appear.

frame count The number of *frames* in a *shot* or any other unit of a *film*.

frame enlargement See *still*.

frame line A line separating *frames* on a piece of *film*.

free recession An arrangement of persons, things, and accents of light and color so that rather than seeming to be presented in ranks parallel to the picture plane (see *parallel recession*) they appear to be freely arranged in depth in relationships that often suggest zigzags or reverse curves.

freeze frame Repetition of a single *frame* in a *film* so that when the film is projected, the movement stops, and the image becomes static.

front projection Similar to *back projection*, except that the image of the setting is projected from in front of the *screen*.

front lighting Illumination from behind the *camera*.

gaffer Chief electrician, responsible under direction of the first *cameraman* for the *lighting* of *sets*.

gate That opening in the *camera, printer,* or *projector* through which the *film* passes and at which it momentarily pauses as light is transmitted to it or through it.

gauge The size of a *film* as measured by its width. Common gauges are 8mm, super 8mm, 16mm, 35mm, 65mm, and 70mm. Super 8mm is the same width as standard 8mm but its *sprocket holes* are so placed as to allow for a larger picture. 8mm is regarded as an amateur gauge, 16mm and larger as professional gauges. Commercial movie houses usually project films of 35mm gauge or larger.

glass shot A method of combining a painted or photographed setting with live *action* in an actual setting. A portion of the setting is painted or, in the case of a photograph, mounted on a sheet of glass. The glass is placed in front of the *camera* so that the edges of the painting or photograph are congruent with parts of the actual setting. The two are photographed together.

grip Person who has charge of minor adjustments and repairs to *props, camera tracks,* and other equipment.

guillotine A *wipe* occurring in a vertical direction.

halation A halo of light surrounding a very bright image on *film*.

head The beginning end of a *film*.

highlighting Creation by means of strong illumination of bright, high *value* points or areas in a subject for the purpose of added interest and emphasis.

hot spot An area of extremely reduced contrast created by intense illumination. While usually undesirable, hot spots can be employed for special expressive effects.

hue That aspect of a color *tone* determined by its wavelength; simply, the characteristic allowing the human eye to distinguish a color as red, blue, and so forth. See also *color mixture*.

informal presentation The organization of the various aspects and elements of a *film* so that there seems to be no obvious calculation. *Camera angles* are usually those of a hypothetical observer, acting, *lighting*, color, and sound are natural, and the length of the *shots* and their interrelationship emerge out of the *narration* or exposition rather than reflecting any theoretical schema.

infrared A section of the spectrum just beyond the visible red wavelengths, portions of which can be registered upon certain specially sensitized emulsions.

intensity The relative degree of saturation of a *hue*, for example, the degree of redness in a red.

intercutting Interrupting a continuous *action* by a *cutaway*.

interlock Electronic *synchronization* of two or more motors so that, for example, filming and *sound recording* can proceed at exactly the same speed.

intermittent movement The manner in which the *film* proceeds through a *camera, printer,* or *projector* or the device that transports it, the film advancing while the *shutter* is closed, remaining still while the shutter is open.

iris A *wipe* that causes a scene to expand or contract in circular form. To "iris in" is to come in on the subject, to expand the circle; to "iris out" is to leave the subject, to contract the circle.

jelly See *diffuser*.

jump cut A *cut* made within a *shot* to eliminate unwanted material or to create a particular expressive effect. In the best of circumstances the cut will be relatively imperceptible; otherwise, a sudden shift or jump will appear within the *frame*.

key In lighting, the general tonality. A *shot* in a high key is generally light in tonality, a shot in low key generally dark.

key grip Chief overseer of the *grips*.

key light The principal illumination of a scene. See *lighting*.

latent image An invisible image recorded in the photographic emulsion after *exposure* to light and prior to the development, which makes it visible.

latitude The range of *exposures*, in terms of *film speed, aperture,* and time, which, given specific conditions of development, will produce a reasonably accurate image on a particular *film*.

leader A piece of *film* attached to the *head* or the *tail* of a film which is used to thread the film through the *projector* and to protect the body of the film from handling and damage. Academy leader is made in accordance with the specifications of the Academy of Motion Picture Arts and Sciences. It contains, among other things, something on which the *projectionist* can *focus* and a count down from ten to three so that the film can be positioned in the projector properly with the first *frame* in the *gate*.

lens A transparent or translucent optical device of glass or plastic which transmits light to the emulsion in a *camera* or *printer* or to the *screen* in a *projector*. It may include one or more components called elements. See also *focal length*.

library shot A *shot* or *sequence* filed for possible use and rented or sold to production companies for inclusion in their *films*. Also called stock shot.

light valve A means of controlling the amount of light passing through an opening. An optical *sound track* is in effect a light valve.

lighting The manner in which a *set* or *scene* is illuminated. Often two types of light are involved: *key light* and *fill light*. The relationship between the key light and the fill light determines the amount of contrast, that is, whether the general tonality will be in a high key or a low key. Lighting can be described according to its direction or the position of the source as *back lighting, cross lighting, front lighting,* and *top lighting*. Filming may be done by *available light*, by available light supplemented by reflected or artificial light, or by artificial light alone. Artificial sources are of various types, the most basic being *floodlights* and *spotlights*.

lip sync *Synchronism* of sound and lip movement.

live recording Original, on-the-spot *sound recording* of the physical world as opposed to rerecording or *dubbing*.

long lens A *lens* distinguished by greater than normal *focal length* and also called a long-focus lens. A distance lens tends to reduce the depth of field and to give the illusion that deep space has been compressed, resulting in distortion of action toward or away from the *camera*. See also *telephoto lens*.

loop 1. A slack arc of *film* arranged on each side of the *gate* to reduce the tension in the film and prevent the *sprocket holes* from being torn as the film passes through a machine. 2. A length of *film* or tape the two ends of which are joined together so that the film or tape will pass repeatedly through the *projector* without rewinding or

rethreading. Used in *dubbing*, promotional films, and some art films.

mask A form of light modulator consisting of a strip of *film* containing opaque areas intended to block transmission of light. See also *matte*.

matching cut A *cut* joining two *shots* that match, resemble, or harmonize with one another in some way, in spatial organization, color, movement, position of subject, and so on. See also *continuity cutting*.

matte Basically a *mask* used to change the shape of the *format*, to create *optical effects* like *wipes*, or to create certain *special effects*. It may be a piece of material with a hole cut in it or a diaphragm capable of changing its shape, in which case it is usually mounted in a *matte box*. Or it may be a strip of *film* on which a mask has been *printed*, in which case it is a *matte roll* or *traveling matte* and is used in a *bipack*.

matte box A box mounted in front of a *lens* which serves as a hood or light shield and as a holder for *mattes* and *filters*.

matte roll A strip of *film* on which a *mask* is printed. Used in *bipack printing* or *shooting*, it is employed to change the *format* of the image or to create *optical effects* like *wipes* or *special effects*. Certain optical effects and special effects require the use not only of a matte but of a *countermatte*.

mirror shot Essentially a *glass shot* that uses a reflected image rather than an image painted or mounted on the glass.

mix To bring together in proper relationship sounds from various sources.

mixer 1. The principal person in charge of recording, *mixing*, and balancing sound for the *sound track*. 2. A term for the mixing equipment.

mixing session A phase in *film* production when sounds from a variety of sources are assembled and adjusted to one another in *tone* and volume.

mode Method of *narration* or exposition.

model shot A *special effect shot* wherein models substitute for things too expensive to rent, construct, or destroy, such as ships or skyscrapers.

montage Basically, the manner in which a *film* or part of a film is put together, hence *editing*. But in the United States, the use of *superimpositions*, rapid *cutting*, fast *dissolves*, and other means to convey a particular point like the passage of time, the ambience of a place. And in the theory and practice of the Russian director Sergei Eisenstein, editing by conflict or contrast in a dialectical scheme in which the statement of a thesis and an antithesis leads to a new idea, the synthesis; that is, one *shot* plus an-

other shot together create an idea different from but including both shots.

moviola The proprietary name of an *editing* machine that allows for viewing the *visuals* and hearing the *sound track* in *synchronization* or separately. Colloquially it has come to be applied to editing machines in general.

narration 1. Spoken commentary or recited story detail accompanying *film visuals*. 2. A method of developing ideas. Several types are differentiated:

Continuous narration: Narration in which events succeed one another in chronological order or exposition developed through a logical sequence of ideas.

Involuted narration: Narration or exposition that moves freely in time, and when past, present, and future seem overlapping and the relationships among them relatively ambiguous.

Narration in indefinite time: Interpolation of *shots, scenes,* and *sequences* that have no specific or even necessary temporal relationship to the chronology of events being narrated. It is used for metaphorical excursions and comments by the author.

Parallel narration or exposition: Arrangement of two or more lines of *action* or thought in alternating or cyclical sequence so that the viewer's attention moves from one time or space to another. See also *cutaway, flash forward, flashback*.

Simultaneous narration: Narration of two or more events taking place simultaneously but in different places, achieved by arranging shots, series, and sequences in alternation or in cycles that move the spectator from one place to another. Often described as parallel narration. See also *cutaway*.

negative A processed *film* in which the *tones* are complementary to the original tones photographed, that is, blacks are whites and reds are greens. See also *color mixture*.

Neo-Realism An approach to filmmaking that stressed an investigation of social problems, the use of nonprofessionals as *actors*, and the utilization of actual settings rather than studio constructions. It began to emerge primarily in Italy just before World War II and continued to be used into the 1970s.

New Wave (nouvelle vague) A group of *filmmakers* who made their first *feature films* in 1959–60, some of them originally critics, others technicians.

normal speed A speed at which the *film* passing through the *camera* and *projector* will provide a reproduction of motion occupying the same span of time as it did in fact.

normal time Time as measured by the clock; *action, narration,* or exposition that occu-

normal time (cont'd.)
pies only that amount of time it would take if actually occuring before the spectator.

open up 1. In using a *camera*, to open up the diaphragm. (See *aperture*.) 2. In constructing a *screenplay*, to find ways of getting away from a single *set*, especially when translating a stage play to the *screen*.

optical effects *Special effects* produced on an optical *printer*. These include: enlargement of part of an image, reduction of the whole image within the *frame*, *superimpositions*, *reverse motion*, simulated *traveling*, *panning*, *tilting* and *zooming*, and *split-screen* and transitional effects such as *dissolves* and *wipes*.

organic In pictorial composition, descriptive of a configuration in which the parts flow into one another to create a continuous whole rather than being sharply distinguished from one another. In filmmaking, revealing *action* or movement in an *informal* way rather than analyzing it into discrete *shots*.

orthochromatic film A black-and-white *film* that, since it is sensitive to all *hues* but red, will produce relatively true color *values* for all hues except red. Used in the early history of the motion picture, it accounts for the black lips often seen in old movies.

out of sync Descriptive of a lack of synchronism in a *film* such that its sound and picture are not perceived in proper relationship.

out-take *Shots*, takes, or bits of *film* not appearing in the *release print*.

overcrank See *camera speed*.

overlap dialogue The extension of a dialogue from one *shot* to another in which it does not belong.

pan *Camera movement* in which the camera rotates horizontally on the vertical axis of its support.

pan focus Clarity of *focus* from foreground to *distance*.

panavision A proprietary wide-*screen* method that uses variable prismatic *anamorphic lenses*, generally in conjunction with 65mm *film*.

panchromatic film Black-and-white film with an emulsion sensitive to all *hues*, so that it correctly translates them into color *values*.

panorama (panoramic shot) As distinct from a *pan*, a *shot* of vast *scope*.

parallel recession An arrangement of visual materials such that they seem to recede in planes parallel to the picture plane.

parallel structure A kind of vertical *montage* in which *action*, color, and sound reinforce or parallel one another in some way, by rhythm of movement, *cutting rate*, or mood, for example.

persistence of vision Tendency of the human retina to retain an image for a short period of time (about a tenth of a second) after the image has in fact disappeared. A phenomenon that allows the viewer to see a series of *projected still* photographs alternating with darkness as presenting a continuously present image.

pixillation See *animation*.

positive A processed *film* in which the *tones* are rendered in their normal relationship of *values* or color.

post-synchronization The adding of speech or *sound effects* to already existing *visuals*.

preview Colloquial term for *trailer*.

primary colors or **hues** Those *hues* whose variously proportioned mixtures will theoretically yield all other hues. In light the primaries are generally identified as red, green, and blue-violet; in pigments red, yellow, and blue.

print Film containing a *positive* image.

printer A machine for making *prints* or *positive* images from *negatives* or from other positives.

process shot A *special effect shot* combining two or more images by *back projection*, *front projection*, or the *Dunning process*.

processing The series of operations involved in revealing and fixing the *latent image* on a *film*, including developing, *fixing*, hardening, washing, and drying.

producer Person who is responsible for the business aspects and commercial success of the *film*, the acquisition of *scripts*, selection of personnel, general supervision of the filming, merchandising, and promotion. The producer may exercise artistic control as well.

project 1. To operate a *projector*, to throw an image on a *screen*. 2. To convey an emotion, feeling, intuition, idea, voice.

projectionist Person who runs a *projector*.

projector Machine for projecting images through space to a *screen*. Projectors vary in their capabilities and functions. Some project only silent *film*; some reproduce sound, which may be recorded on an optical or magnetic track on the film or on a separate *sprocketed* film; some run at a fixed speed and some permit wide variation in running speed, allowing for various kinds of analysis.

props Properties, articles to be used in a *film*.

push-off A *wipe* in which one *shot* seems to push another off the *screen*.

pushover wipe Another term for a *push-off*.

raking light *Lighting* directed across the surface of a volume at an extreme angle of inclination. It has the effect of throwing the volume and the texture into sharp relief.

raw footage Unedited *film*.

raw stock (raw film) Film that has not been *exposed* to light, that contains no *latent image*, and that has not been *processed*.

reaction shot A *cutaway* that reveals the reaction of a person to something that has been said or done or to a general situation.

reader See *sound reader*.

record film A *film* that has as its primary purpose the recording of events, scientific data, and the like.

recording See *sound recording*.

reduction print The opposite of a enlargement; the transfer of a *film* to a smaller *gauge*.

reel 1. The spool on which *film* is wound. Depending on its function, it is designated as a feed reel (or take-off reel) or a take-up reel, the film unwinding from the former as it passes through the *camera*, *printer*, or *projector* and being taken up by the latter. Reels are made in sizes of different capacity. 35mm reels will hold 1000 or 2000 feet of film; 16mm reels will hold 50, 100, 200, 400, 800, 1200, 1600, and 2000 feet. 2. A measure of a length of film that will run about 10 minutes; that is, 900 feet of 35mm film and 350 feet of 16mm when projected at 24 *f.p.s.* See also *split reel*.

reflector A reflecting surface used to deflect light into an area where it is needed or wanted.

registration pins Pins that hold a *film* or an *animation cell* in proper alignment.

release print A *print* for distribution and exhibition.

Rembrandt lighting A *lighting* style characterized by crowding or massing of lights and darks, with the latter dominating and very often with *raking light* and *rim light*.

rerecording See *dub*.

resolution, resolving power Relative capacity of a *lens* or emulsion to provide fine detail, measured in the number of lines per millimeter that can be perceived as separate.

reversal film A type of *film* which after *exposure* and development produces a *positive* image of the subject matter.

reverse motion Motion in a direction that is the reverse of normal motion and often, by implication, of normal chronological relationship; an illusion achieved by *printing* a series of *frames* in reverse order.

rewind 1. To wind the *film* back from the take-up *reel* to the feed reel. 2. A geared device for winding film from one reel to another.

rim light Light on the edges of a person or object.

rough cut A stage in the *editing* of a *work print* following the *assembly* and preceding

rough cut (cont'd.)
the *fine cut.* In the rough cut the *shots* are roughly in proper order but refinements have not been made, *intercutting* achieved, and *optical effects* indicated.

running time The length of time it takes a *film* to run through the *projector.*

rushes See *dailies.*

scenario A *script* for *screen* production organized in *scenes* and *sequences.*

scenarist See *scriptwriter.*

scene A section of *film* in which the location and time remain the same.

Schüfftan process See *mirror shot.*

scope 1. Short for *cinemascope.* 2. The amount of space encompassed by a *shot.*

score Musical composition.

screen The plane on which the *film* is projected.

script The written form of the *film.* It is developed in stages from a synopsis, which briefly tells the story, through a treatment, which fills the story out in *narrative* detail, through a master script (or master-scene script), which introduces all the dialogue and describes the action, to the shooting script, which breaks the screenplay down into *shots* and introduces information about *camera angles* and technical details.

script clerk See *continuity clerk.*

scriptwriter A person who writes the *script* or works on it, either translating already existing material like a play or a novel into filmic terms, or creating original material.

second unit A crew that films material *on location* which does not require the presence of the principal actors; such filming includes spectacular *action,* scenery, material for *back projection,* or crowd scenes.

secondary color A color that is the product of mixing two *primaries.*

segue A sound bridge that provides a transition from one sequence to another by carrying the sound over a visual cut, fade, or dissolve.

sequence A segment of a *film* that forms a more or less complete unit in itself, usually made up of more than one *shot* or *scene.* See also *sequence shot.*

sequence shot A *shot* that operates like or takes the form of a *sequence;* that is, it forms an essentially complete unit in itself and because of the movement of *actors* and *camera* or changes in *lighting* creates effects that are comparable to those that could be achieved by a series of separate shots.

set As in the theater, an artificial construction that forms the *scene* in which *action* takes place.

set dresser Person in charge of putting *properties* on the *set.*

shooting script See *script.*

short A *film* shorter than a *feature* film, usually about 30 minutes or less in length.

short-focus lens A *lens* of less-than-normal *focal length.* See also *wide-angle lens.*

shot A length of *film* during the *exposure* of which the *camera* has been running continuously or, if intermittently (as in *single framing, animation, pixillation, stop motion,* or *time-lapse photography*), seems to have been running continuously. Also, the basic unit of film structure, the shot in this case often being a fragment of the piece of film shot. When, in the course of filming, the subject—setting, scene, objects, *actors, action*—is reshot, each shot is called a take and is distinguished from the rest by a number.

shutter In the *camera,* step *printer,* or *projector,* the shutter is a device that opens to admit light to the *film* during *exposure* and closes to prevent light from reaching the film as it advances. Some shutters are variable in that they have adjustable blades to allow for variation in the amount of light reaching a film.

silent speed 16 *f.p.s.*

single-frame To *expose* the *film* one *frame* at a time rather than in bursts. Used for *animation, pixillation,* and *time-lapse photography.*

single-system See *sound recording.*

slate, slateboard A piece of slate, wood, or paper on which is written the title, *scene, take, director,* and *cameraman.* It is photographed at the head of every *shot* or take. Often it is attached to *clapper boards.*

slow motion See *camera speed.*

soft focus An effect in which the image is not in sharp *focus,* obtained by the use of a special *lens* or screen on the *camera.* Similar effects can be obtained by placing diffusing screens in front of the light source.

solarization A process in which the *film* is *exposed* to light during development so that in effect a *positive* image is *printed* on the film and the image after complete development retains characteristics of both a positive and a *negative.*

sound effects All sounds other than those of dialogue, *narration,* and music.

sound overlap Continuation of a sound associated with one *shot* over a *cut* to another *scene.*

sound reader A device comparable to a tape recorder playback, used for *editing* the *sound track.*

sound recorder Person who makes the *sound recording.* See also *mixer.*

sound recording Recording of sound, usually on quarter-inch magnetic tape or 16mm sprocketed magnetic film. There are two fundamental methods of recording a *sound track:*

Single-system, in which the sound is recorded directly on the *film* while *shooting,* a method pretty much abandoned because of the difficulties it presents in *editing* and building up a complex sound track.

Double-system, in which the sound is recorded on a tape or film separate from the *visuals.* This method facilitates editing and building up a complex sound track. See also *dub, mix, synchronization.*

sound speed 24 *f.p.s.*

sound stage Stage used for shooting *synchronous* sound; it is silenced and isolated from surroundings.

sound track The tape, *film,* or part of a film on which the sound is recorded; by extension, the sounds accompanying the *visuals.* The sound track may be physically separated from the visuals or a part of the film on which the visuals are recorded. In the latter case a magnetic track is a narrow strip of magnetic tape attached to the edge of the film; the optical track is a photographic image printed on the edge of the film. Optical sound tracks act as light *filters* controlling the amount of light reaching a photoelectric cell that transforms light waves into electrical impulses, which ultimately, after amplification, operate magnets in loudspeakers or headsets.
See also *dub, mix, projector, synchronization.*

special effects All effects visible on the *screen* that do not result from the operation of the *camera* at *normal speed* and *exposure* in what may be regarded as the customary relationship to the subject being filmed. Special effects include *fades, dissolves, superimpositions, wipes, freeze frames,* and *reverse motion,* although all of these are usually designated as *optical effects* because they are most often achieved on an optical *printer.* Special effects also include *camera speed* variations: accelerated or fast motion, slow motion, and stop motion. Except for those mentioned above, plus *cheat shots* and *model shots,* special effects are used to combine two or more images in the following ways: the *aerial image process, back* or rear *projection,* the *Dunning process, front projection,* or with the aid of *traveling mattes.*

splice 1. To join two ends of *film* together. 2. The joint that results from joining two ends of film together.

splicer A device used as an aid to *splicing film.* It includes a means of locking the ends of two pieces of film in place, cutting blades

splicer (cont'd.)
for trimming the ends, and a scraper for removing emulsion, a step that is necessary if a film splice is to be achieved.

split reel 1. A *reel* (usually metal or plastic) the sides or *flanges* of which are removable so that it accepts *core*-wound *film*. 2. A reel, that is, a length of film, containing two *short* subjects.

split screen An effect·in which the *screen* is divided into a number of separate spaces in which different images appear or the same image is repeated. The effect is achieved through the use of *traveling mattes* or *matte rolls*.

spotlighting Illumination of a limited area of a visual field in order to direct vision or achieve emphasis.

sprocket holes Holes into which *sprockets* fit.

sprockets Teeth mounted on a disk or cylinder which fit into holes in the film and drive it through a *camera, printer, editing machine,* or *projector.*

still A photograph made for publicity, record, or study. Production shots are stills made in the course of filming on the set or location. Frame enlargements are stills made from the *film* itself.

stock footage, stock shot See *library shot*.

stop down To reduce the size of the *aperture*.

stop motion A method of filming in which the *camera* is stopped while *actors* or things move into position, change position, or leave the set. Used for pixillation, for the sudden appearance and disappearance of things, or for special expressive or magical effects. Stop motion is the basic method of film *animation* in which the film is shot a *frame* at a time rather than in *continuous motion*.

story board Sketches, drawings, paintings, or *still* photographs mounted in sequence to tell the "story" of a *film* to clients, animators, and other crew members.

subjective Descriptive of a *shot, sequence, sound track,* or method of *narration* that shows images as seen by a participant in the *film*.

successive contrast An optical phenomenon in which a field of *tone* becomes alternately darker and lighter and more intense and less intense as one fixes on it.

superimposition Two or more exposures on the same strip of *film*, which may be made in the *camera* or in the *printer*. Double or multiple *exposure*.

sync mark A mark used in *editing* picture and *sound tracks* to indicate how the *film* and sound track should be lined up if the two are to be in *synchronism* (synch). See also *out of synch*.

synchronism A relationship between sound and picture such that the sound occurs in conjunction with the proper visual image.

synchronization The act of putting the *sound track* in alignment with the *visuals* so that when the *film* is *projected* the sound will occur at the proper moment.

synchronous Sound occurring at the same time as the proper visual image in the filmic space. To be distinguished from *synchronization*.

tail The end of the *film*.

take See *shot*.

take-off reel See *reel*.

take-up reel See *reel*.

Technicolor A proprietary color system that uses a special *camera* and makes separate negatives for red, green, and blue which together provide a full range of *hues, values,* and *intensities*.

tectonic In pictorial composition, an arrangement of material on a picture plane so that verticals, horizontals, triangles, and simple regular geometric shapes are stressed or implied and each part is relatively clearly described as separate from the rest and added to the rest like a building block. In *editing*, the building up of a movement, *action*, or *sequence* from separate *shots* describing separate phases.

telephoto A relatively light, compact *long-focus lens*.

theatrical A manner of· organizing space, *lighting, action,* and the overall structure of a *film* so that it resembles a stage play.

time-lapse photography An extreme of slow-motion photography in which, by means of *stop motion*, long periods of time can be condensed. It is used to follow the development of flowers, for example, or the erection of a building or the changing light effects during a day.

title Any reading matter that appears in a *film*. There are various types:
 Continuity title: A title that helps to establish or maintain *continuity* by specifying the relationship of one part of a film to another.
 Crash-in title: A main title that appears after the film has started.
 Credit titles: A list of the personnel involved in the making of a film.
 Creeper or **roll-up titles:** Titles that move or roll vertically or horizontally.
 End title: The title that indicates the end of the film.
 Main title: The title that indicates the name of the film and all the credits.
 Pan title: A title photographed by *panning*.
 Superimposed title: A title *superimposed* on a *shot* from the film.

Todd-AO Proprietary system for wide-screen *projection* employing 70mm *gauge film*.

tone 1. A particular *hue* at specific *value* and *intensity*, or a neutral tone of a particular value (visual tone). 2. A note of a particular frequency, volume, and timbre (aural tone).

top lighting Lighting directed from above the subject to be illuminated.

tracking *Camera movement* while the camera support is mounted on *camera tracks*.

tracks See *camera tracks*.

trailer A filmed advertisement for a *film* to be shown at a given theater at a later date, so called because it formerly came at the end of the exhibition of a *feature film*. Also called preview, from the phrase "Previews of Coming Attractions," which often preceded the trailer.

traveling Descriptive of any *camera movement* through space whether the camera is supported by hand or by some other means.

traveling matte A means of combining two images, for example, an *actor* shot in the studio and a setting shot elsewhere. The actor is photographed against a white background. By photographic processes the image of the actor is transformed into an opaque *matte roll* designated as the *matte* or "male." From this is *printed* a *countermatte* or "female." In the *optical printer* the matte is printed in *bipack* with the setting, which leaves the area occupied by the actor blank. Then the image of the actor is printed in bipack with the countermatte, so that setting and actor are combined.

treatment See *script*.

tripod A three-legged stand for a *camera* or other piece of apparatus.

truck A vehicle for transporting the *camera*. See *camera movement*.

trucking *Camera movement* during which the *camera* is mounted on a truck or vehicle of some kind.

turret A revolving mount attached to the front of the *camera* to which a number of *lenses* are attached.

undercrank See *crank, camera speed*.

value In reference to color, the degree of lightness or darkness.

velocillator A wheeled *camera* support which will carry the camera to a height of about 6 feet.

viewfinder An instrument for viewing, finding, or framing the picture. There are two types:
 Auxiliary finder, which does not use the taking *lens* of the camera but has its own lens system and therefore provides an image subject to parallax.
 Reflex finder, which uses the taking lens of the camera and reveals the image that will

viewfinder (cont'd.)
be registered on the *film*. The light entering the camera through the *aperture* may be reflected from a mirrored shutter blade or *beamsplitter* to a mirror and then to the eye.

vignetting A shading off of the image at the edges.

Vistavision A proprietary system for widescreen *projection* which uses 70mm *gauge film* with an *aspect ratio* of 1.85:1.

visual track The series of *stills* that make up a *film*.

visuals The photographic aspect of the total *film*.

voice-over *Narration* in words heard over the *action*, dialogue, or other sounds.

wide-angle lens A *lens* of less than normal *focal length*. The effect of a wide-angle lens is to create an image that embraces a wider field than the normal lens and gives the illusion of greater *depth of field*. *Action* toward or away from the *camera* is likely to be distorted.

wild recording, wild sound Any *sound effects* not recorded during shooting and hence not actually in *synchronism* with the images.

wipe A transitional device in which one image takes the place of another by moving across it or pushing it aside. Wipes are produced by using *mattes* and *countermattes* like those used in creating a *split screen* except that in wipes the pattern on the *matte roll* is not uniform throughout the length of the piece of film but changes in shape, size, position, or proportion. In a simple wipe one *shot* or a neutral plane seems simply to unroll over another, but great variety is possible; some of the most familiar types are the *flipover wipe*, *guillotine*, *iris*, and *push-off*.

work print A *positive print* made to be used during the *editing* process. It is usually made from a duplicate *negative* or duplicate positive. See *dupe*.

wow See *flutter*.

zoom *Camera movement* in which the camera seems to advance or retreat while maintaining sharp *focus*.

zoom lens A *lens* that varies continuously and smoothly in *focal length* from *wide-angle* to *telephoto*, from short focus to long focus. The effect of the zoom lens on the visual image is quite different from that obtained by *camera movement*, however. With the zoom lens the relative size of nearer and more distant objects does not change as it does when the camera actually moves through space. Rather, the effect is much like that which would obtain if the camera approached or retreated from a flat photograph.

zoom shot (ZS) A shot in which the apparent distance changes from far to near or near to far.

Index